ART DIRECTORS ANNUAL **80**

Executive Director
Myrna Davis

Editor
Emily Henning

Design
Vertigo Design, NYC

Copy Editor
Beth Sutinis

Associate Editor
Adam Parks

Contributing Editors
Myrna Davis, Mary Fichter,
R.O. Blechman, Jeff Goodby

Photography Editors
Emily Henning, T.A. Thomas,
Jennifer Griffiths, Glenn Kubota

Judges Photography
Greg Gorman

Published and distributed by
RotoVision SA
7 Rue du Bugnon
1299 Crans
Switzerland

Sales and Editorial Office
Sheridan House
112-116a Western Road
Hove, East Sussex
BN3 1DD, United Kingdom
Tel: +44 (0)1273 716004
Fax: +44 (0)1273 727269
Sales@RotoVision.com
www.RotoVision.com

Production and color separation by
ProVision Pte Ltd., Singapore
Tel: (65) 334 77 20
Fax: (65) 334 77 21

The Art Directors Club
106 West 29th Street
New York, NY 10001
United States of America

RotoVision SA
ISBN: 2-88046-680-6

Printed in Singapore

contents

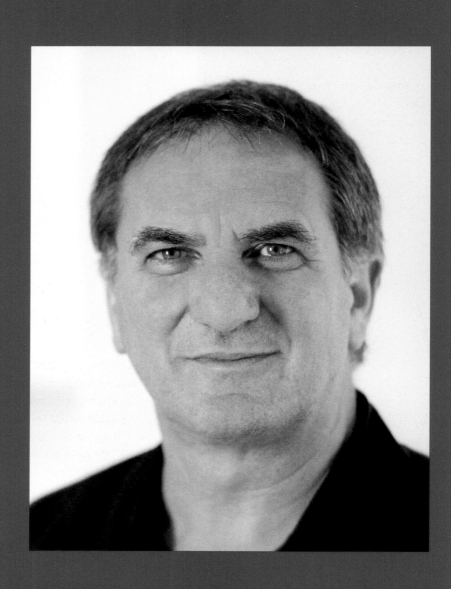

The Art Directors Club is involved in the ongoing process of expanding and upholding its mission to be at the forefront of visual communications excellence. Technology has drastically changed the way we work, think, do business, relate, and entertain. It has fostered a new era.

The amount of information vying for one's attention daily, through print ads, television spots, package design, logos, and billboards, is of staggering proportions. The new generation's attention span has been greatly diminished by television, video games, and an unimaginative educational system. Passivity disguised as interactivity has become the norm.

For eighty years, the Art Directors Club has set standards of excellence by which advertising and design are measured. Over the decades, the industry

For eighty years, the Art Directors Club has set standards of excellence by which advertising and design are measured.

as a whole has gravitated toward this criteria, which have positively impacted the culture in which we live. The ADC maintains the responsibility of safeguarding the conditions that foster creativity.

This effort is supported by the dictum of "Visual Fuel," the newly developed identity program, the new Web site for the club, and the innovative Young Guns NYC exhibitions.

The Art Directors Annual No. 80 is a compendium of the past year's exceptional work in advertising, graphic design, new media, and editorial design. This along with the Hall of Fame, which honors the industry's visionaries by paying homage to their lifetime achievements in the visual arts, serves as the cornerstone of design history. The Board of Directors, a most distinguished group of professionals, is dedicated to preserving this on-going legacy.

As for me, what is most exhilarating is the notion of what is to come.

—Richard Wilde,
PRESIDENT OF THE ART DIRECTORS CLUB

The Art Directors Club is proud to present the best work of the year in advertising, graphic design, and new media from around the world, and these winners of the 80th Annual Awards have earned their place in history. Entries to the 80th Annual Awards Competition reached a record this year, and were selected from more than 17,000 entries from 52 countries. Graphic design chair Stefan Sagmeister, new media chair Peter Girardi of Funny Garbage, and advertising chair Susan Hoffman of Wieden + Kennedy chose judges who were tough and demanding, and the juries worked days on end to insure an inspiring show.

New media entries grew to 1,100 this year, and winners are featured on a DVD-ROM, as well as in this book, as are advertising and graphic design broadcast

Entries to the 80th Annual Awards Competition reached a record this year, and were selected from more than 17,000 entries from 52 countries.

commercials. Gold and Silver Medalists and Distinctive Merit winners from many parts of the world converged at the ADC Gallery in New York on June 6th for the 80th Annual Awards gala party, sponsored by Stone, and the exhibition preview. The works are also being presented on the ADC Web site and in four traveling exhibitions supported by Getty Images that will be on view around the world throughout the year.

Also documented in the book are this year's Hall of Fame laureates, the wide range of events and exhibitions held at the Gallery, the Saturday High School Workshops, and the Art Directors Scholarship Foundation student recipients. Special thanks to Aquent, our international career partner, for funding the Aquent Room for Members, the Young Guns NYC 3 biennial exhibition and catalog, and the ADC Interactive Symposia series; and to Kodak for funding The Kodak Room, a gallery and conference space, and for presenting an exhibition of great cinematographers, "The Art of the Commercial."

Thank you also to all our members, board members, and sponsors who have contributed so much throughout the year. Design Machine has created a new typeface and identity for the organization this year, and Platinum Design has created an all-new Web site, to mention just two. We are grateful for your generous time and support.

—Myrna Davis,
EXECUTIVE DIRECTOR OF THE ART DIRECTORS CLUB

hall of fame

The Art Directors Hall of Fame was established in 1971 to recognize and honor those innovators whose lifetime achievements represent the highest standards of creative excellence.

Eligible for this coveted award, in addition to art directors, are designers, typographers, illustrators, and photographers who have made significant contributions to art direction and visual communications.

The Hall of Fame Committee, from time to time, also presents a Hall of Fame Educators Award to those educators, editors, and writers whose lifetime achievements have significantly shaped the future of these fields.

1972
M.F. Agha
Lester Beall
Alexey Brodovitch
A.M. Cassandre
René Clark
Robert Gage
William Golden
Paul Rand

1973
Charles Coiner
Paul Smith
Jack Tinker

1974
Will Burtin
Leo Lionni

1975
Gordon Aymar
Herbert Bayer
Cipes Pineles Burtin
Heyworth Campbell
Alexander Liberman
L. Moholy-Nagy

1976
E. McKnight Kauffer
Herbert Matter

1977
Saul Bass
Herb Lubalin
Bradbury Thompson

1978
Thomas M. Cleland
Lou Dorfsman
Allen Hurlburt
George Lois

1979
W.A. Dwiggins
George Giusti
Milton Glaser
Helmut Krone
Willem Sandberg
Ladislav Sutnar
Jan Tschichold

1980
Gene Federico
Otto Storch
Henry Wolf

1981
Lucian Bernhard
Ivan Chermayeff
Gyorgy Kepes
George Krikorian
William Taubin

1982
Richard Avedon
Amil Gargano
Jerome Snyder
Massimo Vignelli

1983
Aaron Burns
Seymour Chwast
Steve Frankfurt

1984
Charles Eames
Wallace Elton
Sam Scali
Louis Silverstein

1985
Art Kane
Len Sirowitz
Charles Tudor

1986
Walt Disney
Roy Grace
Alvin Lustig
Arthur Paul

1987
Willy Fleckhaus
Shigeo Fukuda
Steve Horn
Tony Palladino

1988
Ben Shahn
Bert Steinhauser
Mike Tesch

1989
Rudolph de Harak
Raymond Loewy

1990
Lee Clow
Reba Sochis
Frank Zachary

1991
Bea Feitler
Bob Gill
Bob Giraldi
Richard Hess

1992
Eiko Ishioka
Rick Levine
Onofrio Paccione
Gordon Parks

1993
Leo Burnett
Yusaku Kamekura
Robert Wilvers
Howard Zieff

1994
Alan Fletcher
Norman Rockwell
Ikko Tanaka
Rochelle Udell
Andy Warhol

1995
Robert Brownjohn
Paul Davis
Roy Kuhlman
Jay Maisel

1996
William McCaffery
Erik Nitsche
Arnold Varga
Fred Woodward

1997
Allan Beaver
Sheila Metzner
B. Martin Pedersen
George Tscherny

1998
Tom Geismar
Chuck Jones
Paula Scher
Alex Steinweiss

1999
R.O. Blechman
Annie Leibovitz
Stan Richards

2000
Edward Benguiat
Joe Sedelmaier
Pablo Ferro
Tadanori Yokoo

**HALL OF FAME
EDUCATORS AWARD**

1983
Bill Bernbach

1987
Leon Friend

1988
Silas Rhodes

1989
Hershel Levit

1990
Robert Weaver

1991
Jim Henson

1996
Steven Heller

1998
Red Burns

1999
Richard Wilde

T he Art Directors Hall of Fame recognizes and applauds excellence. Now, we all know that excellence is elusive. And at a time when so much is very good, attaining true excellence is even more rare and difficult.

But the four who have been chosen as this year's inductees to the Hall of Fame have achieved an even loftier plateau: excellence over time. Excellence over years. Excellence over decades. Excellence despite changing demands of clients and technology and culture. Excellence despite changing values, changing attitudes, changing times. They are among those few who

The four who have been chosen as this year's inductees to the Hall of Fame have achieved an even loftier plateau: excellence over time.

have hit the moving target again and again, not only effectively, but also poetically, daringly, dramatically. So that the excellence has become simply what we expect.

And so we salute Giorgio Soavi, Ed Sorel, Rich Silverstein, and Phil Meggs for their truly unique accomplishment: reaching that rare level of excellence. Not just once. Not just twice. But over and over and over again.

—Roy Grace, Chairperson
2001 HALL OF FAME SELECTION COMMITTEE

2001 HALL OF FAME SELECTION COMMITTEE

Gennaro Andreozzi	Jackie Merri Meyer
Seymour Chwast	Bill Oberlander
Paul Davis	Robert Pliskin
Lou Dorfsman	Leslie Singer
Steven Heller	Richard Wilde
George Lois	

Giorgio Soavi's biography and work will be featured in *The Art Directors Annual No. 81*

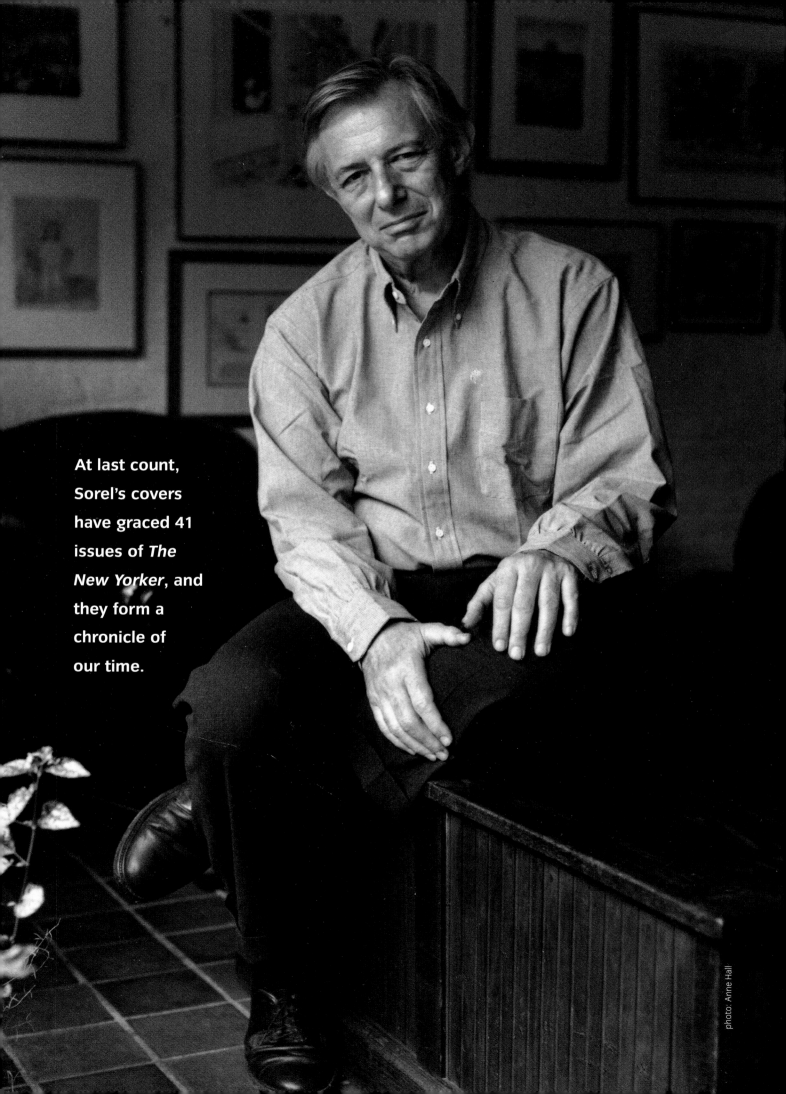

At last count, Sorel's covers have graced 41 issues of *The New Yorker*, and they form a chronicle of our time.

If you think Mona Lisa's smile is enigmatic, take a good look at this photograph of Edward Sorel. Is that expression a grin or a grimace? As it happens, it's both. Together, the smile and the sigh, the wit and the mordancy make him one of the supreme caricaturists of our time. He leaves the viewer weeping and laughing. And best of all—once the handkerchief is pocketed— thinking.

The special quality of Sorel is that he captures our zeitgeist as few artists have, and fells his victims with the rapier of irony rather than the blunderbuss of satire. In his first cover for *The New Yorker*, which happened to be Tina Brown's inaugural issue, Sorel pictures a bare-chested, pink-Mohawked rocker arrogantly draping himself on the seat of a horse-drawn carriage. (Look: Sorel even gets the rocker's shoes right. They are pointed like daggers at the back of the hapless driver) Traveling through the gorgeous autumn scenery of Central Park, our passenger might as well be Yeats's rough beast "slouching towards Bethlehem."

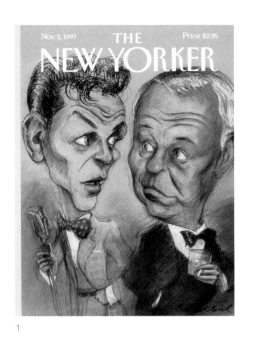

1

13

Edward**Sorel**

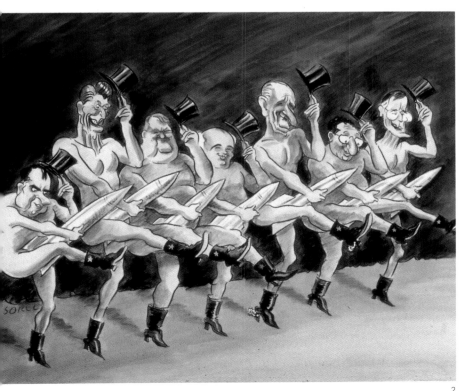

2

In another *New Yorker* cover (one of my favorites), Sorel lovingly portrays some of the many Fifth Avenue department stores that have bit the dust of wrecking balls: Jay Thorpe, Bonwit Teller, Arnold Constable, and Sloane's. Missing is De Pinna, one reader complained, and speaking for myself, I miss that hyper-elegant Black, Starr, and Gorham, shamelessly covered some forty years ago by a blanched '60s facade.

At last count, Sorel's covers have graced 41 issues of *The New Yorker*, and they form a chronicle of our time. A Mother's Day cover portrays four decades of mother and daughter in the kitchen. In a 1934 tableau, Mom and her ringleted daughter bake a cake. Sixty years later, Mom is more harried; a cordless phone squeezed on her hunched shoulder, she orders from a Lotus Wok menu. Sprawling on the kitchen floor, her daughter lies transfixed before a TV. In a Fourth of July cover, an

overweight Uncle Sam struggles to squeeze into his striped pants. The metaphor is apt. We no longer fit a trimmer, more robust age. Recently, Sorel pictured George W. Bush at his inaugural. In the middle of the three-panel sequence, the President-elect leans over to the Vice President for advice. Once given, he raises his right hand to take the oath of office. We are in for some ride, Sorel implies.

His covers, done for *The New Yorker*, *The Nation*, *The Atlantic Monthly* and *Time*, bring to mind another chronicler of our time, the screenwriter Terry Southern, who captured the '50s with *Doctor Strangelove*, and the '60s with *Easy Rider*. In the process, he released our deepest anxieties and gave voice to our fears about nuclear Armageddon and civil violence. "Poetry makes nothing happen," Auden once wrote. Maybe so, but there is some virtue in a purgative. And didn't *Uncle Tom's Cabin*, ringing like a bell in a darkening era, change the mood of half a nation?

Sorel's road to success began on a rocky path. Born in the Bronx in 1929 to a father who was a door-to-door salesman of dry goods, he remembers his father as lounging whole days on the living room sofa. "I hated my father," Sorel has remarked. His mother was the steady wage earner, working full-time in a millinery factory. Drawn to art as a teenager, he was accepted into the prestigious High School of Music and Art, but he remembers it as "awful. They were full of theory, and drawing was discouraged." It was only at Cooper Union that he began to draw—alongside Milton Glaser and Seymour Chwast. "They were in the clique with the talented artists," Sorel reminisced. "I was in the clique with the losers."

After Cooper Union, Sorel and Chwast worked briefly at *Esquire* magazine. They had the distinction of being fired on the same day. But this proved salutary as they decided to join forces and form an art studio. It was called Push Pin after an occasional mailing piece, *The Push Pin Almanack,* which they self-published during their days at *Esquire*. Taking their weekly unemployment checks of $35, Sorel and Chwast rented a cold-water flat on East 17th Street. Two weeks later they informed the phone company that in addition to the coin-operated phone on the wall, they wanted their very own private phone. "We were in business!" Sorel exclaims. Several months later, Milton Glaser returned from a Fulbright year in Italy, and joined the studio.

Sorel quit Push Pin after two years. He felt guilty that "I was doing these cut-out pieces and not pulling my weight in the studio. Yet there I was, drawing the same $65 a week as Milton and Seymour." He left on the same day that the studio moved into plush quarters on East 57th Street. A poverty wish? Some friends have wondered.

Thrown back on himself, Sorel began to perfect his style of "direct drawing," that is, inking directly onto the paper without a preliminary drawing underneath or a tracing below. "Working direct," Sorel remarks today, "is fine art. Tracing is commercial art." What began as Stuart Davis-inspired cubism with *The Push Pin Almanack* and went on, according to Sorel, as Chwast and Glaser imitations, gradually developed into the distinct loose-line

3

4

5

6

7 8

At home in his favorite vermillion chair
Sat Max Maximillion, the French zillionaire,
Exhausted from working all day at his chore
Of buying for less and then selling for more.

9

1 THE NEW YORKER "Young Sinatra Meets Old Sinatra" magazine cover.
Illustrator: Edward Sorel; **Art Director:** Francoise Mouly;
Client: The New Yorker, 1997

2 UNAUTHORIZED POETRY "Chorus Line" book jacket

3 THE NEW YORKER "Christmas Past, Christmas Present" magazine cover.
Illustrator: Edward Sorel; **Art Director:** Franciose Mouly;
Client: The New Yorker, 1996

4 ROLLING STONE "Milhous I" illustration. **Illustrator:** Edward Sorel;
Art Director: Fred Woodward; **Client:** Rolling Stone, 1973

5 TIME magazine cover. **Illustrator:** Edward Sorel; **Client:** Time, 1977

6 FIRST ENCOUNTERS "Edgar Degas and Mary Cassatt" book illustration.
Illustrator: Edward Sorel; **Publisher:** Alfred A. Knopf, 1997

7 ZILLIONAIRE'S DAUGHTER book jacket. **Illustrator:** Edward Sorel;
Art Director: Anne Bobco; **Publisher:** Warner Books, 1990

8 ZILLIONAIRE'S DAUGHTER book illustration. **Illustrator:** Edward Sorel;
Art Director: Anne Bobco; **Publisher:** Warner Books, 1990

9 ATLANTIC MONTHLY magazine cover. **Illustrator:** Edward Sorel;
Client: Atlantic Monthly, 1985

10 THE NEW SCHOOL poster. **Illustrator:** Edward Sorel;
Client: The New School, 1980

style for which Sorel is celebrated today. In the early 1960s he moved to upstate New York. His close neighbor was the watercolor artist Robert Andrew Parker, who became a key influence on him.

Entering Sorel's Soho loft today is like entering a private gallery. Stretching along either side of the long entranceway are his drawings and watercolors. Nearby are original works by some of his favorite artists: James McMullan, Robert Andrew Parker, Lee Lorenz, Arthur Szyck, Rowlandson, and the early *New Yorker* artist, Gluyas Williams. Hanging alongside is a photograph of George Price taken by Sorel's son, Leo, and letters to Ed from the '40s Hollywood star, Mary Astor (Sorel is an avid cinephile), and Eleanor Roosevelt. In an adjoining room is his small studio.

Sorel works directly on lightweight acid-free bond paper (an Italian brand which is no longer produced, he laments). Each drawing consists of what he calls "finding lines" before he applies the definitive lines which give form and shape to his work. Once the ink lines are finished, the watercolor is applied. "That's the fun part," he comments. "Coloring is always fun." On some paintings he uses a wash made from a black china marker dissolved by rubber cement thinner. "You just use everything you can." The paintings are then dry mounted on illustration board.

In much of his work, Sorel deals with paradise lost. This leitmotif was explicitly stated in an autumn *New Yorker* cover in which Adam, expelled from Eden, walks knee-deep in a world strewn with leaves. God points to a rake.

In ways, Sorel himself is a stranger in this world, a castaway from an earlier period. I'll never forget an outfit he wore in the dress-down '70s: a custom-made belted Norfolk jacket cut from heavy Irish wool. He was Beau Brummel in a world where it all hung out.

FOR A HEART, COURAGE OR A BRAIN

THE NEW SCHOOL

10

Edward Sorel has been compared to Daumier, Hogarth, and, in our own time, David Levine. But another comparison may be to Herman Melville's Bartleby the Scrivener. When asked to act against his conscience, Bartleby's refrain was, "I would rather not." Edward Sorel would also "rather not" do many things. He would rather not bow to authority. He would rather not mindlessly honor the sanctity of any flag or religion, creed or institution. He would rather not follow the latest fashion or play anybody's game. What he would rather do is speak his mind, fully, freely, and artfully. And we are all in his debt.

—R. O. Blechman

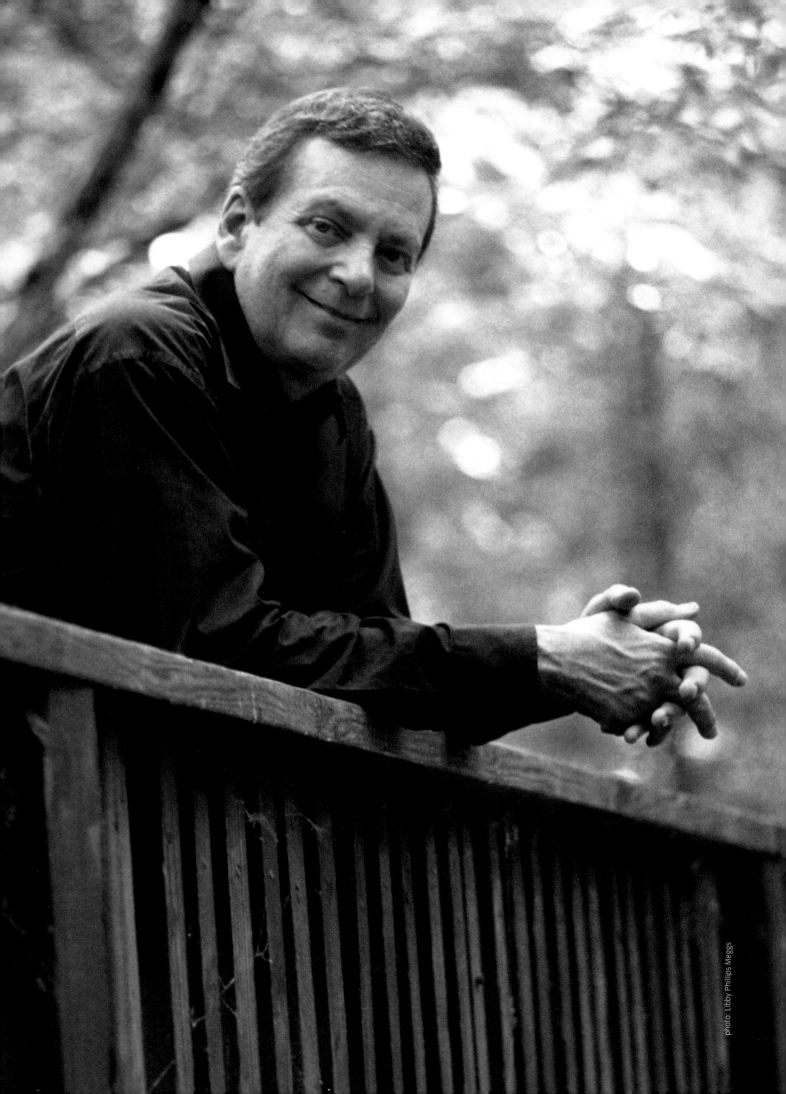

Philip B. Meggs was born in 1942 in Florence, South Carolina. He began his career at age 16, hand setting metal type after school, and developed a great love for the types and the letter forms he printed. An avid reader who pored over the words and illustrations in books and magazines, he also spent many hours drawing and painting. As the time to choose a career approached, he decided to go into graphic design.

In the early 1960s, there was no place to study illustration and layout in his state, but a guidance counselor told him the Richmond Professional Institute (which later merged with the Medical College of Virginia to form Virginia Commonwealth University) was one of the finer

Philip B.Meggs

1

art schools in the country. A train trip to Richmond convinced Meggs that the students were doing exciting work there. After a year at what is now Francis Marion University, he transferred to RPI. His teachers included abstract expressionist painters and European modern designers educated at Moholy-Nagy's Institute of Design in Chicago. Meggs says, "This dualism forced my classmates and me to deal with conflicting aesthetics and find our own paths."

After college, Meggs worked as senior designer at Reynolds Aluminum and at age 24 became art director of A. H. Robins Pharmaceuticals, one of the ten largest pharmaceutical companies in America. These jobs gave him the opportunity to design an amazing range of projects—posters, booklets, packages, a quarterly magazine, exhibitions, annual reports, and even advertising campaigns, because Robins followed the European model of having some of the pharmaceutical product advertising designed by in-house staff. This diversity provided useful experience when he moved into teaching.

In 1968, Meggs's former teacher John Hilton, the Chairman of the Communication Arts and Design Department at Virginia Commonwealth University, invited Meggs to

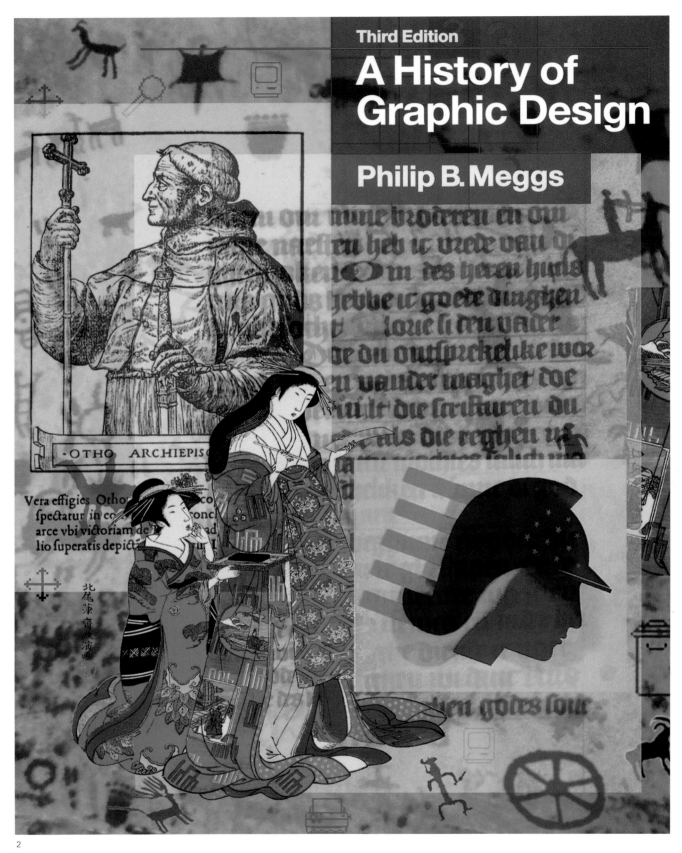

Third Edition

A History of Graphic Design

Philip B. Meggs

2

1 DESIGN AWARENESS poster for high school students. **Designer:** Philip B. Meggs; **Client:** National Endowment for the Arts, Design Arts Program, 1978

2 A HISTORY OF GRAPHIC DESIGN Third Edition book jacket. **Author:** Philip B. Meggs; **Designer:** Philip B. Meggs; **Client:** John Wiley & Sons, 1998

3 TYPOGRAPHIC SPECIMENS: THE GREAT TYPFACES book jacket. **Author:** Rob Carter; **Contributor:** Philip B. Meggs; **Designers:** Philip B. Meggs and Rob Carter; **Client:** John Wiley & Sons, 1993

4 MFA DESIGN PROGRAM booklet. **Designer:** Philip B. Meggs, **Client:** Virginia Commonwealth University, 1986

Typographic Specimens:

The Great Typefaces

Philip Meggs
Rob Carter

3

4

lunch and persuaded him to try his hand at teaching. Meggs recalls, "Although Hilton overstated the advantages and understated the dilemmas of teaching, I found it to be a magical yet challenging experience. Teaching a creative endeavor is a difficult balancing act—imparting information, coaching and critiquing without destroying the student's confidence, and trying not to impose your vision onto the student's work."

From 1974 until 1987, Meggs chaired the VCU Department of Communication Arts and Design. During that time enrollment doubled, and the graphic design program was augmented with majors in illustration, photography, and media. Courses in the history of visual communications, along with design and communications theory, were added to the curriculum. Competency-based instruction was introduced in typography, print production, layout techniques, and later, computer graphics courses. Since the 1970s, the program has been widely respected in the industry as one whose graduates are well prepared for the profession. A Master of Fine Arts in Design program was launched in 1978.

During Meggs's first semester of teaching, a search for information about design history and creative methodology convinced him that educational materials did not exist. He began to compile information for use in his classes, which led to active writing. In 1974, he began teaching a course in the history of visual communications and started his first book, the 500-page *A History of Graphic Design*. The first edition, with over 1200 illustrations, was published in 1983 and received an award for excellence in publishing from the Association of American Publishers. Now in its third edition, *A History of Graphic Design* has been translated into Chinese, Hebrew, Japanese, Korean, and Spanish. A *Communication Arts* reviewer wrote, "I expect it to become a foundation keystone of serious study . . . it is a fortress work." T*he New York Times* hailed it as "A significant attempt at a comprehensive history of graphic design . . . it will be an eye-opener not only for general readers, but for designers who have been unaware of their legacy."

Typographic Design: Form and Communication, written and designed with his colleagues Rob Carter and Ben Day, was selected for the 1985 AIGA "50 Books of the Year." *Type and Image: The Language of Graphic Design* was published in 1989.

He has written a dozen books and over 150 articles and papers on design and typography.

Meggs's graphic designs have been included in the *Art Director's Club Annual*, *Graphis Annual*, *Graphis Posters*, *Communication Arts Design Annual*, and *Print* magazine's *Regional Design Annual*. Since 1993 he has been a member of the U.S. Postal Service's Citizens Stamp Advisory Committee, which recommends subjects and designs for United States postage stamps.

Meggs has been married to his college girlfriend, Libby, an art director and illustrator, for 37 years and has two children. Meggs also serves as visiting faculty at Syracuse University and the National College of Art and Design, Dublin.

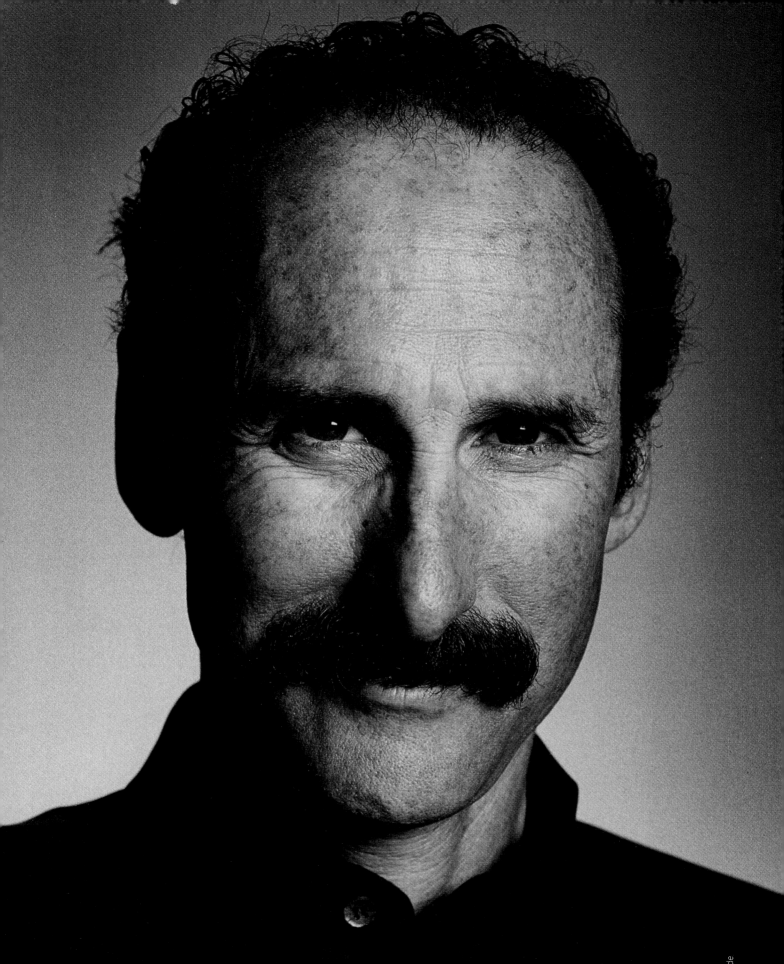

Rich Silverstein has been my partner in every good decision I've ever made in my whole professional life. Every one. Yeah, he's been there for some less than good ones, too. But there certainly would have been a lot more of the latter if it'd just been me.

The point is, whatever cool things have happened to me would never have happened without him.

I have some details of his life here. I just wanted to get that out.

I don't know where or how he got it, but Rich is somehow able to reduce things to a simplicity that accumulates power and elegance all along the way. He can do this better than you can, no matter who you are. He does it by waking up every morning and blasting himself against the world until he's exhausted by mid-afternoon, like a cultural bottle rocket.

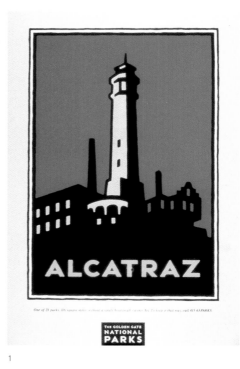

1

Rich**Silverstein**

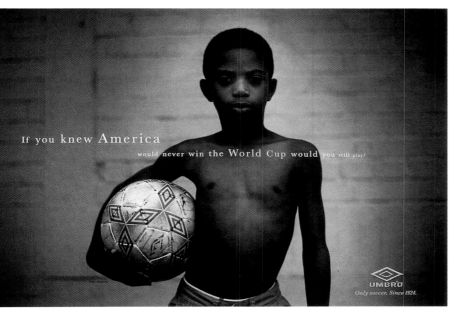

2

Was he always this way? As far as I know. I'm not sure the facts explain anything. But here they are:

Born in 1949, Rich grew up in New York, attended Parsons School of Design, and started his career in San Francisco as a graphic designer. He worked as an art director at *Rolling Stone* and at various advertising agencies—Bozell & Jacobs, McCann Erickson, Foote, Cone & Belding, and Ogilvy & Mather— each for about a year. We met at O&M San Francisco (now Publicis Hal Riney) when Hal put us together to work on the Oakland A's account. Three years later, in a moment of supreme ingratitude, and possessing only one client, we opened an agency with Andy Berlin, which we named ourselves: Electronic Arts.

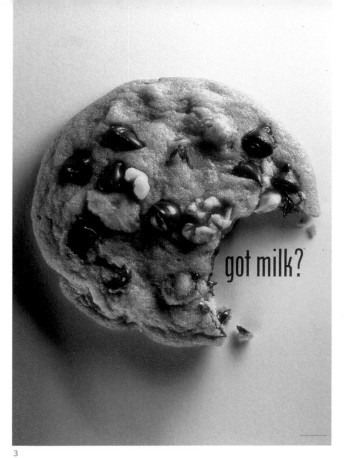

got milk?

3

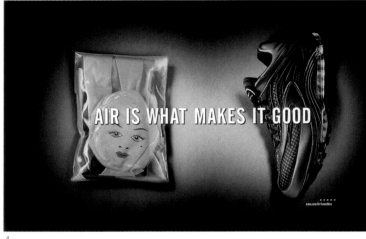

AIR IS WHAT MAKES IT GOOD

4

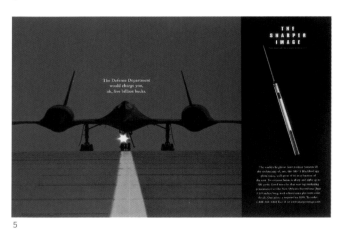

5

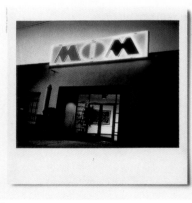

6

7

THE WALL teach your nickels to be quarters **STREET JOURNAL.**

DOW JONES VOL. CCXXXIII ★★★ TUESDAY, SEPTEMBER 7, 1999 INTERNET ADDRESS: http://wsj.com •••• 75 CENTS

Adventures in Capitalism.

8

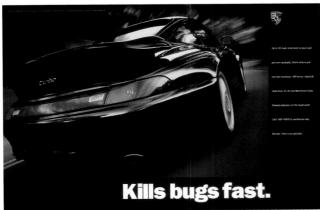

Kills bugs fast.

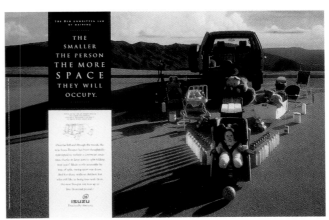

9

10

1 ALCATRAZ bus shelter. **Creative Directors:** Jeffrey Goodby and Rich Silverstein; **Art Director:** Rich Silverstein; **Copywriter:** Steve Simpson; **Producer:** Max Fallon; **Digital Artist:** Mark Rurka; **Illustrator:** Michael Schwab; **Client:** Golden Gate National Parks Association; March 1996

2 WORLD CUP magazine spread. **Creative Directors:** Jeffrey Goodby and Rich Silverstein; **Art Director:** Rich Silverstein and Todd Grant; **Copywriter:** Jeffrey Goodby; **Producer:** Max Fallon; **Digital Artist:** Mark Rurka; **Photographer:** Nadav Kander; **Client:** Umbro, October 1996

3 CHOCOLATE CHIP COOKIE outdoor billboard. **Creative Directors:** Jeffrey Goodby and Rich Silverstein; **Art Directors:** Rich Silverstein and Sean Ehringer; **Copywriter:** Harry Cocciolo; **Producer:** Michael Stock; **Digital Artist:** Patrick Mullins; **Photographer:** Dan Escobar; **Client:** Milk, May 1996

4 BLOW-UP DOLL magazine spread. **Creative Directors:** Jeffrey Goodby and Rich Silverstein; **Art Directors:** Paul Hirsch, Josh Denberg and Claude Shade; **Copywriters:** Josh Denberg and Paul Hirsch; **Producer:** Jim King; **Digital Artist:** Michael Chamorro; **Photographer:** Kenji Toma; **Client:** Nike, August 1999

5 THE DEFENSE DEPARTMENT WOULD CHANGE YOU magazine spread. **Creative Directors:** Jeffrey Goodby and Rich Silverstein; **Art Director:** Rich Silverstein; **Copywriter:** Jeffrey Goodby; **Producer:** Suzy Watson; **Digital Artist:** Mark Rurka; **Photographers:** George Hall and Paul Franz-Moore; **Client:** The Sharper Image, October 1996

6 MOM/WOW magazine spread. **Creative Directors:** Jeffrey Goodby and Rich Silverstein; **Art Director:** Mike Mazza; **Copywriter:** Albert Kelly; **Producer:** Suzee Barrabee; **Digital Artist:** Shui Wong; **Photographer:** Hunter Freeman; **Client:** Polaroid, May 1996

7 THE NEW YORKER "Baseball" magazine spread. **Creative Directors:** Jeffrey Goodby and Rich Silverstein; **Art Director:** Rich Silverstein and Dave Page; **Copywriter:** Jeffrey Goodby; **Producer:** Max Fallon; **Digital Artist:** Nan Cassady; **Photographer:** Stock; **Client:** The New Yorker, May 1991

8 TEACH YOUR NICKELS TO BE QUARTERS highway billboard. **Creative Directors:** Jeffrey Goodby and Rich Silverstein; **Art Director:** Eric King; **Copywriters:** Harold Einstein and Jim Haven; **Producer:** Michael Stock; **Digital Artist:** Mark Rurka; **Photographer:** Hunter Freeman; **Client:** The Wall Street Journal, May 1999

9 KILLS BUGS FAST magazine spread. **Creative Directors:** Jeffrey Goodby and Rich Silverstein; **Art Directors:** Rich Silverstein and Todd Grant; **Copywriter:** Bo Coyner; **Producer:** Max Fallon; **Digital Artist:** Nan Cassady; **Photographer:** Clint Clemens; **Client:** Porsche, April 1995

10 CARGO SPACE magazine spread. **Creative Directors:** Jeffrey Goodby and Rich Silverstein; **Art Director:** Rich Silverstein; **Copywriter:** Dave O'Hare; **Producer:** Suzee Barrabee; **Digital Artist:** Shui Wong; **Photographer:** Gil Smith; **Client:** Isuzu, January 1995

Goodby, Silverstein & Partners is now 18 years old with billings of over $800 million. We were *Advertising Age*'s Agency of the Year in 1989 and 2000, and *Adweek*'s Agency of the Year in 1995. Rich has won the Kelly Award a couple of times, the Mercury Award a couple of times, the Best of Show just about everywhere, and the Palm D'Or at Cannes. He's been named *Adweek*'s Creative Director of the Year and Most Valuable Player a few times.

Rich and his wife, Carla Emil, live in Mill Valley, California in a very white house filled with stunning photography and featuring a whole room devoted to bicycles. He's got two grown children, Aaron and Simone. He serves on the boards of the USA Cycling Development Foundation and the Golden Gate National Parks Association, for whom he's designed a graphics program that's literally raised millions of dollars. (He's attempting the same thing with Central Park.) Rich has a passion for sports car racing and cycling and it's a wonder he hasn't hurt himself (knock on wood).

He considers himself to be one of the luckiest men in the world because he's able to live in Marin County and breezily cycle to work over the Golden Gate Bridge. And when you see it, well, he's got a point.

I am still very happy to see him every morning at work.

—Jeff Goodby

Adobe Acrobat 5.0

The best way to share documents online

Complements Microsoft Office!

- Convert any document to Adobe PDF
- Share documents across a broad range of hardware and software
- Approve and comment on documents from within your Web browser

A Adobe

Adobe After Effects 5.0

The essential tool for motion graphics and visual effects

A Adobe

Adobe InDesign 1.5

Page layout and design for the future of professional publishing

A Adobe

Adobe Illustrator 9.0

The industry-standard vector graphics creation software for print and the Web

A Adobe

Adobe GoLive 5.0

Professional Web authoring and site management

A Adobe

Adobe PageMaker 7.0

Business publishing made easy

- Get started quickly with templates, graphics, and intuitive design tools
- Incorporate content from existing documents, layouts, databases, and graphics files
- Produce professional-caliber publications

A Adobe

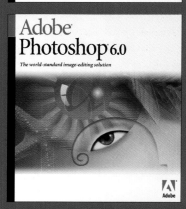

Adobe Photoshop 6.0

The world-standard image-editing solution

A Adobe

Adobe LiveMotion

Professional Web graphics and animation

A Adobe

Adobe Premiere 6.0

The essential tool for professional digital video editing

A Adobe

The Vision Award honors companies who have "consistently recognized the relationship of design to performance, thereby contributing extraordinary creative excellence in communication, education, and social awareness." This year's recipient, Adobe Systems Incorporated, was chosen for its revolutionary position in the publishing industry as well as its corporate philanthropy.

When the first graphical user interface appeared in 1985, it catalyzed the most significant advance in publishing since movable type: desktop publishing. Graphic designers could now use page layout software like PageMaker and printing technologies like PostScript to create professional communications directly from their personal computers.

Adobe's efforts to make a difference outside of the visual communications field also deserve high praise.

Powerful graphics applications like Photoshop and Illustrator quickly followed, putting even greater control into the hands of graphics professionals worldwide.

In 1995, as the Internet grew into a truly global interactive environment, Adobe enabled Web designers to create Web sites based on the same Adobe tools that designers had used to produce images on the printed page. Today, Adobe Systems is instrumental in setting the stage for publishing's Third Wave—Network Publishing.

Adobe's efforts to make a difference outside of the visual communications field also deserve high praise. Adobe's community relations programs focus on K-12 education and poverty-related issues. Adobe software, volunteers, and financial resources are provided to many non-profit organizations, including those that provide services for disadvantaged youth, victims of natural disasters, patients of medical and hospice care, and education and literary programs.

advertising

e saw a lot of work. Had a lot of fun. And hopefully you agree we put an interesting book together.

That said I feel I need to be honest about what I saw.

Yes, there was a lot of work. Some of it was great but not enough of it.

Now I grant you, it's gotten harder and harder to do great work. Clients are scared to take risks. The financial climate has taken a turn for the worst. And more importantly, it's harder to do work that hasn't ever been done before.

But we owe it to the consumer, to our clients, and to ourselves to do great work.

There is no better time than now. When everyone else is afraid to take risks.

Work that is challenging.
Work that is interesting.
Work that has a sense of humor.
Work that makes people talk.
And work that scares the client and us.
There is no better time than now.
When everyone else is afraid to take risks.
Good luck.

—Susan Hoffman
WIEDEN + KENNEDY, PORTLAND
ADVERTISING CHAIR

SUSAN HOFFMAN has a tendency to shake things up. That's probably because she finds the status quo so boring. She started her career at Pihas/Schmidt/Westerdahl and from there moved to Chiat/Day/Livingston in Seattle, working on accounts such as Alaska Airlines and Holland America. Three years later she moved on to Wieden + Kennedy, where she has been for the last 17 years. Susan is never satisfied unless work feels fresh, interesting, and alive. She put that perspective into ads for Nike, Microsoft, Miller Brewing Co., Cartoon Network, and The Paramount Hotel. Susan opened Wieden + Kennedy's Amsterdam and London offices. Now back in Portland as Dan Wieden's partner, Susan is settling into her role of making everyone question virtually everything they do.

SY-JENQ CHENG was born in the year of the Monkey. After graduating from Central St. Martins in 1991, she worked in London before starting her travels: first to Blue Brick Design and *Details* magazine in New York, then on to Amsterdam, and back to London again to work on Nike for Wieden + Kennedy. She then took a sabbatical in the sun. After that, she came across some other monkeys named Anti-Corp; she's been trying to lose them ever since. As hard to please and curious as ever, she is currently freelancing as a design and art director.

Prior to founding BaylessCronin, **JERRY CRONIN** was creative director at Wieden + Kennedy for 10 years, working primarily on Nike and ESPN.

GHISLAIN DE VILLOUTREYS was born on May 10, 1967, in Paris. As a copywriter, he has worked for BDDP Paris (BMW, France Telecom), DDB Paris (Volkswagen, Sony) and Wieden + Kennedy (Nike). He is currently freelancing and is about to start up his own (very small) agency.

WARREN EAKINS worked as an art director for Wieden + Kennedy for six years, during which time the European office was opened in Amsterdam. He then spent four years as Tim Delaney's partner at Leagas Delaney in London. For the past two years he has been at Fallon McElligott's West Wing office in Santa Monica, California.

MARK FENSKE was a visiting professor at the Virginia Commonwealth University AdCenter. Then he went back to The Bomb Factory, Malibu, an ad agency/production company. He also teaches at Art Center in Pasadena.

RICHARD FLINTHAM is joint creative director of Fallon London with his partner, Andy McLeod. Since Fallon's launch two years ago, Richard has been responsible for BBC, Timex, and Skoda, among others. Before launching Fallon, the team worked at BMP DDB and was responsible for acclaimed work for VW, Doritos, Sony, and The Ministry of Sound. Awards include: one D&AD gold, 5 D&AD silvers, two gold Lions, and two One Show golds. Richard is hoping to make good his poor record at the Art Directors Club by getting on the jury.

LARRY FREY studied art education at Western Washington University and graphic design at the Art Center College of Design in Pasadena. Larry worked for NW Ayer, then landed at W + K where his clients included Kink FM, Black Star Beer, and Paramount Pictures, among others. He was a creative director at ESPN and Nike from 1995–1998. After that he worked at W + K Tokyo and started 180 in Amsterdam with 3 partners. The 180 roster included MTV, Infogrames, KPN, Swatch, and others. He joined @radical.media in New York as a director and wonders, "Why did I wait so long?" Awards include: D&AD, New York Art Directors Club, One Show, Emmys, Cannes Film Festival, Clios, and Epicas.

KATHY HEPINSTALL is a novelist and copywriter. She joined The Martin Agency San Francisco as a creative director in the fall of 2000. Her next novel, *The Absence of Nectar*, is coming out in September 2001.

BRIAN LEE HUGHES has worked as an art director for Mad Dogs and Englishmen, Kirshenbaum Bond and Partners, Berlin Cameron and Partners, Mother (London), and MTV, as well as a gross amount of well-meaning but whorish freelance. Brian has plied his trade in the United States of America, Denmark, France, Japan, Mexico, Australia, and England. He founded Public Incorporated in 2000. Public projects include the films 001 (an installation for P.S.1), *Hvem er Tordenskjold?* (Lars von Trier's Zentropa Films), and *Rock Star Scars*. Public is also publishing a book called *Tokyo Face*. Brian designed *Taxi Driver Wisdom* and *Public Love* for Chronicle Books. He is married to the lovely Stine Norgaard. Together, they made the soon-to-be-world-famous baby, Cisca.

ERIK KESSELS was born in 1966 in Roermond, The Netherlands. In 1986, he began working for Ogilvy & Mather, Eindhoven/Amsterdam. He then worked for Lowe, Kuiper & Schouten, Amsterdam, Chiat/Day, London, and GGT before starting KesselsKramer, Amsterdam. Clients have included: Nike, Audi, Levi's, Hans Brinker Budget Hotel, ONVZ, Het Parool, Ben®, Bol.com, Heineken, The Coffee Company, Ilse search engine, and Diesel. Awards include: D&AD Silver Award nomination, Epica, Gold Effie, Silver Effie, Silver Lion, Cannes, Coque d'Honneur, Art Directors Club Best of Show, and two Reclame bureau van het Jaar, Nederland.

31

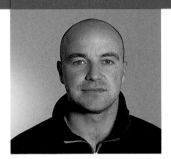
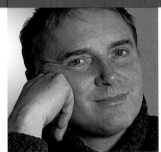

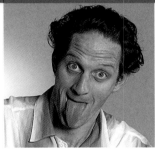

YOUNG KIM is presently a commercial director at Hungry Man New York/Santa Monica. His client list includes, Nike, Adidas, Sega, ESPN, Yohji Yamamoto, Blockbuster, and *The Wall Street Journal*. Previously, he worked for Wieden + Kennedy Portland and was responsible for setting up their Tokyo office. In 1993, he was P.A./design director at QVC West Chester where he was responsible for transforming the corporate identity, TV graphics, and overall image. Before that, he was a freelance art director for Wieden + Kennedy (Coca-Cola), *The New York Times* (men's fashion magazine), Bloomingdale's, and Sony Music. From 1987 to1991, he was a design director at *Fashion* magazine. In 1986, he was a freelance art director, working with N.Y. Arnell, Bickford, Donna Karen (fur campaign), and the development of DKNY.

JONATHAN KNEEBONE is the co-founder and joint creative director of The Glue Society, Australia's foremost independent creative collective, based in East Sydney. He is currently writing and directing projects through @radical.media (both locally and internationally), which have been selected for the New Directors Showcase at Cannes. Other recent projects include: the store design and advertising launch for Virgin Mobile Australia, on-air TV identities for music station Channel V, as well as writing/directing projects for agencies Mojo (Sydney), TBWA (Sydney), and Saatchi (Hong Kong and Tokyo).

GARY KOEPKE, co-founder of Modernista!, is an internationally respected creative director and graphic designer. He has won gold awards in all the major design shows, and his work has been shown at the Cooper-Hewitt National Design Museum, the Nolan/Eckman Gallery in New York, and the DNP Gallery in Japan. Most recently, Gary worked on the Nike, ESPN, and Coca-Cola campaigns at Wieden + Kennedy, producing TV, print, and interactive campaigns. He is also the founding creative director of *Vibe* magazine and has produced award-winning works, including: *26* magazine for Agfa Corp, the design of *Colors* magazine for Benetton, World Tour for Dun & Bradstreet Software, and SoHo Journal for SoHo Partnership. He also designed David Byrne's book of photography, *Strange Ritual*, and served as vice president and creative director for J.Crew.

JON MATTHEWS never got to travel much as a kid. He's making up for it now, working to make Amsterdam more famous for great ads than for sex and drugs. But if either of the latter attract you, it's a great place to work.

JOHN McNEIL is a partner and associate creative director at Ogilvy and Mather, New York, where he has worked on the IBM account for the past four years. His work includes the IBM e-business and global services campaigns, as well as work for *Brill's Content*, American Express, Kodak, Sony, and Lotus. John lives in Brooklyn with his girlfriend Katy and their two pit bulls.

ANTHONY SPERDUTI is in his late 20s and is white. He has worked over the years as an art director at such great shops as Kirshenbaum and Bond, Wieden + Kennedy Portland and Wieden + Kennedy London; unfortunately, not on anything anyone has ever seen. He has also worked at Kate Spade as head art director and is currently working on selling out and freelancing. Anthony also acts and every Valentine's Day can be seen on MTV as Prematurely Balding, Malcontent Cupid. When not working, Anthony enjoys sunsets, chubby girls, and blow.

ELLEN STEINBERG's client list includes: Apriori Clothing, Conseco Insurance, Jim Beam Bourbons, Lee Jeans, Miller Lite, and Nikon. Ellen currently freelances as both an art director and copywriter. She backed off the obviously attractive titles of account executive and media planner to leave time to pursue her interest in comedy writing and performance.

NORIYUKI TANAKA is an artist who has worked with installation, performance, drawing, graphic design, photography, CG, film, CD-ROM, furniture, interior design, and architecture. Exhibitions and installations include 1981's "GOKAN— Urban Deep Stratum," 1991's "X-Department" with Katsuhikoo Hibino and Asuhito Sekiguchi, 1993's "EXPLORE REALITY/Conditions of Reality" with Shinsuke Shimojo, and "Forest" at The Science and Technology Museum in Tokyo. In 1995, he worked on the Asian location of Peter Greenaway's film, *The Pillow Book*. In 1997, he produced CF and graphics as a Nike art director. This year he started "Renaissance Generation," a support system for creators whose work extends beyond conventional borders of science, technology, and art.

GUILLERMO TRAGANT was born in Buenos Aires, Argentina. He studied mass communication and advertising at Universidad del Salvador and at Louisiana State University where he started *Zoo* magazine. Guillermo worked as an art director at Agulla y Baccetti in Argentina for Levi's, Renault, and Aiwa. He then moved to Treviso, Italy, to work for Benetton as a graphic artist and at Fabrica di Oliviero Toscani, where he designed a special project for the Vatican, a book called *Prayer*. After that, he worked as creative editor at *Colors* magazine. Guillermo then moved to Miami, Florida, to open La Comunidad, where he is now working as an art director for clients such as MTV. He teaches art direction at the Miami Ad School. He has also designed clothes and, recently, art directed music videos. His work has been exhibited in Buenos Aires and Rome. It has been published in several design magazines such as *Print*, *Tipografica*, and *Novum*.

TYLER WHISNAND is co-creative director at Ground Zero New York, a new idea swimming pool and brand health club located in the heart of the concrete playground. Previously he has worked with KesselsKramer in the Netherlands, *Colors* magazine in Italy, and BBDO in Asia. Trend prediction: Ground Zero Vegetarian Vegetable Juice from the Meat Packing District!

JEFF WILLIAMS was born January 25, 1953, in Eschwege, Germany. He was adopted by American parents and lived in Morocco before he moved to the good ol' U. S. of A. After graduating from the University of Alabama, he moved to New Orleans where he worked at Rivas Printing as a graphic designer. He then moved to Atlanta where he worked at Jack & Associates as an art director and graphic designer—and got fired along with several other good friends. Then he went to the Portfolio Center, moved to Seattle, worked at Cole & Weber, got fired, sent his portfolio to Wieden + Kennedy, and got rehired at C&W. Then he moved to Portland and worked at Wieden + Kennedy as an art director. Life is good!

Multiple Awards

GOLD

**TV: 30 SECONDS OR LESS,
CAMPAIGN**
India • China • Turkey

and GOLD

TV: 30 SECONDS OR LESS
India

and GOLD

TV: 30 SECONDS OR LESS
China

and GOLD

TV: 30 SECONDS OR LESS
Turkey

Art Directors Rossana Bardales,
Taras Wayner
Creative Director Eric Silver
Copywriter Dan Morales
Producers Catherine Abate,
Clair Grupp
Director Traktor
Editor Gavin Culter
Editing House Mackenzie Cutler
Production Company Partizan/Cape
Direct
Agency Cliff Freeman and Partners
Client FOX Sports
Country United States

Everyone watches ESPN's
SportsCenter, a national sports news
show. Everyone. The challenge is,
How do you take on the incredible
loyalty SportsCenter has built over
20 years and persuade sports fans to
watch a different kind of sports
news—regional sports news?

Our solution was to identify the flaw
in the category leader and exploit it
with advertising that people will talk
about. SportsCenter offers sports
coverage from all over the country.
The 11PM Regional Sports Report
offers "Sports news from the only
region you care about…yours." The
underlying premise of the campaign
is: If you're not getting the sports
news you care about, you might as
well be watching sports highlights
from a different country.

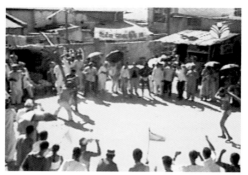

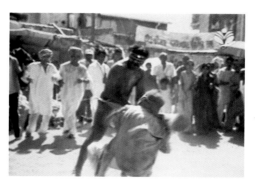

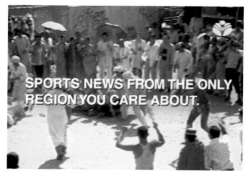

India

The host of a
Bombay sports show
is interviewing the
national clubbing
champion. We cut to
see two blindfolded
men chasing each
other with clubs in
front of a large crowd.
They are swinging
wildly at each
other . . . but missing.
Suddenly, one of the
men loses his
bearings and starts
pounding a gentleman
in the crowd.

SUPER:
Sports news from the
only region you care
about. Yours.

SUPER:
The 11PM Regional
Sports Report—FOX
SPORTS NET

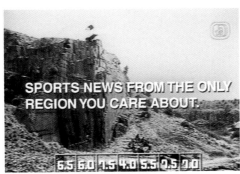

SPORTS NEWS FROM THE ONLY
REGION YOU CARE ABOUT.

6.5 6.0 7.5 4.0 5.5 9.5 9.0

China

A Chinese
sportscaster in the
studio is showing the
highlights of a tree-
catching competition.
We cut to two
lumberjacks chopping
down a giant 200-foot
tree for an athlete
getting into position
to catch it. He is not
successful. And,
therefore, does not
move on to the
next round.

SUPER:
Sports news from
the only region you
care about. Yours.

SUPER:
The 11PM Regional
Sports Report—FOX
SPORTS NET

Turkey

A Turkish sports
reporter is at a cliff-
diving tournament.
We cut to a diver in a
very small bathing
suit. He jumps off a
steep cliff, goes into a
swan dive, and lands
on dirt. (There is no
water anywhere.)
Turkish peasants clap
politely as the diver's
scores come across
the bottom of
the screen.

SUPER:
Sports news from
the only region you
care about. Yours.

SUPER:
The 11PM Regional
Sports Report—FOX
SPORTS NET

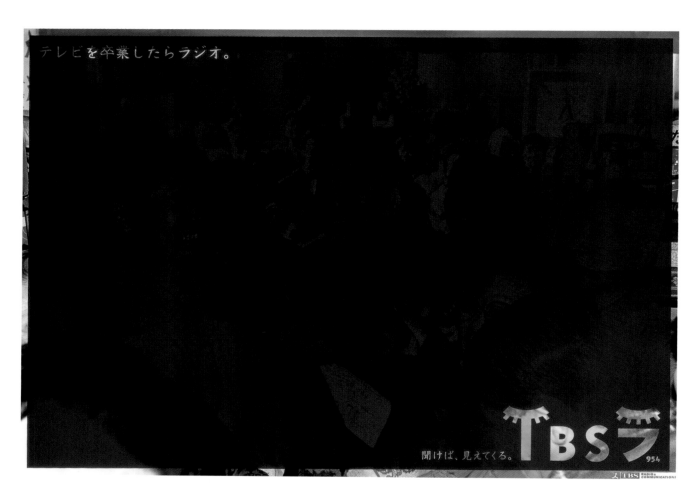

GOLD

POSTERS: PROMOTIONAL, CAMPAIGN

You Will See If You Listen

Art Directors Tatsuro Ebina, Takaaki Naito
Creative Director Masaru Kitakaze
Copywriter Hideyuki Azuma
Producer Takaaki Naito
Designers Shigeyuki Ougi, Takuro Tanabe
Photographers Hiroshi Hirasawa, Tadashi Tomono
Agency Hakuhodo Inc.
Client TBS Radio & Communications
Country Japan

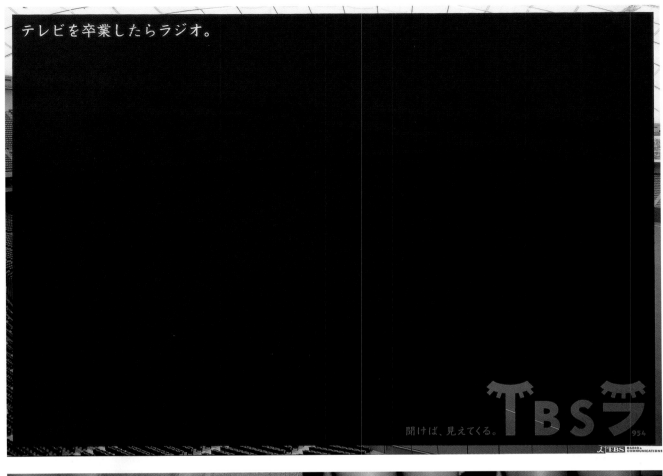

テレビを卒業したらラジオ。

聞けば、見えてくる。 TBSラ 954

テレビを卒業したらラジオ

聞けば、見えてくる。 TBSラ 954

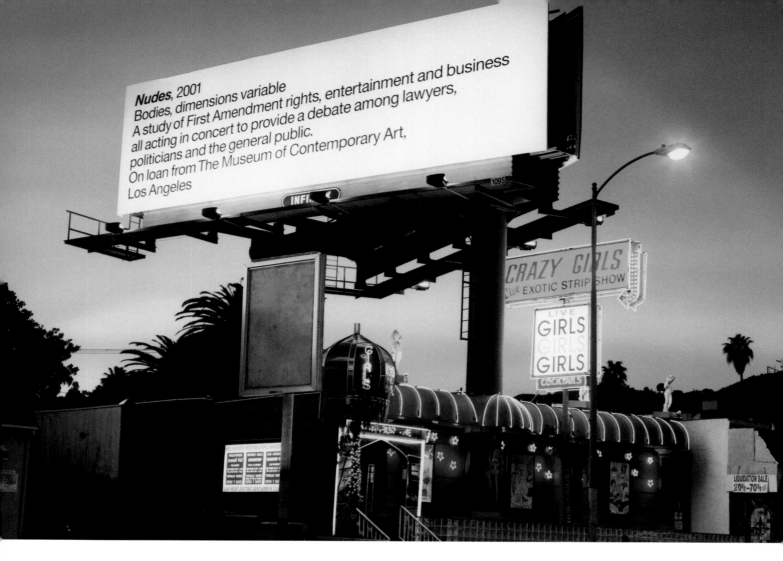

Nudes, 2001 • Church with Red Ribbon, 2001 • Still Life, 2001 • A Study in Human Shapes, 2001

Art Directors Maya Rao, Moe Verbrugge
Copywriters Maya Rao, Moe Verbrugge
Print Producer Shannon Espinosa
Agency TBWA/Chiat/Day
Client The Museum of Contemporary Art, Los Angeles
Country United States

Multiple Awards

GOLD

BILLBOARD/DIORAMA/PAINTED SPECTACULAR, CAMPAIGN

and SILVER

BILLBOARD/DIORAMA/PAINTED SPECTACULAR
Nudes, 2001

and SILVER

BILLBOARD/DIORAMA/PAINTED SPECTACULAR
Church with Red Ribbon, 2001

and SILVER

BILLBOARD/DIORAMA/PAINTED SPECTACULAR
Still Life, 2001

and SILVER

BILLBOARD/DIORAMA/PAINTED SPECTACULAR
A Study in Human Shapes, 2001

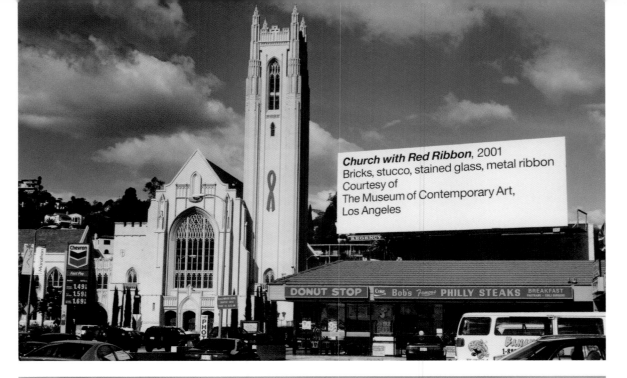

Church with Red Ribbon, 2001
Bricks, stucco, stained glass, metal ribbon
Courtesy of
The Museum of Contemporary Art,
Los Angeles

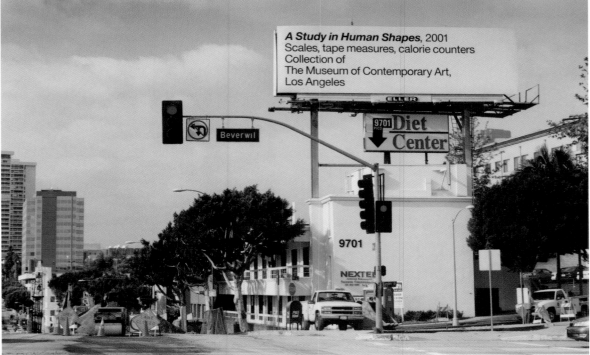

A Study in Human Shapes, 2001
Scales, tape measures, calorie counters
Collection of
The Museum of Contemporary Art,
Los Angeles

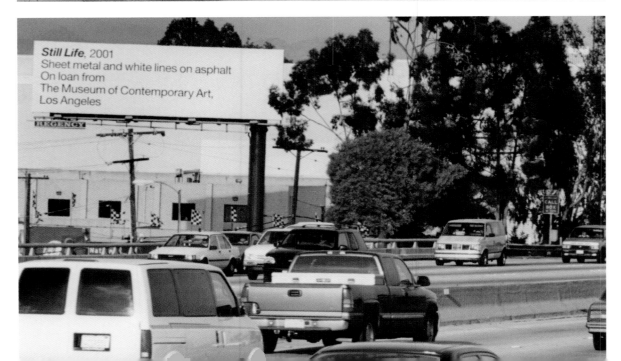

Still Life, 2001
Sheet metal and white lines on asphalt
On loan from
The Museum of Contemporary Art,
Los Angeles

SILVER

TV: 30 SECONDS OR LESS, CAMPAIGN
The King Rocks Hawaii •
1971 Love & Peace

Art Director Yoshio Tanahashi
Creative Director Ichiro Kinoshita
Copywriters Yuichi Sasaki,
Michael Joiner (The King Rocks
Hawaii), Yosuke Yamagami
Photographer Kojiro Tahara
Producer Fumihiko Kataya
Client Nissin Food Products Co., Ltd.
Agency Dentsu Inc.
Country Japan

This campaign was created to
position Cup Noodle as one of the
most innovative food products of
the 20th Century. By borrowing
footage from existing films, we were
able to place the product in the
hands of some of the 20th Century's
most famous and influential people.
The overwhelmingly positive
reaction to the Elvis spot stands
as a testament to the King's ongoing
popularity. The John Lennon spot
has also received accolades,
much of which should go to Ms.
Yoko Ono. She liked the Cup Noodle
campaign so much, she allowed us
access to timeless film footage of
John Lennon.

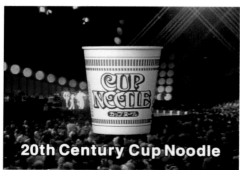

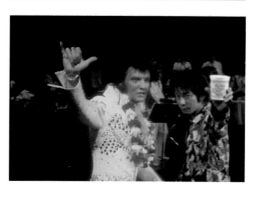

The King Rocks Hawaii

Open on Elvis in
concert. The concert
is a typical show by
the King, except there
is a man sharing the
stage with him. The
man is eating Nissin
Cup Noodle and
showing off for
the audience.

SUPER:
20th Century Cup
Noodle

VO:
Stirring up history.
Cup Noodle.

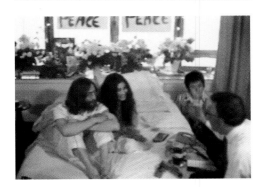

1971 Love and Peace

Classic footage of John Lennon and Yoko Ono in the studio, at home, etc. However, there is an unknown man hanging out with John and Yoko eating Cup Noodle.

SUPER:
20th Century Cup Noodle

VO:
A great moment in the history of the 20th Century. 20th Century Cup Noodle. Nissin.

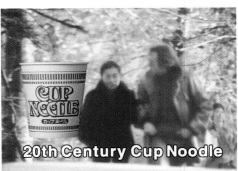

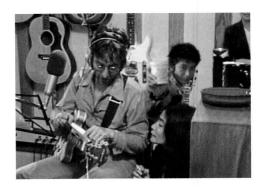

Multiple Awards

SILVER

TV: 30 SECONDS OR LESS, CAMPAIGN
It's Fun Time:
Sneeze • Desert • Drown

and DISTINCTIVE MERIT

TV: 30 SECONDS OR LESS
It's Fun Time: Drown

Art Directors Yasuaki Iwamoto,
Shunichiro Miki
Copywriters Yasuaki Iwamoto,
Yasuhito Nakae
Photographers Hiroshi Machida,
Kosuke Matsushima
CM Planners Mitsuaki Imura,
Yutaka Yokota
Production Company AOI
Advertising Production Inc.
Agency Hakuhodo Inc./Hakuhodo
Creative Vox
Client Coca-Cola Japan Co., Ltd.
Country Japan

42

With Fanta losing its cool status
among Japanese youth, Hakuhodo
decided to create a series of
meaningless jokes about the drink
that teenagers would talk about.
There are 20 spots in all, although
Hakuhodo creative director Yasuaki
Iwamoto plans to make 100. That
way, they can cater to everyone's
sense of humor, no matter how
bizarre. The rule was to shoot in
one cut with a fixed camera. Non-
professionals were also selected
and asked not to act in order to
create the impression of a hidden
camera. The result is weird,
funny, and captivating.

Sneeze

While studying at his
desk, a man seems
like he is starting to
sneeze. After a big
sneeze, a can of Fanta
comes out of his
mouth. The man sits
there in shock.

SUPER:
(Display of product.)

Desert

A man is lost in the desert. He finds a can of Fanta buried in the sand. Because he is dying of thirst, he tries to pull the Fanta from the sand. No matter how fast or how hard he pulls on the can it never comes out. The man starts to freak out.

SUPER:
(Display of product.)

Drown

A girl is at a seaside shop. She hears some kind of voice come out of the drink cooler with an air bubble. When the girl picks up the can of Fanta from the cooler it seems to be having a hard time breathing. The girl looks at the can and is completely confused.

SUPER:
(Display of product.)

SILVER

TV: LOW BUDGET (UNDER $50,000), CAMPAIGN

Remote Control, 2001 • The Demise of Culture, 2001 • Husband and Wife on a Sofa, a Study of Still Life, 2001

Art Directors Maya Rao, Moe Verbrugge
Copywriters Maya Rao, Moe Verbrugge
Producer Mila Davis
Print Producer Shannon Espinosa
Agency TBWA/Chiat/Day
Client The Museum of Contemporary Art, Los Angeles
Country United States

The objective was to build brand awareness for The Museum of Contemporary Art, Los Angeles, among the 25–34-year-old segment. With a very media savvy target and a restrictive production budget we were forced to take an unconventional approach, but our biggest challenge was to try to be as engaging and surprising as the contemporary art in the museum.

By borrowing a graphic element found in the museum, we were able to recreate the museum experience. We applied the museum "label" to television screens to make a commentary on daily life. A lucky happenstance was that the label device is naturally a simple, cost-effective solution. Film, photography, and talent costs did not have to be considered.

The goal of the campaign was to incorporate the viewer into the museum experience and turn an everyday occurrence—sitting at home watching television—into something artful.

Husband and Wife on a Sofa, a Study of Still Life, 2001
People on wood, springs, crushed velvet

Husband and Wife on a Sofa, a Study of Still Life, 2001
People on wood, springs, crushed velvet
On loan from The Museum of Contemporary Art, Los Angeles

Husband and Wife on a Sofa

SUPER:	SFX:
Husband and a Wife on a Sofa, 2001	VO of sleazy retail car salesman on television
People on wood, springs, crushed velvet	
On loan from the Museum of Contemporary Art, Los Angeles	

The Demise of Culture, 2001
Glass, plastic, metal, wires
A large black box sits prominently in the living room,
signifying one doesn't just arrange one's life
around the box but also one's furniture.

Remote Control, 2001
Plastic, metal, rubber, battery
The frenetic movement of sound and light particles
in contrast with the slower movement of the remote
being passed from person to person creates an
interesting dilemma:
The remote controls the television,
but who controls the remote?

The Demise of Culture, 2001
Glass, plastic, metal, wires
A large black box sits prominently in the living room,
signifying one doesn't just arrange one's life
around the box but also one's furniture.
On loan from The Museum of Contemporary Art,
Los Angeles

Remote Control, 2001
Plastic, metal, rubber, battery
The frenetic movement of sound and light particles
in contrast with the slower movement of the remote
being passed from person to person creates an
interesting dilemma:
The remote controls the television,
but who controls the remote?
Collection of The Museum of Contemporary Art,
Los Angeles

The Demise of Culture

SUPER:	SFX:
The Demise of Culture, 2001	Old transistor AM/FM radio buzzing noise
Glass, plastic, metal, wires	
A large black box sits prominently in the living room, signifying one doesn't just arrange one's life around the box but also one's furniture.	
On loan from the Museum of Contemporary Art, Los Angeles	

Remote Control

SUPER :	SFX:
Remote Control, 2001	Channel surfing
Plastic, metal, rubber, batteries	
The frenetic movement of sound and light particles in contrast with the slower movement of the remote being passed from person to person creates an interesting dilemma: The remote controls the television, but who controls the remote?	
Collection of the Museum of Contemporary Art, Los Angeles	

SILVER

CINEMA: 30 SECONDS OR LESS, CAMPAIGN

People in a Movie Theater, 2001 •
Please Don't Sit in Front of Me,
2001 • First Date, 2001

Art Directors Maya Rao,
Moe Verbrugge
Copywriters Maya Rao,
Moe Verbrugge
Print Producer Shannon Espinosa
Agency TBWA/Chiat/Day
Client The Museum of
Contemporary Art, Los Angeles
Country United States

We applied the museum "label" to
the movie theater screen to make a
commentary on daily life. By placing
labels in places people don't usually
find them, we were able to create
the sense of inspiration and
discovery one might experience
in a museum.

The goal of the campaign was to
incorporate the viewer into the
museum experience and turn
an everyday occurrence—sitting
in a movie theater—into
something artful.

People in a Movie Theater, 2001
People on metal and upholstered seats,
popcorn, 35mm film
On loan from The Museum of Contemporary Art,
Los Angeles

People in a Movie Theater

SUPER:
People in a Movie
Theater, 2001

People on metal and
upholstered seats,
popcorn, 35mm film

On loan from the
Museum of
Contemporary Art,
Los Angeles

Please Don't Sit in Front of Me, 2001
Theater, seats, tall people, short people
On loan from The Museum of Contemporary Art,
Los Angeles

First Date, 2001
Theater, 35mm film, men, women,
breath-mints
Courtesy of The Museum of Contemporary Art,
Los Angeles

Please Don't Sit in Front of Me

SUPER:
Please Don't Sit in
Front of Me, 2001

Theater, seats, tall
people, short people

On loan from the
Museum of
Contemporary Art,
Los Angeles

First Date

SUPER:
First Date, 2001

Theater, 35mm film,
men, women,
breath mints

Courtesy of the
Museum of
Contemporary Art,
Los Angeles

SILVER

TV: OVER 30 SECONDS
Holy Cow

Copywriter Martin Juarez
Producer Carlos Volpe
Client Mundo Celular
Agency CraveroLanis Euro RSCG
Creative Directors Juan Cravero,
Dario Lanis
Studio Peluca Films
Country Argentina

Holy Cow

The commercial starts with a general shot of a living room, where we see a man sitting in a chair reading the newspaper. He suddenly directs his vision toward the door where he notices that the mailman has slipped an envelope under the door. He gets up sighing and goes toward the door where he picks up the envelope.

MAN:
The cellular phone bill...

Cut to the man opening the envelope and taking out the bill. The man reads his bill in silence. Then he makes a gesture as if he is uncomfortable.

MAN:
Ay...

He throws himself against the door, grabbing his behind with his hands in a gesture of great pain as he is screaming.

MAN:
Ay...holy cow...ayyy...

Writhing in pain, he looks at the bill again then shoves it in his mouth, biting it with force, and he starts walking off with great difficulty.

VO:
How much are you paying for your cellular phone?

Cut to image of the same man sitting in front of his computer, trying to get comfortable in his chair. On the computer's monitor we see the logo for mundocelular.com. The camera zooms toward the monitor so we close with the logo of the company on screen. The voice over accompanies this entire action, saying:

VO:
Enter mundocelular.com, compare and choose the best

Reading the Paper, 2001
Ink on hands
Courtesy of The Museum of Contemporary Art,
Los Angeles

We applied the museum "label" to newspaper pages to make a commentary on the editorial page on which it appears. By placing labels in places people don't usually find them, we were able to create the sense of inspiration and discovery one might experience in a museum.

The goal of the campaign was to incorporate the viewer into the museum experience and turn an everyday occurrence—reading a newspaper—into something artful.

SILVER

CONSUMER NEWSPAPER: LESS THAN A FULL PAGE

Reading the Paper, 2001

Art Directors Maya Rao, Moe Verbrugge
Copywriters Maya Rao, Moe Verbrugge
Print Producer Shannon Espinosa
Agency TBWA/Chiat/Day
Client The Museum of Contemporary Art, Los Angeles
Country United States

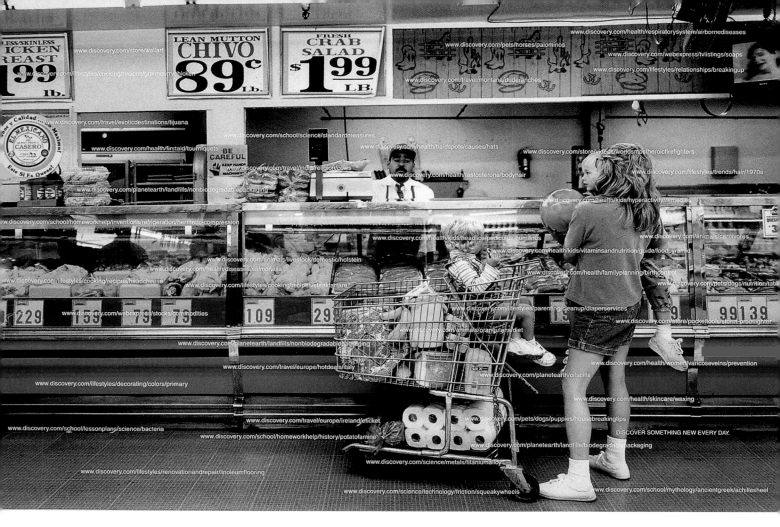

Supermarket • Prom • Bedroom

Art Directors Roger Camp, Mike McCommon
Copywriters Roger Camp, Mike McCommon
Producer Francine Kipreos
Photographers Lauren Greenfield, Stefan Ruiz
Agency Publicis & Hal Riney
Client Discovery.com
Country United States

Multiple Awards

SILVER

CONSUMER MAGAZINE: SPREAD, CAMPAIGN

and MERIT

CONSUMER MAGAZINE: SPREAD
Supermarket

and MERIT

CONSUMER MAGAZINE: SPREAD
Prom

and MERIT

CONSUMER MAGAZINE: SPREAD
Bedroom

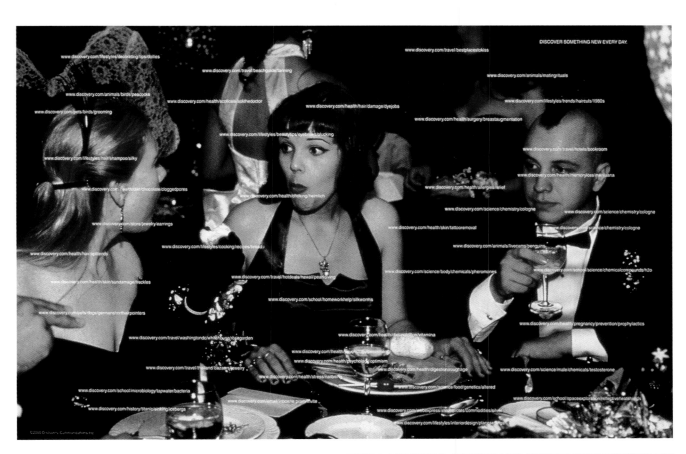

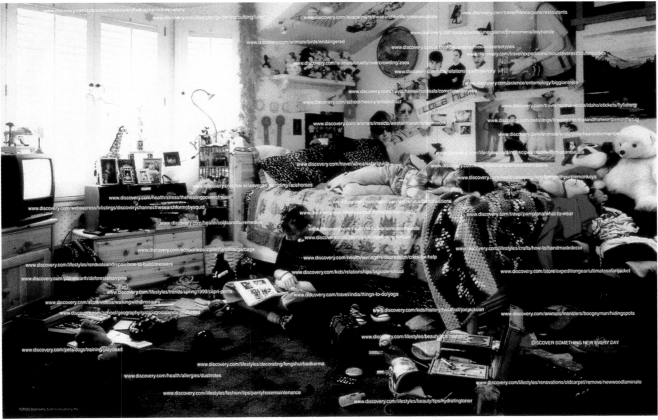

Since its introduction in 1998, the New Beetle has become part of the landscape. It has remained one of the most recognizable shapes in the world. So the question arose, how much can it blend in? That's what led us to these ads, where nothing, no matter how visually arresting, was able to upstage the New Beetle. The line, Hey, there's a yellow one! or, Hey, there's a black one! seemed to match the level of recognition people were giving the car at that particular point in time. Most people no longer stopped in their tracks when they saw one, but they always made a mental note when one drove by.

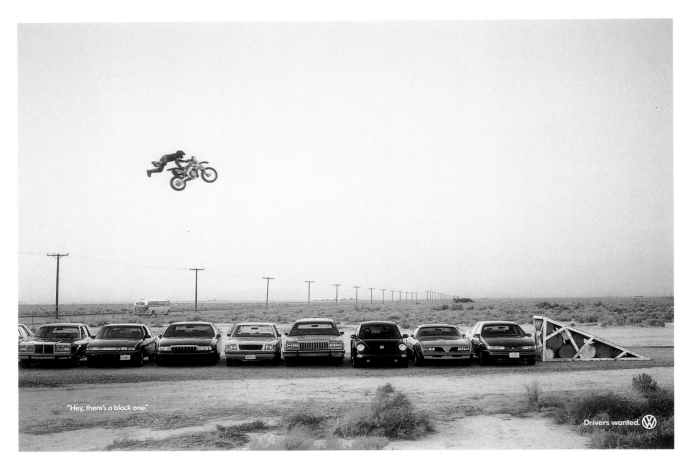

"Hey, there's a black one."

Drivers wanted.

Hey There's a...:
Jumper • Lettuce Girl •
Bulls • Shuttle

Multiple Awards

SILVER

CONSUMER MAGAZINE: SPREAD, CAMPAIGN

and MERIT

CONSUMER MAGAZINE: SPREAD
Jumper

Chief Creative Officer Ron Lawner
Group Creative Director Alan Pafenbach
Art Director Don Shelford
Copywriter Dave Weist
Production Manager Sally Bertolet
Photographer Bill Cash
Printer Liguid Picture
Agency Arnold Worldwide
Client Volkswagen of America, Inc.
Country United States

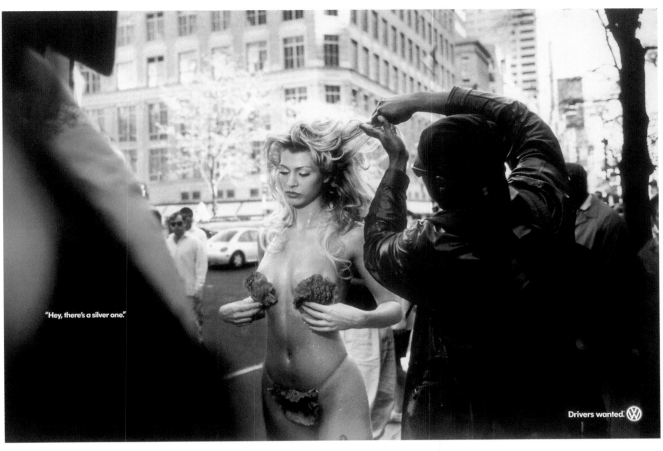

"Hey, there's a silver one."

Drivers wanted.

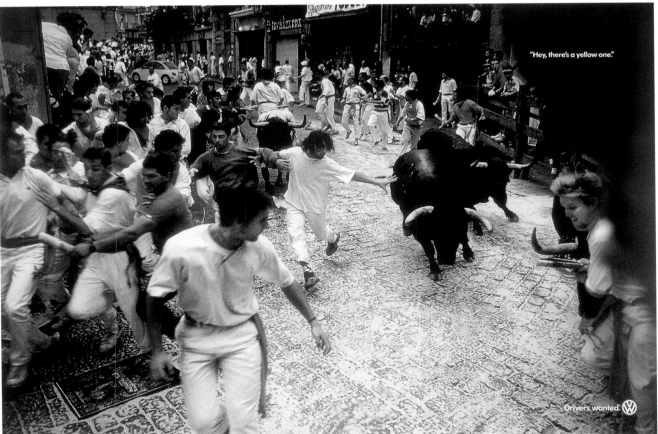

"Hey, there's a yellow one."

Drivers wanted.

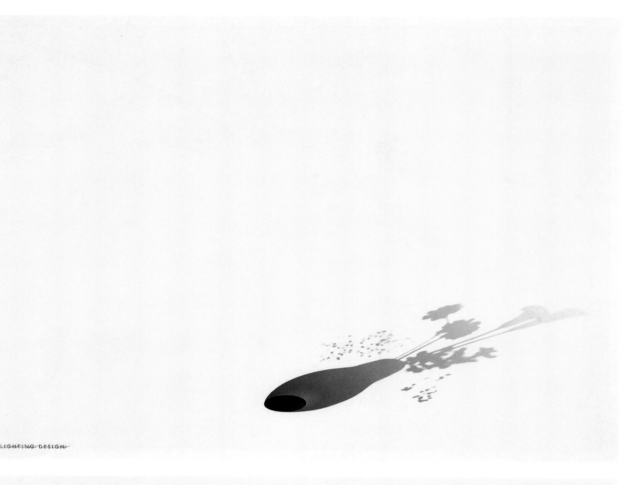

JAPAN LIGHTING DESIGN

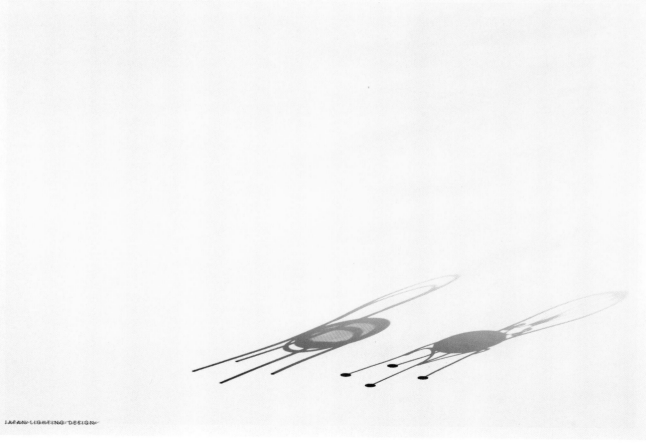

JAPAN LIGHTING DESIGN

SILVER

POSTERS: PROMOTIONAL, CAMPAIGN

Light

Art Director Yuji Tokuda
Creative Director Yuji Tokuda
Designers Ryo Taniyama, Yuji Tokuda, Fumihiro Yokoyama
Photographer Takashi Seo
Agency Dentsu Inc.
Client Japan Lighting Design
Country Japan

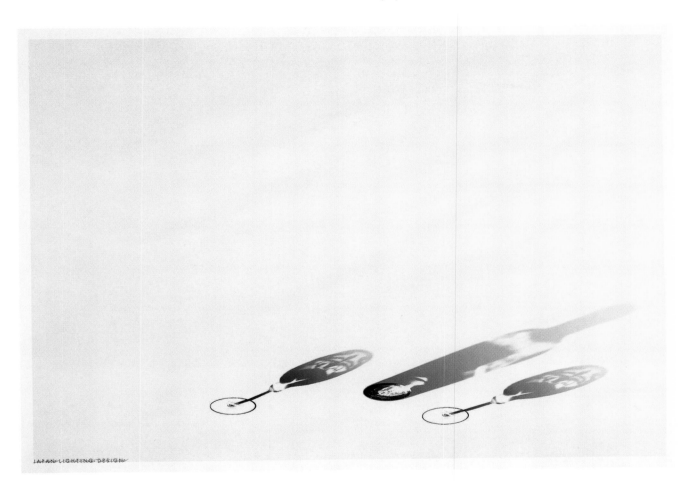

This company designs interior lighting. Lights are what create a beautiful, warm atmosphere for a family, but, at the same time, there is something ephemeral about them. The reason is that they disappear at the flick of a switch.

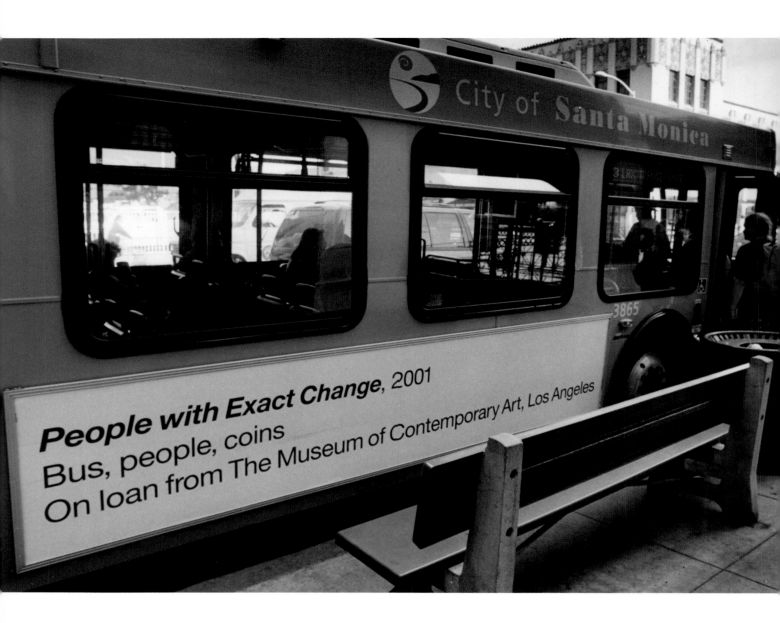

People with Exact Change, 2001

SILVER

POSTERS: TRANSIT

Art Directors Maya Rao,
Moe Verbrugge
Copywriters Maya Rao,
Moe Verbrugge
Print Producer Shannon Espinosa
Agency TBWA/Chiat/Day
Client The Museum of Contemporary Art,
Los Angeles
Country United States

We applied the museum "label" to buses throughout the city of Los Angeles to make a commentary on daily life and, more specifically, the people on the buses.

By turning the city of Los Angeles into a museum experience, the city became a source of discovery and inspiration for the viewer.

SILVER

**BILLBOARD/DIORAMA/PAINTED
SPECTACULAR**

Untitled (Public Course), 2001

Art Directors Maya Rao, Moe Verbrugge
Copywriters Maya Rao, Moe Verbrugge
Print Producer Shannon Espinosa
Agency TBWA/Chiat/Day
Client The Museum of Contemporary Art,
Los Angeles
Country United States

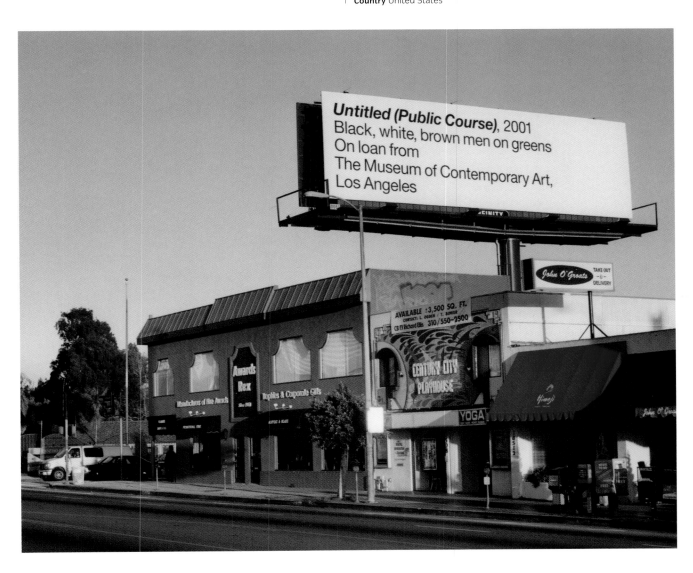

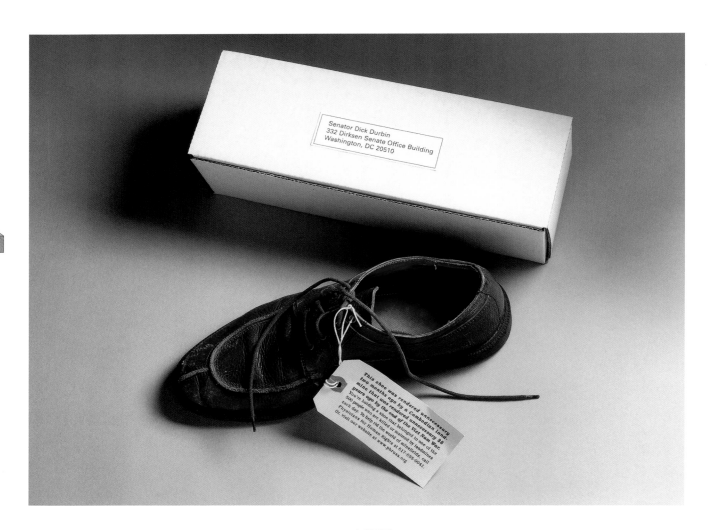

SILVER

DIRECT MAIL, CAMPAIGN

Shoebox

Art Director Jeff DeChausse
Copywriter Jim Schmidt
Client Physicians for Human Rights
Agency Euro RSCG Tatham
Country United States

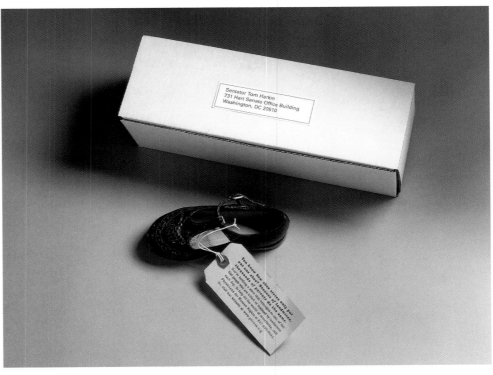

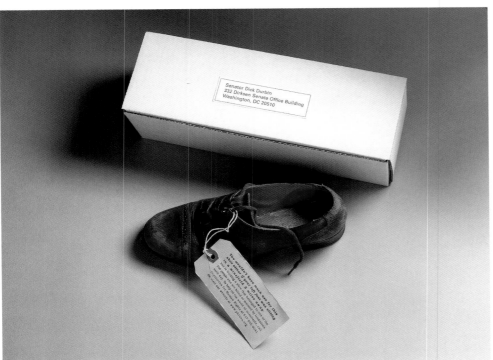

Our client was Physicians for
Human Rights. Their goal was to
raise awareness of the horror of
landmines, so we sent politicians
and other opinionmakers shoe boxes
bearing only one shoe—the other
having been rendered unnecessary
to the owner because of a landmine.

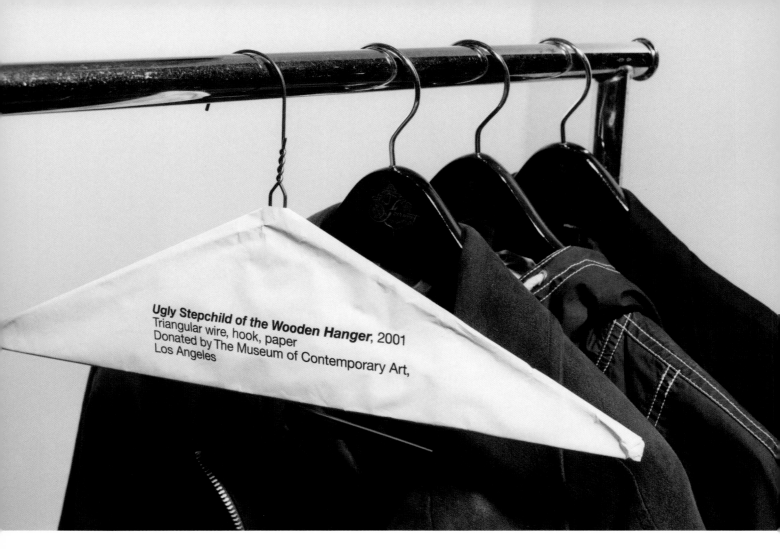

Ugly Stepchild of the Wooden Hanger, 2001
Triangular wire, hook, paper
Donated by The Museum of Contemporary Art,
Los Angeles

SILVER

**GUERILLA ADVERTISING/
UNCONVENTIONAL ADVERTISING
MEDIA, CAMPAIGN**

**Ugly Stepchild of the
Wooden Hanger, 2001 •
Dependency, 2001 •
Middle East
Dependency, 2001 •
News, 2001**

Art Directors Maya Rao,
Moe Verbrugge
Copywriters Maya Rao,
Moe Verbrugge
Print Producer Shannon Espinosa
Agency TBWA/Chiat/Day
Client The Museum of Contemporary Art,
Los Angeles
Country United States

We applied the museum "label" to gas pumps, coffee-cup sleeves, and dry cleaner hangers to make a commentary on daily life. By placing labels in places people don't usually find them we were able to contribute to the sense of inspiration and discovery one might experience in a museum.

The campaign ran throughout the Los Angeles metro area. The goal was to incorporate the viewer into the museum experience and turn an everyday occurrence—drinking coffee, buying gas—into something artful.

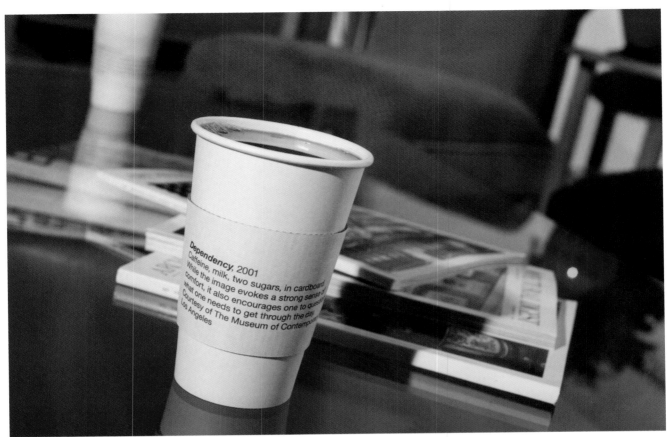

Dependency, 2001
Caffeine, milk, two sugars, in cardboard.
While the image evokes a strong sense of
comfort, it also encourages one to question
what one needs to get through the day.
Courtesy of The Museum of Contemporary,
Los Angeles

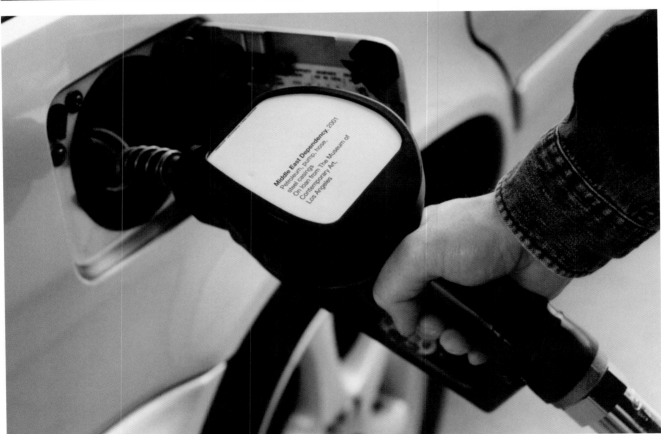

Middle East Dependency, 2001
Petroleum, pump, hose,
steel casings
On loan from The Museum of
Contemporary Art,
Los Angeles

DISTINCTIVE MERIT

**TV: 30 SECONDS OR LESS,
CAMPAIGN**

Break • Vegetarian • Trapped

Art Director Adam Chiappe
Copywriter Matthew Saunby
Producer Julia Methold
Studio Propaganda
Agency BBH—London
Client UDL Foods/Bifi
Country United States

62

BREAK

SUPER:
ZOMTEC

Open on five men
in the break room of
a factory.

MAN 1:
Eggplant? I couldn't do that
with a string bean! (Everyone
laughs.)

MAN 2:
Where would we be without
Corvettes, hygiene clippers,
and our Bifi breaks?

MAN 3:
One time I dressed up like a
schoolgirl, with long socks and
pink panties!

The other four
men appear disgusted
as Man 3 laughs
excitedly.

MAN 3:
Sorry.

Cut to close-up of
thigh with pink
panties showing and a
Bifi stuck in a garter.

VEGETARIAN

Open on four men working on a mouthwash assembly line.	<u>MAN 1:</u> So, uh, Mitch, tell us about her.
Cut to Mitch.	<u>MITCH:</u> Oh, man. She was gorgeous. Dark. Tanned.
Cut to Man 2.	<u>MAN 2:</u> Wow.
Cut to Mitch.	<u>MITCH:</u> Purty teeth. Dreadlocks.
Cut to Man 3.	<u>MAN 1:</u> I'm down with dreadlocks!
Cut to wide shot.	<u>MAN 1:</u> So what happened?
Cut to Mitch, who is now eating a Bifi.	<u>MITCH:</u> (Shrugs.) She was a vegetarian.
Cut to the close-ups of the other three men, who all look disappointed and confused.	

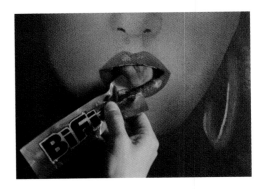

Multiple Awards

DISTINCTIVE MERIT

**TV: 30 SECONDS OR LESS,
CAMPAIGN**
WNBA: WNFL • WNHL • WMLB

and MERIT

TV: 30 SECONDS OR LESS
WNHL

and MERIT

TV: 30 SECONDS OR LESS
WNFL

Art Director Monica Taylor
Creative Directors Hal Curtis,
Jim Riswold
Copywriter Allison Forsythe
Producers Dan Duffy, Chris Noble,
Stephen Orent
Director Hank Perlman
Director of Photography John
Lindley
Agency Wieden & Kennedy
Client Nike
Country United States

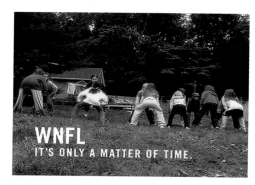

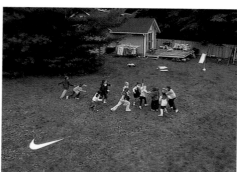

WNBA: WNFL

Open on a modest backyard. There are 8 or 9 girls between the ages of 8 and 12 playing football. It is the end of a play. We just catch a nasty looking side-tackle.

Cut to one of the teams falling in. There are only four of them. Joan, the quarterback, is holding an exhausted bigger girl named Sarah. She is so winded, she appears a bit out of it.

JOAN
(Urgently) Sarah, look at me, what's your gerbil's name?

Cut to Becky falling in. She is the prima donna of the group.

BECKY
(Interrupting Joan with her whiny complaint.) I was wide open!

JOAN
(She is growing tired of this line.) You were covered.

Cut to tiny 8-year-old. You wonder if she even knows how to spell football.

JOAN
(Speaking a little softer and slower now to the 8-year-old.) Where's your head? 'Cause it sure isn't in the game. (Returning to her regular voice.) OK. 33 Tootsie Roll right.

Cut to view of opposing team from the huddle's perspective. The girl closest to them has turned her head to flash a menacing glare as she readjusts her shorts.

Cut back to Joan.

JOAN
(To Sarah, who is now much more alert in a hushed voice.) Sarah, this time when you pull around for the trap block, try hitting her in the midsection. She had hot lunch today. OK, on two. On two. Ready, break! They all snap their fingers in total seriousness and spread out with the precision of a military group carrying out orders.

TITLE:
WNFL
It's only a matter of time.
Nike. Just do it.

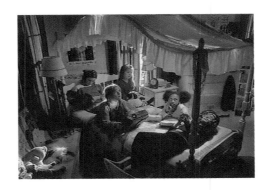

WNBA: WNHL

Open in a girl's bedroom. There are five girls heaped onto the canopy bed, situated so that they are all looking up at the canopy. They all have on some sort of hockey gear. Girl 1 is aiming a slide projector up at the canopy. Girl 2 is wearing a facemask. She is playing with a fortuneteller. Girl 3 is wearing only her kneepads and is holding a clipboard.

GIRL1
This one just moved onto Parkside Drive.

Cut to Girl 2 who has been, up to this point, idly playing with the fortuneteller. She stops moving her fingers and quickly raises her mask to get a better look.

GIRL 2
(With extreme interest and urgency) Is she available for pre-season?

GIRL 3
(Looking at her clipboard) She's baby-sitting tomorrow afternoon. (She pauses and then, with dread) We think she's talking to the Elm Street Raiders. They gave her cuts at Dairy Queen.

GIRL 2
(This is troubling; she thinks for a minute) Save her a seat on the bus tomorrow. Find out what she wants.

Girl 2 puts back down her mask and resumes playing with the fortuneteller as Girl 3 writes on her clipboard.

TITLE:
WNHL.
It's only a matter of time.
Nike. Just do it.

Multiple Awards

DISTINCTIVE MERIT

**TV: 30 SECONDS OR LESS,
CAMPAIGN**
Mosquito • Chum • Meteors

and DISTINCTIVE MERIT

TV: OVER 30 SECONDS
Chum

and DISTINCTIVE MERIT

TV: OVER 30 SECONDS
Mosquito

and MERIT

TV: 30 SECONDS OR LESS
Chum

and MERIT

TV: 30 SECONDS OR LESS
Mosquito

66

Art Directors Roger Camp,
Mike McCommon
Copywriters Roger Camp,
Mike McCommon
Producer Kelly Green
Agency Publicis & Hal Riney
Client Discovery.com
Country United States

MOSQUITO

Open on nature
footage of a man in
a swamp. Cut to
mosquitoes landing
on a giant pink arm.

MAN 1:
Buzz, buzz.

MAN 2:
Buzz, buzz.

MAN 1:
Hello, mosquito.

MAN 2:
Hello, mosquito.

MAN 1:
Have you heard about the Web
site called Discovery.com ?

MAN 2:
No.

MAN 1:
They have a very useful travel
section.

MAN 2:
I love to travel.

Just then a large
hand comes down and
squishes them.

SUPER:
Discovery.com
Discover something
new everyday.

CHUM

METEORS

Open on a shark eating a fish. Cut to the inside of the shark's stomach where two fish stand in a pool of muck.

Open on meteors in space.

MAN 1:
Hello, fellow partially eaten fish.

MAN 1:
Hello, meteor.

MAN 2:
Hello.

MAN 2:
Hello, meteor.

MAN 1:
Have you heard about the Web site called Discovery.com?

MAN 1:
Have you heard about the Web site called Discovery.com?

MAN 2:
Why, yes. They have lots of practical information on stuff like health, traveling, and pets. I learned that sharks eat up to 10 % of their body weight per week.

MAN 2:
Discovery.com is my guidebook for life. I learned how to plant an herb garden, train my dog, and cure my dandruff.

MAN 2:
Wow.

MAN 1:
I learned that most meteors burn up entering Earth's atmosphere.

Another fish joins them.

They look at each other, then burst into flames.

NEW GUY:
They even have the news and weather.

MAN 2:
Aahhh! The atmosphere!

SUPER:
Discovery.com
Discover something new everyday.

SUPER:
Discovery.com
Discover something new everyday.

Multiple Awards

IF ONLY EVERY QUESTION
WAS A SPORTS QUESTION.

SPORTS GENIUSES
The new game show premieres March 27.

FOX
SPORTS NET
www.foxsports.com

BABY

A guy stares at a woman while she breast feeds. The woman catches him, but to his relief she asks him a sports trivia question.

TITLE:
If only every question was a sports trivia question.

SUPER:
Sports Geniuses. The new game show premieres March 27. Fox Sports Net.

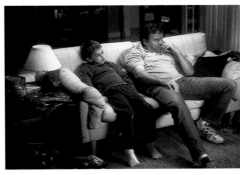

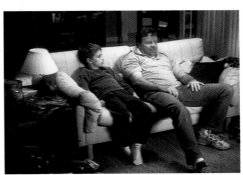

MILK

A guy spills milk on his
chest and his cat licks
it off his nipple. His
girlfriend catches him
in the act, but to his
relief she asks him a
sports trivia question.

TITLE:
If only every
question was a sports
trivia question.

SUPER:
Sports Geniuses.
The new game show
premieres March 27.
Fox Sports Net.

NATURE CHANNEL

A father and his
young son awkwardly
watch wolves mating
on television. To his
father's relief, his son
asks him a sports
trivia question.

TITLE:
If only every
question was a sports
trivia question.

SUPER:
Sports Geniuses.
The new game show
premieres March 27.
Fox Sports Net.

TV: 30 SECONDS OR LESS, CAMPAIGN

Safety First: Bear • Bunny • Squirrel

Art Director Kim Schoen
Copywriter Kevin Proudfoot
Producer Tony Stearns
Director Geoff McFetridge
Animator Geoff McFetridge
Designer Geoff McFetridge
Agency Wieden + Kennedy NY
Client ESPN
Country United States

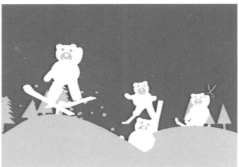

BEAR

Open on five animated bears in the starting gate of the Skier X course.

At the sound of the starting tone, the bears push off and begin racing down the treacherous course.

Midway through the race we see that one of the bears is hurtling down the mountain holding a pair of scissors. He's skiing like a champion— he's cornering, he's jumping, he's got a shot to win it all. But then he catches an edge.

He loses control, accidentally cutting off his own head, which flies through the air and lands in the snow in the foreground. In the background, his body and the other skiers continue on.

SUPER:
Never Ski
with Scissors

SUPER:
Safety First

SUPER:
Winter X Games
February 2–6 Mount
Snow, VT
ESPN

BUNNY

A pack of bunnies snowmobile around the treacherous Winter X SnoCross course. They jostle, jump, and jockey for position.

As the pack rounds a corner, we see that one of the riders is wearing a long, billowing scarf. We see him checking himself out in the mirror. Suddenly he's jerked backward.

The scarf is tangled in the snowmobile's treads and the bunny is sucked into the gears. What's left of the bunny is shot out the back of the snowmobile.

The riderless snowmobile races off into the distance with the bunny's head banging along behind.

The head dislodges, landing, skewered, on a branch.

SUPER:
Keep Clothing Away from Machinery

SUPER:
Safety First

SUPER:
Winter X Games
February 2–6
Mount Snow, VT
ESPN

SQUIRREL

An animated squirrel sits on a motorcycle equipped with spiked tires. As he waits at the starting line, he makes a "whatup" type gesture to the camera. Then he's off.

He races down the snowy runway going full throttle, spraying slush everywhere.

Right before a huge snow ramp, the squirrel guns it, launching himself into the air. He twists, flips, and pulls off a one-handed superman. Then he nails the landing.

The squirrel waves to the crowd, he's enjoying the moment. He unscrews the gas cap, inserts a flexi-straw, and gulps down some gasoline—and keels over instantly.

After an awkward pause, someone pokes him with a stick.

SUPER:
Do Not Drink Gasoline

SUPER:
Safety First

SUPER:
Winter X Games
February 2–6
Mount Snow, VT
ESPN

Multiple Awards

DISTINCTIVE MERIT

**TV: 30 SECONDS OR LESS,
CAMPAIGN**
L.A. • Utah • San Antonio

and DISTINCTIVE MERIT

TV: 30 SECONDS OR LESS
Utah

and DISTINCTIVE MERIT

TV: 30 SECONDS OR LESS
San Antonio

Art Director Reed Collins
Creative Director Eric Silver
Copywriter Eric Silver
Producer Kevin Diller
Director Kuntz & Macguire
Editor Gavin Cutler
Editing House Mackenzie Cutler
Production Company Propaganda
Agency Cliff Freeman and Partners
Client FOX Sports
Country United States

LOS ANGELES

Open on Alan
and Jerome inside a
pizza parlor.

ALAN:
I'd love to punish the Lakers.

(Cut to the fantasy.)
Alan works from
one end of the court
to the other, eluding
defenders the whole
way. Not even the
mighty Shaq can stop
him. This, of course,
leads to the
mighty showboat.

ALAN:
I'm fresh like a can of picante!

LIVE THE GAME

FOX
SPORTS NET

UTAH

SAN ANTONIO

Open on Alan and Jerome sitting on a stoop talking trash.

ALAN:
If I had the chance, I'd lead the league in assists.

(Cut to the fantasy.) Alan puts some moves on Karl Malone and gets the ball to Jerome, who knocks down the easy jump shot. They then take to the sidelines and put on a little dance for the fans in Utah.

Open on Alan and Jerome chillin' by a wall.

JEROME:
Who says you gotta be a big man to compete in the NBA?

(Cut to the fantasy.) Alan feeds the ball to Jerome who blows by Robinson and scores the sweet bucket. After a bit of celebration, Jerome makes a suggestion to David Robinson.

JEROME:
You'd better get some Coppertone, 'cause you just got burned!

DISTINCTIVE MERIT

TV: OVER 30 SECONDS
Animals

Art Directors Hidehisa Kitaoka,
Tatsuya Tsujinaka, Ryoji Yamamoto
Creative Director Ryoji Yamamoto
Copywriters Tatsuya Tsujinaka,
Ryoji Yamamoto
Producers Kazutoshi Igarashi,
Masanobu Maekawa
Illustrator Tatsuya Tsujinaka
Animator Kazuhisa Kamakura
Music Kyoko Kimura
Agency Dentsu Inc.
Client Kansai Telecasting
Corporation
Country Japan

ANIMALS

SUPER:	
Kansai Television	
SUPER:	
There's more . . .	
SUPER:	
Kansai–TV	
SUPER:	VO:
A lot more . . .	What the heck?
SUPER:	
Kansai–TV	
SUPER:	
So much more . . .	
SUPER:	
Kansai–TV	
SUPER:	
Annoyed yet?	
SUPER:	
Kansai–TV	
SUPER:	
More to come . . .	
SUPER:	VO:
Kansai–TV	Cool baby.
SUPER:	
Come again . . .	
SUPER:	
Kansai–TV	
SUPER:	
Come another . . .	
SUPER:	
Kansai–TV	
SUPER:	
The End.	

Multiple Awards

DISTINCTIVE MERIT

TV: SPOTS OF VARYING LENGTH, CAMPAIGN

Photo Booth • Dishwasher • Fishbowl

and DISTINCTIVE MERIT

TV: OVER 30 SECONDS

Photo Booth

Art Director Chris Lange
Copywriter Michael Hart
Executive Producers Robert Fernandez, Jon Kamen
Producer Damian Stevens
Line Producer Tom O'Malley
Director Errol Morris
Production Company @radical.media
Agency Fallon McElligott
Client PBS
Country United States

PHOTOBOOTH

The screen is completely black except for a small round hole. The camera goes through the hole to reveal the whole scene.

A man in a photobooth. We see his legs and the flash of the camera.

Cut to him inside the booth, posing with a series of strange facial expressions.

Close-up of a dozen or so photo strips that have come out of the machine.

Open on the man in his living room. He puts a record on the turntable and picks up a small booklet.

As the music starts, the man begins to flip the pages of the small booklet. He's made a flipbook out of the photos from the booth. It's him lip-synching the song.

The camera backs out of the scene through the round hole. When the camera stops, the hole is filled with the PBS logo.

SUPER:
Stay curious.

SFX:
The scratch of the needle at the beginning of the record. And then "Di Quella Pira" from Verdi's "Il Trovatore."

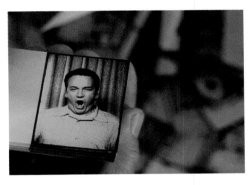

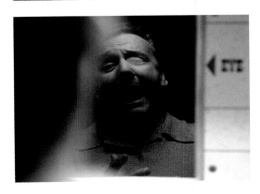

DISTINCTIVE MERIT

TV: PUBLIC SERVICE/NONPROFIT
Police Control

Art Director Claude Catsky
Copywriter Claude Catsky
Producer Daniela Berther
Director Guntmar Lasnig
Studio Pumpkin Film, Zurich
Agency McCann-Erickson, Zurich
Client Alcoholics Anonymous
Country Switzerland

Alcoholism.
It can happen to anyone.

Alcoholics Anonymous.

Call 0848 848 846

POLICE CONTROL

Open on an obviously drunk man trying to get into his car.

He gets behind the wheel and starts to drive—poorly.

He gets pulled over by a police officer at a drunk driving checkpoint.

The drunk man pulls the car onto the sidewalk and rolls down the window.

The Officer stumbles over to the window. He is also obviously drunk.

SUPER:
Alcoholism. It can happen to anyone.

SUPER:
We can help.

LOGO:
Alcoholics Anonymous.

DRUNK MAN:
(Babbles something incomprehensible to the officer.)

OFFICER:
(Replies with something equally incomprehensible.)

TV: LOW BUDGET (UNDER $50,000), CAMPAIGN

Foam Finger: Car • Rip • Rescue

Art Director Mark Peters
Creative Director Kerry Feuerman
Copywriters Joe Alexander,
Josh Gold
Producer Steve Humble
Director Jim Jenkins
Production Company hungry man
Agency The Martin Agency
Client Alltel Communications, Inc.
Country United States

CAR • RIP • RESCUE

Open on two guys driving to a game.

Cut to fans of the other team walking by.

MAN 1:
Hey, whatta we got here?

MAN 2:
We got a bunch of losers!

Cut back to car. Man 1 honks horn so you can't hear the fans.

FANS:
Why don't you . . .

They park and get out. Man 2 is standing next to the passenger side door with a glazed look on his face.

MAN 1:
What? What?

MAN 2:
. . .

Man 1 goes to the other side of the car and sees that Man 2 has caught the end of his foam finger in the door.

MAN 1:
What are you looking at me like that for?

MAN 1:
Ooh! All right. All right. That's gotta hurt. Just don't move.

MAN 2:
. . .

MAN 1:
Someone wanna help me out? I got a situation here. Okay. You gotta relax and look over there.

Man 1 grabs the foam hand and rips it from the door. The end of the finger rips off. Man 2 sees this and passes out.

MAN 1:
Okay. Okay. Just sit up. Whoa. Whoa! Just hang in there. Just think about something pretty.

Cut to an ambulance crew bursting through the crowd.

Cut to close-up of crew shaking their heads as if Man 2 is a goner.

EMT:
You're going to be okay. You're going to be all right.

EMT:
(Aside to Man 1.) He's got a big hand. I hope he has a heart to match.

They wheel him onto the ambulance. Man 1 races behind them carrying a cooler. The end of the finger is inside on ice.

MAN 1:
Wait, wait, wait!

SUPER:
Not just fans.
ACC fans.

LOGO:
Alltel
Nokia

Not just fans. ACC fans.

DISTINCTIVE MERIT

RADIO: OVER 30 SECONDS
The Sixth Sense

Creative Director Arthur Bijur
Copywriter Adam Chasnow
Producer Leigh Fuchs
Engineer Roy Kamen
Production Company Kamen
Entertainment Group
Agency Cliff Freeman and Partners
Client Hollywood Video
Country United States

SIXTH SENSE

ANNCR:
Hollywood Video presents, Sixty-second
Theater, where we try (unsuccessfully) to
pack all the drama and suspense of a two-
hour Hollywood production into 60 seconds.
Today's presentation, *The Sixth Sense*:
SFX:
Door bell. Door open.
COLE (HALEY JOEL OSMENT SOUNDALIKE):
Who are you?
DR. (BRUCE WILLIS-SOUNDALIKE):
I'm a child psychologist. Heard you've
been having some nightmares. What's
bothering you?
COLE (WHISPERS):
I see dead people.
DR.:
You got to speak up, kid.
COLE (WHISPERS):
I see dead people.
DR.:
I can't hear a thing you're saying.
COLE (WHISPERS):
I see dead people.
DR.:
What? Let's pick this up next week.
SFX:
Door bell. Door open.
DR.:
Hi. Last time we met you were
saying...
COLE (WHISPERS):
I see dead people.
DR.:
Why are you whispering?
COLE (WHISPERS):
I see dead people.
DR.:
You see Fred who?
COLE (WHISPERS):
I see (SPEAKS UP) dead people.
DR.:
Oh, that. Are you sure you don't have
an Oedipal complex? I'm good at those.
COLE:
Nope.
DR.:
How about bed wetting? That's my specialty.
COLE:
Just dead people. Can you help me?
DR.:
Sorry, time's up.
SFX:
Door bell. Door open.
COLE:
Dead people are everywhere.

DR.:
Are they here?
COLE:
Yes.
DR.:
Where?
COLE:
You can't see them.
DR.:
Can they see you?
COLE:
They see what they want to see.
DR.:
So they want to see you?
COLE:
Yes. Every day.
DR.:
Can I see you again tomorrow?
COLE:
Okay.
SFX:
Door bell. Door open.
DR.:
Sorry I'm late. Tell me more about
the dead people.
COLE:
They have no concept of time.
DR.:
What else do they do?
COLE:
Ask lots of questions.
DR.:
They do? How come? About what?
COLE:
You tell me.
DR.:
How would I know about
dead people?
COLE:
Because you're... (WHISPERS SOMETHING
UNINTELLIGIBLE)
DR.:
What did you say?
ANNCR:
If this doesn't satisfy your urge to
see *The Sixth Sense* (and we can't say
we blame you) then rent it for five days
at Hollywood Video. Where we'll help
you find *The Sixth Sense* or exactly the
movie you're in the mood for. Celebrity
voices impersonated.

CURSOR MOVEMENT ANALYSIS

USER: Götz Alsmann
PROFESSION: showmaster

DISTANCE: 93.64 cm
TIME: 16 min 59 sec

VISITS: 01 E-mail to Steffi Graf. Subject: „Come on my show"
02 Book order „The songs of Leiber/Stoller" (N. Michna)
03 Routemaster: Hamburg – Frankfurt
04 Check on personal portfolio

SITE: **FAZ.NET**
INFORMATION MADE PERSONAL

CURSOR-BEWEGUNGS-ANALYSE

USER: Benjamin v. Stuckrad-Barre
BERUF: Schriftsteller

STRECKE: 231.71 cm
ZEIT: 21:47 min

VISITS: 01 Buchkauf: „Chronik der Gefühle" (A. Kluge)
02 Hörprobe Audiobook: „Pooh's Corner" (H. Rowohlt)
03 Archivrecherche: Was macht eigentlich Reinhard Klimmt?
04 E-Mail an Michael Neumann: Betr. „Praktikumsplatz"

SITE: **FAZ.NET**
THE FIRST SMART SITE

DISTINCTIVE MERIT

**TRADE MAGAZINE: SPREAD,
CAMPAIGN**
FAZ.NET: The F.A.Z.-Curser-Analysis

Art Director Matthias Spaetgens
Creative Directors Johannes Krempl,
Pius Walker
Copywriter Jan Leube
Photographer Heribert Schindler
Graphic Designer Kay Luebke
Agency Scholz & Friends
Client Frankfurter Allgemeine
Zeitung GmbH
Country Germany

DISTINCTIVE MERIT

POSTERS: PROMOTIONAL

Dot Screen

Art Director Paul Belford
Copywriter Nigel Roberts
Designer Paul Belford
Illustrator Paul Belford
Agency TBWA/London
Country United Kingdom

DISTINCTIVE MERIT

POSTERS: POINT-OF-PURCHASE
Apple

Art Directors Tay Guan Hin, Eric Yeo
Executive Creative Director Linda Locke
Creative Director Tay Guan Hin
Copywriter Simon Beaumont
Photographer Alex KaiKeong Studio
Agency Leo Burnett Singapore
Client Kitchen Culture
Country Singapore

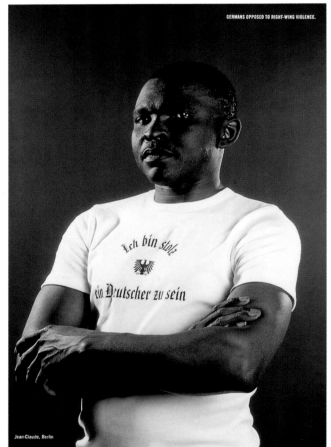

DISTINCTIVE MERIT

**POSTERS: PUBLIC SERVICE/
NONPROFIT, CAMPAIGN**
I Am Proud to Be a German

Art Director Ralph Puettmann
Creative Directors Lutz Pluemecke,
Sebastian Turner
Photographer Matthias Koslik
Copywriter Oliver Handlos
Agency Scholz & Friends
Client Initiative Deutsche
gegen rechte Gewalt
Country Germany

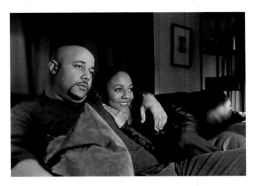

MERIT

TV: 30 SECONDS OR LESS
Whassup Girlfriend

Art Directors Justin Reardon,
Chuck Taylor
Copywriter Vinny Warren
Producer Kent Kwiatt
Studio C & C Storm Films, New York
Agency DDB Chicago
Client Anheuser-Busch Inc.
Country United States

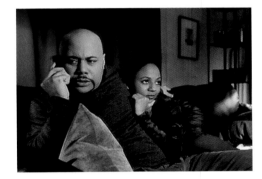

WHASSUP GIRLFRIEND

Open on a man watching TV with his girlfriend. The phone rings and he answers it.

MAN:
(Very calmly) Yo.

Cut to three of his friends in a loud bar.

MAN IN BAR:
Whassuuuuuup!

MAN:
(Still calmly) Whassup.

ALL THREE MEN IN BAR:
WHASSUUUUUUP!

Man looks nervously at his girlfriend.

MAN:
(Now whispering) Yo, what y'all doin'?

MAN IN BAR:
Just watchin' the game, havin' a Bud. Whassup wit' you?

MAN:
Watchin' the game, havin' a Bud.

His girlfriend gets excited at something on the TV and screams.

GIRLFRIEND:
Yes, yes, yes!

The man in the bar hears this and is confused.

MAN IN BAR:
What game you watchin'?

SUPER:
Budweiser
True

© 2000, ANHEUSER-BUSCH, INC. BUDWEISER BEER. ST. LOUIS. MO

Multiple Awards

MERIT

TV: 30 SECONDS OR LESS, CAMPAIGN
Giant • Farmer • Pool

and MERIT

TV: 30 SECONDS OR LESS
Pool

Art Director Joe Kayser
Copywriter Michael Barti
Producer Julie Shannon
Agency Publicis & Hal Riney
Client iomega
Country United States

GIANT

Open on a knight in a castle courtyard	VO: This is Cedric.
The knight sees a damsel locked behind a gate. He goes to help her.	VO: Let's pretend he represents digital photos you took at a medieval faire. Nifty!
It's a trap! The damsel is actually a marionette. A hidden giant crushes Cedric.	VO: Oh, my, a hacker has destroyed Cedric! Bye-bye, Cedric.
With a "zip" sound, Cedric reappears. He's fighting mad.	VO: Wait! It's a backup copy of Cedric you saved on an iomega Zip disk. Cedric is back. Take that, you hacker.
	VO: Zip. It. Zip it.

FARMER

Open on a farmer and mule plowing a field.

VO:
This is Jeb and his mule, Bo. Imagine they represent software on your computer. They work hard for you. Thanks, fellas.

A bomb falls from the sky and blows them up leaving only a crater.

SFX:
BOOM!

VO:
Gosh darn it! Your computer crashed. Jeb and Bo are gone. Now who will do the work?

With a "zip" sound, Jeb and Bo reappear. They continue plowing.

VO:
Hey, it's a copy of Jeb and Bo you saved on an iomega Zip disk. Go, Jeb! Go, Bo!

VO:
Zip. It. Zip it.

POOL

Open on a man lounging on a raft in a pool.

VO:
This is Fred. Let's pretend Fred is a file on your computer. He's a thesis you've worked on for two years. You're very proud of Fred.

Suddenly, a giant squid bursts out of the water and attacks Fred.

VO:
Oh, no! A computer virus has struck!

The monster drags Fred underwater.

VO:
There goes Fred. Darn!

With a "zip" sound, Fred reappears. He continues lounging.

VO:
Look! It's a backup copy of Fred you saved on an iomega Zip disk. Welcome back, Fred.

VO:
Zip. It. Zip it.

**TV: 30 SECONDS OR LESS,
CAMPAIGN**
Snowball • Racing Marion • Celebrity

Art Director Andy Fackrell
Creative Directors Hal Curtis,
Bob Moore, Chuck McBride,
Steve Sandoz
Copywriter Dylan Lee
Producers Vic Palumbo,
Shannon Worley
Director Johan Renck
Agency Wieden + Kennedy
Client Nike
Country United States

SNOWBALL

SUPER:
Cross Training

Open on a
snowboarder pulling
a trick off a ramp.

SNOWBOARDER:
(To camera) Think you can do
that?

Cut to first-person
view of someone
checking his stunt
bike skis. He goes off
a ramp and looks up
to see a humongous
snowball bearing
down on him.

VO:
Oh, my gosh!

Cut to wide shot of
snowball behind four
snowboarders.

Back to first-person
view of man riding
bike downhill through
trees, trying to escape
the snowball.

VO:
Hurry up! Come on!

They get to the house
and the door opens.
The kid inside sees the
snowball barreling
toward his house and
screams.

SUPER:
Continued at
whatever.nike.com

LOGO:
Nike Swoosh

RACING MARION

SUPER:
Cross Training

Open on first-person view of a man reading *Fast Women* magazine with Marion Jones on the cover. The man looks up to see Marion Jones walking by. He double-takes and then gets up and chases her.

MAN:
Whoa.

Marion notices him and takes off.

MARION:
Oh, you wanna race?

He chases her through apartments, backyards, and alleys and into the middle of a street fair. He runs into a man juggling chainsaws. The last thing we see is a chainsaw falling toward the man.

SUPER:
Continued at whatever.nike.com

LOGO:
Nike Swoosh

CELEBRITY

SUPER:
Cross Training

Open on Mark McGwire waiting on a pitch at the "Super Star Celebrity Challenge!" on a cruise ship.

VO:
Next up, Mark McGwire.

The pitch hits Mark, who angrily charges the mound. The pitcher takes off and Mark chases him through a restaurant and onto the deck.

MARK:
You're mine.

The pitcher has run out of places to go. He spots an open pipe on the deck. He looks at Mark, then back at the pipe, and desides to go for it. He jumps headfirst into the pipe.

SUPER:
Continued at whatever.nike.com

LOGO:
Nike Swoosh

MERIT

TV: 30 SECONDS OR LESS, CAMPAIGN
Shox: Chair • Silhouette • Stampede

Art Director Jayanta Jenkins
Copywriter Mike Byrne
Producer Jennifer Smieja
Agency Wieden + Kennedy
Client Nike
Country United States

CHAIR

Open on empty frame with the side of a chair facing camera left. Some time elapses, then Gary Payton enters screen right carrying a large bag and very carefully sits down in the chair. He is not looking at the camera, but in the direction he is seated— left. He is mumbling something about how someone is not going to do something to him. He pulls a large afro out of the bag and puts it on his head. He sits and waits patiently. Then suddenly in the near distance we hear some boing sounds. They get louder and louder. Suddenly we see Vince Carter boing into frame, jump and float over Gary in the chair. He dunks and exits frame. Gary continues to mumble.

SUPER:
Boing

Cut to choreographed shots of Shox basketball shoe.

SUPER: SFX:
Shox Logo Boing!

SILHOUETTES

Open on the silhouetted profiles of a man and a woman. They are facing each other about six inches apart. We see the man's lips move as he says, "buh." At this point the letter B comes out of his mouth and sits between him and the woman. The woman follows up by saying "oing." The letters OING come out of her mouth and sit between the two. They both in unison say "boing" which pushes all the letters together. Cut to another couple doing the same thing.

SUPER:
Boing

Cut to choreographed shots of running and basketball shoe.

SUPER: SFX:
Shox Logo Boing!

STAMPEDE

Empty screen. We hear the distant sound of boing. It is approaching. Finally one lone runner comes into frame right moving at a very quick pace: boing boing boing boing. He leaves frame. A second of nothing. Then we see a pack of three runners that boing into frame. Close behind them is one runner who boings quickly in and out of frame. A moment of nothing. Then suddenly the whole screen is full as a stampede of runners takes over. The boing sounds are manic and overwhelming. Hundreds of boings. They all exit frame. A moment of silence then one last runner boings through frame.

SUPER:
Boing

Cut to choreographed shots of running shoe.

SUPER: SFX:
Shox Logo Boing!

TV: 30 SECONDS OR LESS, CAMPAIGN
Pop the Top • Grandma • Grass Seed

Art Director Jeff Williams
Copywriter Jeff Kling
Producer Tieneke Pavesic
Agency Wieden + Kennedy
Client Miller High Life
Country United States

POP THE TOP

Open on close up shot of a lake. Cut to top of a man's head casting his rod. Cut to wide shot of man standing on the shore, cut to medium shot of man opening a beer. Cut to wide shot of man on the shore.

SUPER:
Miller High Life

VO:
Of course you're supposed to be quiet out here. But any fish that'd be scared off by that sound is no fish for a man's table.

GRANDMA

Open on grandma bringing food out from the kitchen. Cut to her bringing more food out. Cut to table full of food. Cut to her bringing more food.

SUPER:
Miller High Life Light

VO:
Grandma's cooking for her boys tonight.

SFX:
Grunt like someone is full

VO:
Good to know there's a light way to live the High Life.

GRASS SEED

Open on a guy spreading seed by hand.

VO:
In some circles the debate still rages: use a mechanical seed spreader or sow by hand. Perhaps those on the fence haven't properly valued the method that leaves one hand free. Advantage . . . High Life.

MERIT

TV: 30 SECONDS OR LESS
Jailhouse Rock

Art Directors John Hobbs,
Mickey Paxton
Copywriters Brian Connaughton,
Michael Eilperin, David Smith
Producer Gregg Singer
Director Ken Lidster
Production Company Loose Moose
Agency J. Walter Thompson
Client Pepsi-Lipton Tea Partnership
Country United States

JAILHOUSE ROCK

Open on Elvis in jail.	ELVIS: I'm bluer than my suede shoes.
James Brown hands Elvis a book.	BROWN: This'll make you feel good. Haaaayyyy!
Elvis chugs the contraband Brisk.	ELVIS: Mercy, that's Brisk, baby!
Up "Jailhouse Rock"	ELVIS: Warden threw a party in the county jail.
Elvis gyrates his pelvis.	ELVIS: James Brown was there and he began to wail.
James does a split.	BROWN: Haaaaaay!
Willie Nelson joins in.	ELVIS: Willie Nelson sliding on his ol' six-string.
Coolio struts his stuff.	ELVIS: Coolio was droppin' a hip-hop thing.
Elvis leads "The Gang" down a corridor.	ELVIS: Let's rock, everybody let's rock.
Elvis and James make a license plate out of the empty can.	ELVIS: Everybody in the whole cell block, was dancin' to the jailhouse rock.

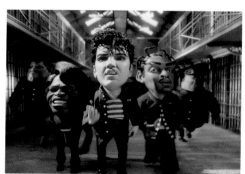

MERIT

TV: 30 SECONDS OR LESS
Igloo

Art Director Keith Courtney
Copywriter Rob Janowski
Producer Susie Lau
Production Company All Films
Agency Publicis Limited
Client McVities
Country United Kingdom

IGLOO

Open on a little kid at a kitchen table. He looks fed up.

An excited mum is holding up various empty Mini Jaffa Cakes containers.

She is scoffing the cakes while making a pathetic attempt to convince the kid she's making toys.

MUM:
Look, look what Mummy's made you . . . A fabulous sailing boat to put in your lunchbox.

Wow! Look a Fireman's helmet.

Hey! A little igloo . . .

She pulls two packs apart and holds them up to her ears with a little wiggle.

(Excitedly) Now, would you like Mummy to make you a set of funny ears?

She quickly unwraps more mini packs, scoops some out, eats them, and smiles.

What do you think?

The kid shakes his head in disbelief.

Cut to glowing pack device.

SUPER:
Deliciously self-centred.

MERIT

TV: 30 SECONDS OR LESS
Dakara—Fat

Art Director Shinya Nakajima
Photographer Yoshihiko Ueda
Copywriter Taku Tada
Producers Yuka Asano,
Hiroyuki Taniguchi
Creative Agency Tugboat
Agency Dentsu Inc.
Client Suntory Ltd.
Country Japan

FAT

PEEING STATUE 1:
Once you get fat, it sticks with
you.

PEEING STATUE 2:
Like here.

PEEING STATUE 1:
So act fast.

Pinches the side of his
stomach.

SUPER:
Fat—Calcium
Salt—Magnesium
Calories—Vegetable

ANNOUNCER:
The drink for good body
balance—Suntory. Dakara.

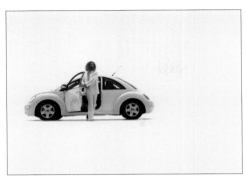

TV: 30 SECONDS OR LESS
Beatles

Art Directors Valdir Bianchi, Andre Laurentino, Jose Carlos Lollo
Copywriters Ricardo Chester, Cassio Zanatta
Producer Trattoria di Frame
Studio Andre Abujamra
Agency Almap BBDO Comunicacões Ltda.
Client Volkswagen
Country Brazil

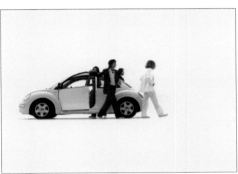

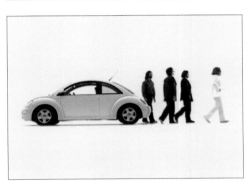

BEATLES

A New Beetle enters the frame and parks.

The doors open, and four Beatles lookalikes get out of the car in single line, forming the famous *Abbey Road* album cover.

Finally the trunk opens and we see that there was a double of Yoko Ono hidden inside it. She gets out rapidly and runs after them.

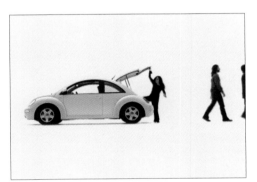

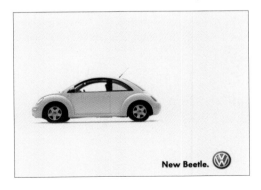

New Beetle.

MERIT

TV: 30 SECONDS OR LESS
Body

Art Director James Selman
Copywriter Steve Skibba
Agency Producer Chris Noble
Executive Producers Robert
Fernandez, Jon Kamen
Director Ralf Schmerberg
Production Company
@radical.media
Agency Wieden + Kennedy
Client Nike
Country United States

BODY

Various shots of Lance
Armstrong—having
blood taken, training
on bike, sleeping.

Shot of Lance riding
bike in the rain. He
rides into his garage.

VO (LANCE):
This is my body, and I can do
whatever I want to it. I can push
it and study it, tweak it, listen
to it. Everybody wants to know
what I am on. What am I on? I'm
on my bike six hours a day.
What are you on?

MERIT

TV: 30 SECONDS OR LESS
Hand

Art Director Marion Donneweg
Copywriters Marion Donneweg,
Toni Segarra, Jorge Virgos
Producer Darrin Ball
Client BMW
Director Victor Garcia
Agency Segarra, Cuesta, Puig,
Fernandez De Castro
Country United States

ADVERTISING TELEVISION

97

HAND

Various scenic shots
of an arm hanging
out the driver's
side window.

SUPER: VO:
BMW logo Love to drive?

Love to drive?

MERIT

TV: 30 SECONDS OR LESS
Dolls

Art Director Adam Chiappe
Copywriter Matthew Saunby
Producer Frances Royle
Studio Propaganda
Agency BBH, London
Client Levi Strauss & Co.
Country United States

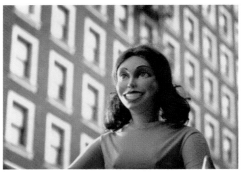

DOLLS

Open on a male doll,
wearing Levi's, floating
down a busy street.

Cut to a female doll,
also wearing Levi's,
floating toward him.

They meet and
embrace.

Just then, a truck
drives by, and the
wind blows them
apart. The male doll is
hurled into a barbed
wire fence and
deflates. The female
doll sees this and col-
lapses in front of him.

SUPER:
(Display of product)
Levi's Engineered
Jeans
The Twisted Original

TV: 30 SECONDS OR LESS
Badger

Art Directors Jeff Labbe, Jon Soto
Executive Creative Director Chuck McBride
Creative Director Jon Soto
Copywriter Stephanie Crippen
Producer Jennifer Golub
Assistant Producer Jenifer Wallrapp
Agency TBWA/Chiat/Day
Client Levi Strauss & Co.
Country United States

LEVI'S CORDS

We see a young man walking through the woods. He is carrying a drink.	SFX: The noise of cords rubbing together, a voop-voop sound
We see a close up of the young man's legs. He is wearing Levi's cords.	
We see a badger exiting his burrow.	The badger grunts, making a sound similar to the cords noise.
The badger is looking for the source of the cords noise. He sees the man and starts to pursue. The man notices the badger and quickens his pace. The badger begins to run. The man turns to see the badger running after him, and he begins to sprint away. We see the man and the badger cross a road.	We hear the noise of the cords and badger's grunts as the pursuit quickens. We hear the ambulance come to a screeching halt.
SUPER: Levi's cords	VO: Levi's cords
SUPER: Levi's make them your own.	
SUPER: Levi.com	

TV: 30 SECONDS OR LESS
Punch

Art Director Shelley Lewis
Copywriters Wade Hesson,
Ron MacDonald
Producer Angy Loftus
Studio Spy Films
Agency MacLaren McCann
Client Sony of Canada Ltd.
Country Canada

PUNCH

Open inside an
electronics store. A
salesman attends to
customer in
background. A giant
display reads: Free
demo: Anti-Skip Sony
CD-Walkman with G-
Protection. A young
guy walks up to the
display and puts on
the Walkman. He
starts shaking the
Walkman, which still
doesn't skip. The
salesman notices the
young guy and walks
up to him.

demonstration in progress

Title card:
Demonstration in
progress.

SFX:
Sound effect of a punch under
the title card

Cut back to the kid
on the floor. The
salesman calmly
walks away.

SUPER:
Ultimate skip
protection.

SUPER:
G-Protection. Skip
Free.

Cut to product shot.

SUPER:
Sony
www.sony.ca

TV: 30 SECONDS OR LESS
Undressed

Art Directors Matt Saunby,
Adam Scholes
Copywriters Adam Chiappe,
Shawn Preston
Producer Frances Royle
Studio Outsider
Agency BBH, London
Client Levi Strauss & Co.
Country United States

UNDRESSED

Open on a young
couple lying naked on
a couch. They begin to
seductively dress
each other.

The girl looks up and
is surprised to see her
parents and little
brother standing in
the doorway. They are
completely naked. The
mother covers her
son's eyes.

SUPER:
(Display of product)
Levi's Engineered
Jeans
The Twisted Original

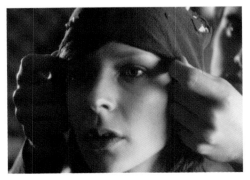

TV: 30 SECONDS OR LESS
Wig

Art Director Lisa Leone
Executive Creative Director Jonathan Hoffman
Copywriter Paul Nies
Executive Producer Ron Nelken
Producer Veronica Puc
Director Jim Tozzi
Studio 14-80
Agency Leo Burnett
Client Kellogg's Rice Krispies
Country United States

From the knees to the feet you see a man tying his shoe; he is wearing pants, socks, jacket, shirt, and shoes that are all dark brown squares.

Man is putting on a brown-with-brown-squares tie and he looks at himself in the mirror. He is completely bald.

VO:
Want to be the best looking man in the world?

Extreme close-up of man holding a Double Chocolate Chunk Rice Krispies Treat up to camera; begins to take treat out of package.

VO:
Try wearing new Kellogg's Double Chocolate Chunk Rice Krispies Treats Squares.

Man is looking at himself in mirror as he places a horribly fashioned Double Chocolate Chunk wig on his head.

Close-up of man as he carefully smooths a chunk into place on his head.

Man is at party, flanked by women.

Women suddenly leave his side and are surrounding another man, who is very darkly tanned and is wearing an off-white suit, tie, shirt, shoes, and socks with an Original Rice Krispies Treats wig.

VO:
Oh, dear. Is this world big enough . . .

Brown Man and Off-white Man face each other in a moment of tension, and women watch in anticipation.

VO:
. . . for two love machines?

Men switch ties. Now their ties are complimentary.

VO:
New Double Chocolate Chunk.

Men engage in fraternity-type handshake and go their separate ways.

VO:
Great for looking sassy.

Extreme close-up of man biting a Kellogg's Double Chocolate Chunk Rice Krispies Treat. You can see his chocolate chunk sideburn.

VO:
Best when eaten.

SUPER:
©2000 Kellogg's Company

SUPER:
Kellogg® Company

Art Director Daryl Vasilinda
Creative Director John Brockenbrough
Copywriter Pete Lefebvre
Executive Producer Bob Carney
Producer Normandie Glassi
Studio @radical.media
Agency Leo Burnett
Client Nintendo
Country United States

SEE-SAW

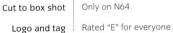

Open on medium shot of boy sitting alone on see-saw.	SFX: Ambient noises
Motocross bike falls from sky and hits other side of see-saw, sending boy out of frame.	SFX: Motocross bike
Motocross rider pops wheelie and rides off.	
Quick cuts of game footage.	ANNOUNCER: Excitebike 64. Get serious air.
Cut to box shot	Only on N64.
Logo and tag	Rated "E" for everyone.

www.nintendo.com

TV: 30 SECONDS OR LESS
Tennis: Pete vs. Andre

Art Director Andy Fackrell
Copywriter Simon Mainwaring
Producer Alicia Hamilton
Agency Wieden + Kennedy
Client Nike
Country United States

104

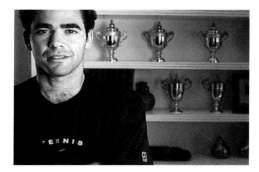

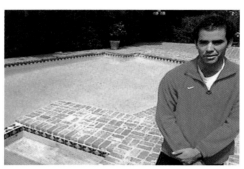

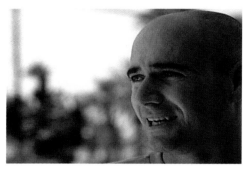

PETE VS. ANDRE

We see Pete Sampras and Andre Agassi answer a barrage of questions, from the very personal to the mundane. The framing of each athlete and the rapid fire editing produces an intensive verbal rally.

ANDRE:
Jeopardy
PETE:
Seinfeld
ANDRE:
Eggs
PETE:
Butter and Jam
ANDRE:
Jesus
PETE:
Princess Diana
ANDRE:
Swing
PETE:
Salsa
ANDRE:
Coffee
PETE:
Tea
ANDRE:
Drama
PETE:
Comedy
ANDRE:
I like the coyote. I hope he gets that little—
PETE:
Road Runner.
ANDRE:
Independent
PETE:
Republican
ANDRE:
Boxers
PETE:
Briefs
ANDRE:
I don't know.
PETE:
The death of my coach.
ANDRE:
Train
PETE:
Train
ANDRE:
Sour
PETE:
Sweet
ANDRE:
Crushed
PETE:
Cubed
ANDRE:
Sinner
PETE:
Saint
ANDRE:
Breast
PETE:
Leg
ANDRE:
Aaaah.
PETE:
Nothing
ANDRE:
My backside
PETE:
My movement
ANDRE:
Salt
PETE:
Pepper
ANDRE:
Aaaaah, Santana.
PETE:
Pearl Jam
ANDRE:
Backhand
PETE:
Forehand
ANDRE:
Wear down
PETE:
Demolish
ANDRE:
I don't know.

SUPER:
Nike Swoosh

TV: 30 SECONDS OR LESS
Empty Lake

Art Director Jeff Williams
Copywriter Jeff Kling
Producer Tieneke Pavesic
Agency Wieden + Kennedy
Client Miller High Life
Country United States

EMPTY LAKE

Open on a lake.

VO:
Marvel at how many men have forgotten their calling. Used to be the prospect of a cold beer and some fishing would catch many a man on these shores, packed shoulder to shoulder. When the last man turns in his Miller High Life for a cappuccino don't come crying if all you get is fish sticks.

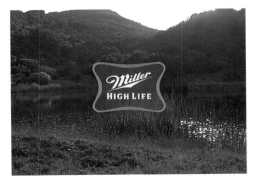

MERIT

TV: 30 SECONDS OR LESS, CAMPAIGN
The Break-up •
Wife vs. Mother-in-law • Club

Art Director Takuma Takasaki
Creative Director Yuya Furukawa
Copywriters Yuya Furukawa,
Takuma Takasaki
Producers Nobuko Nogami,
Takeshi Onayama
Director Masahiro Takata
Photographer Yoshikatsu Yazaki
Studio Engine Film
Agency Dentsu Inc.
Client Isao.net
Country Japan

106

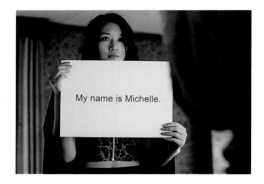

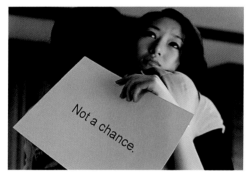

THE BREAK-UP

MAN:
I'm leaving you.
WOMAN:
Huh?
MAN:
I met someone else.
WOMAN:
You're kidding.
MAN:
. . .
WOMAN:
You're not kidding.
MAN:
Please understand.
WOMAN:
No.
MAN:
I'm sorry, Michael.
WOMAN:
My name is Michelle.
MAN:
I'm sorry, Michelle.

SUPER:
Until now, chat rooms
couldn't really "chat."

MAN:
Let's be friends.
WOMAN:
Not a chance.
Breaks my heart.

SUPER:
Internet with a voice
www.isao.net
Your innovative
Internet service
provider.

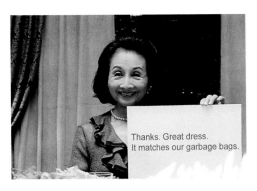

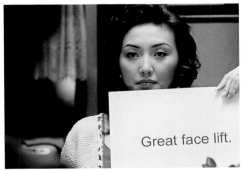

WIFE VS. MOTHER-IN-LAW

CLUB

WIFE:
Happy Birthday, Mother-in-law.
MOTHER-IN-LAW:
Thanks. Great dress. It matches our garbage bags.
WIFE:
So does your lipstick.
MOTHER-IN-LAW:
Ha.
WIFE:
Ha.
MOTHER-IN-LAW:
Nice nose job.
WIFE:
Great face lift.
MOTHER-IN-LAW:
Slut.
WIFE:
Old cow.
MOTHER-IN-LAW:
Money grabbing whore.
WIFE:
Arrogant bitch.
MOTHER-IN-LAW:
Ha.
WIFE:
Ha.

SUPER:
Until now, chat rooms couldn't really "chat."

HUSBAND/SON:
Help . . .

SUPER:
Internet with a voice
www.isao.net
Your innovative
Internet service
provider.

MAN 1:
What's the problema dude?
MAN 2:
Pain pays the income of each precious thing.
MAN 1:
. . .
MAN 2:
Oft expectation falls and most oft where it most promises.
MAN 1:
What are you talking about man?
MAN 2:
In facile quarrels there is no true valor.
WOMAN:
Love looks not with the eyes but with the mind.
MAN 2:
Ignoramus. Ignoramus. Ignoramus.
WOMAN:
Noble minds keep ever with their likes.

SUPER:
Until now, chat rooms couldn't really "chat."

MAN 1:
Arghhhhhhhhhhhhhhh!

SUPER:
Internet with a voice
www.isao.net
Your innovative
Internet service
provider.

TV: 30 SECONDS OR LESS, CAMPAIGN
They're Better Than You Are:
Streetball B • Wall Street Wizards •
Suburbs B

Art Director Kim Schoen
Copywriter Kevin Proudfoot
Producer Brian Cooper
Director Evan Bernard
Agency Wieden + Kennedy NY
Client ESPN
Country United States

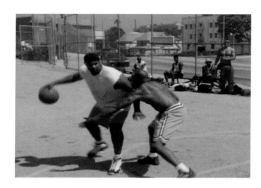

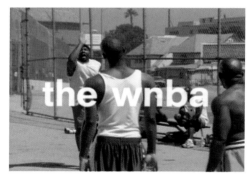

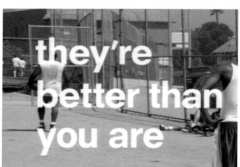

STREETBALL B

Open on a street basketball game in downtown Los Angeles. The players are busy trash talking and showing off for the crowd.

After an ugly shot and a questionable foul call, the game completely unravels.

DEFENDER:
I got you posted big man, I got you posted. Come on, big man!

SHOOTER:
Foul!
DEFENDER:
Foul?
SHOOTER:
Foul!
DEFENDER:
No, don't give him the ball, don't give him the ball! That's not a foul!

SUPER:
The WNBA

SHOOTER:
You gonna respect my call? You gonna respect my call? You gonna respect my call!
DEFENDER:
That's not a foul, dog!
SHOOTER:
Forget you then. If I don't get my foul, I'm going home.

SUPER:
They're better than you are.

SECOND DEFENDER:
Take the ball home then!
DEFENDER:
Go home, you big ol' baby! He's always crying every time he comes out here.
SECOND DEFENDER:
Does someone have another ball?

SUPER:
Lynx v. Sparks—Tonight 7.30 PM ET on ESPN

SUBURBS B

Open on two suburban jocks playing an ugly game of driveway basketball.

The big man labors to score a basket. After backing his way to the basket and putting up a weak shot, he gets his own rebound and scores.

BIG MAN:
Yes! That's a tie, baby!

After a brief celebration, the big man makes his way back to the top of the key. He bends over, exhausted.

SUPER:
The WNBA

Both players are winded. The big man's having a hard time catching his breath.

SUPER:
They're better than you are.

SUPER:
Comets v. Monarchs—Wednesday 8.30 PM ET on ESPN

WALL STREET WIZARDS

Open on a corporate B-League basketball game.

The player who has appointed himself the "floor general" of the blue team has the ball and is trying to direct traffic.

FLOOR GENERAL:
All right, here we go, boys. Move Ricky, get on the blocks! Post up, post up! Get open down there, baby. Awww, man!

He's so busy telling everyone else where to go that he loses the ball.

FLOOR GENERAL:
Go, go, go!

Shot after shot goes up but nobody seems to be able to put it in or grab a rebound.

SUPER:
The WNBA

Finally, one of the players gets his shot to fall.

FLOOR GENERAL:
Ahhhh. No way, ah man. come on!

An over-enthusiastic celebration ensues.

SUPER:
They're better than you are

SUPER:
Comets v. Mercury—Tonight 8.00 PM ET on ESPN

MERIT

TV: 30 SECONDS OR LESS
Cat

Art Director Julian Pugsley
Copywriter Jim Garaventi
Producer Kim Burns
Agency Mullen
Client Cozone.com
Country United States

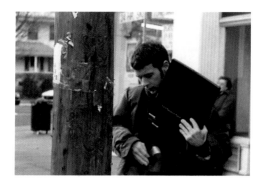

CAT

Open on a city sidewalk. A boy rides a scooter up to a telephone pole, takes his laptop out of his bag, and duct tapes it to the pole. We see the screen as he rides away: "Have you seen my cat?" Onlookers are surprised by what they have seen.

SUPER:
Need a printer?

LOGO:
Cozone.com

OFFER:
Free Xerox laser printer. See site for details.

SFX:
City noises

MERIT

TV: 30 SECONDS OR LESS
Lion

Art Directors Roger Camp,
Mike McCommon
Copywriters Roger Camp,
Mike McCommon
Producer Kelly Green
Agency Publicis & Hal Riney
Client Discovery.com
Country United States

LION

Open on a family of
lions eating a freshly
killed gazelle.

MAN 1:
Hello, lion.

MAN 2:
Hello, lion.

MAN 1:
Have you heard about the Web
site Discovery.com?

MAN 2:
Yes, their Web site is a whole
lot more than nature films. They
have useful information on all
kinds of pets and animals; from
hamsters to wooly mammoths.
They even taught me how to
housebreak my Labrador.

MAN 1:
That sounds really great.

ZEBRA:
You can even check your
stock quotes.

CARD:
Discovery.com
Discover something
new everyday.

MERIT

TV: 30 SECONDS OR LESS
Spirit

Art Director Matt Vescoco
Copywriter Kevin Roddy
Executive Producers Robert
Fernandez, Jon Kamen
Line Producer Tom O'Malley
Agency Producer Julie Roddy
Director Errol Morris
Production Company
@radical.media
Agency Fallon McElligott, NY
Client ABC Sports
Country United States

SPIRIT

Open on two marching
band drummers
practicing in their
dorm. They go
through their whole
routine, mouthing
the rhythms.

MAN 1:
Again.

They start over.

SUPER:
Spirit

SUPER:
As much a part of
college football
as ABC

TV: 30 SECONDS OR LESS
Dog

Art Director Ty Harper
Creative Director Hal Tench
Copywriter Raymond McKinney
Agency Producer Judy Wittenberg
Director Bruce Hurwitt
Editor Andre Betz
Composer Andre Betz
Strategic Planner Sean Denny
Production Company Crossroads Films
Editing Company Bug Editorial
Agency The Martin Agency
Country United States

DOG

Open on a man in the passenger seat of a pick-up truck, talking to the driver.	MAN: I don't even know why I bother. Do you want to go home?
Cut to the driver, who is actually a dog.	DOG: (Moans)
	MAN: You don't pay attention to what I say. You're not even listening now, are you?
The dog spots some ducks in a field next to the road. He floors it and takes the truck off-road after them.	MAN: NO! NO! What are you doing? No ducks! You are so in trouble. Bad dog!
The dog takes the truck over a hill and into a pond in pursuit of the ducks.	MAN: Noooo! Mother of pearl!
Cut to screen shot of carfax.com Web site.	VO: People do some strange things to cars. That's why there's Carfax. We'll give you the real history of any used car.
SUPER: Carfax Vehicle History Reports	

TV: 30 SECONDS OR LESS
Office

Art Director Kevin Smith
Copywriters Dean Buckhorn,
Mike Gibbs
Producer Clarissa Troop
Director Rocky Morton
Agency Fallon McElligott
Client Holiday Inn Express
Country United States

114

Open on the lobby of what appears to be a small office. We see a businessman waiting patiently. He is holding his briefcase in his lap. There are a few other people waiting in the lobby as well. We hear a commotion down the hall. The guy leans forward and looks down a long hall to where the main office is. The door is open a few inches. Through the door, he can see another guy on the phone. The guy is having a very animated, very angry conversation. He paces back and forth. We can hear him yelling. He is a real jerk.

GUY:
. . . Fine! FINE!! I'm not saying it's YOUR fault I'm getting audited, but I'm not the accountant, now am I? (LISTENS) WHAT? They didn't get the return?? You left it WHERE? Oh, for crying out loud! What kind of ignoramus? No . . . YOU LISTEN! (LISTENS) YEA, WELL, SAME TO YOU, BUDDY!

He slams the phone down. The people in the lobby jump. They exchange nervous glances. The door flies all the way open. The guy storms out of the office and into an adjacent office. In there, we see a dentist's chair. He is a dentist. There is a nurse in there. She timidly hands the dentist his white coat. He is still very angry.

Our hero is glancing around as if he is about to bolt. The nurse walks out into the lobby. She is holding a clipboard. She calls out to our hero.

NURSE:
Mr. O'Leary, the dentist will see you . . . (She looks up. He's gone.)

Cut back to the lobby. The guy's chair is now empty. Maybe the imprint of his butt on the vinyl chair?

SUPER:
Stayed at a Holiday Inn Express® last night.

VO:
Stay Smart.

SUPER:
Stay Smart®

VO:
Stay at a Holiday Inn Express.

SUPER:
Holiday Inn Express®
Free Breakfast Bar.

MERIT

TV: 30 SECONDS OR LESS
The End

Art Director Alan Madill
Copywriter Terry Drummond
Producer Louise Blouin
Director Pete Henderson
Studio Spy Films
Agency Taxi
Client Toronto Worldwide Short Film Festival
Country Canada

THE END

Epic film opening on two cowboys sitting on horses, watching over their herd.	BOY: Pa, is Miss Kitty a whore?
Pa is speechless.	
Cut to a wide shot.	SFX: Epic movie music.
SUPER: The End	
TITLE CARD: Toronto Worldwide Short Film Festival. June 5 to 11. Miles from Hollywood.	VO: The Toronto Worldwide Short Film Festival. Miles from Hollywood.

MERIT

TV: 30 SECONDS OR LESS
Hooker

Art Directors Eric Liebhauser,
Jonathan Schoenberg
Copywriters Eric Liebhauser,
Jonathan Schoenberg
Producer Jenny Reiss
Director Pete Sillen
Editor Walter Padgett
Sound Designer Jim Donnelly
Production Company Washington
Square Films, NY
Editing Company CPG, Denver
Sound Coupe Studios
Agency TDA Advertising & Design
Country United States

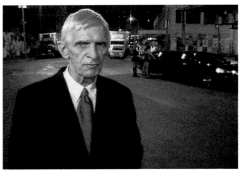

HOOKER

Open on a hooker leaning into limo carrying two men in suits.	HOOKER: So you guys want a date or what? ADVERTISING EXECUTIVE: Oh, we do. We're really lonely.
Cut to serious pitchman.	PITCHMAN: Sure, this transaction looks innocent enough. But the truth is, these advertising executives plan to bill their client for these young ladies' services. But TDA is different. At TDA Advertising and Design, we never bill our prostitutes to your account.
SUPER: TDA logo	VO: TDA Advertising and Design—where the client is never billed for prostitutes.

TV: OVER 30 SECONDS
Lynx: Strike

Art Director Tony Davidson
Copywriter Kim Papworth
Producer Julia Methold
Studio Partizan—Midi Minuit
Agency BBH, London
Client Elida Faberge
Country United States

ADVERTISING TELEVISION

117

LYNX: STRIKE

Open on a man in his apartment getting ready for a date. He shaves with his Lynx razor and gets dressed. Before he leaves, he takes a single match from a case and puts it between his teeth.

He boards his scooter and goes down the block to a hot night-club. He sees his date at a table. She blows out the candle on the table.

He walks over and sits down. He pulls the match from his teeth and tries, unsuccessfully, to strike the match against his cheek. His date takes the match from him and strikes it under her arm.

SUPER:
(Display of product)

VO:
The Lynx effect.

MERIT

TV: OVER 30 SECONDS, CAMPAIGN
Soccer Zombies • Bond Girls • Greyhounds

Art Director Gary Freedman
Copywriter Jonathan Kneebone
Agency Producer Nigel Kenneally
Executive Producers Ned Brown, Loewn Steel
Producers Martha Coleman, Joel Tabbush
Directors Roman Coppola, Bruce Hunt, Chris Milk
Production Companies The Director's Bureau, @radical.media
Agency Mojo Partners
Client Telstra.com
Country United States

SOCCER ZOMBIES

We open on a teenage boy in his bedroom.	BOY: I'm into horror movies.
Slide of grotesque mask	BOY: And I like soccer.
Slide of soccer ball	BOY: I love mambo music.
Slide of mambo magazine	
	BOY: My name is Danny Kelly, and this is my dot.com.
Various views of a beautiful park. Camera dollies until it comes upon a soccer ball. Suddenly a zombie hand emerges from the ground. The earth starts to part and the zombie's head and shoulders pry themselves from the grass. Another group of zombies start up a soccer game. Zombie legs and arms fall off as they try to play.	SFX: Mambo music
Teenage boy smiles at camera	VO: There's one place where all of your interests come together. Telstra.com—it's your dot.com.

BOND GIRLS

Open on a man in his garage.	MAN: I really like spy movies.
Slide of minature spy car	MAN: I'm into home improvement.
Slide of paint cans	MAN: I like karaoke.
Slide of microphone	
Man in garage	MAN: My name is Basil Daniel, and this is my dot.com
Montage of James Bond-type girls dancing with paint cans and electric drills	(MAN SINGING KARAOKE): I know I'll never love this way again, so I'll keep holding on before the good is gone.
Man standing in front of his house	VO: There's one place where all your interests come together. Telstra.com—it's your dot.com.

GREYHOUNDS

We open on a 60-year-old woman in an internet cafe.	WOMAN: I'm really into greyhounds.
Slide of greyhounds	WOMAN: I like beer.
Slide of a mug of beer	WOMAN: And I've recently taken up life drawing.
Slide of a life drawing	WOMAN: I'm Shirley Topper and this is my dot-com.
We cut to see a classic male drawing model (private parts covered). We pull back to reveal that he is on the track at a greyhound track and he is wearing bunny rabbit ears and tail. He starts running while holding his beer as the greyhounds chase him.	
We return to Shirley in an Internet café.	VO: There's one place where all your interests come together. Telstra.com—it's your dot.com.

MERIT

TV: OVER 30 SECONDS
Suicide

Art Director Matthias Spaetgens
Creative Directors Johannes Krempl,
Sebastian Turner
Copywriter Jan Leube
Film Production Manuel Werner
Agency Scholz & Friends Berlin
Clients GAP, New Economy
Business School
Country Germany

If the economy takes you by surprise,
you should have known better.

NEW ECONOMY
BUSINESS SCHOOL

SUICIDE

SFX:
Classical music from fade-in of
first image

SUPER:
If the economy takes
you by surprise,
you should have
known better.

LOGO:
New Economy
Business School

SUPER:
www.nebs.de

TV: OVER 30 SECONDS

Martian

Art Director H. Cambiaso

Creative Directors F. Militerno,
M. Vinacur

Copywriters M. Corbelle, C. Morano

Producer Armando Morando

Director Stuart Little

Production Company The End

Agency Grey Worldwide

Client Omega Car Insurance

Country Argentina

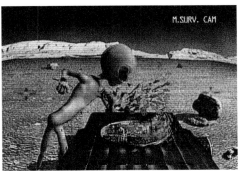

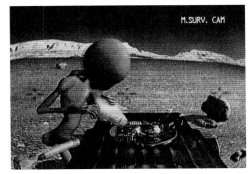

MARTIAN

Open on martian landscape seen from the TV camera mounted on the Pathfinder that studies the red planet's surface. We can hear the N.A.S.A. commentary from Houston.

N.A.S.A.:
Freeze image. Sample 37, quadrant five, martian surface. Camera one, camera two . . .

Unexpectedly, an alien approaches the Pathfinder. He looks thoroughly, with prudence. The voices from Houston get very excited.

N.A.S.A.:
Look! Look! Look! A Martian! He's coming closer. It seems he wants to make contact!

The little green guy, realizing nobody's around, breaks the Pathfinder's glass with his elbow and steals the stereo.

N.A.S.A. voices go crazy:
The martian runs away with his prize.

N.A.S.A.:
Oh, shit! F*!&ing Martian! He stole the stereo!

SUPER:
Shit happens.

LOGO:
Omega Car Insurance.

MERIT

TV: PUBLIC SERVICE/NONPROFIT
Counting Sheep

Art Director Patrick They
Creative Directors Christian Seifert,
Patrick They
Copywriter Christian Seifert
Studio Stockmaterial/Archiv
O&M Frankfurt
Agency Ogilvy and Mather Frankfurt
Client SWR Television Station
Baden Baden
Country Germany

What does your child count to fall asleep?

Watch out what your child is watching.
SWR Television

COUNTING SHEEP

Several violent scenes
from movies flash
onto the screen, one
after the other.

SUPER:
What does your child
count to fall asleep?

SUPER:
Watch out what your
child is watching. SWR
Television.

CHILD:
A child's voice lists the scenes,
as if he were counting sheep in
order to fall asleep.

FIFA

SETH BLATTER:
Yes.

MARK BANKS:
Mr. Seth Blatter:?

SETH BLATTER:
Yes, that's me.

MARK BANKS:
It's Mark Banks, phoning from the *Sunday Tribune* in South Africa. How are you today?

SETH BLATTER:
I'm fine, and you?

MARK BANKS:
Well, we're all a bit miserable as you know. We still haven't got over not winning the World Cup bid. As I am sure millions and millions of people have written and told you. Our expectations were so high here in South Africa—we had all the balloons and the flags and the posters and the billboards and the buses and the outdoor hoardings and the television advertisements and all the catering awards had been awarded, airplane routes had been diverted for all the different games. Then came that fateful day when we heard the word "Deutchland." Do you think it should have gone to South Africa, personally?

SETH BLATTER:
Absolutely, absolutely. You know my support for this continent is still ongoing.

MARK BANKS:
Do you think there was much bribery and corruption?

SETH BLATTER:
No, I would put my hand into boiling oil or into a fire or all of that.

MARK BANKS:
Boiling oil or fire?

SETH BLATTER:
Or fire, ja.

MARK BANKS:
So you think we will see it in 2010?

SETH BLATTER:
I am sure. I can say I love you all.

MARK BANKS:
Thank you very much, Mr. Joseph Seth Blatter, President of Federation of International Football Association.

SETH BLATTER:
Thank you, good-bye.

VO
The *Sunday Tribune*—we bring the news home.

OLYMPICS

MILTON COBORN:
General Manager Media.

MARK BANKS:
Hello, is that Milton Coborn:?

MILTON COBORN:
Yes.

MARK BANKS:
My name is Mark Banks. I am phoning from the *Sunday Tribune*, Durban, South Africa. I believe you are spokesperson for the sharks in Sydney Harbour.

MILTON COBORN:
Amongst other things, I am.

MARK BANKS:
Apparently the triathletes for the Olympics will be swimming in Sydney Harbour.

MILTON COBORN:
OK, as a precaution we will have divers in the water with electronic shark pods which are designed to repel sharks.

MARK BANKS:
Right, and one of the things we are told here to avoid shark attack is to not swim like a seal. So I think anyone who does swim like a seal should be eaten by a shark quite honestly.

MILTON COBORN:
Exactly, yes.

MARK BANKS:
And this is the biggest media contingency ever in the history of the Olympics.

MILTON COBORN:
Yes, around about 17,000—1.7 media representatives for every athlete.

MARK BANKS:
And which country's media do you find the worst, the absolute dog pigs of media?

MILTON COBORN:
That's easy, the Australians.

MARK BANKS:
Wonderful, thank you very much for your time, Milton.

MILTON COBORN:
Pleasure, bye.

VO
The *Sunday Tribune*—we bring the news home.

MERIT

RADIO: SPOTS OF VARYING LENGTH, CAMPAIGN
Mark Banks Live Interviews:
Fifa • Olympics • Smoking

Art Director Michael Bond
Copywriter Lynton Heath
Producer Hazel Bartlett
Studio Sterling Sound
Agency FCB Durban
Client Sunday Tribune Newspaper
Country South Africa

MERIT

CONSUMER NEWSPAPER: FULL PAGE
Gappy

Art Director Alexander Heill
Creative Director Christian Seifert
Copywriter Christian Seifert
Photographer Joachim Bacherl
Agency Ogilvy and Mather Frankfurt
Client IBM Germany
Country Germany

MERIT

CONSUMER NEWSPAPER: INSERT
Helmut Lang Parfums

Art Director Marc Atlan
Copywriter Jenny Holzer
Designer Marc Atlan
Photographer Marc Atlan
Client Helmut Lang
Country United States

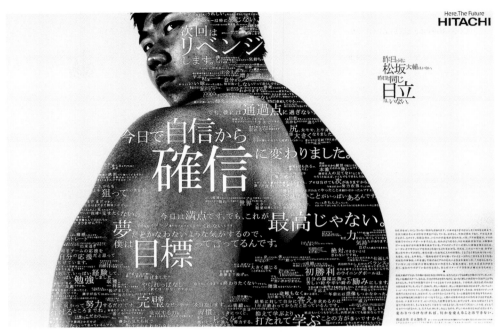

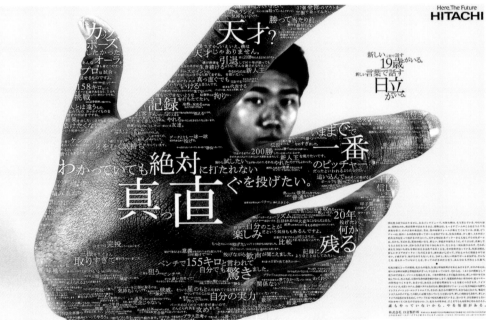

MERIT

CONSUMER NEWSPAPER: SPREAD, CAMPAIGN

Inspire the Next

Art Director Yoichi Komatsu
Creative Director Makoto Tsunoda
Copywriter Akihisa Gotoh
Designers Yoichi Komatsu, Kazuko Taku
Photographer Naka
Agency Dentsu Inc.
Client Hitachi Co.
Country Japan

MERIT

CONSUMER MAGAZINE: FULL PAGE, CAMPAIGN
Pedal

Art Directors Fernando Codina, Dani Ilario
Copywriters Nuria Argelich, Alberto Astorga
Client V.A.E.S.A./AUDI A4
Country Spain

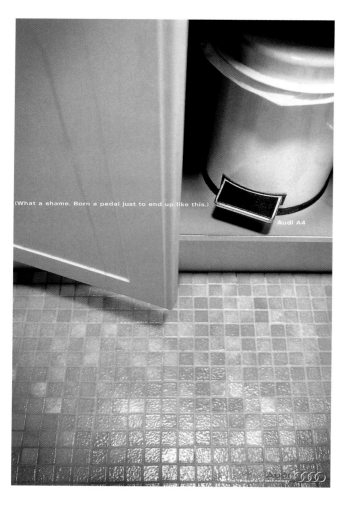

MERIT

CONSUMER MAGAZINE: SPREAD
Nike Paralympics: Hands

Art Director Vanessa Norman
Photographer David Prior
Copywriter Peter Callaghan
Client Nike South Africa
Agency The Jupiter Drawing Room
Country South Africa

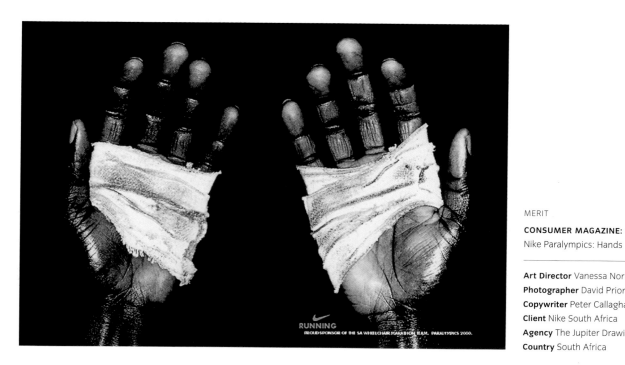

Multiple Awards

Art Director Adele Ellis
Chief Creative Officer Ron Lawner
Group Creative Director Alan Pafenbach
Copywriter Tim Gillingham
Production Manager Stephanie Kailher
Photographer Stuart Hall
Printer Unigraphic
Separator Unigraphic
Agency Arnold Worldwide
Client Volkswagen of America, Inc.
Country United States

MERIT

CONSUMER MAGAZINE: SPREAD
Out of Focus

Art Director Paulo Pretti
Creative Director Silvio Matos
Copywriter Paulo Pretti
Photographer Maria Teresa
Ramos Dutra
Agency Fischer América
Client Abrafoto
Country Brazil

MERIT

CONSUMER MAGAZINE: SPREAD
Packs

Art Directors Barbara Esses,
Demián Veldeda
Copywriters Barbara Esses,
Demián Veldeda
Producers Fernando Costanza,
Carlos Pezzani
Designer Demián Veldeda
Photographer Martín Sigal
Illustrator Hugo Orita
Agency Young & Rubicam
Client Merisant SA/Nutrasweet
Country Argentina

MERIT

CONSUMER MAGAZINE: SPREAD
GENCon

Art Director Jeff Williams
Photographer Clayton Brothers
Copywriter David Schermer
Client Gamers.com
Agency Wieden + Kennedy
Country United States

MERIT

CONSUMER MAGAZINE: SPREAD
Music Note

Art Director Fernando Macia
Copywriter Xavi Valero
Agency Tandem Company
Guasch DDB
Client Sony España S.A./
Sony Walkman
Country Spain

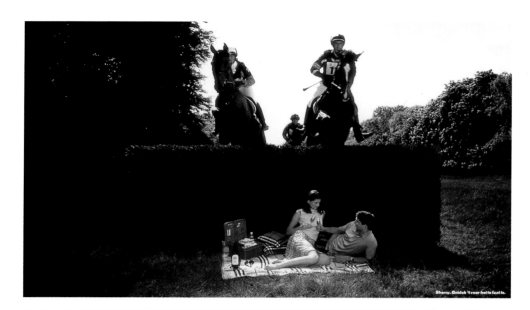

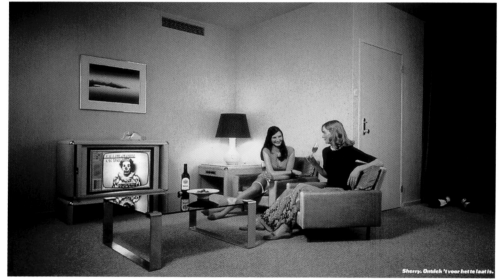

MERIT

CONSUMER MAGAZINE:
SPREAD, CAMPAIGN
Picknick • Killer Clown •
Japanese Room

Art Director Jorn Kruysen
Copywriter Jeroen van de Sande
Photographer Paul Ruigrok
Advertiser's Supervisor W. Perez-
Sanchiz van Marken
Agency Benjamens van Doorn
Euro RSCG
Client Sherry Instituut van Spanje
Country Holland

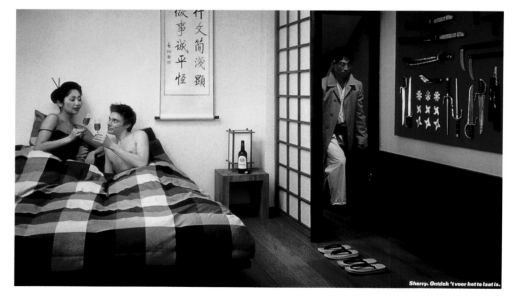

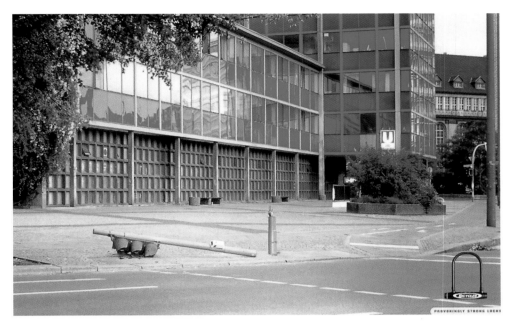

MERIT

**CONSUMER MAGAZINE:
SPREAD, CAMPAIGN**
Strong-Locks

Art Director Matthias Spaetgens
Creative Directors Johannes Krempl,
Olaf Schumann
Copywriter Jan Leube
Photographer Ralph Baiker
Agency Scholz & Friends Berlin
Client Bicycles AG
Country Germany

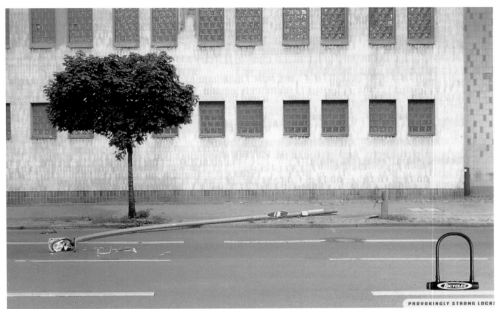

MERIT

**CONSUMER MAGAZINE:
SPREAD, CAMPAIGN**

Mosca • Laranja • Sabonete • Alicate
(Fly • Orange • Soap • Pliers)

Art Director Sibely Silveira
Copywriter Leandro Castilho
Producer Elaine Carvalho
Photographer Fernando Moussalli
Agency age
Client Propaganda & Marketing
Newspaper
Country Brazil

MERIT

**CONSUMER MAGAZINE:
SPREAD, CAMPAIGN**

Old Man • Forest • Oxcart •
Fisherman • Kids

Art Director Erik Vervroegen
Copywriter Wendy Moorcroft
Photographer Mike Lewis
Studio Beith Lab
Agency TBWA Hunt Lascaris
Johannesburg
Client Seychelles
Country South Africa

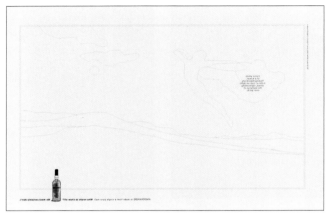

MERIT

**CONSUMER MAGAZINE:
SPREAD, CAMPAIGN**

Mansion • Castle •
Handkerchief Woman

Art Director Jose Luis Ferragut
Illustrator Jose Luis Ferragut
Copywriter Luis Acebes
Agency Young & Rubicam
Client Knockando
Country Spain

**TRADE MAGAZINE:
SPREAD, CAMPAIGN**
Attention: Doorframe

Art Director Bjoern Ruehmann
Creative Director Sebastian Turner
Photographer Sven Ulrich Glage
Agency Scholz & Friends Berlin
Client Riccardo Cartillone
Country Germany

MERIT

POSTERS: PROMOTIONAL
Toothbrush

Art Director Thomas Dooley
Copywriter Jonathan Schoenberg
Photographer Brooks Freehill
Client Cannondale
Country United States

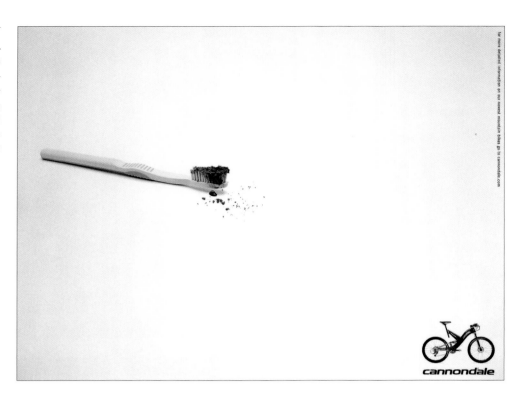

MERIT

POSTERS: PROMOTIONAL
The Kamanashi River: Quenching the
Thirst of the Most Demanding Critics

Art Director Yuji Tokuda
Creative Directors Yoshio Kato, Yukio
Ohshima
Copywriter Yoko Seki
Designers Seiji Nakamura, Katsuya
Ono, Yuji Tokuda
Illustrators Yoshitaka Kakizaki,
Kazumasa Uchino
Photographer Takashi Seo
Studio Common Inc.
Agency Dentsu Inc.
Client Suntory Ltd.
Country Japan

POSTERS: PROMOTIONAL, CAMPAIGN
Comme Ca du Mode Planets

Art Director Ryo Teshima
Designer Chie Morimoto
Agency Hakuhodo Inc.
Client Five Foxes Co. Ltd.
Country Japan

MERIT

**POSTERS:
PROMOTIONAL, CAMPAIGN**
Nail Art

Art Directors Tatsuya Miyake,
Yuzuru Mizuhara
Copywriters Shoichi Furuta,
Eitaro Yuasa
Designer Yosuke Uno
Photographer Naka
Illustrator Yasuhide Kobayashi
Agency Hakuhodo Inc.
Client Excite Japan Co., Ltd.
Country Japan

138

www.excite.co.jp/deai

www.excite.co.jp/travel

www.excite.co.jp/business

MERIT

POSTERS: PROMOTIONAL
Abandoned House

Art Director Julia Schmidt
Creative Directors Martin Pross,
Joachim Schoepfer
Copywriter Beate Steiner
Photographer Arwed Messmer
Agency Scholz & Friends Berlin
Client DaimlerChrysler AG
Country Germany

MERIT

POSTERS: POINT-OF-PURCHASE
Meat

Art Directors Tay Guan Hin, Eric Yeo
Executive Creative Director Linda
Locke
Creative Director Tay Guan Hin
Copywriter Simon Beaumont
Photographer Alex KaiKeong Studio
Agency Leo Burnett
Client Kitchen Culture
Country Singapore

MERIT

**POSTERS: EDUCATIONAL/
ENTERTAINMENT**
The Convoy Show

Art Director Toshihiro Komatsu
Copywriter Kyoko Nakamura
Designer Toshihiro Komatsu
Photographer Hideyuki Takahashi
Agency Hakuhodo Inc.
Client The Convoy
Country Japan

MERIT

**POSTERS: EDUCATIONAL/
ENTERTAINMENT, CAMPAIGN**
Let's Go to Toshimaen

Art Directors Kenjiro Sano,
Yuki Sugiyama
Creative Director Shinsuke Kasahara
Copywriter Nobuhiro Hishiya
Designers Kenjiro Sano,
Yuki Sugiyama
Photographer Mikiya Takimoto
Agency Hakuhodo Inc.
Client Toshima-en Co., Ltd.
Country Japan

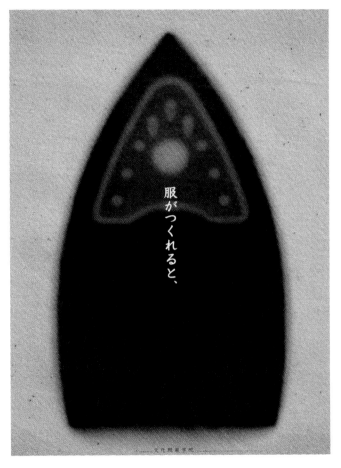

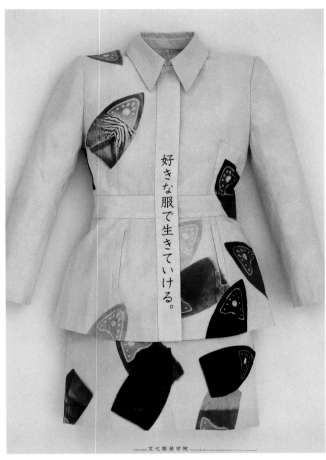

MERIT

**POSTERS: EDUCATIONAL/
ENTERTAINMENT, CAMPAIGN**
Iron

Art Director Takeshi Nagata
Copywriter Tae Muto
Designers Takeshi Nagata, Aki Sugie
Photographer Tadashi Tomono
Client Bunka Fashion College
Country Japan

MERIT

POSTERS:
PUBLIC SERVICE/NONPROFIT
Entrecotte

Art Directors Joao Coutinho,
Jose Javier Perez
Photographer Manuel Diaz
Copywriter German Silva
Country Spain

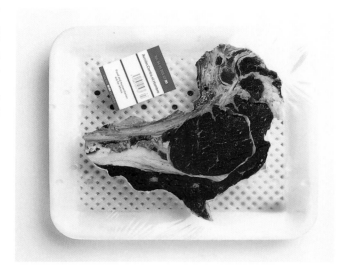

DOESN'T ANYBODY CARE ABOUT GREAT TITS ANY MORE?

Not just any old tits, of course.

But Great ones, surely?

Well, as you might expect, the warmer weather is bringing them out sooner than before.

A recent survey, taking four long years of intense study, has revealed that the Scottish Great Tit is breeding earlier in the year, these days. The effect of global warming, apparently. The poor things are obviously confused.

This means that their dear little eggs hatch sooner, and the bewildered babies are bursting out into the big wide world before the big wide world is ready for them.

Being tough little fellows, they seem to be coping with the surprise just fine at the moment.

But the bad news is that these very same conditions are threatening the Great White Pelican. And Polar Bears, and Monarch Butterflies. And, as if they hadn't got enough problems already, Indian Tigers.

Species in the higher latitudes of the northern hemisphere, where the warming will be greatest, may have to migrate. Plants may need to move ten times faster than they did at the end of the last ice age.

In fact, worldwide, one third of all plant and animal habitats are in immediate danger.

To put this in cold, numerical terms: Last year an estimated thirty thousand species disappeared forever. The number is increasing, year by year, as the climate changes.

Shaking your head, and tutting sympathetically won't help. Blaming 'Big Business' won't help, either.

In fact, the only person who can help is you. You and the millions like you, who still feel a bit responsible for our little planet.

Global warming can be halted, or at the very least, slowed down, so that nature can adapt.

Right now, the sixth World Climate Conference is being held. The delegates of your country are representing your elected government.

Your government works for you, remember.

And your representatives in that government are your paid servants. Send them an e-mail at www.climatevoice.org.

Tell them that you're concerned, and that you will be watching them.

Because, if we do nothing now, one fine summer's day, there won't be many Great Tits left to watch.

The World Climate Conference, November 13-24, The Hague, Netherlands. This message, and this plea, comes to you from the WWF.

MERIT

POSTERS:
PUBLIC SERVICE/NONPROFIT
Great Tits

Art Director Neil French
Creative Directors Thomas Hofbeck,
Stephan Vogel
Copywriters Neil French,
Paul von Mühlendahl, Stephan Vogel
Designer Philipp Böttcher
Agency Ogilvy & Mather Frankfurt
Client WWF Germany
Country Germany

Citylights as X-ray Illuminators

The motifs used are based on actual X-ray photos.
The idea toys with the analogy between the illuminator with which physicians view X-ray pictures, and an illuminated Citylights advertising display. To achieve maximum authenticity, the X-ray motifs (thorax, pelvis, skull) are therefore clamped to the outside of the glass. All motifs pose the same question: *"Do you really know how things look deep inside you?"* And point toward a solution: *"Early diagnosis saves lives".*

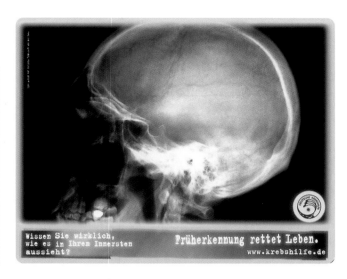

MERIT

**POSTERS: PUBLIC SERVICE/
NONPROFIT, CAMPAIGN**
The Original X-ray Posters

Art Directors Michael Boebel, Dirk Bugdahn, Denise Overkamp
Copywriter Hadi Geiser
Agency Publicis Werbeagentur GmbH
Client Deutsche Krebshilfe e.V.
Country Germany

DIRECT MAIL, CAMPAIGN
Calendar 2001–2100

Art Director Marita Kuntonen
Copywriter Hedvig Hagwall-Bruckner
Client Bold Printing Group
Country Sweden

144

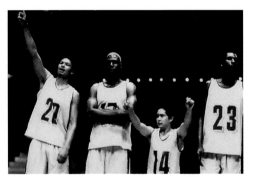

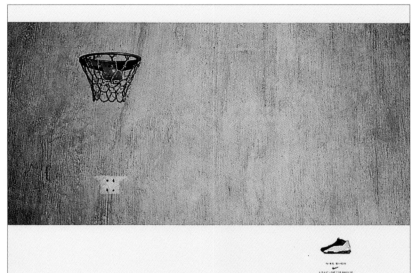

MERIT

INTEGRATED ADVERTISING, CAMPAIGN

Shox

Art Directors Paul Anderson, Michael Bond
Copywriters Peter Callaghan, Bernard Hunter, Leon Van Huyssteen
Photographer David Prior
Agency The Jupiter Drawing Room
Client Nike South Africa
Country South Africa

MERIT

INTEGRATED ADVERTISING
Rules for Creating Advertising

Art Director Jon Rosen
Creative Directors Neil Powell, Kevin Roddy
Copywriter Jenna Hall
Producer Louise Raicht
Designer Genevieve Gorder
Photographer Maribel Dato
Illustrator Genevieve Gorder
Agency Fallon McElligott, NY
Client Advertising Women of New York
Country United States

NIKE "PARALYMPICS CAR PARK"
JUDGES NOTE:

In the run-up to the Paralympics 2000 the South African team
(sponsored by Nike) was on a number of special appearances
at shopping malls to meet the public, sign autographs etc.

Press ads in the local papers advised the public of when the
paralympians would be appearing and in which malls.

On the day of their appearances, all the disabled signs in the parking bays
were sprayed as shown in the photograph (they are situated near the entrances
and are therefore clearly visible to the public).

These modified disabled signs provided a talking point for visitors to the
mall and dovetailed nicely with the appearance of the paralympians.
The spray paint used was non-permanent.

This exercise was conducted with the consent of the shopping malls
and the support of the South African Paralympics Committee.

MERIT

GUERILLA ADVERTISING/
UNCONVENTIONAL MEDIA
Wheelchair Parking Bay

Art Director Michael Bond
Copywriters Bernard Hunter, Leon Van Huyssteen
Photographer Michael Meyersfeld
Agency The Jupiter Drawing Room
Client Nike South Africa
Country South Africa

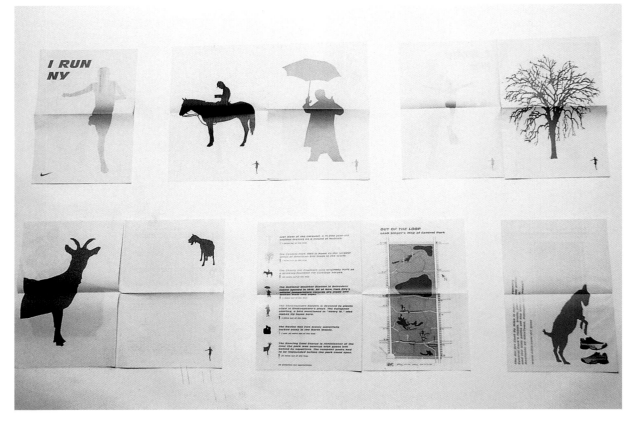

**GUERILLA ADVERTISING/
UNCONVENTIONAL MEDIA**
Park

Art Director Kim Schoen
Copywriter Ilicia Winokur
Design Director Kim Schoen
Designers Sarah Foelske, Leah Singer
Illustrator Leah Singer
Agency Wieden + Kennedy NY
Client Nike
Country United States

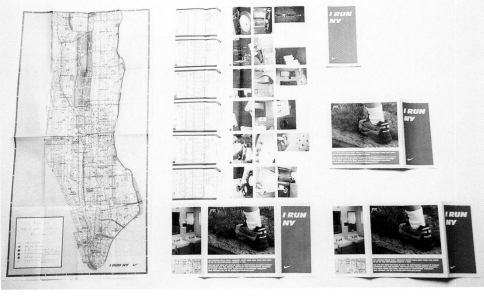

Multiple Awards

MERIT

**GUERILLA ADVERTISING/
UNCONVENTIONAL MEDIA,
CAMPAIGN**
I Run NY

and MERIT

CONSUMER MAGAZINE: INSERT
River

Art Director Kim Schoen
Copywriter Ilicia Winokur
Design Director Kim Schoen
Designers Sarah Foelske,
Miranda Maher, Leah Singer,
Dylan Stone
Photographer Dylan Stone
Illustrators Miranda Maher,
Leah Singer, Dylan Stone
Agency Wieden + Kennedy NY
Client Nike
Country United States

new media

It seems that not a lot has changed since last year's chair, my friend John Maeda, wrote: "Reviewing the current state of cutting-edge new media development proved to be, in general, a great disappointment. . . . Our society has confused 'innovative design' with any work from the latest tool or latest upgrade of a tool—there is nothing truly creative about being the first in line for the latest digital gimmickry."

Again, this year's entries seemed plagued by software. Lots of whiz-bang effects. Scaling, spinning, rotating, and glowing. Lots and lots of glowing. The inherent limitations of current software means that most designers using these tools are all pulling from the same bag of tricks.

As an industry, we need to start appreciating the other forms of design that work in conjunction with the more formal aspects of new media design.

Everything starts to look similar. This becomes really evident when you spend two days in a room looking at hundreds of entries.

In the end the most interesting conversations among the judges were over issues of content, regardless of execution.

As an industry, we need to start appreciating the other forms of design that work in conjunction with the more formal aspects of new media design. Database design, information design, application design—all of these are under-appreciated forms of design that happen before the graphic design can begin.

Now that I've gotten all that out of my system, there were some real standouts this year. Take a look. The work speaks for itself. Finally, I'd like to thank the judges for their time and patience, and also everyone who chose to enter their work.

Oh, yeah, one more thing.

Can we please come up with a better name for this work than new media design?

—Peter Girardi
FUNNY GARBAGE, NYC
NEW MEDIA CHAIR

PETER GIRARDI, who coined the Funny Garbage name as a child while re-designing New York City subway cars with graffiti, recently became the youngest person ever to be given the prestigious DaimlerChrysler Award for Design Excellence. He is commonly recognized as one of the great designers of his generation and among the best who have applied their skills to interactive media. Peter had been a creative director at the Voyager Company, the preeminent producer of CD-ROMs and Laser Discs, when he and John Carlin started Funny Garbage in 1996. Currently, Peter is Funny Garbage's executive creative director and also serves as an adjunct professor at the School of Visual Arts. Funny Garbage's clients include: The Cartoon Network, HBO, Warner Music Group, VH1, the Experience Music Project in Seattle, Compaq, The Wolfsonian Museum, and Knoll, Inc.

GIORGIO CAMUFFO, born in Venice in 1955, is the owner and creative director of Studio Camuffo. Founded in 1990 with Sebastiano Girardi and Massimo De Luca, Studio Camuffo is especially active in planning a coordinated image, designing signs, and creating cultural initiatives. The studio has won many prestigious assignments and earned international recognition for work carried out in various disciplines.

MALCOLM GARRETT is the creative director at the interactive communications company AMX, one of the first UK design companies to devote itself exclusively to digital interactive media. Malcolm is a visiting professor at the RCA, London, and last year became a Royal Designer for Industry for his work in interactive media.

COLIN HOLGATE has been programming multimedia content since he moved to the U.S. nine years ago. During his six years at The Voyager Company, Colin worked on 25 CD-ROMs including: *A Hard Day's Night*, *Comic Book Confidential*, and *This Is Spinal Tap*. Now one of the senior programmers at Funny Garbage, Colin has worked on the kiosks at the new planetarium in NYC, and the recently opened Experience Music Project in Seattle. In addition to winning many awards for work, including, Best of Show in the 1999 Invision Awards for willing-to-try.com, he has programmed three of the *I.D.* magazine New Media CD-ROMs, and two of the Art Directors Club Annual discs. The ADC 2001 competition will be the first time he's a juror!

DAVID KARAM is half of the San Francisco-based Post Tool, founded with partner Gigi Biederman in 1993. Post Tool's multimedia work has been featured in numerous recent books and most major design publications, including: *Eye*, *I.D.*, *Graphis*, and *AIGA Journal*. They've also been featured in *Rolling Stone* and Japan's *Popeye*. Their work is in the collection of the San Francisco Museum of Modern Art, and the Cooper-Hewitt National Design Museum. Post Tool was a Chrysler Award nominee for Innovation in Design in both 1995 and 1997. David also served as the director of the design and media department, and as the assistant chair of graphic design at the California College of Arts and Crafts.

KAREN SIDEMAN is a visual/interactive designer who specializes in play experiences involving both game design and edutainment creation. As Online Creative Director at Sesame Workshop, she led the development of a series of online creativity tools, including, Sticker World, Make-A-Story, and Clickle-Me Elmo. Prior to that, she was Senior Interactive Designer at R/GA Digital Studios (R/Greenberg and Assoc.) and supplied visual design on the company's entertainment efforts: Gearheads, The Robot Club, and NetWits, as well as the company's Web site. She was a designer at Edwin Schlossberg, Inc., and is currently working as a freelance designer and conceptual developer on several projects all of which are super top secret but will surely change the world or at least make people smile.

BONNIE SIEGLER is a partner at Number Seventeen, a multi-disciplinary design firm working in television, film, print, and the Web. The Number Seventeen client list includes: Saturday Night Live, Condé Nast, Herman Miller, Calvin Klein, Nickelodeon, HBO, Hyperion, and PBS. Bonnie also teaches in the graduate programs at Yale University and The School of Visual Arts, and serves on the New York board of the AIGA.

DAVID SMALL, having completed three degrees at MIT, designs interactive information environments through the Small Design Firm in Cambridge, MA. His work examines how digital media (in particular the use of three-dimensional and dynamic typography) will change the way designers approach large bodies of information.

SCOTT STOWELL is the proprietor of Open, a New York design studio that produces print, packaging, broadcast, and Web projects. His clients include: the American Museum of the Moving Image, art:21, Fallon McElligott, *The Nation*, MTV, Nickelodeon and Nick at Nite, Smithsonian Folkways Recordings, and Wieden + Kennedy. He teaches design at Yale University and was recently appointed vice president of the board of directors of the New York chapter of the AIGA. His work has received awards from the American Center for Design, the AIGA, the Art Directors Club, Critique, Communication Arts, *I.D.*, *Print*, the Society of Publication Designers, and the Tokyo Type Directors Club.

JANET ABRAMS is director of the University of Minnesota Design Institute, a new interdisciplinary initiative on design for the public realm. She has previously worked in New York, producing conferences and editorial consulting through her firm, Leading Questions, and in Amsterdam, where she edited *IF/THEN: Design Implications of New Media* at the Netherlands Design Institute.

BOB STRATTON is an interactive multimedia programmer and designer. He is a founding partner of Controlled Entropy Ventures (CEV), a New York-based company specializing in entertainment applications for video conferencing, multimedia, and Web-based technologies. CEV is currently developing "Remote," a technology-themed bar/lounge slated to open in May 2001. Prior to CEV, he founded the Internet consulting firm Rare Medium with five partners in 1995, leaving at the end of 1999. He built and managed the Design Technology department in the original New York office, and then coordinated all the local Design Technology departments nationally as Rare Medium grew to over a thousand employees in eight cities.

DREW TAKAHASHI is presently the emperor of Funjacket Enterprises. Previously, he co-founded and served as the chief creative officer of Colossal Pictures. While he was there, he used every film and video technique in making broadcast identities for MTV, Showtime, the Disney Channel, and Nickelodeon. He also made commercials for Coca-Cola, Honda, and Levi's and, most recently, experience designs for Americast, WebTV, Microsoft, and Real Networks.

JAMES KHAZAR is a seasoned multimedia designer and producer who's been in the business since the early 80s. He has developed multimedia for clients ranging from BMW to IBM, and for rock-and-roll CDs and children's storybooks. He has spoken at Comdex and Macromedia's developer conferences and lectured at C.C.A.C., S.F. State, and Kala Art Institute.

GOLD

PRODUCT ADVERTISING

www.mtv2.co.uk

Art Director Mickey Stretton
Designers Merlin Nation, Brad Smith,
Mickey Stretton
Illustrators Merlin Nation,
Brad Smith, Mickey Stretton
Producer Mickey Stretton
Studio Digit
Agency Digit
Country United Kingdom

The redesign of the MTV2
Web site (MTV's digital alternative
music channel) required a leftfield,
artsy, and contemporary look. The
Web site needed to communicate
effectively to MTV2's target
audience: 16- to 28-year-old style
conscious, Internet-aware
music fans.

The ultimate business objective was
to increase awareness, publicity, and
subscription take-up of the channel.

The design took into account the
importance of the community aspect
of alternative music. The graphic
style of the site was developed as a
metaphor for the different areas
of the site and was given different
characteristics, behaviors,
and magnitude.

The community aspect was achieved
by developing the "create your own
hour" section of the Web site,
allowing users to search a database
of tracks, artists, and images to
compile their own VJ hour.

Each area of the site is represented
in a different graphic manner
to encourage user exploration.

156

SELF-PROMOTION

www.motiontheory.com

Art Director Mathew Cullen
Designers Ryan Alexander,
Mathew Cullen
Producer Javier Jimenez
Studio Motion Theory
Country United States

The goal of the project was to
develop a site that is simple in its
design but complex in its
interactivity. The work had to be
representative of the quality that
Motion Theory encapsulates. It's an
experiment in showing how motion
can be expressed. Finding the
right programming language for
attaining our goals consistently
posed the greatest challenge.

Much of the design relates to
the beauty of mathematics. On the
surface, its function is to explain our
objectives, style, and direction; on a
deeper level, however, our hope was
that the user could have fun
with the dynamic fluidity of the
site's movement.

PRODUCT ADVERTISING, CAMPAIGN

Scout

Art Director Eric Ludlum
Designer Mary Phillipuk
Illustrator Henry Yoo
Coordinator Jamie Becker
Producer Allan Chochinov
Client Herman Miller Inc.
Country United States

Scout is an interactive learning and visualization tool exploring Resolve™, a new office furniture system from Herman Miller. The client needed an extremely user-friendly, engaging, and realistic application to present the system's new geometry—a point-based system utilizing 120° angles and nature-based growth patterns.

The application needs no in-depth study: the office planner, architect, designer, or salesperson can easily investigate a multitude of furniture arrangements by specifying different desired effects. Scout helps the user learn about the Resolve™ system from micro to macro, from the individual workstation level up to the floorplan/pattern level, through photo-realistic, computer-generated renderings.

Scout is also available in a multilingual version, offering the user the ability to run the software in French, German, Italian, Spanish, as well as English.

SILVER

PRODUCT ADVERTISING, CAMPAIGN

www.fjallfil.com

Art Director Nicke Bergström
Designer Magnus Ingerstedt
Copywriter Jacob Nelson
Multimedia Programming Per Ekstig
Serverside Programming Pontus Kindblad
Photographer Per Nesholm
Pixelpushing Per Hansson
Producers Anders Gustavsson, Matias Palm-Jensen
Studio farfar
Client Milko/Romson
Country Sweden

Milko Music Machine was created to strengthen the brand Fjällfil. The viewer participates in a "talent contest" by helping the now-popular Mountain Cow compose music, vocals, and moving images into a hip-hop, disco, or heavy metal video.

Everybody fell in love with the cow. The Web site had more than 1,200,000 visitors, and after six months on the Web, Fjällfil's sales had increased by more than 23%.

Traffic to the site was driven by advertisement on milk packages as well as by the possibility of sending your own video to friends. The virtual cow effect was amazing!

159

SILVER

PRODUCT ADVERTISING

Narrative Spaces:
www.aamertaher.com

Art Director Benjy Choo
Designer Benjy Choo
Illustrator Benjy Choo
Copywriter Benjy Choo
Composer Victor Low
Agency Kinetic Interactive
Client Aamer Taher Design Studio
Country Singapore

Aamer Taher Design Studio is a creative architectural company that incorporates the character of its occupants into the concept of its designs. Given the client's brief, our task was to demonstrate that quality through the Web site. The narrative of the written brief is given form and projected into the work, hence the name "Narrative Spaces," where space interacts with people, almost as if they are speaking.

Laramara Foundation's HotSite:
www.thunderhouse.com.br/ awards/laramara

Art Director André Matarazzo
Creative Directors Bob Gebara,
Clóvis La Pastina, André Matarazzo
Designer André Matarazzo
Copywriter Clóvis La Pastina
Photographer Laramara Foundation
Illustrator André Matarazzo
Producer Zentropy Partners/Thunder
House Brazil
Agency Zentropy Partners/Thunder
House Brazil
Client Laramara Foundation
Country Brazil

161

Laramara Foundation diagnoses,
accompanies, and orients visually
impaired children and teenagers in
Brazil, integrating them into society.
To demonstrate the difficulties these
children face, we placed the user
in a blind person's position, making
them navigate "in darkness."
In this way we hope to make people
experience some of the real-life
difficulties faced by blind people, and
gain an understanding of what it is
like. We did this in a happy, playful
manner, with no room for sadness,
because the visually impaired do not
need sympathy, they need support,
respect, and opportunities just like
anybody else. We have tried to
create awareness for this cause,
and hopefully raise funds for
the organization.

www.bemboszoo.com

Art Director Roberto de Vicq
de Cumptich
Designer Roberto de Vicq
de Cumptich
Designers Matteo Bologna,
Federico Chieli
Client Henry Holt Books
for Young Readers
Country United States

My wife's family has a tradition
of making handmade gifts for the
holidays. It was my daughter
Genevieve's first Christmas, and
I wanted to make something for her.
Bembo's Zoo, an abecedary of
animals created entirely from the
letters of their names, was the result.
Since I am a graphic designer,
I decided to create the illustrations
from a typeface. Bembo was chosen
because of its weight, balance,
and color; the cuts of its serif and
the relationship of its capital
to lowercase characters are
sublime and work well for text
and display settings.

In order to support the book,
I decided to create a Web site. It
was the most economic way to
publicize it—and a reason for me
to learn how to do one.
The Flash animations add a new
layer of interest to the book.

Plane Modulator

Designer Casey Reas
Studio MIT Media Laboratory
Country United States

Plane Modulator is a dynamic system for analyzing and experiencing the relationships between time and space. Manipulating the location, phase, and transparency of multiple instances of the same moving object creates new kinematic forms.
An interface was created to provide control over the geometry. The speed, size, and placement of the objects can be manipulated and a near limitless number of geometric primitives can be added to the system. Creating different patterns in time on the lower portion of the screen relates to patterns in space, which appear in the main image area.

DISTINCTIVE MERIT

ADVERTISING BANNERS
IBM CRM Eye Banner:
www.wwpl.net/~adc/ibm/eye/html

Art Director Kellie Kalvig
Creative Directors Audrey Fleisher,
Greg Kaplan
Producers Matt Calos, Greg Halpern
Agency OgilvyInteractive Worldwide
Country United States

Our goal was to generate interest among our audience of customer relationship professionals, IT implementors, and support systems owners. We had to show them that the Customer Relationship Management Solution offered by IBM would engage their customers at all "touch" points, and would allow their business to accommodate a perpetual flow of customer information and dialogue.

At first the banner looks as though it is a static photograph, a close and intimate view of the eye of a customer. But the user's attention is quickly captured when a single drop of a clear solution is applied to the center of the eye. This distorts the static photo into a rippling pool, pulling the user in for a closer examination of the message and the opportunity to play with the banner in a reactive, intuitive manner. Organic ripples appear when a user brushes past the banner with the mouse.

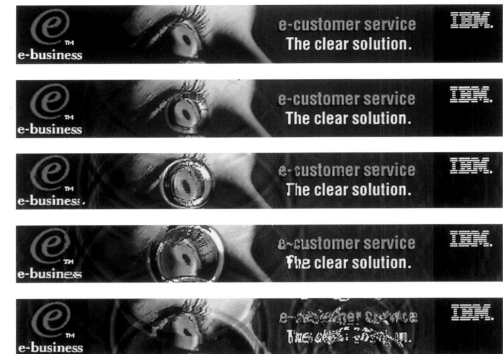

DISTINCTIVE MERIT
PRODUCT ADVERTISING
Millennium Three:
www.m-three.com

Art Director Jeff Faulkner
Creative Directors Jeff Faulkner,
Doug Lowell
Designer Jed Berk
Copywriter Doug Lowell
Producer Scott Trotter
Consultant Phillip Kerman
Strategic Planning Chuck Nobles
Engineer Aaron Anderson
Agency Paris France
Client Millennium Three Snowboards
Country United States

The challenge of the Millennium
Three Snowboard site was to engage
14- to 24-year-old hardcore freestyle
snowboarders without the slightest
whiff of marketing. One of M3's
biggest differences is that it was
started by team riders, and they
have unprecedented influence on
the boards and the brand.

Our solution was to give the
hardcore freestyle snowboarder the
kind of challenging experience they
seek in their own riding. Created in
Flash, it launches into a window
where the visitor finds five content
areas: riders, posts, boards, scrap,
and M3. Inside, visitors find a series
of in-depth interviews with the riders
(released serially over the course
of the year), board descriptions and
graphics, soft goods, snippets of
rider videos, field reports from the
team, and lots of photos. The board
information, while clearly present,
is still outweighed by the rider
information. The experience is more
about riding than marketing.

DISTINCTIVE MERIT

PRODUCT ADVERTISING

www.nasa20.com

Art Director Oliver Hinrichs
Creative Director John Eberstein
Screen Designers Oliver Hinrichs,
Sabine Kleedorfer
Copywriters Alf Frommer,
Ulrich Scheele
Sound Design rabatz.de
Project Manager Joerg Tremmel
Technical Production Thien Bui,
Achim Gosse
Agency n.a.s.a.2.0 GmbH
Client n.a.s.a.2.0 GmbH
Country Germany

Visionary Web sites have to outgrow
common norms. They have to create
emotion, be fun, and surprise, too.
The Web site at www.nasa20.com
invites users to experience the
Internet in another way: surprise
wins over habituation, function turns
into emotion, and something we
know becomes a vision.

The aim was to create a modern
Web site with high technical authority
and design competence; a Web
site that is fun to use, in which
information and facts are presented
and communicated in a personal
and creative way.

Producer Rick Valicenti
Designers Patricking, Rick Valicenti
Animator Gregg Brokaw
Programmer Rich Hanson
Technologist Erin Smith
Studio Thirstype, Inc.
Client Thirstype, Inc.
Country United States

Thirstype.com is the Internet
source for Thirstype's library,
featuring typeface designs by Rick
Valicenti, Barry Deck, Magnus
Rakeng, Patricking, chester, Patrick
Giasson, and others. Browsers can
peruse the collection, view typeface
samples, download PDFs, and
use the revolutionary Thirstyper.
The Thirstyper allows users to try
each typeface live by typing on
their keyboard.

DISTINCTIVE MERIT

INSTITUTIONAL PROMOTION
pres.co.uk/2000

Art Directors Paul Filby,
Mark Padfield
Creative Directors Paul Brooks,
Harvey Funder
Illustrator Mick Marston
Country United Kingdom

Pres.co's (now Wheel's) previous
Web presence was little more than
a referral page to client sites.
The agency's growth from 50 to 200
people demanded a site that
represented its client base, the
quality of its thinking and creative
work, and the spirit of the
company—that they take their work
seriously but not themselves.

The entire site is produced in Flash,
providing movement, interactivity,
and a restrained use of sound.
By combining flat color illustrations
and a restricted color palette,
file size was kept to a minimum, thus
allowing fast access through the
site, even on basic machines. Too
many sites, it was felt, rely on
gimmicks, have more style than
substance; the quality of copywriting
often leaving a lot to be desired.
Special effort was given to ensure
this didn't happen here.

The site is quite large, dealing with
every aspect of the agency, but room
was still found for games and
graphics that enhance and amplify
the underlying themes—a belief that
while clients want hard-nosed
results, the process of arriving at the
right solution can be still be
stimulating and fun.

DISTINCTIVE MERIT

SELF-PROMOTION
Portfolio 2000

Art Director Soojin Jun
Designer Soojin Jun
Producer Soojin Jun
Country United States

This is a self-promotional
CD-ROM, which includes selected
works created between 1993 and
2000. What I focused on here is how
to make lots of information easily
accessible and how to make
the viewer interact with it through
visualization. To approach this,
I used the metaphor of pulling out
each book on a bookshelf. Here,
different color bars are visual cues
for identifying each work as on
the spines of books. You can access
each work by itself and some by
categories. Also, all the works are
organized chronologically from
left to right.

DISTINCTIVE MERIT

SELF-PROMOTION

www.choppingblock.com

Designers Rob Reed,
Matthew Richmond, Tom Romer
Country United States

The Chopping Block, established
in 1996, is a graphic design firm
founded on the principle that good
design spans all media. Privately
held and profitable since its first
day, The Chopping Block focuses
its talents online by helping the
aggressive Internet start-ups
establish their Web presence, as well
as extending the Web component
of larger corporate clients, such as
Miramax Films, Nickelodeon, and
Turner Entertainment. Because they
are a boutique and not an agency,
they are able to move quickly
and nimbly in an environment that
demands flexibility. This unique
position has allowed them to
experiment with melding design and
technology in various new ways,
in the end proving to their clients
that their audience is smarter than
they thought. The site serves to
showcase recent client work as well
as experimental side projects.

170

DISTINCTIVE MERIT

SELF-PROMOTION
Cartoons and You

Art Director Mark Newgarden
Designer Mark Newgarden
Copywriter Mark Newgarden
Illustrator Mark Newgarden
Producer Mark Newgarden
Studio Laffpix
Client Laffpix
Country United States

171

Laffpix feels a keen responsibility to educate, serve, and amuse its viewing public, especially our young people. "Cartoons and You," the pilot in our Public Service Announcements series, delivers a dire warning to the modern entertainment consumer about the very real threat of overexposure to animated cartoons in all their subversive guises. Mark Newgarden's internationally beloved cartoon character Em™ was coaxed out of a well-earned retirement to star in this cautionary tale. Since its initial posting, Laffpix has received thousands of letters of testimony and gratitude congratulating us on our efforts to alert the public to the virulent plague of ACAS (Animated Cartoon Abuse Syndrome).

DISTINCTIVE MERIT

SELF-PROMOTION

www.rui-camilo.de

Art Director Heike Brockmann
Creative Director Michael Volkmer
Screen Designers Angela Hoos,
Melanie Lenz
Copywriters Rui Camilo,
Annika Koehler
Flash Programmer Mathias Schaab
Programmers Peter Reichard,
Mathias Schaab
Project Managers Heike Brockmann,
Mathias Schaab
Agency Scholz & Volkmer
Intermediales Design GmbH
Client Rui Camilo Photography
Country Germany

The Web site was realized by
order of the German photographer
Rui Camilo. The target was a clear
visualization of his large portfolio.
The introduction puts the visitor in
the emotional mood for the page.
The full-size pictures are the central
stylistic elements. No frame design
distracts the visitor from the
pictures. The clear navigation also
fits into this principle. It is
transparently integrated into the
pictures, and the user can even turn
it off completely in order to view
the whole picture.

The Web site is completely based
on Flash4 technology. This makes a
streaming of the extensive picture
galleries possible. The user can enjoy
the work in a size and quality that
is rather unusual for the Web.

DISTINCTIVE MERIT

GAME/ENTERTAINMENT
Datazord

Art Director Elliot Fan
Creative Director Joel Hladecek
Program Architect Marc Blanchard
Technical Lead Greg Meyers
Lead Engineer Ian Bigelow
Senior Engineer Adam Kane
Engineer Frances Chen
Production Engineer Alicia Durity
Lead Production Artist Pam Miklaski
Production Artists Catherine Block,
Michael Davison, Divya Srinivasan
Sound Design Jeff Essex
Quality Assurance Engineer Tim Yee
Titles Guy Hundere
3D Animation Matte World Digital,
Stormfront Studios
Senior Producer Rachel Power
Agency Red Sky Interactive,
San Francisco
Client Bandai
Country United States

173

Bandai's objective for this
project was to create a new type
of interactive toy that might inspire
a new "play pattern" for kids who
watch the Power Rangers TV show.

Red Sky's solution was simple
yet grounded in the principles of
interactive story-telling (being object
oriented as opposed to hierarchical),
and also took into account the
fact that very young children rarely
encounter computer programs
which produce positive reactions
from their interactions.

Red Sky turned the child's household
computer into a role-playing toy
itself. Datazord configures the users'
computer so that any keyboard
stroke or mouse click will create a
positive reaction from what looks
like an ultra high-tech computer
program—a control center. It was
designed to be contextually abstract,
not directing the child's private story
flow but allowing the child to imagine
that the program is doing exactly
what they wanted it to do:
control Mom's mind, remote-control
the cat, or fly a spaceship.

DISTINCTIVE MERIT

GAME/ENTERTAINMENT
Flakemaster—Tongue of Flurry:
www.iconmedialab.com/flakemaster

Creative Directors Matt Berninger,
Wells Packard
Copywriters Peter Leviten,
Wells Packard
Programmers Ben Abraham,
Miles Kafka, Jonah Kraus,
Wells Packard
Animation, Illustration Vas Kottas,
Trevor VanMeter
Design, Illustration Luke Hughett,
Trevor VanMeter
Sound Design Vas Kottas,
Trevor VanMeter
**Information Architecture/
Additional Art Direction**
Sambudda Saha
Agency IconMedialab
Client IconMedialab
Country United States

Icon Nicholson's 2000 holiday
card is a whimsical parody of a side-
scrolling Kung Fu arcade game
that conjures up joyful childhood
memories of the first snowfall of the
season. Catching snow on your
tongue gives you the power to fight
off the evil monkeys, grab the key
from the abominable snowman, and
explore the ice caverns in search of
stolen childhood memories. The
game is filled with references to old
movies usually shown on TV this
time of year, and the overall tone is
meant to rekindle the sense of
nostalgia that all of us feel during the
approach of the holiday season.

HYBRID/ART/EXPERIMENTAL
QRIME:
www.qrime.com

Art Director Motomichi Nakamura
Copywriter Pilar Larrea
Country United States

Like many new media designers, Motomichi Nakamura uses the Web to reach a broader audience and to experiment with new forms of expression in his work. In the year 2000, he developed "Qrime," an experimental Flash-animated episodic series for the Web and in short film format, which explores the relationship between violence and human nature, and uses literary extracts as one of its main components.

In order to find a personal aesthetic that would coherently represent the universality of the theme of violence, Motomichi opted to reduce the palettes of the animations to three basic colors: red, black, and white, while changing the graphic style in each episode according to its specific theme. The eight episodes were then showcased at Qrime.com, a fully animated Web site that presents the animations in a non-linear fashion and reinforces a sense of simplicity in the choices of colors and function.

175

DISTINCTIVE MERIT

HYBRID/ART/EXPERIMENTAL

Errol Morris's Mr. Debt:
www.errolmorris.com/story9

Art Director Rafael Esquer
Designers Rafael Esquer,
Angela Fung, Chakaras Johnson,
Jay Miolla, Wendy Wen
Programmers Matt Holford,
Jay Miolla
Flash Animator Jay Miolla
Producer Angela Fung
Client The Globe Department Store
Country United States

Mr. Debt is an extension of
Errol Morris's television series "First
Person." Episode Nine focuses on
"Credit Card Revolutionary" Andrew
Capoccia, who is embroiled in a
crusade that threatens the system
of credit as we know it.

First the user is asked, "Isn't it wrong
not to repay your debt?" Next, there
is a choice of three common debt
scenarios. The viewer continues on
to a sequence of window diptychs,
representing separate paths through
the site. This main navigation was
inspired by the central idea in Jorge
Luis Borges's *The Garden of Forking
Paths*: a multiple, ramified time in
which every present instant splits into
two futures. The "debt calculator"
is an alternative navigation, offering
direct access to any diptych and
tracking the status of each user's debt
choice. The site also creates a sense
of community by encouraging
personal stories in the "Debtors
Support Group," which contains
testimonials of people in debt
around the globe.

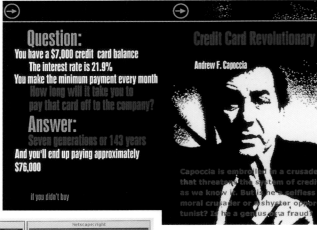

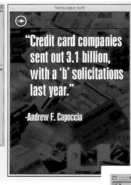

MERIT

ADVERTISING BANNERS
Vibrator
www.dm9.com.br/artdir2000

Art Director Mauricio Mazzariol
Creative Directors Michel Lent,
Erh Ray
Copywriter Thomaz Costa
Agency Producers Alexandre
Gutierrez, Zeno Millet
Agency DM9 DDB
Client Obsidiana.com
Country Brazil

The challenge of this piece was
to create impact about a new Web
portal for women called
Obsidiana.com. It was decided that
nothing would better represent
modern women than a good amount
of attitude. We came up with the
phrase "have fun by yourself." Then
we started thinking about something
that could represent, with a great
dose of impact, how a woman could
really have fun by herself. How would
she, not depending on anyone,
have a really good time. As you can
see, we found that something.
We colored it pink to show how a
woman can be delicate and
aggressive at the same time.

MERIT

ADVERTISING BANNERS, CAMPAIGN
WaMuLand

Art Director Casey Purdie
Creative Director Michael Gramlow
Designer Henry Chi
Copywriter Bob Baty
Producer Charla Myers
Client Washington Mutual Mortgage
Country United States

Washington Mutual, one of the nation's leading financial institutions, asked Organic to promote the launch of its new mortgage site, wamumortgage.com.

Faced with the understanding that shopping for a mortgage is an intimidating process, and for many consumers a once-in-a-lifetime experience, the WaMuLand campaign was developed to extend WaMuMortgage's brand promise, "The Power of Yes," to the online medium. Campaign objectives included building consumer familiarity with WaMu's online offering, encouraging consumer use of wamumortgage.com, and positioning WaMuMortgage as the most trusted mortgage resource on- and offline.

The creative strategy strove to immerse users in the WaMuMortgage brand through beyond-the-banner creative. Brightly animated using Flash, the creative illustrates how WaMuMortgage delivers on the brand promise by depicting a community where each consumer's own personal "Yes" resides.

PRODUCT ADVERTISING
FelonsUnited
www.humpbackoak.com

Art Director Sean Lam
Designer Sean Lam
Copywriters Sean Lam, Leslie Low
Programmers Benjy Choo, Sean Lam
Producer Sean Lam
Agency Kinetic Interactive
Client Humpback Oak
Country Singapore

The atmosphere that is FelonsUnited is directly inspired by the emotive music and moving lyrics of the band Humpback Oak. The almost futuristic appearance of the site is meant to contrast with the raw acoustic quality of their music. The site's dark nature also echoes the subtle yet cynical lyrics of Humpback Oak. Ultimately, FelonsUnited is a visual representation of the psyche of the band.

MERIT

PRODUCT ADVERTISING
Ericsson T20 Microsite
www.ericsson.com/t20/emeal

Art Director Ian Mitchell
Creative Director Louise Perry
Designers David Alcock,
Darren Glenister, Anthony Lelliot
Copywriter Richard Johnson
Illustrator Nicola Cunningham
Producer Rachel Clein
Studio Impiric
Agency Impiric
Client Ericsson
Country United Kingdom

MERIT

PRODUCT ADVERTISING
Final Home Web Site
www.finalhome.com

Art Directors Sayuri Shoji,
Nelson Wong
Designer Mariko Lizuka
Music Yu (ST Sound)
Studio Sayuri Studio
Client Issey Miyake, USA
Country United States

The client wanted to expand awareness of this Tokyo-based brand in the U.S. market. Our approach was to reinforce their basic concept: Clothing as survival tool. The Web site is symbolic of the clothing, the harmonious marriage of design and technology.

Final Home's New York store is located in the former Liquid Sky lounge and is closely aligned with the club music scene. We created the "Sonic Solutions" section to give visitors a place to play and mix music like DJs.

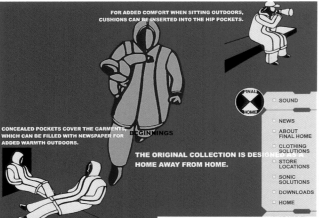

PRODUCT ADVERTISING
Potlatch McCoy Matte
www.potlatchpaper.com/hot/
mattemccoy.html

Art Director Brian Jacobs
Creative Director Kit Hinrichs
Designer Douglas McDonald
Client Potlatch Corporation
Country United States

This portion of Potlatch Paper's
Web site is part of a promotion
for Potlatch's McCoy matte paper,
which also includes a swatch
book and brochure.

The design problem was to create
a paper promotion in an unusual
manner, using the latest in Web
technology. Instead of the usual
promotions, which include samples
of the paper, this Web-based
promotion needed to highlight the
qualities of the paper intuitively. The
promotion features two portions.
The first part contains testimonials of
the fictional character, Matte McCoy.
The second part is designed using
typography and is a description of
the qualities of McCoy Matte paper.

MERIT

PRODUCT ADVERTISING
Expo-Logomotion 2000

Creative Directors Michael Gais,
Iris Utikal
Designers Sebastian Kutscher,
Simonex
Client Expo 2000 Hannover GmbH
Country Germany

Signal, network, communication,
spectacle, process, vision,
innovation, interactive, vibration,
emotion, energy, fractal, an impulse
in process which accompanies the
ideas and dynamic developments of
the world exposition in Germany.
The constantly changing colors and
shapes express, on the one hand, a
flowing extension of time and
space, while, on the other hand, the
imaginative structure forms an
unmistakable field of energy. This
deliberately allows a variety of image
associations which, both in content
and in form, relate to the Expo 2000
themes of mankind, nature, and
technology. The logo points far
beyond the horizon of linear thought
and action and symbolizes the Expo
2000 claim to be an impulse
for the 21st century.

PRODUCT ADVERTISING
A Second Chance at Life!

Art Director Mark Newgarden
Designer Mark Newgarden
Copywriter Mark Newgarden
Illustrators Bill Alger,
Mark Newgarden
Producer Jeff Sehgal
Agency Laffpix
Client The Corporate Presence
Country United States

When The Corporate Presence—the world's largest firm catering to the custom commemorative needs of the world investment banking community—began developing their unique client-access-only Web sites, they knew from the start that educating and amusing their clientele would be as important as simply providing them with an alternate means of placing orders.

Laffpix was commissioned to create special Flash-based animated content, and proposed the paradigm and tenets of the classic 16mm "industrial" film, which had flourished for decades by addressing similar needs. A mindlessly cheerful corporate mascot, Professor Lucite, was created and a serial format was decided upon, chronicling the career of everyman banker "Bob" from raw analyst to investment banking CEO in five episodes.

The initial entry, "A Second Chance at Life!," marries the filmmaking conceits of the industrial with its graphic cousin, the clip art source book. Laffpix customized original mid-century clip art from its archives for use in Flash and created a soundtrack composed of both vintage and newly created "library" music and effects to deliver a convincing yet humorous and ultimately persuasive "industrial."

PRODUCT ADVERTISING
Gucci.com Web Site
www.gucci.com

Art Director Eunyoung Lee
Senior Creative Director Deanne Draeger
Creative Director Claudia Franzen
Engagement Leader/Strategist Marysia Woroniecka
Site Builder Pete Tandon
Technical Director Mitch Golden
Project Manager David Gerridge
Agency Agency.com
Client Gucci
Country United States

186

MERIT

PRODUCT ADVERTISING

www.gmund.com

Art Directors Allison Williams,
JP Williams
Designers Abby Clawson, Ray Elder,
Mats Hakansson
Photographer Gentl & Hyers
Studio Design: M/W
Client Büttenpapierfabric Gmund
Country United States

MERIT

PRODUCT ADVERTISING

www.mercedes-benz.com/genf2001

Art Director Philipp Bareiss
Creative Director Anette Scholz
Copywriter Chris Kohl
Flash Composers Katja Beikert,
Norbert Gilles, Sebastian Klein
Programmer Thorsten Kraus
Head of Project Sabine Lee
Project Managers Ellen Thuemmler,
Kyeong-i Shin
Agency Scholz & Volkmer
Intermediales Design GmbH
Client DaimlerChrysler AG
Country Germany

On the occasion of the 71st
Geneva International Motor Show, a
Web special was developed for
the DaimlerChrysler AG introduction
of a new chapter in the 100-year-old
"Story of Passion," the passionate
relationship between the trademark
of Mercedes-Benz and its customers.

The Web special orients
customers in the Mercedes-Benz
style while presenting the latest
exhibition highlights: the new and
longer A-Class and the world
premiere of the new, personalizable
Multichannel Portal.

The Web special communicates
facts and data about the exhibition,
while emphasizing the connections
between cultivation and customer
service, between clientele and
passion—everything that makes the
link-up between Mercedes-Benz
and its customers so unique.

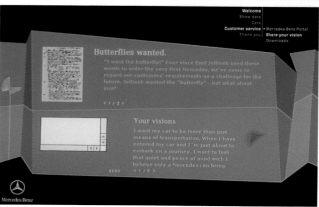

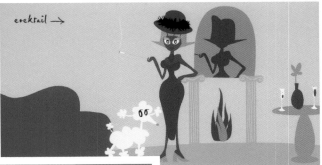

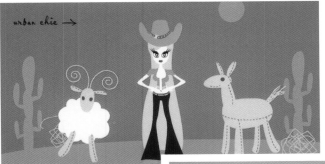

MERIT

PRODUCT ADVERTISING

www.lilyhats.com

Art Director Nina Dietzel
Designer Shiro Hamamoto
Illustrator Shiro Hamamoto
Producer Mary Flood
Studio 300 Feet Out
Client Lily Fighera
Country United States

What do you say to a good friend who's a wonderful hat designer and who lives, walks, and talks her own brand? "Quickly! Get in here, girl." Lily offered us the chance to position and brand her incredible talent. The results: a Web site in Flash to tease her buyers, a system of hang tags, labels, stationery, and business cards to tease her sensibility.

OK, so it wasn't cheap to print.

189

MERIT

PRODUCT ADVERTISING

Online Special for the BMW 5 Series
www.bmw.com/bmwe/products/auto
mobiles/5series_sedan/popup.html

Art Director Nathalie Zimmerman
Creative Director Hannes Schmidt
Copywriters Rachel McLaughlin,
Jan-Hendrik Simons
Programmers Kevin Breynck,
Eric Funk, Till Steinmetz
Content Development Oliver Bentz,
Katja Krumm
Screen Design Torben Cording
Product Managers Jutta Frisch,
Olaf Schlüter
Agency Kable New Media Hamburg
Client BMW AG 80788
Country Germany

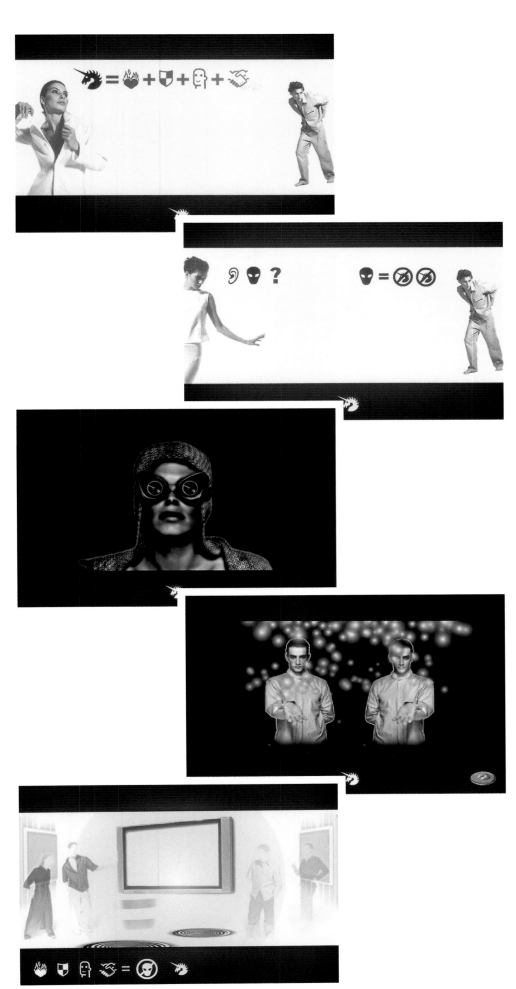

MERIT

PRODUCT ADVERTISING
The Einhorn Challenge
www.einhorn.de/challenge

Art Director Sebastian Schier
Creative Director Christian Schwarm
Designer Olivier Sternberg
Programmer Markus Heckel
Sound Design Sebastian Schier
Conceptionists Dave Bruckmayr,
Stefanie Katzschke
Project Manager Klaus-Dieter
Krueger
Associate Project Manager Daniel Oh
Agency AGI
Client Zeeb & Hornung GmbH & Co.
Country Germany

The shirt manufacturer Einhorn
(unicorn in English) is covering new
ground! The unicorn, a mythical
creature symbolizing individualism,
aesthetics, and wisdom, comes
alive in a virtual product game.
This completely new form of label
presentation compliments the
corporate Web site. In a mystical
work on the Web, a censor holds
unicorns captive—and only you
can free them! To guide your way
through this world, we have
developed a universally
comprehensible language.
Discover the unicorn in you!

MERIT

ONLINE CATALOG
Nike iD
www.nikeid.nike.com

Agency Critical Mass
Client Nike
Country Canada

Nike, the world's leading sportswear company, has a heritage of one-to-one service. In the company's early years, the Nike team toured the U.S. in a bus, bringing footwear solutions directly to athletes. Through Nike iD, Nike hoped to restore the tradition of product personalization that made Nike a household name.

Critical Mass helped Nike develop and deploy this e-commerce initiative which puts personalization at the forefront. The centerpiece is the iD configurator, which lets visitors customize their Nike gear by choosing from hundreds of possible color combinations and adding 3- to 16-character personal iDs. Products change in real time with each design decision a user makes. Another tool, the Fit Consultant, extends Nike iD's commitment to personalization by recommending shoe sizes based on user input. The site is being built largely on visitor feedback—a clear reflection of Nike iD's responsiveness to the needs of its customers. The success of the site has prompted Nike to embrace personalization as a core marketing strategy in moving forward.

ONLINE CATALOG

www.frenchpaper.com

Art Directors Charles S. Anderson,
Todd Piper-Hauswirth

Designers Charles S. Anderson,
Aaron Hansen, Todd Piper-Hauswirth

Copywriters Charles S. Anderson,
P J Chmiel, John Gross,
Todd Piper-Hauswirth

Photographer CSA Plastock:
Aaron Dimmel

Illustrator French Printstock
and Elements

Studio Charles S. Anderson Design

Client French Paper Company

Country United States

Frenchpaper.com was designed
for function. No Flash. No animation.
No chasing menus, hidden buttons,
or gratuitous animations. And no
3-D fluff. It's an intentionally 2-D site
in appearance, reflecting what it
promotes—paper. Our first question
when we started thinking about a
Web site for French Paper was why
would art directors and designers
visit a site to look at swatchbooks
of paper online when obviously the
real thing is more accurate? Our goal
became to go beyond paper and
make the site into a massively deep,
complete design resource where
you could not only buy paper and
envelopes in every grade, color,
weight, and size (over 20,000 SKUs),
but also an ever-expanding resource
of royalty free images, fonts, and
design elements to make French
Paper the first mill to provide not
only paper but also the images to
print on it.

MERIT

ONLINE CATALOG

www.10socks.com

Art Director William Hjorth
Designer William Hjorth
Copywriter Anders Schepelern
Photographer Brummer
Producer Carsten Vigh
Agency BBDO Denmark
Client www.10socks.com
Country Denmark

A limited advertising budget always calls for a small miracle. And we feel 10socks.com is just that. The process of making this site took no more than a couple of weeks since the brief, in short, was "make a cool site," and the client was rock 'n roll. We had a clear idea to use the square format to stand out from the crowd. With a narrow product line of three colors and sizes, 10socks.com has to rely on customer sympathy and word-of-mouth. Fortunately, numbered socks make a great story. 10socks.com is programmed entirely in Flash with an HTML pop-up window at the check-out.

ONLINE CATALOG

www.music3w.com

Art Director Fred Flade
Designers Fred Flade, Jez Nash
Producer Louise Holben
Technical Director Robin Gilby
Studio Deepend London
Client Music3w.com
Country United Kingdom

Music3W.com targets rock/pop music lovers of all ages and tastes and guarantees access to unique content from recognized artists in the form of up-to-the-minute news and exclusive interviews.

Since retail is an intrinsic feature and USP of the portal, it offers the user the opportunity to purchase associated videos, CDs, books, and other merchandise as well as the ability to purchase concert tickets. A rock-and-pop memorabilia auction site is planned, too.

Deepend delivered a strongly branded Web presence that resolves one of the key functions of the Music3W identity—signposting and directing music fans around the Internet. The identity is instantly recognizable on official artists' Web sites but integrates with them seamlessly, working in a diverse range of online environments. Its iconic nature allows legibility when reproduced at a small size, such as on the screen of WAP phones.

MERIT

INSTITUTIONAL PROMOTION
Rhode Island School of Design
www.risd.edu

Art Director Sasha Kurtz
Senior Visual Designer Lesli Karavil
Flash Designer Kohsuke Yamada
Interaction Designers Dan Harvey,
Max Kazemzadeh
Lead Programmer George Matthes
Programmer Charoonkit Thahong
Quality Assurance Tester Sunny Nan
Technical Team Leader Tom
Freudenheim
Senior Producer Elizabeth Rankich
Associate Producer Lee Passavia
Studio R/GA Digital Studios
Client Rhode Island School of Design
Country United States

Designing a Web site for a design
school presented a special challenge
to R/GA. As a leading institution in
its field, Rhode Island School of
Design required an online presence
that would reflect the richness of
the educational experience as well
as the graphic aesthetic on which its
reputation depends. In September
2000, the new site, which categorizes
over 400 pages of content, was
launched. It invites potential students
into the life and process that exists
behind the studio walls, while
maintaining an elegance suitable for
patrons of the RISD Museum.

For the redesign, R/GA thoroughly
examined the site's navigation and
gave it a more simplified and intuitive
structure. To accomodate the breadth
of content, R/GA devised a system of
hierarchical templates that maintain
a visual sense of place as users
navigate deeper into the site. Vibrant
images were incorporated
throughout the new design, most
notably on the Flash-animated
home page.

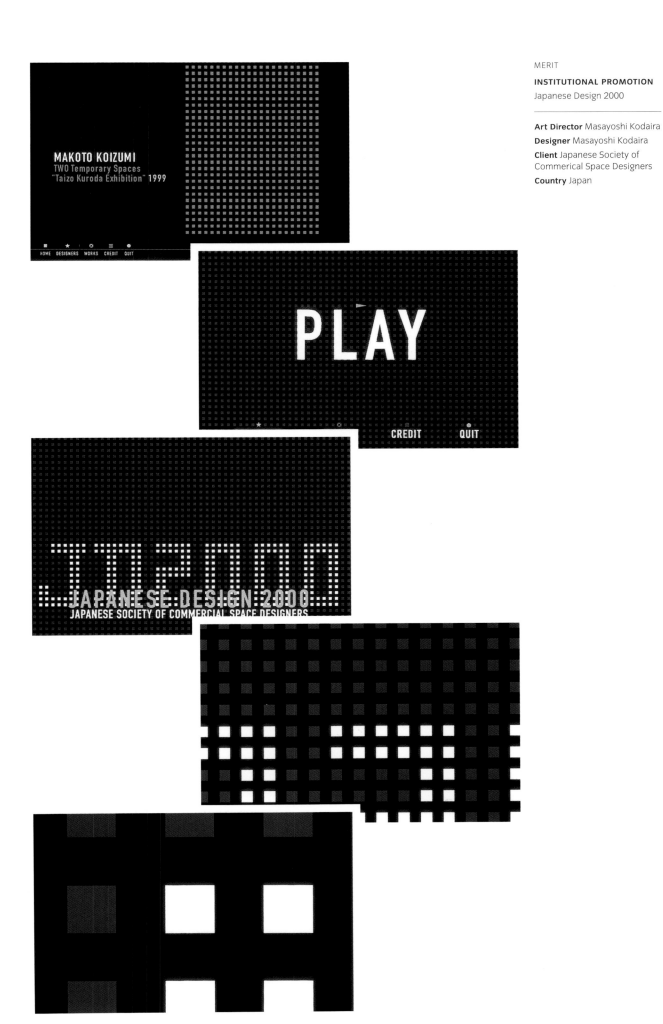

MERIT

INSTITUTIONAL PROMOTION
Japanese Design 2000

Art Director Masayoshi Kodaira
Designer Masayoshi Kodaira
Client Japanese Society of
Commerical Space Designers
Country Japan

MERIT

INSTITUTIONAL PROMOTION
Versace Web Site
www.versace.com

Creative Director Ayshe
Farman-Farmaian
Senior Designers Marko Bon,
Isabel Hernandez, Rita Kesselman
Designers Natalya Bagrova, Stefanie
Keller, Yah-Leng Yu, Karen Zorich
Copywriter Glen Belverio
Chief Interactive Architect Asa Mader
Flash Developers Anthony Krauss,
Jason Mortara
HTML Builder Sebastian Wintermute
Back End Developer Mike Wiley
Information Architect Marko Bon
Producer Jessica Lim
QA Producer Andrea Frolich
Editorial Director Massoumeh
Farman-Farmaian
Client Versace Group
Country United States

Digitalform was approached
by Versace, the innovative fashion
house, to create its official Web site.
Versace wanted to bring to life
not only its advertising, runway
collections, and current events, but
it also wanted to communicate
the lifestyle of the brand.

For Digitalform, this endeavor
was particularly challenging and
exciting, as Versace has strong
brand equities and is synonymous
with cutting-edge innovation.

Digitalform developed a highly
interactive space using Flash
animation, video streaming, and
original music, as well as ad
campaigns with original mini-movies
offering complete immersion in the
world of Versace. The site features
brands such as Atelier, Versace, and
Versus, and includes sections
dedicated to the Home Collection
and Perfumes and Makeup.
A "Spotlight" area, announcing
seasonal news, currently features
the opening of the Palazzo Versace,
a one-of-a-kind luxury hotel and
resort in Australia.

SELF-PROMOTION
ZP Thunder House Web Site
www.thunderhouse.com.br/awards

Art Director Rico Villas-Bôas
Creative Directors Rico Villas-Bôas,
Bob Gebara
Designer Rico Villas-Bôas
Copywriter Bob Gebara
Photographer Romeu Semprini
Illustrators Rico Villas-Bôas,
Alexandre Tozzatti
Producer Zentropy Partners/
Thunder House
Agency Zentropy Partners/
Thunder House
Client Zentropy Partners/
Thunder House
Country Brazil

Our challenge was to create a unique
Web site with its own personality,
far from design tendencies like "pixel
dirty." We also wanted the chosen
technology to speak for itself.
Indeed, it has done just that without
any additional resources. We had to
put the site through the worst sieve:
our own. It couldn't be just a creative
site—we wanted something
completely different, from the
uploading to the end.

The solution was to build a Web site
in Macromedia Shockwave. During
the loading, there is a walking
washing machine. In the introduction,
there is a clothesline with a dark
urban metropolitan background.
For additional charm, there is an
impacting menu that leads the user
to the job images and pictures of the
design team. Straight, different, and
funny. Just like everything we do.

MERIT

SELF-PROMOTION
Resources Sales Presenter

Designers James Coulson,
Andrew Wood
Producers Lucy Cooper,
Louise Elstone, Shane Grobler
Agency BBC Media Arc
Client BBC Resources
Country United Kingdom

The brief was to produce a DVD to be used as a sales presenter for London-based BBC Resources. The content was to consist of department showreels and other relevant information, such as studio plans, broadcast vehicle specifications, and contact details. The DVD would then be used by sales and marketing staff to promote BBC Resources and generate new business. The DVD was shown to prospective clients on portable DVD players and at relevant trade shows/exhibitions. The DVD needed to be modular so that content, such as showreels, could be updated.

The concept behind the interface was based on the architecture of BBC Television Centre. We wanted to build on the heritage of the BBC and give it a contemporary edge. The DVD starts with footage of the Franco-British exhibition of 1908, White City. The scene then shifts to a pub in 1949, where architect Graham Dawbarn ponders over a scrap piece of envelope. Recognizing that Television Centre must be circular, he sketches a question mark, upon which he realizes the solution. The DVD then transitions into a science fiction world. The question mark acts as an architectural interface, allowing the user to select different departments and sections of the building. The DVD contains 40 showreels and approximately 180 screens of text-based information.

MERIT

SELF-PROMOTION
Online Portfolio for Marc Lafia
www.metabolichouse.com

Art Director Janice Natchek
Designer Janice Natchek
Copywriter Daniel Coffeen
Video Compositing Sri Prabha
Video Prep & Editing Sandra Helsa
Client Marc Lafia
Country United States

The "client's brief," as such, never officially existed in this project. Conceptual artist Marc Lafia and I worked closely in an ever-evolving process. He approached me intially to create an online portfolio, which seemed straightforward enough. I suppose I should have guessed, that, like his body of work—everything from Web-based experiences to films, fiction, performances, photographs, video works, and drawings—this site would be something more complex.

Marc's concept of the "metabolic house" drove this site from the beginning. The architectural metaphor quickly followed. More than a repository or archive, which it is, the site was to be a space which processed information and considered how it presented the work.

The complexity of Marc's ideas drove me to constantly organize and simplify. The result is a visual metaphor, complex in concept more so than execution, which invites the user in to explore. And with the somewhat obscured sections, all is not always revealed on the first visit.

MERIT

SELF-PROMOTION
www.waxnyc.com

Art Director Paul Weston
Designer Chad Spicer
Copywriter Daniel Janoff
Photographer Paul Weston
Illustrator Chad Spicer
Producer Callie Janoff for WAX
Studio Leadbased
Agency Leadbased
Client WAX Music & Sound Design
Country United States

Pictures of a sound studio say nothing! Wax Music and Sound Design wanted a site that showcased their sound effects and music. The problem with sound on the Web is file size, a consideration since Wax also wanted a lean site. After a bit of experimentation with Flash, we at Leadbased realized that when sound files are made into a "symbol" they are no different than a graphic "symbol." This allows you to repeat an element over and over again, without adding additional weight to the site.

Working as "producers" we had the composers at Wax create many mini loops that we could then "mix" in the final timelines of Flash. The viewer will notice at the beginning of the site that the audio reflects Wax's sound-design skills. The backend of the site features all original music, with each page showcasing an individual piece.

SELF-PROMOTION

www.workincorporated.com

Art Directors Cabell Harris,
Paul Howalt
Creative Director Cabell Harris
Designer Paul Howalt
Copywriter Steve Covert
Client Work, Inc.
Country United States

After Work, Inc. partnered with
Howalt Design to establish Work's
design division, it was determined
that a new Web site should be
developed to showcase the
company's newly expanded branding
capabilities. The company's new
design division was directed by
Cabell Harris to build a site that
would overwhelm clients and
prospects with the company's
award-winning work, as well as
inform visitors about Work, Inc. and
its ever-expanding product line.
Since the site was going to be
lengthy as well as image heavy, the
main struggles were optimizing file
size and building a slightly
progressive navigational logic.

Howalt used the capabilities
handbook he had designed for Work,
Inc. as a starting point for content
organization. After the site mapping
was done, custom fonts, navigation
bars, and smart layouts were
generated in order to make the most
of screen real estate and the user's
preconceived navigational intuitions.
The end result was an overwhelming
immersion into the talents, mantras,
and branding of Work, Inc.

MERIT

SELF-PROMOTION
www.wl2.com

Art Directors William Hovard, Lee Iley
Designer Lee Iley
Copywriter Deirdre McMennamin
Studio WL2 inc.
Client WL2 inc.
Country United States

The Web site developed for WL2 needed to visually communicate the dimension of the firm and scope of the work in an enticing format. The objective was to showcase a diverse portfolio and communicate the company's capabilities to both the design and business communities. The site was constructed without hyperlinks, providing a linear architecture and unobstructed navigation. By having several movies load into the main window, the content can be easily updated without having to alter the primary interface. The emphasis on pure design offers a refreshing destination and clean digital experience in a crowded and competitive media.

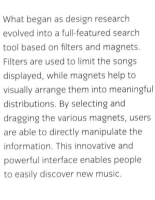

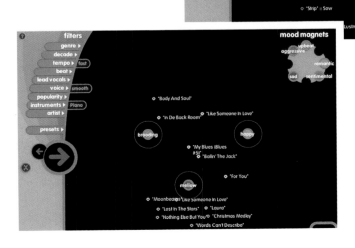

MERIT

REFERENCE/EDUCATION
MoodLogic Magnet Browser
www.moodlogic.com

Art Directors Pascal Wever,
David Young
Programmer Lindi Emoungu
Studio Triplecode
Client MoodLogic
Country United States

From startup to launch, Triplecode
worked with MoodLogic to help
define what could be done with their
core technology. No easy task, since
they were developing the world's
largest source of multidimensional,
perception-based music metadata—
including nearly 700 million data
points collected on over 550,000
songs.

What began as design research
evolved into a full-featured search
tool based on filters and magnets.
Filters are used to limit the songs
displayed, while magnets help to
visually arrange them into meaningful
distributions. By selecting and
dragging the various magnets, users
are able to directly manipulate the
information. This innovative and
powerful interface enables people
to easily discover new music.

205

MERIT

REFERENCE/EDUCATION

www.schwablearning.org

Art Director Samantha Tripodi
Designers Cheryn Flanagan,
Brian Forst, Paul Wang
Photographer Doug Menuez
Developers John George, Judith
Hengeveld, Christopher Jones,
Ylva Wickberg-Brown
Information Designer Darcy DiNucci
Experience Design Jared Braiterman
Project Manager Annelise Staal
Brand Strategy Seth Bain
Client Schwab Foundation
for Learning
Country United States

206

Schwab Learning is a non-profit
organization dedicated to helping
parents of children with learning
differences (LD). Our objective was
to create a Web site where parents
would feel comfortable, come to
understand their role in living with
LD, find easy access to information,
and share ideas with other parents
of LD children.

With careful interactive user testing
and art direction, we designed a
solution that made navigating this
emotional subject easy for novice
parents. Photographer Doug Menuez
helped build a new visual vocabulary
using real children in their school
environment that could be used not
only on the Web site but also
across other media.

Small Pond Studios successfully
integrated the design by leading the
development and implementation of
the entire site. Drawing on internal
strengths along with the specialized
talents of Carbon Five and Otivo,
Small Pond Studios was able to meet
a demanding schedule and complex
content management requirements.

HYBRID/ART/EXPERIMENTAL
Circuland

Designer Peiyi Chen
Digital Score and Audio FX Jonathan Lupo
Country United States

The inspiration for Circuland came from a love for the intricately patterned designs of China. Rather than presenting my own expressions of this art form within the context of a flat environment, I wanted to design a world in which patterns would slowly unveil their form upon interaction and exploration. A convincing experience needed a soundtrack that was woven from the same fabric as the visual elements. Each level of Circuland has its own texture, and the challenge was to cohesively tie these tapestries together, finding the common thread leading the participant to another level, and another feeling.

MERIT

HYBRID/ART/EXPERIMENTAL
Mandala the Sacred Cosmos

Art Director Naomi Enami
Designer Masaki Kimura
Copywriter Geshe Thupten Jinpa
Photographer Tadayuki Naito
Music Somei Sato
Producer Naomi Enami
Editorial Director Takako Terunuma
Studio Propeller Art Works Co., Ltd.
Agency Accompany Co., Ltd.
Client Digitalogue Co., Ltd.
Country Japan

Mandala sand paintings,
a tradition that continues to this day,
have played a significant role in
Tibetan Buddhism throughout the
ages. Mandala are created by trained
monks using colored sand for tantric
rituals and are destroyed upon
completion. This mystic art form is
said to represent an imaginary
"palace" that can only be
contemplated through meditation.
With the help of multimedia
innovation, we hope to explore the
circles of eternal beauty—and
the macrocosm that is
Tibetan Buddhism.

MERIT

HYBRID/ART/EXPERIMENTAL

010101: Art in Technological Times
www.010101.sfmoma.org

Art Directors Anthony Amidei,
Steve Barretto, Stephen Jaycox
Designer Vanessa Dina-Barlow
Client San Francisco Museum
of Modern Art
Country United States

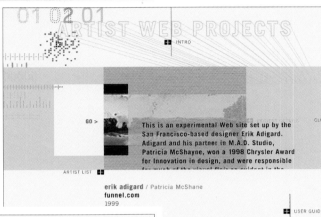

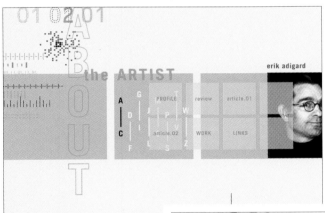

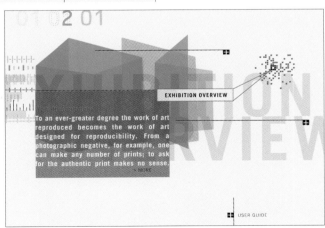

graphic design

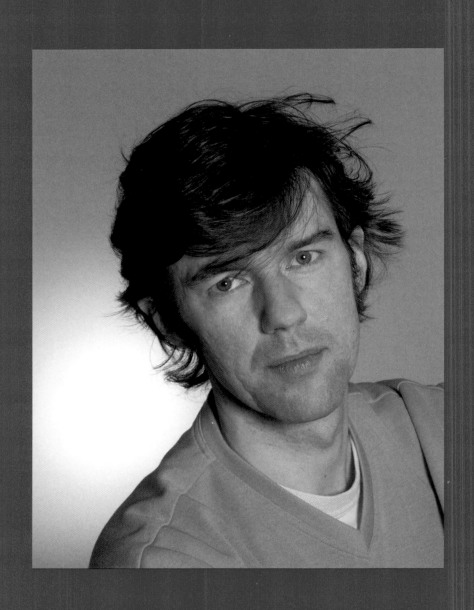

I happily agreed to chair the graphic design section of the Art Directors Annual because these things are always fun. Over three days you get a great overview of what's happening in design. As chair I got to select the judges (and therefore with whom I was going to hang out during those three days), and for a time it's great to talk nothing but design. I made a list of all my favorite designers, and, to my surprise, they almost all accepted.

But, to quote David Foster Wallace: A supposedly fun thing I'll never do again. It was three days of hell. This was the toughest, most argumentative bunch of judges I've ever witnessed: endless discussions, entries already stored away being brought out again, opposing factions, and a screaming fit (mine). I was glad I did not enter any of my company's own work.

The 100-odd pieces selected for the book are of truly high standard, not a stinker among them.

Because of the incredible number of entries, we had to get rid of many good pieces, but then that's unavoidable when you have over 7,000 entries in the graphic design section alone. Somehow, at the end, miraculously, it worked. The 100-odd pieces selected for the book are of truly high standard, not a stinker among them.

—Stefan Sagmeister
SAGMEISTER, INC., NYC
GRAPHIC DESIGN CHAIR

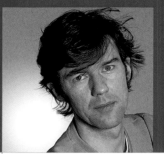

STEFAN SAGMEISTER formed the New York based Sagmeister Inc. in 1993 and has since designed graphics and packaging for the Rolling Stones, David Byrne, Lou Reed, Aerosmith, and Pat Metheny. His work has been nominated four times for Grammy Awards and has won most international design awards.

PETER HALL was a staff writer and editor at *I.D.* magazine from 1993–2000 and currently writes for *Metropolis*, *The Guardian*, *One*, and *Trace*. He wrote and co-edited *Sagmeister: Made You Look* (Booth-Clibborn Editions, 2001), *Tibor Kalman: Perverse Optimist* (Princeton Architectural Press, 1998), and co-authored *Pause: 59 Minutes of Motion Graphics* (Rizzoli/Universe, 2000). He also lectures at the Yale School of Art.

ELISABETH KOPF was working in completely design-unrelated fields until 1993, when her son Luc was born. That was her first conscious experience of having created something wonderful. Ever since, she has been obsessed with hunting down ideas and developing extraordinary concepts. She has made portraits, CD covers, and experimental films among other things. Her clients include: Vienna Art Orchestra, Azizamusic New York, and Echoraum Vienna. Elisabeth's awards include: The Joseph Binder Design Award, ADCNY, and *Print* magazine.

NOREEN MORIOKA is currently a partner of AdamsMorioka, in Beverly Hills. Morioka has been credited as one of the forces behind a renewed movement in the design world toward a simpler, more direct approach. In 1997, Morioka, with partner Sean Adams, was named to *International Design* magazine's *ID40*, a list of the 40 most influential designers internationally. Morioka has lectured extensively throughout the world, and recently served as a juror for the AIGA's Communication Graphics Show. She has received the Award of Distinction from the International Design Annual Design Review, and was named a fellow of the International Design Conference at Aspen. Noreen is currently president of the AIGA Los Angeles Chapter.

CHEE PEARLMAN is a design and editorial consultant, a writer for *The New York Times* and other publications, and the co-chair of the annual Chrysler Design Award. She is the former editor-in-chief of *I.D.* magazine, which was honored with five National Magazine Awards (the Oscars of the profession) under her tenure.

TRISTAN J. PRANYKO was born in 1957 in Pula, now Croatia. Exploring in particular the art of photography, he concentrated on the transfer of artistic strategies to the graphic arts: product, shop, and interior design. He achieved international renown with the global co-ordination of corporate images for Børding and Sabotage™, aesthetically influencing the German Techno movement. He has received several international art and design prizes.

PAUL SAHRE is a graphic designer/educator whose work explores the divergence between design and art. He hand-prints posters for non-profit institutions such as the Fells Point Corner Theatre in Baltimore and the Soho Repertory Theatre in New York. He also designs book covers for Beacon Press, Knopf, Vintage, Little Brown, Verso, and others. Sahre teaches graphic design and typography at The School of Visual Arts and Parsons School of Design. He does all of this while overseeing the operation of his own design office in New York City. Sahre received a B.F.A. and M.F.A. in graphic design from Kent State in Ohio.

RALPH SCHRAIVOGEL opened his design studio, 1982, in Zurich, where he graduated from the School of Design in the same year. His clients are mainly cultural institutions, such as the Zurich Repertory Cinema and the Zurich Museum of Design. His posters have won most international design awards.

CARLOS SEGURA was born in Cuba and came to the United States in 1965, at age nine. He grew up in Miami where he drummed in a band and was responsible for its promotion. This led to his first job as a production artist at an envelope company where he designed return addresses. He then worked for an agency in New Orleans, and then in Chicago, where he met his wonderful wife, Sun. He worked for advertising agencies such as Marsteller, Foote, Cone & Belding, Young & Rubicam, Ketchum, DDB Needham, and others in Chicago and Pittsburgh. In 1991, he started Segura Inc. to pursue design. In 1994, the [T-26] digital type foundry was born to explore the typographical side of the business. In 1996, he started the independent record label, THICKFACE. In February of 2001, he founded 5inch.com, which will be launched this fall.

NORITO SHINMURA was born in Japan in 1960. After tenures at the Shin Matsunaga Design and I&S/BBDO, he established the Shinmura Design Office in 1995. Awards and honors include: New York ADC Silver Medals and Distinctive Merit Awards, London International Advertisement Award Finalist, Cannes International Advertisement Festival Award Finalist, Tokyo TDC Bronze Prize, and Japan Graphic Designers Award.

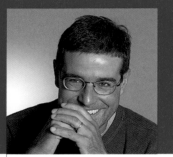

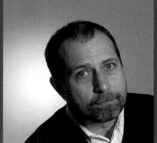

FELIPE TABORDA is a graphic designer from Rio de Janeiro. A graduate of Rio's Catholic University, he studied cinema and photography at the London International Film School, communication arts at the New York Institute of Technology, and graphic design at the School of Visual Arts (USA). A professor at UniverCidade/RJ, he has had his own office since 1990, working mainly in the cultural, publishing, and recording areas. He also devotes himself to personal projects such as the co-ordination and publishing of *Brazil Designs*, a special edition of the American magazine *Print*, the conceptualization and curatorship of the event "30 Posters on Environment and Development" (during Eco '92 in Rio), the art direction of "Private Landscapes," and the concept and curatorship of "The Image of Sound," a project paying tribute to Brazil's leading composers through the visual creation of contemporary artists.

Born in Hiroshima, Japan, in 1968, **FUMIO TACHIBANA** received a B.A. from the Musashino Art University and an M.A. from the Tokyo National University of Fine Arts and Music. Fumio's solo exhibitions include, "Made in U.S.A." at Sagacho Exhibit Space in Tokyo, "Fumio Tachibana" at Obscure Gallery in Tokyo, "Kami-Gami (papers)" at Gallery 360 in Tokyo, and "Karada" at Nadiff in Tokyo. Group exhibitions include: "Selections Winter '97" at the Drawing Center, New York and "Installations by Asian Artists-in-Residence" at Mattress Factory, Pittsburgh. In 1998, Tachibana and his brother established the book label "Burner Bros" and published Tachibana's own art books: *Kami-Gami*, *Hi-Bi* (fire), and *Clara*. Tachibana has received the Gold Medal from the 17th Brno International Graphic Design Biennale and a Gold Prize from the Tokyo Type Directors Club.

BARUCH GORKIN is a graphic designer whose passion for speech-based typography drives his work, his writing, and his teaching. Gorkin believes in the power of typography as a branding tool. As a Founding Partner and creative director of Access Factory, he worked for Agfa, Kodak, Monotype, MeccaUSA, and others. There he designed international system fonts for Apple and Microsoft. As creative director at Ogilvy & Mather he was responsible for cross-media campaigns for ONDCP (Office of the National Drug Control Policy) and American Express. Gorkin teaches typography at the School of Visual Arts where his students explore the anatomy of textual communication without the usual reliance on the crutches of typographic style. Two of his books on typography were published by Graphis Press. He received a B.F.A. in graphic design from the Rhode Island School of Design.

Born in Middlesex, England, **STORM THORGERSON** attended the Leicester University Royal College of Art. After designing the cover for the first Pink Floyd album he founded the design team Hipgnosis. Books by Thorgerson include: *100 Best Album Covers, Mind Over Matter,* and, with Peter Curzon and Jon Crossland, *Eye of the Storm: The Album Graphics of Storm Thorgerson.*

RICK VALICENTI, AGI (member of Alliance Graphique International), is an artist and designer. He is the founder of Thirst and Thirstype.com. Rick brings passion to life through these two design consultancies, which serve clients who also are devoted to art with function. Thirst's creative versatility continues to pursue elusive ideals of intelligence and beauty in today's world of commerce. Thirst's clients include: Gilbert Paper, Gary Fisher Bikes, The Lyric Opera of Chicago, Herman Miller, *The Monacelli Press*, and The Illinois Institute of Technology School of Architecture.

JAMES VICTORE's work ranges from publishing, posters, and advertising to illustration and animation. His clients include Moet and Chandon, Watson Guptill, The Shakespeare Project, *The New York Times*, MTV, The Lower East Side Tenement Museum, and the Portfolio Center. Awards include: an Emmy for television animation, a gold medal from the Broadcast Designers Association, the Grand Prix from the Brno (Czech Republic) Biennale, and gold and silver medals from the New York Art Directors Club. Victore's posters are in the permanent collections of the Palais du Louvre, Paris, the Library of Congress, Washington D.C., and the Museum für Gestaltung, Zürich, among others. Recently, a book of his design work was published in China. He teaches graphic design at the School of Visual Arts in New York City. He is a member of AGI.

ROBERT WONG is 5'7" and weighs 140 lbs. He's right-handed, left-hearted, and center-brained. Robert snores. He complains that his belly is too soft. He refuses to join a gym. After 35 years, he's finally accepted his receding hairline. Some have said he has nice taste in clothes. Some have said they can't believe he's not gay. Most agree that he has too much energy. He is the chief creative officer of the company formerly known as marchFIRST.

WANG XU, graphic designer, is a member of the American Institute of Graphic Arts, New York Type Directors Club, Art Directors Club, and Alliance Graphique Internationale (AGI). Awards include: a silver medal and distinctive merit award in the 77th New York Art Directors Club Annual Awards; New York Type Directors Club; Typography 16, 19, 20, 21; ICOGRADA Excellence Award in the 17th International Biennale of Graphic Design, Brno; Golden Bee Awards in the Golden Bee 4 and Golden Bee 5; International Biennale of Graphic Design, Moscow, 1998 and 2000. He was selected as a jury member for the 19th International Biennale of Graphic Design, Brno, 2000, and Nagoya Design Do!, Japan, 2000. He has edited and designed 15 issues of *Design Exchange* magazine and more than 40 design books.

A former Detroit commercial artist (1957—1987), **ED FELLA** is presently teaching graphic design at CalArts (since 1987) in Los Angeles. His work is in the National Design Museum, MOMA in New York, and has appeared in many design publications and anthologies. He received the 1997 Chrysler Award for Innovation in Design.

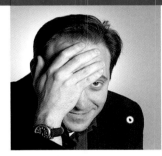 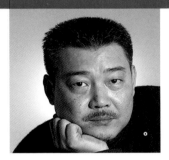 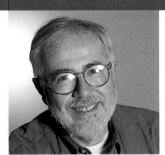

Bodé

GOLD

CONSUMER MAGAZINE: MULTIPAGE

Art Director Fumio Tachibana
Designer Fumio Tachibana
Photographer Fumio Tachibana
Artist Fumio Tachibana
Client Idea magazine
Country Japan

SPECIAL TRADE BOOK: IMAGE DRIVEN

Edward Fella—
Letters on America

Art Directors Edward Fella, Lorraine Wild
Designers Edward Fella, Lorraine Wild
Photographer Edward Fella
Illustrator Edward Fella
Client Calmann + King Publishers
Country United States

POSTERS: PROMOTIONAL, SERIES

Michinoku Pro Wrestling

Art Director Tsudou Honda
Designer Hiroaki Tanabe
Illustrator Tomoo Gokita
Agency JIC Corporation
Client North Eastern Wrestling
Country Japan

Everyday during my childhood, I saw an enormous amount of advertising for consumer goods from a variety of stores. The memory of this information gave me the idea to make my design for Michinoku Pro Wrestling, which I called "The Great Power Sasuke." It recalls a boy playing with a great power.

I made the main poster by imagining myself using this great power, borrowed from the majestic ideas of my childhood, to show something to a mass audience.
I arranged it using cheap, wick poster sheet. The result was a conspicuous and strongly graphic advertisement.

In this diary we have tried to visualize the passing of the days using purely graphic means. The 365 days of the year are divided into 12 months. Each month naturally has a first, a second, a third, a fourth, and sometimes a fifth Monday, Tuesday, Wednesday, Thursday, Friday, Saturday, and Sunday. Here these particular days are coded with a unique symbol, which means that there are a total of 35 different symbols. The symbols are constructed by overprinting up to three varying sized concentric circles in a combination of one to three different colors. On the page where January 1, 2, and 3 appear, the complete pattern of circles representing the 365 days of the year 2001 can be seen. The pattern is in fact mirror-printed on the reverse side of the Japanese folded sheet. On the following page, January 4, 5, 6, and 7, the symbols have moved three positions forward. This twice weekly rhythm continues throughout the diary. Consequently, the empty space grows from the bottom right of the page and the year 2001 gradually disappears.

GOLD

SELF-PROMOTION: PRINT

Diary 2001

Designers Hans Bockting, Sabine Reinhardt
Studio UNA (Amsterdam) Designers
Client UNA/Veenman/Hexspoor/Callenbach
Country The Netherlands

TYPOGRAPHY, SERIES
Artists Against Piracy—
Circle C 1 & 2

Art Director Paul Matthaeus
Designers Chace Hartman,
Mason Nicoll, James Webber
Producer Lane Jensen
Editor Eric Anderson
Client Dailey & Associates
Country United States

We felt these spots needed to be sight-sound metaphors for music's capacity to be a messenger of human emotion, and music's boundless capacity to deliver a personal vision. To insist that musicians be compensated for their effort would be futile, unless we demonstrated relevance and poignancy on a human level.

The agency suggested a simple approach, which made a lot of sense. We developed a process using "motion math," where we applied motion algorithms to graphic elements to make them respond to the pitch and volume of the music. The result is an animation unlike your typical palette of blur and kern effects that litter the screen nowadays. The animation is intrinsically linked to the sound, in ways conventional animation can't approximate. The treatment moves from rough and simplistic to embellished and fantastic. The purpose: to create a sequence that is a visual embodiment of the creative process itself, and the human connection required to get there.

Artists Against Piracy

Orange Screen with
small white "Circle C"
© copyright symbol

Letters fade in and
jumble to form the
word "pra©tice"

Extraneous letters
scan away to
"dedi©ation"

Letters roll off to
"sa©rifice"

These in turn
disintegrate into
"©reation"

Which melts into
"musi©"

Which rolls into
"respe©t"

All text fades

Main title fades in:
Artists Against Piracy
www.artistsagainst
piracy.com

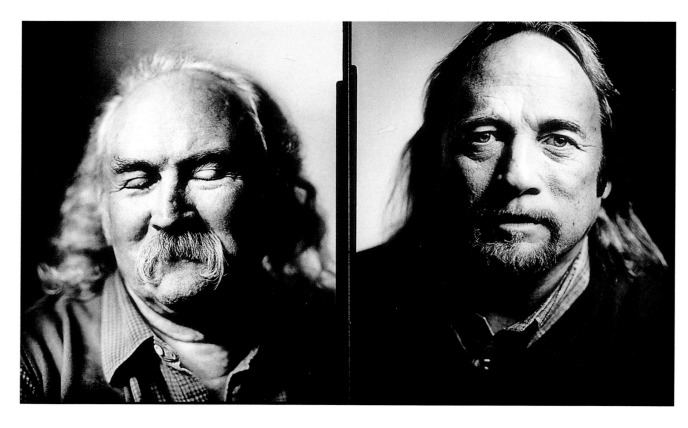

Crosby, Stills, Nash, Young

Multiple Awards
(see also Photography)

SILVER

**CONSUMER MAGAZINE:
MULTIPAGE, SERIES**

Art Director Fred Woodward
Designers Siung Tjia, Fred Woodward
Photographer Mark Seliger
Photo Editor Rachel Knepfer
Client Rolling Stone
Country United States

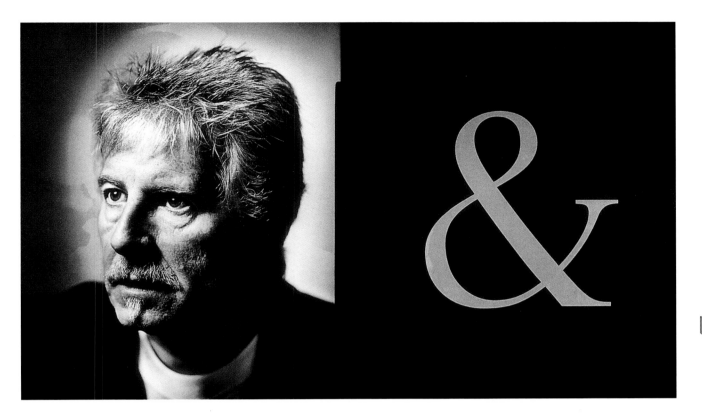

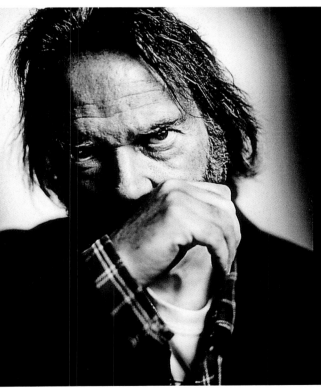

David Crosby, Stephen Stills, Graham Nash & Neil Young sit shoulder to shoulder on wooden stools around a forest of microphones. On the far left, Stills plays a gentle riff on a snow-white, wide-body electric guitar. Across from him, Young, wearing a red flannel shirt and a black baseball cap, strums an acoustic guitar and sings "Old Man," from his 1972 album, *Harvest*.

Young's shivery tenor sounds fragile in the cold dark space of the Convocation Center in Cleveland. But when the other three enter the chorus with swan-diving harmonies – "Old man, look at my life/I'm a lot like you" – the song blooms with fresh meaning. Crosby Stills Nash and Young are no longer the four young bucks who overwhelmed rock in 1969 with pedigree and promise. They are in their fifties, and they sing "Old Man," a reflection on passing youth and lost opportunity, with electrifying honesty. Unfinished business runs deep in those bruised-gold voices.

There is no applause at the end – because there is no audience. CSNY are in final rehearsals for their first concert tour since 1974. Opening night, in Detroit, is four days away. But to hear this band in a big, empty room is to experience magic in its native state. Everything that makes CSNY one of rock's premier melodramas – drugs; feuds; Crosby's 1994 liver transplant and new celebrity as a sperm donor for lesbian moms Melissa Etheridge and Julie Cypher; Nash's boating accident BY DAVID FRICKE >>> PHOTOGRAPHS BY MARK SELIGER >

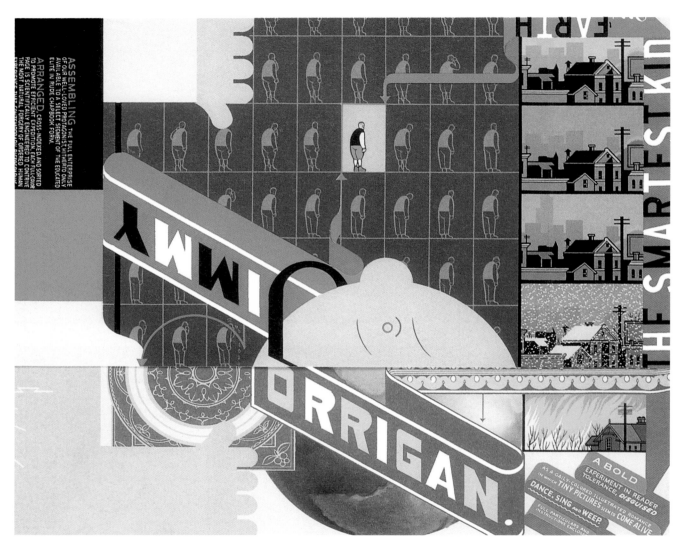

Jimmy Corrigan:
The Smartest Kid on Earth

SILVER

**SPECIAL TRADE BOOK:
IMAGE DRIVEN**

Art Director Chip Kidd
Designer Chris Ware
Copywriter Chris Ware
Illustrator Chris Ware
Client Pantheon Books
Country United States

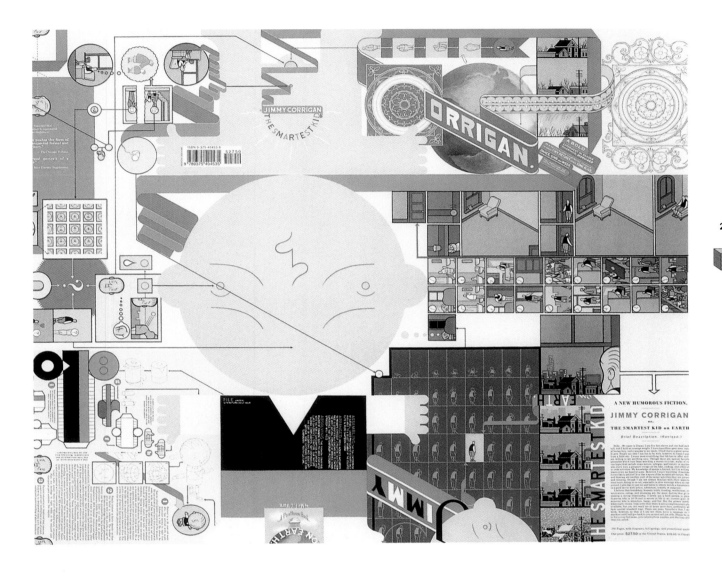

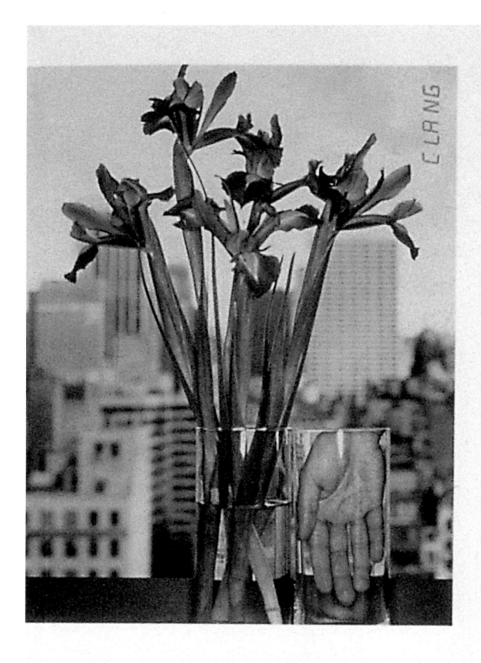

Multiple Awards
(see also Photography)

Clang | SILVER

**LIMITED EDITION/PRIVATE PRESS/
SPECIAL FORMAT BOOK**

Art Directors Theseus Chan, Mina
Designers Theseus Chan, Mina
Photographer Clang
Producer Elin Tew
Agency WORK
Client Clang
Country Singapore

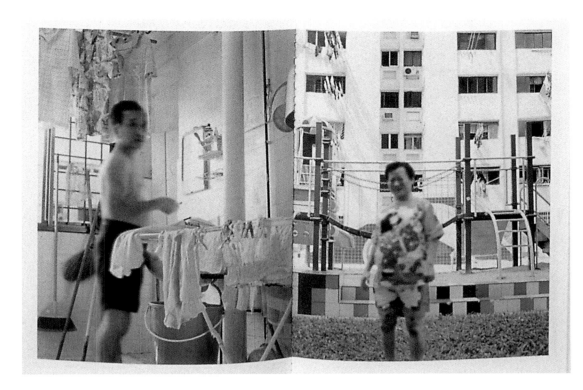

The design of *Clang* reflects the experimental nature of the client's art. Going against publishing conventions, the book is a book/magazine hybrid, featuring a gatefold on the cover and content that begins in the center, rather than on the very first page. The reader is encouraged to explore beyond the blank pink pages and is rewarded with Clang's extraordinary photography on the white pages in the middle of the book.

SILVER

MUSEUM/GALLERY/LIBRARY BOOK

Sugimoto—Theatres

Art Director Takaaki Matsumoto
Designer Takaaki Matsumoto
Photographer Hiroshi Sugimoto
Studio Matsumoto Inc.
Clients Sonnabend Gallery, Eyestorm.com
Country United States

Sugimoto Theatres was published to feature the complete theatres series, including movie theatres and drive-in theatres, by the fine arts photographer Hiroshi Sugimoto. With the use of the traditional dry-trap offset printing process—printing one color at a time and allowing the ink to dry between runs—we have managed to represent the artist's photographs as close to the originals as is possible in book form. The cover was silkscreened with day-glo ink and then matte film laminated to recreate the illusion of light that is portrayed in these photographs. The slipcase was made in brushed aluminum.

SILVER

PROMOTIONAL APPAREL

asylum01anniversary limited edition shirt

Art Director Christopher Lee
Creative Director Christopher Lee
Designer Christopher Lee
Copywriter Evelyn Tan
Client Design Asylum Pte. Ltd.
Agency Design Asylum Pte. Ltd.
Country Singapore

Celebrating our first anniversary with our friends called for a novel idea since most of them are in the creative industry. At the commemorative exhibition we hosted, a DIY shirt was distributed. Two pieces of cloth were sewn together along the seams, printed with a cut-along-the-dotted-line instruction, then vacuum packed in a transparent plastic bag. This cut-and-wear T-shirt allowed our friends and guests to tap their creative juices and create their own styles.

233

Collateral Therapeutics is developing non-surgical gene therapy products to treat cardiovascular disease. The 1999 annual report is meant to harmonize in size and emotional impact with the prior year's report. To reinforce the company's concentration on cardiovascular disease, an anatomical heart model is presented from various elevations. Small captions accompany the photos of the model, which read: provider, worker, struggler, healer, and pioneer, thereby personifying different functional aspects of the heart. The company's products take these qualities and enhance the heart's own strengths in order to help it heal itself. Also included in the report are a photo essay about the clinical trial process and portraits of patients. The main goal of the report is to help the audience visualize the potential hope this technology holds for heart disease patients, as well as to present non-surgical gene therapy as a better alternative to the more traditional treatments of drugs, angioplasty, and surgery.

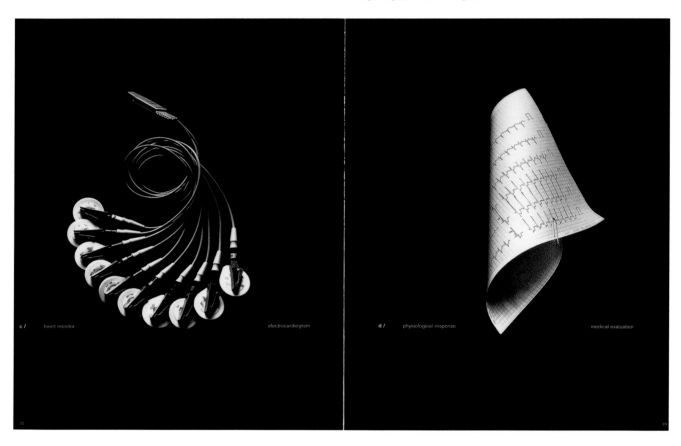

c / heart monitor electrocardiogram d / physiological response medical evaluation

Collateral Therapeutics 1999

SILVER

ANNUAL REPORT

Art Director Bill Cahan
Designer Kevin Roberson
Copywriters Thom Elkjer, Kevin Roberson
Photographer Robert Schlatter
Studio Cahan and Associates
Client Collateral Therapeutics
Country United States

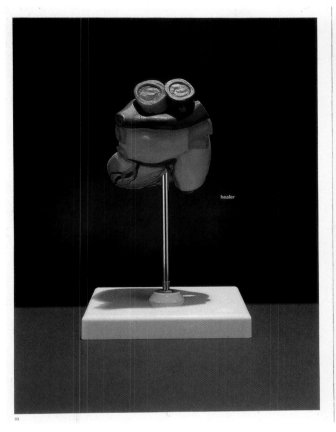

healer

02

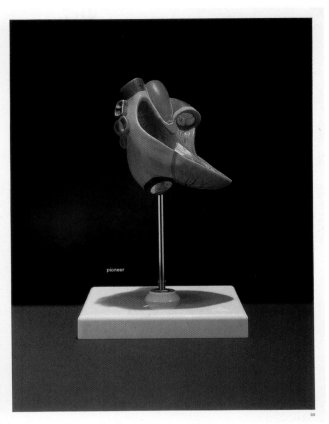

pioneer

03

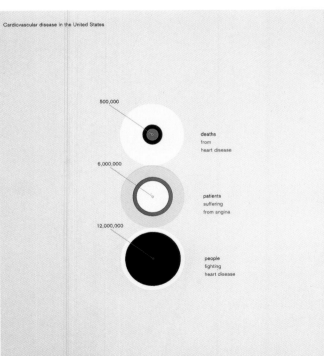

Cardiovascular disease in the United States

500,000 — deaths
from
heart disease

6,000,000 — patients
suffering
from angina

12,000,000 — people
fighting
heart disease

08

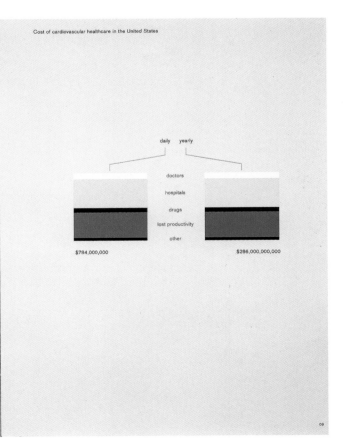

Cost of cardiovascular healthcare in the United States

daily yearly

doctors

hospitals

drugs

lost productivity

other

$784,000,000 $286,000,000,000

09

SILVER

**POSTCARD/GREETING CARD/
INVITATION**

Miharayasuhiro

Art Director Eiki Hidaka
Designer Ryosuke Uehara
Photographer Ryosuke Uehara
Client Sosu Co. Ltd.
Country Japan

SILVER

POSTERS: PROMOTIONAL

Hakone Museum of Photography

Art Director Shinya Nojima
Designer Shinya Nojima
Artist Shinya Nojima
Client Hakone Museum of Photography
Country Japan

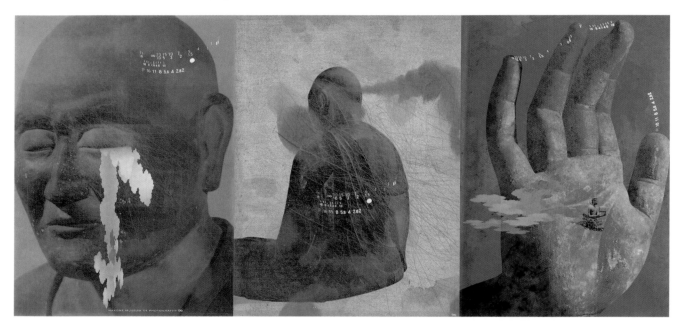

The theme chosen by my client, Hakone Museum of Photography, was "five senses," with an intent to activate contemporary people through the aural, olfactory, tactile, and gustatory senses that are perceived through the visual sense in photographic art. The reasoning behind this concept is that the Japanese have enjoyed the five senses in all seasons from the earliest times in their history, as they fostered and developed their culture and arts. However, because of the serious economic crisis, there is perhaps no space for such feelings now, and the five senses, people feel, seem to have changed a little. Thus, there is now an indifference, especially apparent in the young, to Japanese traditional culture and classical art, together with an indifference to politics.

With this in mind, I have been choosing issues and creating my work with "Japan" as my theme. Just coincidentally, this "five senses" concept of the Hakone Museum of Photography that commissioned me has much in common with my ideas, and so I went the distance to exhibit this work.

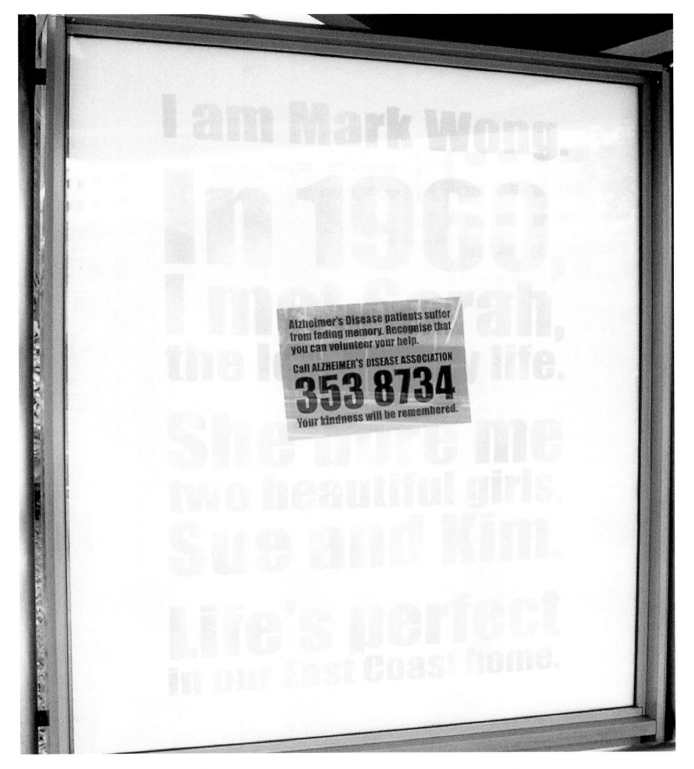

There was a lack of social awareness about Alzheimer's disease, particularly about how this incurable disease affected its victims. The brief from Alzheimer's Disease Association was to increase awareness so as to attract much-needed volunteers for its affiliated care homes. Because the primary symptom of Alzheimer's disease is memory loss over time, this was used as the main message to be communicated. The technique of using thermal paper, on which printed words (personal information about the victim's family and interests) would fade away after three weeks, was employed to demonstrate the effects of Alzheimer's disease on someone's memory. At the end of the second week, a call-to-action sticker was placed over this thermal poster.

Mark Wong

SILVER

POSTERS: PUBLIC SERVICE/ NONPROFIT/EDUCATIONAL, SERIES

Art Directors Pann Lim, Roy Poh
Designers Pann Lim, Roy Poh
Photographer Roy Poh
Agency Kinetic Design & Advertising
Client Alzheimer's Disease Association
Country Singapore

240

SILVER

**POSTERS: PUBLIC SERVICE/
NONPROFIT/EDUCATIONAL**

**Ellery Eskelin—
Han Bennink**

Art Director Niklaus Troxler
Designer Niklaus Troxler
Client Jazz in Willisau
Country Switzerland

This poster was designed for a free jazz concert featuring two individuals: saxophonist Ellery Eskelin and drummer Han Bennink. I wanted to express the spontaneity of the music. I worked very spontaneously with brush and ink while I was listening to the music of the two. The poster had to be an action-writing-playing thing. All the information is in the content and expression of the poster—just ink drops and letters: free jazz, free poster.

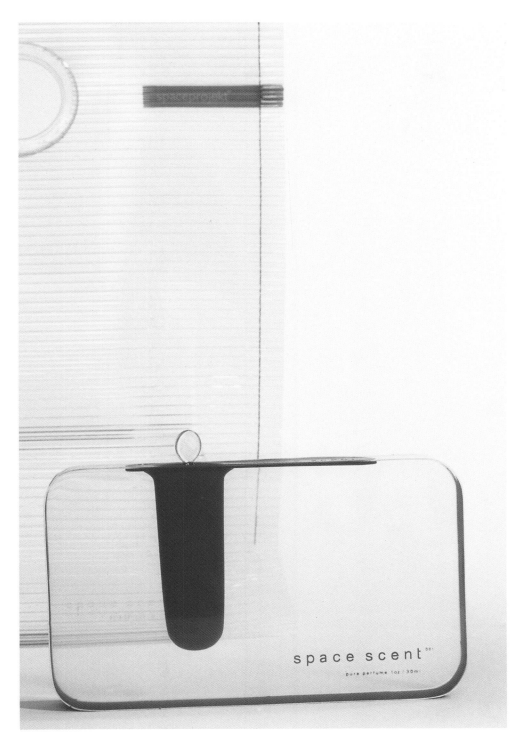

Space Scent is a limited-edition pure perfume. Space Scent is the launch product of a new personal care and cosmetics brand and is creating media attention and expectation for the entire upcoming line. The Space Scent bottle is an exercise in redefining the notion of container and space. Instead of having the pure perfume slushing around in a clear bottle, we confined it to a precious area while surrounding it by an oversized solid and clear mass. The larger, clear bottle area is solid while the perfume cavity is opaque and visually connected to the outside red-colored edge. Space Scent fluidly mingles the ancient rituals of perfume with modern graphic expression.

The Space Scent bottle enhances the experience of pure perfume by featuring a fragrance of time-honored luxury in a bottle of unnerving futurism. The bottle embodies the tradition of perfume by expressing the lush intensity of the Scent itself to the incorporation of a perfume wand for applying the pure oil-based essence, making each application an event. Space Scent was recently acquired by the permanent collection of the San Francisco Museum of Modern Art.

Space Scent Perfume

SILVER

PACKAGING: COSMETICS

Designers Yves Béhar, Johan Lidén
Photographer Marcus Hanschen
Manufacturer Corey Jones
Studio Fuseproject
Client Space Projekt/Brent Haas
Country United States

SILVER

ENVIRONMENT

Lax Gateway 2000

Art Director Robin Perkins
Designers Nick Groh, Clint Woesner
Photographers Andrew Davey, Anton Grassl
Client Los Angeles World Airports
Country United States

Visible to airline passengers at 30,000 feet, the colorful ring of 100-foot-tall pylons at the Los Angeles World Airports LAX Gateway Enhancement Project provides a landmark entry experience into the United States, Los Angeles, and LAX. This new icon for the City of Los Angeles is part of the identity and environmental communications system designed to beautify the airport and facilitate arrival and departure for LAX travelers.

At Century Boulevard, the gateway begins evoking the feeling of takeoff and landing with equally spaced columns that steadily increase in height along a 1.5-mile roadway median, culminating in a ring of 15 dramatically lit 100-foot-tall circular pylons. At the entrance to the airport, 32-foot-high "L-A-X" letterforms greet visitors. The nighttime personality of the gateway dramatically changes from its daytime appearance through the use of computerized lighting effects. The project is the world's largest permanent lighting installation.

museum mobile

SILVER

GALLERY/MUSEUM EXHIBIT/INSTALLATION

Art Directors Michael Keller, Christoph Rohrer
Designers Xuyen Dam, Marc Ziegler
Copywriters Wolf Bruns, Karin Finan, Dominik Neubauer
Photographer Stefan Müller-Naumann
Producers Christina Baur, Karin Fugmann
Project Manager Eva Sigl
Studio KMS
Architects Henn Architekten Ingenieure
Video Production Velvet Medien Design
Interactive Jangled Nerves
Clients Audi AG, Ingolstadt
Country Germany

Our task was to design and implement the master plan for a museum of the history of Audi. Our principle idea was the connection between mobility, growth, and transparency. As the symbolic basis of our design, we chose the image of the disk of a tree trunk with its annual rings: The entire museum is characterized by a mobile structure of concentric circles.

A sunshade system on wheels rotates around the building. The interior features rotating walls with chronological charts, and, on a paternoster, Audi prototypes cross the planes in a vertical direction. Through the fully glazed façade, daylight helps to render the interior spaces, while from the outside, the building appears as an animated sculpture of light.

The museum mobile is more than an exhibit of historical vehicles; it recounts the history of the automobile and its social and economic background. An elevator transports visitors to the uppermost level, back to the establishment of Audi in 1899. From there, the tour leads across two levels down to the present day. Visitors are drawn into the story by means of interactive productions as well as through headlines that are posed as questions. The museum mobile is conceived as a place of openness and mutual encounter and also of the encounter between architecture and design.

Multiple Awards

SILVER

SPECIAL EFFECTS, SERIES
Tornado • Jump • Birds

and SILVER

SPECIAL EFFECTS
Tornado

Art Director Mickey Surasky
Executive Creative Director Brent
Bouchez
Group Creative Director David Nobay
Executive Director, Broadcast
Andrew Chinich
Copywriter David Nobay
Agency Producer Mary Ellen Verrusio
Director Gerard De Thame
Music Peter Lawlor (Water Music)
Production Companies H.S.I.
Productions, Gerard De Thame Films
Agency Bozell New York
Client The New York Times
Country United States

The objective of the "Invitational"
campaign was to communicate the
uniqueness of *The New York Times*
and its key brand strengths—quality,
trust, leadership—in order to attract
like-minded non-readers. The
challenge was to deliver the message
in a powerful, thought-provoking way,
while remaining accessible and
inviting. This was accomplished by
using simple visual metaphors to
suggest the qualities of the paper.
The cutting-edge visuals and poetic
tone communicate that *The Times* is
also innovative, artistic, and moving.
By delivering on both the intellectual
and emotional levels, this campaign
highlights the uniqueness of
The Times in a compelling and
engaging way.

"Tornado," one of the three spots
which comprise the campaign, deals
with the quality of truth. The
challenge was to deliver the message
in a sophisticated, thought-provoking
way while remaining relevant to the
audience. This was accomplished by
using the tornado as a metaphor for
truth. Just as a tornado twists and
turns and ultimately reshapes the
environment into a new sense of
calm, so, too, does *The Times* create
clarity, logic, and order out of the
chaotic world of news. The
compelling visuals and poetic style
reinforce the paper as an engaging,
innovative, and powerful
journalistic force.

Tornado

	SFX: Music throughout
Aerial shot of barn roof as surrounding countryside blows in the wind.	VO (MAYA ANGELOU): The truth does not still for a moment.
A tornado approaches. High winds blow against a wheelbarrow and pick up telephone and utility poles.	It twists and turns, picks up your opinions,
The twister hits and the barn breaks up into splinters of debris that mix with typed letters.	and sets them down a thousand miles away.
The letters fall from the grip of the tornado, neatly into place as part of *The New York Times* newspaper text.	When was the last time something you read moved you?
SUPER: *The New York Times* logo.	*The New York Times.*

Jump

Swimmer walks to edge of diving board and jumps off.

He twists in air, flips, and completes a perfect dive.

The diver's impact creates underwater bubbles and type letters.

The bubbles and letters rise to the surface where they fall into place among the text of a wet *New York Times* newspaper.

SUPER:
The New York Times logo.

SFX:
Music throughout

VO (MAYA ANGELOU):
The real story will never be captured from a safe distance.

Only discovered by those who delve beneath the surface.

When was the last time something you read challenged you?

The New York Times.

Birds

Open on a mass of moving, ambiguous white shapes. Camera pans to reveal hundreds of birds flying through the air.

Birds begin to fly apart and morph into type letters.

Letters fall from the sky neatly into place as part of *The New York Times* newspaper text.

SUPER:
The New York Times logo.

SFX:
Music throughout

VO (MAYA ANGELOU):
Original thinking migrates each day in search of nourishment.

Fashion, sports, and politics are among its favorite destinations.

When was the last time something you read carried you away?

The New York Times.

DISTINCTIVE MERIT

**CONSUMER MAGAZINE:
MULTIPAGE, SERIES**
Cut Magazine, Oct. 2000 Issue

Art Director Hideki Nakajima
Designer Hideki Nakajima
Photographers Regan Cameron,
Dah Len, Lee Strickland, SWIRC
Client rockin' on inc.
Country Japan

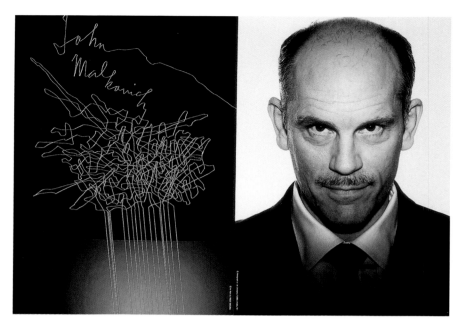

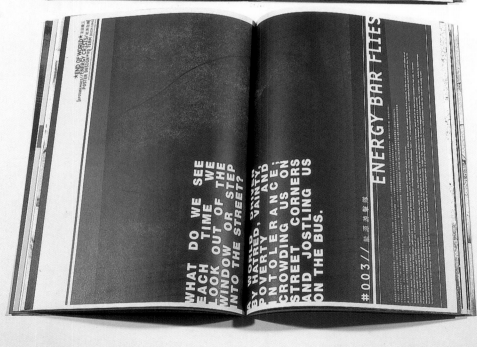

DISTINCTIVE MERIT

**CONSUMER MAGAZINE:
MULTIPAGE, SERIES**
VQ Magazine, Issue 3—Interview

Art Director Tommy Li
Designers Jenny Cheng, Eliza Ling,
Javin Mo
Client VQ Magazine
Country China

DISTINCTIVE MERIT

CONSUMER MAGAZINE: FULL ISSUE
2wice Ice Issue

Art Director J. Abbott Miller
Designers Jeremy Hoffman,
J. Abbott Miller
Client 2wice Arts Foundation
Country United States

DISTINCTIVE MERIT

SPECIAL TRADE BOOK:
IMAGE DRIVEN
Life Counts—A Global Balance
Sheet of Life

Art Director Fabian Nicolay
Designers Mini Misra, Fabian Nicolay
Copywriter Berlin Verlag
Photographer Gabriele Lorenzer
Illustrator Gundhild Eder
Authors M. Gleich, D. Maxeiner,
M. Miersch, F. Nicolay
Producer Berlin Verlag
Studio usus.kommunikation
Client Aventis S.A.
Country Germany

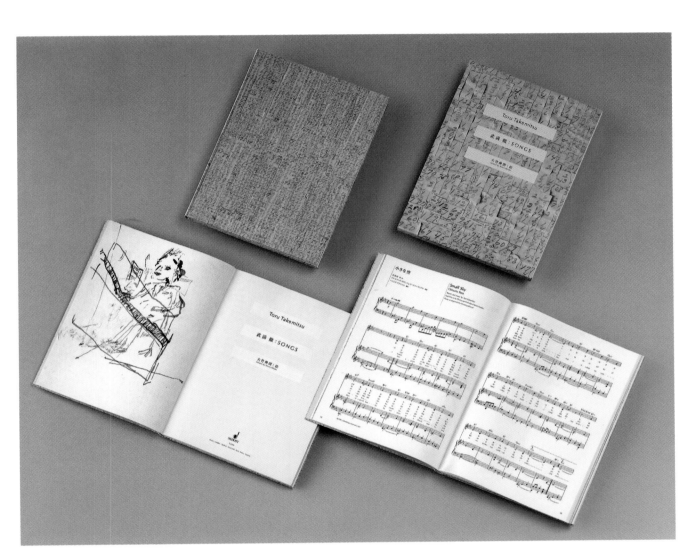

DISTINCTIVE MERIT

SPECIAL TRADE BOOK: IMAGE DRIVEN
Toru Takemitsu: SONGS

Art Director Kinoshita Katsuhiro
Designer Kinoshita Katsuhiro
Artist Ohtake Shinro
Client Schott Japan Company Ltd.
Country Japan

DISTINCTIVE MERIT

MUSEUM/GALLERY/LIBRARY BOOK
Fabric of Fashion

Art Directors Henrik Kubel,
Scott Williams
Designers Henrik Kubel,
Scott Williams
Photographer Michael Danner
Studio A2-Graphics/SW/HK
Client British Council
Country United Kingdom

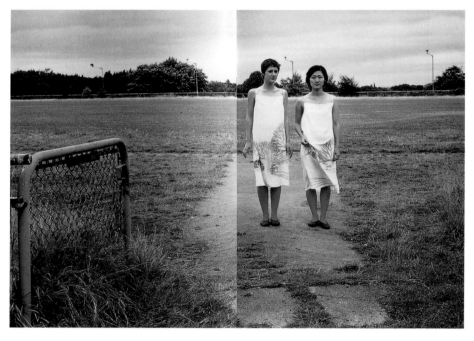

Hussein Chalayan has a conceptual approach to design. He is equally at ease employing the latest technologies, as he is using natural and synthetic fabrics. This may seem like a lot to bring to the design of garments, but the end result has a purity that makes his clothes very wearable.

Chalayan's graduate collection from Central Saint Martins was the now infamous series of buried garments. These had been buried in a friend's back garden, then exhumed just before the show. The work was given the accolade of a window display in Browns. Since then he has worked with a number of designers including textile and product designers as well as architects and artists. The working relationship in each case is different. He collaborated with textile designer Sophie Roet to develop a very fine woven fabric to be used as an overdress with the underdress glowing underneath. The fabric was a double-weave cloth, using polyamide monofilament and cotton yarns. It was finished with a chemical etching process that was a variation on the devoré technique eating away at the cellulose areas. Chalayan has also worked with Eley Kishimoto who designed a pixelated print fabric specially for his Spring/Summer 1996 collection. The design echoed the pixels found on computer images, though in fact the fabric itself was only partially designed on the computer. Flowers were hand-drawn then scanned into a computer to enhance the colour and accentuate the pixellated effect. The very bright colours used in the prints reflect the intensity of the computer's light-based colour.

Not all of Chalayan's collaborations have been with textile designers. He has also worked with a product designer and architects. A series of airplane dresses have been made specially for his catwalk shows, which are maintained for exhibition purposes only. The dresses are made using composite technology more usually

associated with the aircraft industry, hence the title of the series. Product designer Paul Topen combines glass fibre and resin, placing them in moulds using a hand lay-up technique. As the name suggests, this involves placing the glass fibres in a mould by hand then pouring resin over it. Once hardened, or cured, the glass fibre and resin material is removed from the mould. The model wears an underdress as protection against the fibre and the dress is clipped onto the body using metal clips. A variant of this uses a remote control device to open and close some of the panels on the dress to reveal a frilly pink tutu.

Chalayan's early interest was in architecture which he considered as a career until discouraged by a friend who advised that he would spend his life designing tower blocks and offices. The spatial awareness of an architect's eye is always evident in the relationship between his garments and the body. Forms work with and against the body, creating positive and negative spaces. His series of architecture dresses from his Spring/Summer 2000 collection are the continuing influence of architecture on his work. Designed with architectural engineers & consultants, the dresses are printed with wireframe architectural drawings. The images have been computer generated using Microstation software. The programme allows the viewer to move through the architectural landscape and select viewpoints which are then freeze-framed. The frozen images are then transferred onto a fabric printing process and printed on silk and cotton fabrics.

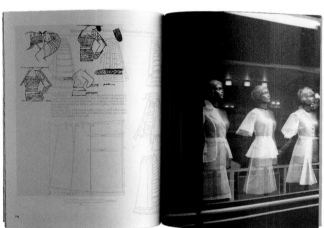

DISTINCTIVE MERIT

MUSEUM/GALLERY/LIBRARY BOOK

Christina Ramberg Drawings

Designer Marcia Lausen
Photographer Christina Ramberg
Illustrator Christina Ramberg
Editor Judith Russi Kirshner
Authors Molly McQuade, Barbara Rossi, Judith Russi Kirshner
Client University of Illinois at Chicago, College of Architecture and the Arts
Country United States

CHAKAIA BOOKER

Chakaia Booker uses old rubber tires to give form to social commentaries that address issues from black identity to urban ecology. In *Homage to Thy Mother (Landscape)*, hundreds of tires have been rendered—and apparently wrestled—into a massive, high-relief wall sculpture. As in other, more figurative works, such as the 1995 *Repugnant Rapunzel (Let Down Your Hair)*, Booker's touch is transforming, as tires are retooled into a sensual being with entirely new allusions. The ropes and knots of sliced rubber create an abstract relief, but the surface can be read as a chunk of upturned terrain—perhaps a piece of post-industrial reef or junkyard pasture land.

The use of tires in art can be traced back to such earlier twentieth-century icons as Marcel Duchamp's readymade *Bicycle Wheel* (1913). Booker, however, extracts an intense concentration of meanings from the tires. Their black color signifies African skin, while their patterned treads resemble tribal decorations and the welts of ritual scarification. The tires' resilience and versatility represent, to Booker, the "survival of Africans in the diaspora." In this context, her work intercepts that of David Hammons, an artist well known for elevating humble trash to potent images of African-American life. Finally, because discarded tires are tires that have been worn down by travel over countless roads, they also symbolize the journey of life. In reclaiming these tires for her art, Booker engages in a resourceful act of recycling, transforming one of today's most indestructible waste products into things of furious beauty.

TOP: *Homage to Thy Mother (Landscape)*, 1996. Rubber tires and wood, 96 x 192 x 24 in. (243.8 x 487.7 x 61 cm). Collection of Jon and Melissa Butcher. BOTTOM: *Homage to Thy Mother (Landscape)* (detail).

JOSEPH MARIONI

Joseph Marioni makes paintings of colors in which surfaces convey an imagery of paint, not brushstrokes or gestures, and colors have no symbolic value. Despite these apparently Minimalist means, however, the works are lush, resonant, and, in the most traditional sense, painterly. Who needs metaphor, they imply, when just the medium of paint alone can create more than words can describe? This challenge has sustained Marioni's work for over thirty years, during which time the essentials of his art have changed little.

Marioni paints with a roller, applying layers of paint in broad, flat swags that drip downward. He cultivates signs of paint's viscosity by tapering his vertical canvases almost imperceptibly toward the bottom, in effect exaggerating the tendency of paint to flow inward, away from the sides, as gravity pulls it down. The canvas's lower stretcher bar is rounded, causing the paint to collect and hang in pendulous drops that reveal a surprising range of colors, all veiled behind the seemingly monochrome facade. To underscore his art's structural nature, Marioni precisely describes the medium of each painting as "acrylic and linen on stretcher." In contrast, his titles offer only the most general indications of what is in store for the patient viewer: *Blue Painting, Red Painting, White Painting*—the words simply fail to capture the extraordinary nuances of these deeply colored surfaces, which change constantly with the light that pools, reflects, and shifts with the viewer's gaze.

Blue Painting, 1997. Acrylic on linen, 24 x 22 in. (61 x 55.9 cm). Collection of Charlotte Jackson.

DISTINCTIVE MERIT

ANNUAL REPORT
Gartner Group 2000 Annual Report

Art Director Bill Cahan
Designer Kevin Roberson
Copywriter Tony Leighton
Illustrator Steve Hussey
Photographers Steven Ahlgren,
Catherine Ledner, Lars Tunbjork
Studio Cahan and Associates
Client Gartner Group
Country United States

DISTINCTIVE MERIT

ANNUAL REPORT
Comic Relief Annual Review '99

Art Directors Andrew Gorman,
Rob Riche
Designer Rob Riche
Copywriter Keme Nzerem
Photography Various
Illustrator Paul Dixon
Client Comic Relief
Country United Kingdom

Multiple Awards
(see also Student)

DISTINCTIVE MERIT

BOOKLET/BROCHURE

Grad Book

Art Directors Chris Dooley, Sean Dougherty, Gary Williams
Designer Gary Williams
Photographer Stephen Franco
Illustrator Saiman Chow
Country United States

DISTINCTIVE MERIT

BOOKLET/BROCHURE
Zen

Art Director Katsuhiko Shibuya
Designer Katsuhiko Shibuya
Copywriter Cat
Photographer Mario Sorrenti
Producer Shunsaku Sugiura
Studio Shiseido Advertising
Creation Department
Client Shiseido Co.
Country Japan

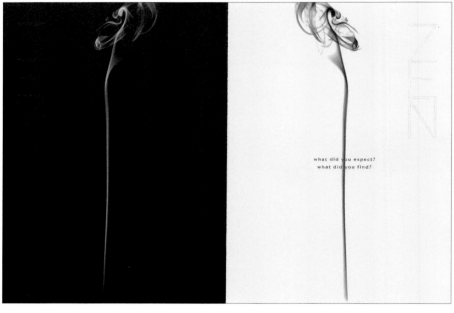

DISTINCTIVE MERIT

STATIONERY
Make it Happen Stationery System

Art Director Steve Barretto
Senior Designer Vanessa Dina-Barlow
Junior Designer Leo Calderon
Client Jeanne Stewart
Country United States

DISTINCTIVE MERIT

STATIONERY
Made from Recycled Paper

Art Director Masayoshi Kodaira
Designer Masayoshi Kodaira
Client Masayoshi Kodaira
Country Japan

DISTINCTIVE MERIT

STATIONERY
Thirst Business Cards

Art Director Ewa Sarnacka
Designers Dakota Brown,
Rich Hanson, Ewa Sarnacka,
Barbara Valicenti, Rick Valicenti,
Rob Wittig
Illustrators Dakota Brown,
Rich Hanson, Ewa Sarnacka,
Barbara Valicenti, Rick Valicenti,
Rob Wittig
Producer Ewa Sarnacka
Studio Thirst
Client Thirst
Country United States

262

DISTINCTIVE MERIT

STATIONERY
Green Smile

Art Director Norito Shinmura
Designer Norito Shinmura
Photographer Kogo Inoue
Client Shinmura Design Office
Country Japan

DISTINCTIVE MERIT

COMPLETE PRESS/PROMOTIONAL KIT
American Center for Design Living
Surfaces Conference—
The Landscape of Experience

Art Director Rick Lowe
Designer Neil Sadler
Photographer Melissa Guzman
Producer Elizabeth Glenewinkel
Country United States

DISTINCTIVE MERIT

POSTERS: PROMOTIONAL
Hihoukan

Art Director Tadanori Yokoo
Designer Tadanori Yokoo
Copywriter Tadanori Yokoo
Illustrator Tadanori Yokoo
Client Lapnet Inc.
Country Japan

264

DISTINCTIVE MERIT

POSTERS: PROMOTIONAL
A View from the Bridge

Art Director Rick Valicenti
Designers Chester, Rick Valicenti
Photographers Wm & Rick Valicenti
Producer Barbara Valicenti
Studio Thirst
Client Lyric Opera of Chicago
Country United States

The 20th TAMARIS GLOBAL SALON
TAMARIS BIG PRESENTATION
REMOVE «MASA ABE

2000年11月20日（月）　PM2:45－PM3:15
シェラトン・グランデ・トーキョーベイ・ホテル
出演 MASA ABE（HAIR ARTIST）小林照雄（盆栽作家）清水三男（氷彫作家）

DISTINCTIVE MERIT

POSTERS: PROMOTIONAL, SERIES
Remove/Masa Abe

Art Director Daisaku Nojiri
Designer Daisaku Nojiri
Photographer Mikiya Takimoto
Producer Yuko Birukawa
Agency Les Mains Plus Inc.
Client Tamaris Inc.
Country Japan

DISTINCTIVE MERIT

POSTERS: PROMOTIONAL
M

Art Director Tadanori Yokoo
Designer Tadanori Yokoo
Photographers Eikoh Hosoe,
Yoshihiro Kawaguchi
Client The Tokyo Ballet
Country Japan

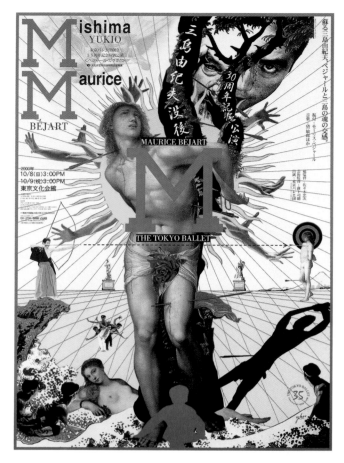

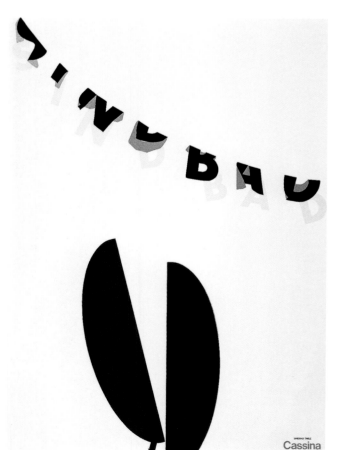

DISTINCTIVE MERIT

POSTERS: PROMOTIONAL
Cassina—Sindbad Table

Art Director Akihiko Tsukamoto
Designer Akihiko Tsukamoto
Photographer Takao Nakamura
Studio Zuan Club
Client Cassina—Inter Decor
Japan Inc.
Country Japan

DISTINCTIVE MERIT

POSTERS: PROMOTIONAL, SERIES
Kao Creation Infinity

Art Director Noriaki Hayashi
Designer Noriaki Hayashi
Illustrator Noriaki Hayashi
Client Kao Creation
Country Japan

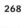

DISTINCTIVE MERIT

POSTERS: PROMOTIONAL, SERIES
The Choice Award 2000

Art Director Masaaki Izumiya
Designer Masaaki Izumiya
Illustrator Kazuhiro Aruga
Copywriter Jun Maki
Client Recruit Co., Ltd.
Country Japan

Art Director Keisuke Nagatomo
Designer Mizuki Sakatomo
Illustrator Seitaro Kuroda
Client Mano Kenkyusho Co., Ltd.
Country Japan

DISTINCTIVE MERIT

**POSTERS: PUBLIC SERVICE/
NONPROFIT/EDUCATIONAL**

Art Nyon reçoit Niklaus
Troxler à Arzier

Art Director Niklaus Troxler
Designer Niklaus Troxler
Illustrator Niklaus Troxler
Studio Niklaus Troxler Design
Client Art Nyon, Switzerland
Country Switzerland

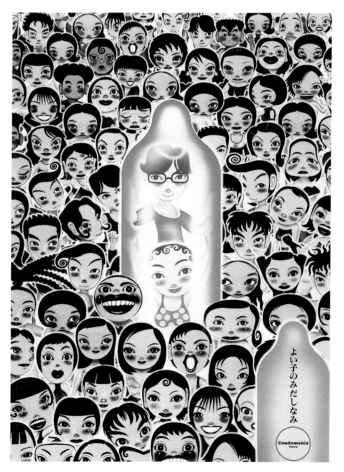

DISTINCTIVE MERIT

**POSTERS: PUBLIC SERVICE/
NONPROFIT/EDUCATIONAL**

Condomania Tokyo—
Friendly Etiquette

Art Director Akihiko Tsukamoto
Designer Akihiko Tsukamoto
Copywriters Masayuki Minoda,
Masami Ouchi
Illustrator Radical Suzuki
Studio Zuan Club
Client Sea Road International
Corporation
Country Japan

DISTINCTIVE MERIT

**POSTERS: PUBLIC SERVICE/
NONPROFIT/EDUCATIONAL**
Go with Snoopy

Art Director Makoto Saito
Designer Makoto Saito
Client Suntory Museum
Studio Makoto Saito Design
Office Inc.
Country Japan

DISTINCTIVE MERIT

**POSTERS: PUBLIC SERVICE/
NONPROFIT/EDUCATIONAL**
Richard Wright

Designer John Kieselhorst
Studio A-100
Client California Institute of the Arts
Visiting Artist Lecture Series
Country United States

DISTINCTIVE MERIT

**POSTERS: PUBLIC SERVICE/
NONPROFIT/EDUCATIONAL, SERIES**
The Ar-Rasheed Mosque

Art Director Hiromi Inayoshi
Designers Masahiro Iwashige,
Shinsuke Watanabe
Copywriter Todd A. Thomas
Illustrator Hiromi Inayoshi
Producers Nasrine R. Karim,
Hiroko Kawahara
Studios Studio Super Compass Inc.,
Super Graphic Co., Ltd.
Agencies Super Graphic Co., Ltd.,
Kawahara Tent Co., Ltd.
Client Humayan Rasheed
Choudhury MP
Country Japan

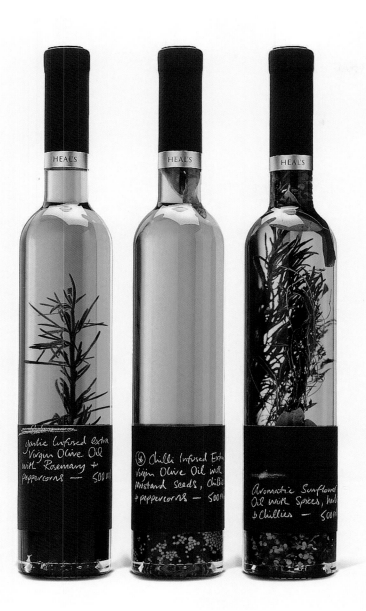

DISTINCTIVE MERIT

**PACKAGING: GIFT/SPECIALTY
PRODUCT, SERIES**
Heals Oils/Gift Products

Art Director Garrick Hamm
Designer Fiona Curran
Copywriter Kellie Chapple
Photographer Fiona Curran
Illustrator Fiona Curran
Agency Williams Murray Hamm
Client Heals and Sons
Country United Kingdom

Principal Ralph Appelbaum

Project & Design Director Melanie Ide

Project Manager Marianne E. Schuit

Senior Content Coordinator Mary
Beth Byrne, Eliot Hoyt

Senior Exhibition Designer Joshua
Dudley

Senior Graphic Designer Shari Berman

Media Coordinator Allegra Burnette

Exhibit Designers Paul de Koninck,
Dominique Ng, Nathalie Rozot,
David Wolf, Merton Wu, Jon Zast

Graphic Designers Lisa David,
Robert Homack, Ellen Weiner

Content Coordinator Mia Hatgis

Administrative Assistant Hanna
Varady

Script Editing Miranda K. Smith

Copy Editor Sylvia Juran

Client American Museum of
Natural History

Country United States

DISTINCTIVE MERIT

**FILM TRAILER/TEASER (UP TO 4
MINUTES LONG)**
102 Dalmations

Art Director Karin Fong
Designer Peggy Oei
Producer Anita Olan
Client Buena Vista Pictures
Marketing
Country United States

Für Ihren Teint
For your complexion

Hamburg Airport
EINFACH FLIEGEN
SIMPLY FLY

Für Ihren Kurzurlaub
For your shorttrip

Hamburg Airport
EINFACH FLIEGEN
SIMPLY FLY

MERIT

**CONSUMER NEWSPAPER:
FULL PAGE, SERIES**

Airport

Art Director Christoph Everke

Creative Directors Alexander Schill,
Axel Thomsen

Copywriter Daniel Schmidtmann

Illustrator Jürgen und Ich

Art Buyer Katja Kühl

Agency Springer & Jacoby Werbung
GmbH & Co. KG

Client Flughafen Hamburg GmbH

Country Germany

MERIT

**CONSUMER NEWSPAPER:
MULTIPAGE**

QIORA' NY Times

Art Director Keiko Hirano

Creative Director Aoshi Kudo

Designer Keiko Hirano

Copywriter Lang Phipps

Photographer Yasuo Saji

Studio Hirano Studio

Client Shiseido Co., Ltd.

Country Japan

MERIT

**CONSUMER MAGAZINE:
MULTIPAGE, SERIES**

VQ Magazine, Issue 3—
Incurable Disease

Art Director Tommy Li
Designer Jenny Cheng
Client VQ Magazine
Country China

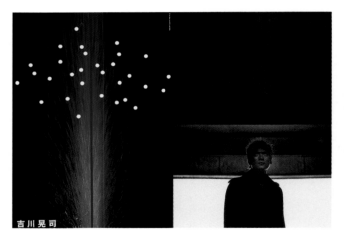

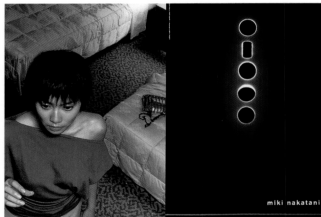

MERIT

**CONSUMER MAGAZINE:
MULTIPAGE, SERIES**

Cut Magazine, November 2000

Art Director Hideki Nakajima
Designer Hideki Nakajima
Photographers Katsuo Hanzawa,
Hiroshi Hatate, Mikiya Takimoto
Client rockin' on inc.
Country Japan

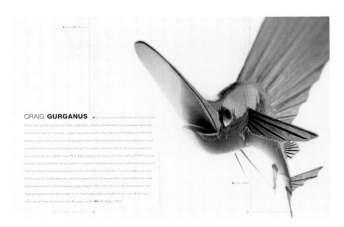

CRAIG **GURGANUS**

MERIT

**CONSUMER MAGAZINE:
MULTIPAGE, SERIES**

Artist Showcase—Craig Gurganus

Art Director Jaimey Easler
Photographer Mark Wagoner
Client United Airlines
Country United States

MERIT

**CONSUMER MAGAZINE:
MULTIPAGE, SERIES**

Cut Magazine, December 2000

Art Director Hideki Nakajima
Designer Hideki Nakajima
Photographers David Daigle,
Akira Matsuo, Vincent Peters
Client rockin' on inc.
Country Japan

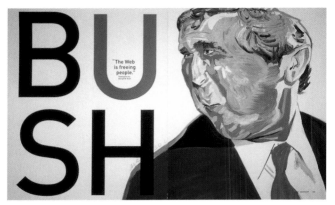

Multiple Awards
(see also Illustration)

MERIT

CONSUMER MAGAZINE:
MULTIPAGE, SERIES
Oct 2000/Vote Section

Design Director Patrick Mitchell
Designer Julia Moburg
Photographer Timothy Greenfield- Sanders
Illustrator Philip Burke
Country United States

MERIT

CONSUMER MAGAZINE:
MULTIPAGE, SERIES
April 2000/CUST/All Openers

Design Director Patrick Mitchell
Designer Emily Crawford
Photo Coordinator Alicia Jylkka
Photographers Robbie McClaren,
Frank Ockenfels 3, Daniela Stallinger,
Dan Winters
Country United States

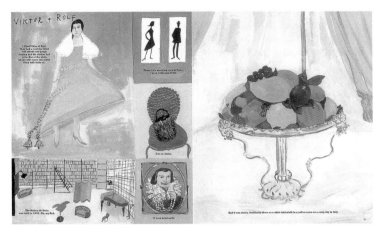

Multiple Awards
(see also Illustration)

MERIT

**CONSUMER MAGAZINE:
MULTIPAGE, SERIES**
Couture Voyeur

Art Director Janet Froelich
Designer Claude Martel
Illustrator Maira Kalman

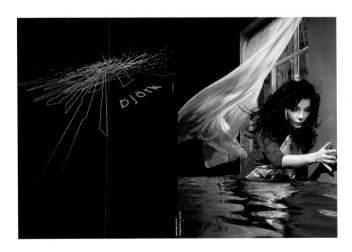

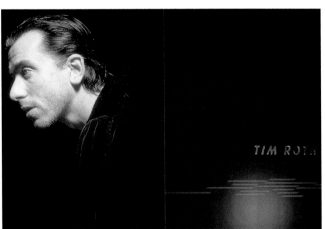

MERIT

**CONSUMER MAGAZINE:
MULTIPAGE, SERIES**
Cut Magazine, September 2000

Art Director Hideki Nakajima
Designer Hideki Nakajima
Photographers Matt Atlas, Sarah Dunn,
Alistair Morrison, Marcus Piggot
Client rockin' on inc.
Country Japan

MERIT

CONSUMER MAGAZINE: FULL ISSUE
2wice, Spring Issue

Art Director J. Abbott Miller
Designers Roy Brooks,
Elizabeth Glickfeld, J. Abbott Miller
Client 2wice Arts Foundation
Country United States

Multiple Awards
(see also Photography)

MERIT

CONSUMER MAGAZINE: FULL ISSUE
Colors 41

Art Director Fernando Gutiérrez
Designer Anna Maria Stillone
Copywriters Michael Holden,
Jonathan Steinberg
Producers Samantha Bartoletti,
Carlos Mustienes
Photographers Adam Broomberg,
Oliver Chanarin, James Mollison,
Stefan Ruiz
Client Colors Magazine
Country Italy

MERIT

**CONSUMER MAGAZINE:
FULL ISSUE, SERIES**

+81 Magazine

Art Directors Toru Hachiga, Hideki Inaba
Producer Satoru Yamashita
Country Japan

MERIT

CONSUMER MAGAZINE: COVER
Sheet Cover

Art Director Richard Hart
Designer Richard Hart
Copywriter Richard Hart
Illustrator Richard Hart
Studio Disturbance Design
Client Sheet
Country South Africa

MERIT

**TRADE MAGAZINE:
MULTIPAGE, SERIES**
PDN Photo Design Awards

Art Director Bridget De Socio
Designers Christine Heslin,
Agnieszka Stachowicz
Photographers Christopher Baker,
Fredrik Brodén, Hugh Kretschmer,
Carter Smith, Rodney Smith,
Martyn Thompson
Studio Socio X
Client Photo District News
Country United States

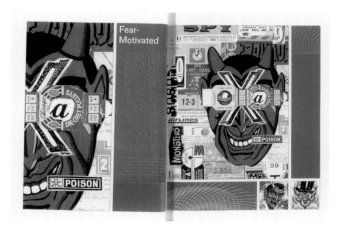

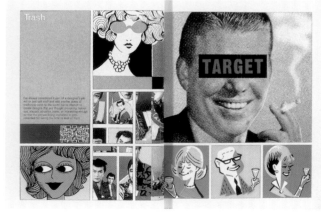

MERIT

TRADE MAGAZINE: FULL ISSUE
Idea Magazine

Art Directors Charles S. Anderson, Todd Piper-Hauswirth
Designers Charles S. Anderson, Zack Custer,
Todd Piper-Hauswirth
Copywriter Charles S. Anderson
Illustrators Charles S. Anderson, Kyle Hames,
Todd Piper-Hauswirth, Mr. French Printstock
Client Idea Magazine
Studio Charles S. Anderson Design
Country United States

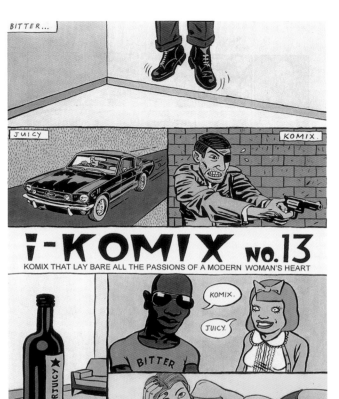

TRADE MAGAZINE: FULL ISSUE
I-Jusi No. 13—Bitter Jusi/Komix

Art Direction I-Jusi Creative Team
Design I-Jusi Creative Team
Studio Orange Juice Design
Country South Africa

TRADE MAGAZINE: FULL ISSUE
I-Jusi No. 11—National Typografika

Art Direction I-Jusi Creative Team
Design I-Jusi Creative Team
Studio Orange Juice Design
Country South Africa

MERIT

TRADE MAGAZINE: FULL ISSUE
Target Equipt Catalog

Art Directors Richard Boynton,
Brad Hartmann, Scott Thares
Designers Richard Boynton,
Scott Thares
Photographers John Barber,
Karl Herber, Earl Kendall,
Klaus Thymann
Writer Scott Jorgenson
Studio Wink
Client Target
Country United States

286

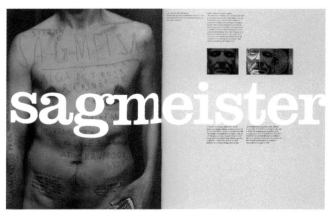

MERIT

TRADE MAGAZINE: FULL ISSUE
Typographic Circle—Circular 9

Art Director Domenic Lippa
Designer Domenic Lippa
Photographer John Ross
Client Typographic Circle
Country United Kingdom

MERIT

BOOK JACKET

and MERIT

**SPECIAL TRADE BOOK:
IMAGE DRIVEN**
Rethink

Art Director Michael Johnson
Designers Harriet Devoy,
Michael Johnson
Studio Johnson Banks
Client Conran Octopus
Country United Kingdom

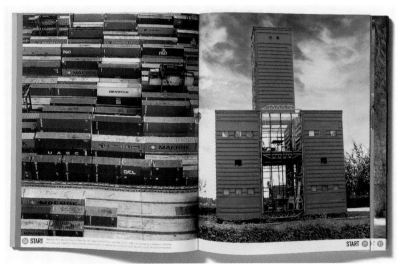

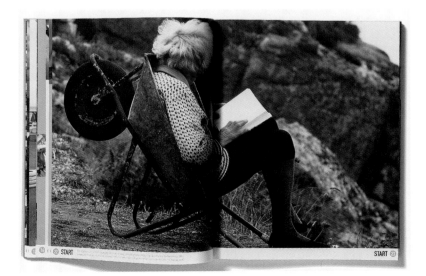

Multiple Awards

MERIT

BOOK JACKET

and MERIT

**LIMITED EDITION/PRIVATE PRESS/
SPECIAL FORMAT BOOK**
Tuna Book

Art Director Greg Quinton
Designers Dana Robertson,
Tony De Ste. Croix
Photographer Marcus Lyon
Producers Christina Boyes,
Katherine Crawford
Printer Gavin Martin
Binder Hipwell Bookbinders
Client Marcus Lyon
Country United Kingdom

MERIT

BOOK JACKET, SERIES
Projects File 2000

Art Director Masayoshi Kodaira
Designer Masayoshi Kodaira
Illustrator Mizue Uematsu
Client Tokai University
Country Japan

MERIT

**SPECIAL TRADE BOOK:
IMAGE DRIVEN**
Water Planet 01

Art Director Hiroyuki Yamamoto
Designers Tomoki Furukawa,
Jun Ogita
Photographers Shinji Ashizawa,
Mieko Mizushima
Writers Kenji Fujimoto, Yuka Kinba,
Yuko Sato
Studio Picto Inc.
Client Gram Inc.
Country Japan

MERIT

**SPECIAL TRADE BOOK:
IMAGE DRIVEN**
Water Planet 02

Art Director Hiroyuki Yamamoto
Designers Takeru Ogawa,
Hideichiro Ohsumi
Photographer Nob Fukuda,
Yasushi Nakamura
Illustrator Hideko Kuno
Writers Mitsuhiko Terashita,
Kimiko Yamada
Studio Picto Inc.
Client Gram Inc.
Country Japan

FACES BY FRANÇOIS AND JEAN ROBERT

MERIT

**SPECIAL TRADE BOOK:
IMAGE DRIVEN**

Faces

Art Director Jane Gittings
Designers Jane Gittings, Francois Robert
Copywriter Dana Arnett
Photographers Francois Robert, Jean Robert
Studio Francois Robert Studio
Agency Gittings Design—Tucson
Client Chronicle Books
Country United States

MERIT

**SPECIAL TRADE BOOK:
IMAGE DRIVEN**
Vaticano Magazine

Art Director Tomas Lorente
Photography Various
Producer Elaine Carvalho
Client Editora Gráficos Burti
Agency age
Country Brazil

MERIT

**SPECIAL TRADE BOOK:
IMAGE DRIVEN**
Unbuilt

Art Director Kan Akita
Designers Kan Akita, Emiko
Nagashima, Shigeru Orihara
Author Arata Isozaki
Client TOTO Shuppan
Country Japan

On the large panel ruined structures of a future city were montaged on the scorched earth of Hiroshima. This scene provided the background on which were projected some of the countless radiant and optimistic images of future cities painted by Japanese architects in the early 1960s.

A proposal advanced in order to be realized is always under the threat of an extinction much like Hiroshim's. Only when we realize that construction and destruction, planning and extinction are synonymous can meaningful spaces that are in touch with reality come into being.

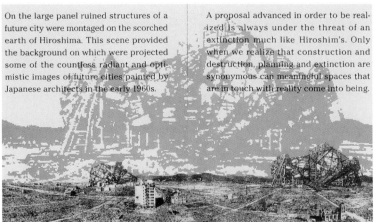

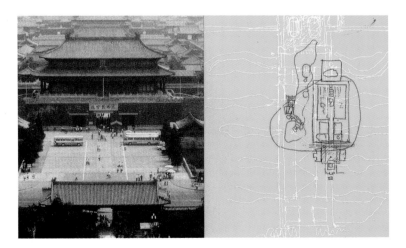

Specific others contained in a cube called "urban space" with a tentative outline.

MERIT

SPECIAL TRADE BOOK:
IMAGE DRIVEN
Subtraction

Art Directors Alexander Gelman,
Kaoru Sato
Designers Alexander Gelman,
Kaoru Sato
Writers Mel Byars, Alexander Gelman,
Baruch Gorkin
Editors Baruch Gorkin,
Kate Nöel Paton, Kaoru Sato
Research Coordinator Yanitza
Tavarez
Client Rotovision
Studio Design Machine
Country United States

MERIT

SPECIAL TRADE BOOK:
IMAGE DRIVEN
The Egg Book

Art Director Jesper Holst
Designer Torbjorn Krantz
Photographer Mikael Strinnhed
Copywriters Goran Akestam,
Mia Akestam
Client Svenska Lantagg
Agency Akestam Holst
Country Sweden

MERIT

**SPECIAL TRADE BOOK:
IMAGE DRIVEN**
Life Style

Designer Bruce Mau Design
Country United States

MERIT

MUSEUM/GALLERY/LIBRARY BOOK
Glee

Art Directors Cornelia Blatter,
Marcel Hermans
Designers Cornelia Blatter,
Marcel Hermans
Photography Various
Clients The Aldrich Museum Of
Contemporary Art, Palm Beach
Institute of Contemporary Art
Country United States

MERIT

MUSEUM/GALLERY/LIBRARY BOOK
Logg Buch Bazon Brock

Art Director Gertrud Nolte
Designer Gertrud Nolte
Copywriter Bazon Brock
Producer Dumont Buchverlag
Cologne
Agency Botschaft Gertrud Nolte
Visuelle Kommunikation und
Gestaltung
Clients Bazon Brock and Dumont
Buchverlag Cologne
Country Germany

With the risks that we carry,
our business is growing.

We know a lot.
We can do a lot.

MERIT

ANNUAL REPORT
Munich Re Annual Report

Art Directors Christoph Steinegger, Dirk Thieme
Creative Directors Christoph Steinegger, Hanno Tietgens
Designers Christoph Steinegger, Dirk Thieme
Copywriters Hanno Tietgens, Harald Willenbrock
Photographers Henning Bock, Florian Geiss, Jo Magrean
Illustrator Merten Kaatz
Producer Jörg von Malottky
Studio Büro X
Agency Büro X
Client Munich Re
Country Germany

MERIT

ANNUAL REPORT
Fogdog 1999

Art Director Bill Cahan
Designer Todd Simmons
Copywriter John Frazier
Photographer Todd Hido
Studio Cahan and Associates
Client Fogdog Sports
Country United States

MERIT

ANNUAL REPORT

Adaptec 2000 Annual Report

Creative Director Steve Turner
Designer Todd Simmons
Copywriter Eric La Breque
Photographer Todd Hido
Director Phil Hamlett
Producer H. MacDonald
Studio Turner & Associates
Client Adaptec
Country United States

MERIT

BOOKLET/BROCHURE

ikono Books

Art Director John Bateson
Designer Paul Ingle
Photographer Dean Hollowood
Agency Roundel
Client Zanders Fine Paper
Country United Kingdom

BOOKLET/BROCHURE
Takashimaya Volume 8

Art Director Allison Williams
Designers Yael Eisele,
Allison Williams
Copywriter Laura Silverman
Photographer Gentl & Hyers
Producer Lithographix
Studio Design M/W
Client Takashimaya New York
Country United States

MERIT

BOOKLET/BROCHURE
70s Brazilian Art Exhibition Catalogue

MERIT

BOOKLET/BROCHURE
70s Brazilian Art Exhibition Catalogue

Art Director Ney Valle
Designers Claudia Gamboa,
Andre Vela
Photographer Artists' Archives
Producers Fernanda Paes,
Paulo Paixao
Client Casa Franca—
Brasil Foundation
Country Brazil

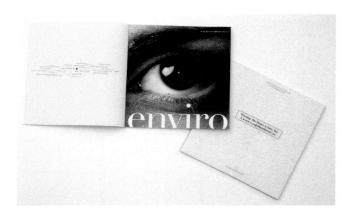

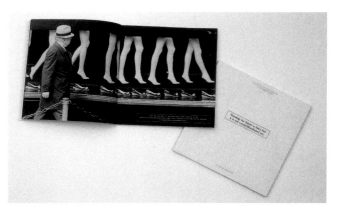

MERIT

BOOKLET/BROCHURE
Global Design Alliance

Art Director Lana Rigsby
Designers Thomas Hull,
Pamela Zuccker
Copywriter Lana Rigsby
Illustrators Thomas Hull,
Pamela Zuccker
Client Global Design Alliance
Country United States

MERIT

BOOKLET/BROCHURE

Brook Mews Property Brochure

Designer Paul Stanton
Copywriter Simon Matanle
Producer Artomatic
Studio Bubble
Agency Bubble
Client Berkeley Homes
Country United Kingdom

MERIT

BOOKLET/BROCHURE

Uncommon Threads—
Plain Clothes—
Made to Measure Piece

Art Director Marion English
Designers Marion English,
Jeanne Renneker
Copywriters Laura Holmes,
Kathy Oldman
Illustrator David Webb
Photographer Don Harbor
Studio Slaughter Hanson
Agency Slaughter Hanson
Client Plain Clothes
Country United States

MERIT

BOOKLET/BROCHURE
Mop Catalog 2000

Art Directors Marcos Chavez,
Mark Naden
Designer Aimee Sealfon
Copywriters Edward Ebel,
Laurence Hegarty, Rachelle Geller,
Mary Beth Jansen
Photographers David Raccuglia,
Tim Tucker
Studio TODA
Client Modern Organic Products
Country United States

MERIT

BOOKLET/BROCHURE
VMA Bob Book

Art Director Stacy Drummond
Creative Directors Stacy Drummond,
Jeffrey Keyton
Designer Stacy Drummond
Photographer Michael Greenberg
Writer Claudia Svoboda
Country United States

MERIT

BOOKLET/BROCHURE
BMW Clean Energy Catalogue

Art Director Heinrich Paravicini
Designers Jessica Hoppe,
Carsten Raffel, Till Raubacher
Copywriters Various
Illustrator Carsten Raffel
Photographers Enno Kapitza,
Dörte Krützfeld, Julia Wrede
Producer Peter Groschupf & Partner
Studio Mutabor Design
Agency Mutabor Design
Client BMW AG, Munich
Country Germany

301

MERIT

BOOKLET/BROCHURE
The Colors of Modernism

Designer Emanuela Frattini
Magnusson
Copywriter Phil Patton
Client Spinneybeck
Country United States

MERIT

BOOK/BOOKLETS
Good Stuff

Art Director Stephen Frykholm
Designer Brian Edlefson
Copywriters Dick Holm,
Clark Malcolm
Photographers Bill Hebert,
Jim Warych, Various
Producer Marlene Capotosto
Client Herman Miller Inc.
Country United States

302

Things to do by age 18.

Don't let decision making slow you down.

Envision change. Work in a variety of media.

18.
Young enough to try anything,
old enough to know better.

MERIT

BOOKLET/BROCHURE
Things to Do by Age 18

Art Director Hans Seeger
Creative Director Curt Schreiber
Designer Hans Seeger
Copywriters Dana Arnett, Tom Raith
Photographers Jamie Robinson, Kipling Swehla
Studio VSA Partners, Inc.
Client VSA Partners, Inc.
Country United States

MERIT

BOOKLET/BROCHURE
Arsenic Theater Program—
Season 2000/2001

Art Director Giorgio Pesce
Designer Giorgio Pesce
Photographer Giorgio Pesce
Illustrator Giorgio Pesce
Producer Imprimerie Campiche
Printer Imprimerie Campiche
Client Theatre Arsenic
Agency Atelier Poisson
Country Switzerland

MERIT

BOOKLET/BROCHURE
Mohawk Satin 2.0 Promo

Art Director Sharon Werner
Designers Sarah Nelson,
Sharon Werner
Copywriter Joe Weismann
Photographer Darrell Eager
Studio Werner Design Werks, Inc.
Client Mohawk Paper Mills
Country United States

MERIT

BOOKLET/BROCHURE
Soundblast 2000 Catalog

Art Director Stefan G. Bucher
Copywriter Stefan G. Bucher
Photographer Jason Ware
Illustrator Stefan G. Bucher
Agency 344 Design, LLC
Client AIGA Los Angeles
Country United States

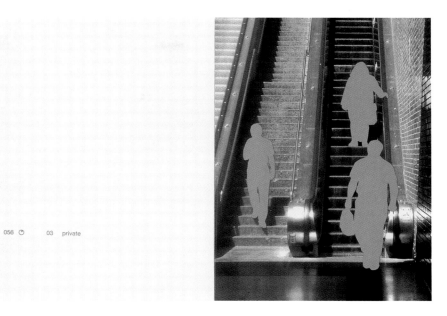

056 ○ 03 private

MERIT

BOOKLET/BROCHURE
Consolidated Paper Promo

Art Director Bill Cahan
Designers Bob Dinetz, Mark Giglio, Kevin Roberson
Copywriters Bob Dinetz, Mark Giglio, Kevin Roberson
Photographers Glen Allison, Peter Brown, Paul Chesley,
Bob Dinetz, Mark Giglio, Wade Goddard, Graham MacIndoe,
Steve McCurry, Richard Nowitz, Ken Probst,
Robert Schlatter, Lars Tunbjork, David Turnley
Illustrators Bob Dinetz, Mark Giglio, Kevin Roberson
Studio Cahan and Associates
Client Consolidated Papers
Country United States

MERIT

BOOKLET/BROCHURE
Covetables, a Mohawk
Superfine Promotion

Art Director David Salanitro
Designer Ted Bluey
Copywriter Ross Viator
Photography Scott Peterson, Various
Illustrator Ted Bluey
Client Mohawk Paper Mills
Country United States

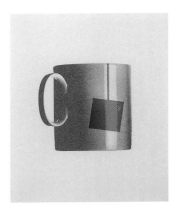

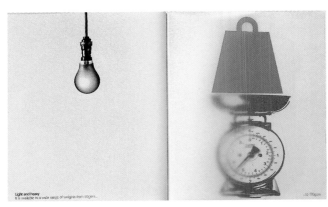

MERIT

BOOKLET/BROCHURE
T2000 Promo Brochure

Art Director Andrew Gorman
Designer Rob Riche
Copywriters Andrew Gorman, Rob Riche
Photographer John Edwards
Illustrator Paul Dixon
Client McNaughton Paper Group
Country United Kingdom

MERIT

BOOKLET/BROCHURE
Jessie Lim 2000

Art Director Edmund Wee
Designer Wong Wai Han
Photographers Gerald Gay, Nicholas Leong
Agency Epigram
Client Jessie Lim
Country Singapore

MERIT

BOOKLET/BROCHURE
mr.french.com Dur-O-Tone Brochure

Art Director Charles S. Anderson
Designers Charles S. Anderson,
Kyle Hames, Jason Schulte
Copywriter Lisa Pemrick
Illustrator Mr. French Printstock
and Elements
Studio Charles S. Anderson
Client French Paper Company
Country United States

MERIT

BOOKLET/BROCHURE
Fong & Fong Promotional
Donut Book

Art Director Jill Howry
Designer Robert Williams
Photographers Ty Whittington, Robert Williams
Client Fong & Fong Printers & Lithographers
Country United States

MERIT

BOOKLET/BROCHURE
Zagwear Catalog

Art Director Marcos Chavez
Designer Aimee Sealfon
Copywriter Rachel Orvino
Photographers Wes Bender,
Mark Naden, Aimee Sealfon
Studio TODA
Client Zagwear
Country United States

Bartlett & Associates designs interior spaces.

Inside

MERIT

BOOKLET/BROCHURE

Inside Bartlett & Associates

Art Directors Diti Katona, John Pylypczak
Designer John Pylypczak
Studio Concrete Design Communications Inc.
Client Bartlett & Associates
Country Canada

MERIT

**CORPORATE IDENTITY
PROGRAM, SERIES**

Ologi Brand Identity

Art Directors Bruce Duckworth,
David Turner
Designer David Turner
Photographer Michael Lamotte
Client Golden State International
Country United States

MERIT

CORPORATE IDENTITY PROGRAM, SERIES

Asterisk Project: National Design Awards Identity

Art Directors William Drenttel, Jen Roos

Designers Dan Bowman, Alicia Cheng, Tamara Maletic, Chuck Routhier, Gary Tooth, Jeffrey Tyson

Studio Helfand/Drenttel

Client Cooper-Hewitt National Design Museum

Country United States

310

MERIT

CORPORATE IDENTITY PROGRAM, SERIES

K DE KAN

Art Director Base Design

Designer Base Design

Client K DE KAN

Country United States

MERIT

CORPORATE IDENTITY PROGRAM
Indiscipline—Exhibition Brussel 2000

Art Director Christoph Steinegger
Designer Christoph Steinegger
Studio Büro X
Agency Büro X
Client Brussel 2000
Country Germany

MERIT

CORPORATE IDENTITY PROGRAM
QIORA' Brand Identity

Art Director Keiko Hirano
Creative Director Aoshi Kudo
Designer Keiko Hirano
Photographer Yasuo Saji
Studio Hirano Studio
Client Shiseido Co., Ltd.
Country Japan

MERIT

**CORPORATE IDENTITY
PROGRAM, SERIES**
Identity

Art Directors John Rushworth,
Daniel Weil
Designers John Dowling, Six Wu
Client Pantone
Country United Kingdom

MERIT

**CORPORATE IDENTITY
PROGRAM, SERIES**
The Jane Goodall Institute Notecards

Art Director Julie Poth
Designers Frida Clements,
Kelly Okumura
Copywriter The Jane Goodall Institute
Illustrator Meredith Yasui
Agency Werkhaus Creative
Communications
Client The Jane Goodall Institute
Country United States

Visuals

MERIT

CORPORATE IDENTITY PROGRAM, SERIES
Pass

Art Direction Base Design
Design Base Design
Country United States

MERIT

CORPORATE IDENTITY PROGRAM, SERIES
MEYOUHESHEHIMHERTHINGS

Art Director Peter Donohoe
Designers Peter Donohoe, Paul Reardon
Photographers Nigel Barker, David Short
Stylist Emma Bridgeman
Studio Design Association
Client The Salvation Army
Country United Kingdom

MERIT

STATIONERY
Farmhouse Stationery System

Art Directors Gaby Brink,
Joel Templin
Designer Brian Gunderson
Studio Templin Brink Design
Client Farmhouse Web Company
Country United States

314

MERIT

STATIONERY
Paper Plane Studio Stationery

Art Director Jennifer Olsen
Designer Jennifer Olsen
Printers Digital Engraving,
Leewood Press
Studio Paper Plane Studio
Country United States

MERIT

STATIONERY
Pin

Art Director Alexander Emil Möller
Designer Alexander Emil Möller
Client Su Bühler
Agency Heye & Partner
Country Germany

MERIT

STATIONERY
Hair Make Up—Refrex, Stationery
and Opening Tools

Art Director Miyoko Sukenari
Designer Miyoko Sukenari
Photographer Satoshi Shiozaki
Studio Design Studio Avst.
Client Refrex
Country Japan

MERIT

STATIONERY
Myownshirt.com

Art Director Lars Hartmann
Designer Lars Hartmann
Agency BBDO Denmark
Client myownshirt.com
Country Denmark

MERIT

STATIONERY
Atelier Stationery

Art Director Robert Valentine
Designers David Meredith, Enoch Palmer
Client Atelier
Country United States

MERIT

STATIONERY
Gilo Ventures Business System

Art Director Jennifer Sterling
Designers Clare Rhinelander,
Jennifer Sterling
Studio Jennifer Sterling Design
Client Gilo Ventures
Country United States

MERIT

STATIONERY
2 KA Architects Stationery

Art Director Thomas Kurppa
Illustrator Thomas Kurppa
Agency Bobby United Design
Client 2 KA Arkitekter AB
Country Sweden

MERIT

STATIONERY, SERIES
Pet Store Stationery

Art Directors Jim Sutherland,
Pierre Vermeir
Designer Pak Ying Chan
Photographer John Edwards
Country United Kingdom

MERIT

STATIONERY
Stationery Set for Boon

Art Directors Boyoung Lee, Alex Suh
Designers Boyoung Lee, Alex Suh
Printer El Communication
Client Shinsegae International LTD.
Country Korea

MERIT

STATIONERY

The Designer Chairs Business Cards

Art Directors Mariko Neumeister, Michael Schacht
Creative Directors Uwe Marquardt, Kerrin Nausch
Copywriter Jens Sabri
Producer Monika Nikot
Agency Michael Conrad & Leo Burnett Agency
Client Holger Jahn, Jahn Furniture Design
Country Germany

MERIT

LOGO/TRADEMARK

Dome: Body Zone Stamps

Art Director Michael Denny
Designers Christine Fent, Alyn Lambert
Photographer Gideon Mendel
Agency Roundel
Client Royal Mail
Country United Kingdom

MERIT

LOGO/TRADEMARK
Finca Flichman

Art Director Mary Lewis
Designer Joanne Smith
Client Finca Flichman S. A.
Agency Lewis Moberly
Country United Kingdom

MERIT

LOGO/TRADEMARK
Logo: (CAF) Children
Awaiting Families

Designer Felixsockwell
Illustrator Felixsockwell
Studio Felixsockwell.com
Client Pact
Country United States

MERIT

**COMPLETE PRESS/
PROMOTIONAL KIT**

QIORA' Promotional Kit

Art Director Keiko Hirano
Creative Director Aoshi Kudo
Designer Keiko Hirano
Photographer Yasuo Saji
Studio Hirano Studio
Client Shiseido Co., Ltd.
Country Japan

MERIT

SELF-PROMOTION (PRINT)
Base Book

Art Direction Base Design
Design Base Design
Photographer Serge Rovenne
Client Base
Country United States

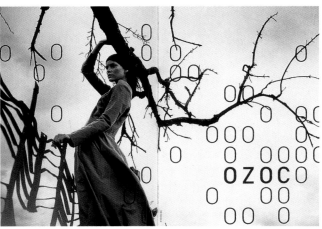

MERIT

**POSTCARD/GREETING CARD/
INVITATION**

Larsen 25th Birthday Party Invitation

Creative Director Jo Davison
Designers Chris Cornejo,
Todd Nesser
Illustrator Chris Cornejo
Copywriters Rick Emerson,
Pam Powell
Client Larsen Design + Interactive
Country United States

322

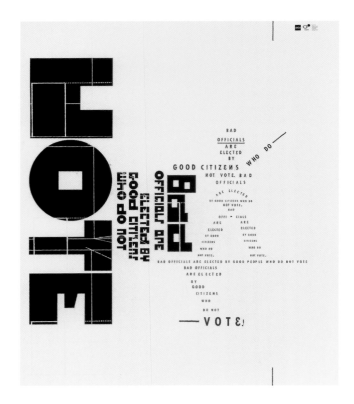

MERIT

POSTERS: PROMOTIONAL

Get Out the Vote

Art Director Jennifer Sterling
Designer Jennifer Sterling
Studio Jennifer Sterling Design
Client AIGA
Country United States

MERIT

POSTERS: PROMOTIONAL, SERIES

In Spite of a Storm

Art Director Shuichi Miyagishi
Designer Shuichi Miyagishi
Copywriter Shuichi Miyagishi
Studio Euphoria Graphic Design Inc.
Client Euphoria Graphic Design Inc.
Country Japan

MERIT

POSTERS: PROMOTIONAL

Spring Rays

Art Director Shinya Nojima
Designer Shinya Nojima
Copywriter Hajime Morita
Illustrator Hiroshi Tanabe
Agency ATA Co., Ltd.
Client Takashimaya Co., Ltd.
Country Japan

MERIT

POSTERS: PROMOTIONAL
All About the Money

Art Director Rick Valicenti
Designer Rick Valicenti
Producer Rick Valicenti
Programmer Matt Daly
Studio Thirst
Client The Graphic Arts Studio/
ESPN Magazine
Country United States

324

MERIT

POSTERS: PROMOTIONAL
A Vague Memory

Art Director Motoya Sugisaki
Designer Motoya Sugisaki
Photographer Masaru Asano
Illustrator Motoya Sugisaki
Copywriter Motoya Sugisaki
Client Wise Corporation
Studio Motoya Sugisaki Design Office
Country Japan

MERIT

POSTERS: PROMOTIONAL
Consolidated Works—
Imagined Landscapes

Art Director Jason Thomas Faulkner
Designer Jason Thomas Faulkner
Photographer Mat Richter
Illustrator Paul Gillis
Producer Mat Richter
Studio Olivv
Client Consolidated Works
Country United States

325

MERIT

POSTERS: PROMOTIONAL
Ongaku no Tamatebako

Art Director Jun Takechi
Designer Jun Takechi
Clients Aoyama Round Theatre/
The Foundation for Child Well-being
Country Japan

MERIT

POSTERS: PROMOTIONAL
Year of the Snake

Art Directors Petra Janssen,
Edwin Vollebergh
Designers Petra Janssen,
Edwin Vollebergh
Copywriters Petra Janssen,
Edwin Vollebergh
Illustrator Edwin Vollebergh
Agency Studio Boot
Client Kerlensky Silk Screen Prints
Country The Netherlands

MERIT

POSTERS: PROMOTIONAL
Audley Seasonal Poster

Art Director Harry Pearce
Designer Jeremy Roots
Copywriter Harry Pearce
Client Audley Shoes
Country United Kingdom

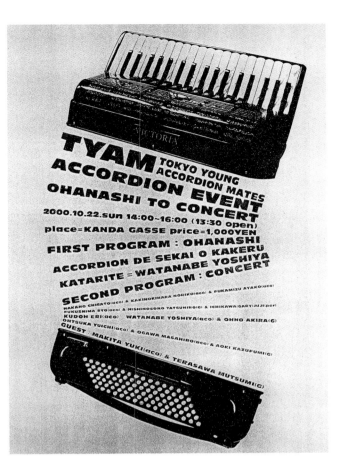

MERIT

POSTERS: PROMOTIONAL
Tokyo Young Accordion Mates

Art Director Masahiro Kakinokihara
Designer Masahiro Kakinokihara
Photographer Masahiro Kakinokihara
Client Tokyo Young Accordion Mates
Country Japan

MERIT

POSTERS: PROMOTIONAL, SERIES
FSP London

Art Director Naomi Hirabayashi
Designers Naomi Hirabayashi, Katsura Marubashi
Copywriter Kuniaki Yamamoto
Photographer Higashi Ishida
Stylist Sonya S. Park
Producer Mick Nakamura
Planner Shoko Yoshida
Client Axe Co., Ltd.
Country Japan

MERIT
POSTERS: PROMOTIONAL, SERIES
Gokanshi

Art Director Ken Miki
Designers Ken Miki,
Shigeyuki Sakaida
Copywriter Junichi Hayano
Illustrator Shigeru Okawa
Client Heiwa Paper Co., Ltd.
Country Japan

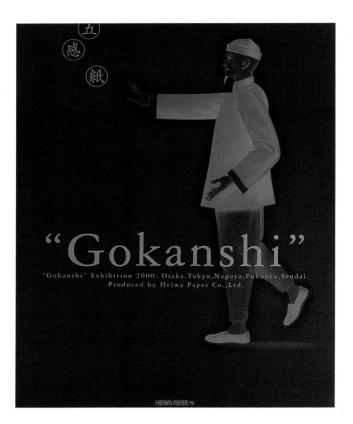

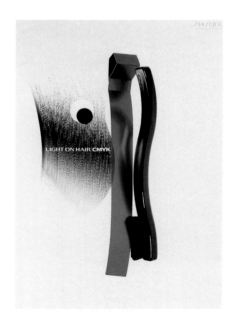
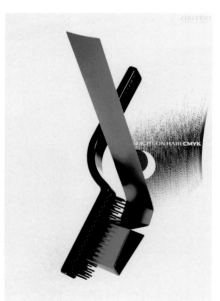
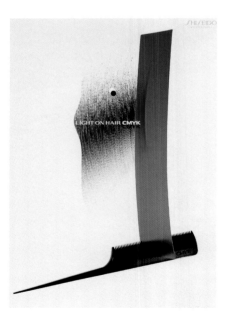

MERIT
POSTERS: PROMOTIONAL, SERIES
CMYK

Art Director Katsuhiko Shibuya
Designer Masatoshi Takagi
Copywriter Tetsuro Kanegae
Photographer Seiichi Nakamura
Studio Shiseido Advertising Creation Department
Client Shiseido Co., Ltd.
Country Japan

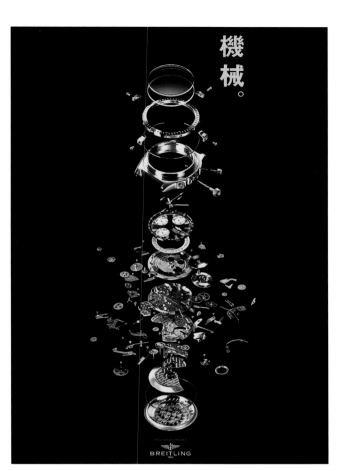

機械。

BREITLING

MERIT

POSTERS: PROMOTIONAL
Breitling Poster 2000

Art Director Hiroaki Watanabe
Designer Hiroaki Watanabe
Creative Directors Masaaki Hirose, Satoru Miyata
Copywriter Asaji Kato
Photographer Kazunari Koyama
Client Breitling Japan Co., Ltd.
Country Japan

MERIT

POSTERS: PROMOTIONAL, SERIES
New Order

Art Director Katsunori Nishi
Designers Yuko Harada, Katsunori Nishi
Illustrator Yoshimi Sakuma
Studio Brahman Co., Ltd.
Client New Order
Country Japan

MERIT

POSTERS: PROMOTIONAL, SERIES
Wearing the Hair

Art Director Daisaku Nojiri
Designer Daisaku Nojiri
Copywriter Tetsuya Sakai
Photographer Mikiya Takimoto
Stylist Yuki Watanabe
Hair and Makeup Nikaido
Agency Les Mains Plus Inc.
Client Heavens
Country Japan

MERIT

POSTERS: PROMOTIONAL, SERIES
Mushroom/Male & Female

Art Director Katsunori Nishi
Designer Katsunori Nishi
Studio Brahman Co., Ltd.
Client Happy Committee
Country Japan

MERIT

POSTERS: PROMOTIONAL, SERIES
Thirstype.com New Release Posters

Designers Chester, Warren Corbitt,
Rick Valicenti
Type Designers Chester,
Patrick Giasson, Patricking
Writer Tom Standage
Producer Rick Valicenti
Studio Thirstype, Inc.
Client Thirstype, Inc.
Country United States

MERIT

POSTERS: PROMOTIONAL
Bread

Art Directors Manmohan Anchan,
Rajesh Kulkarni
Copywriter Avinash S.
Photographer Sugathan
Studio Sugathan Photography
Client Madura Garments
Country India

Louis Philippe Breakfast Collection. Shirts in the colors of bread, cheese and coffee.

MERIT

POSTERS: PROMOTIONAL

Making Future—
Future Is Not That Far Away

Art Director Satoji Kashimoto
Designer Yuji Nagai
Copywriter Jurou Shigaki
Illustrator Yuji Nagai
Client Recruit Co., Ltd.
Country Japan

MERIT

POSTERS: POINT-OF-PURCHASE
The Sideburns—Exodus

Art Director Ikuo Nakamura
Designer Ikuo Nakamura
Illustrator Ikuo Nakamura
Producer Hiroo Takahashi
Client Olive Disk & Records
Country Japan

MERIT

POSTERS: POINT-OF-PURCHASE, SERIES

Mountain • Bumps • Ridges

Art Directors Pann Lim, Roy Poh
Designers Pann Lim, Roy Poh
Copywriter Kok Hong
Photographer Jimmy Fok
Agency Kinetic Design & Advertising
Client Singletrek Cycle
Country Singapore

MERIT

POSTERS: PUBLIC SERVICE/ NONPROFIT/EDUCATIONAL
AIGA Houston—Read Foundation

Art Director Lana Rigsby
Designer Pamela Zuccker
Copywriter Larry McMurtrey
Calligraphy Lana Rigsby
Studio Rigsby Design
Client AIGA Houston
Country United States

MERIT

POSTERS: POINT-OF-PURCHASE
Hurricane Resistance Kit—
Monica Bonvicini

Designer John Kieselhorst
Client California Institute of the Arts
Visting Artist Lecture Series
Studio A-100
Country United States

334

MERIT

POSTERS: POINT-OF-PURCHASE
Parsons Fall 2000

Designer Felixsockwell
Illustrator Felixsockwell
Studio Felixsockwell.com
Agency Felixsockwell.com
Client Parsons
Country United States

MERIT

POSTERS: POINT-OF-PURCHASE

Parsons Summer 2001

Designer Felixsockwell
Illustrator Felixsockwell
Studio Felixsockwell.com
Agency Felixsockwell.com
Client Parsons
Country United States

MERIT

POSTERS: POINT-OF-PURCHASE

Japan

Art Director Kazumasa Nagai
Studio Nippon Design Center, Inc.
Client Japan Graphic
Designers Association
Country Japan

MERIT

POSTERS: POINT-OF-PURCHASE
Recess

Art Directors Jeremy Mende,
Yoram Wolberger
Designers Jeremy Mende,
Yoram Wolberger
Photographers Daniel Desousa,
Jeremy Mende
Client San Francisco Art Institute
Country United States

MERIT

POSTERS: POINT-OF-PURCHASE
Wind

Art Director Akio Okumura
Designer Yasuyo Fukumoto
Client Osaka Zokei Center
Country Japan

POSTERS: POINT-OF-PURCHASE
Catherine Lord

Designer John Kieselhorst
Client California Institute of the Arts
Visiting Artist Lecture Series
Studio A-100
Country United States

**POSTERS: POINT-OF-PURCHASE,
SERIES**
Unfinished

Art Director Hideki Nakajima
Designer Hideki Nakajima
Country Japan

MERIT

POSTERS: POINT-OF-PURCHASE, SERIES

The Japanese Happiness—
Sakasa Fuku

Art Director Masato Watanabe
Designers Hiro Watanabe,
Masato Watanabe
Copywriter Tomoko Watanabe
Typographers Hiro Watanabe,
Masato Watanabe
Producer Mirai Watanabe
Studio Research Institute of Designs,
Earth Walker Launch
Client The Shuwa Building
Maintenance, Ltd.
Country Japan

338

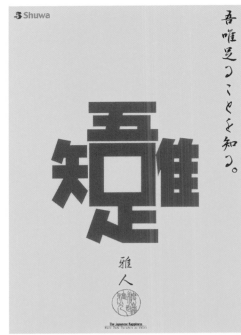

MERIT

POSTERS: POINT-OF-PURCHASE, SERIES

X'ian Image

Art Director Akio Okumura
Designer Yasuyo Fukumoto
Client X'ian Image Playbill Exhibition
Organization Committee
Country Japan

MERIT

POSTERS: POINT-OF-PURCHASE, SERIES
No Landmine

Art Director Masayuki Terashima
Designer Masayuki Terashima
Photographer Hitoshi Yoneyama
Studio Terashima Design Co.
Client Japan Campaign to Ban Landmines
Country Japan

MERIT

POSTERS: POINT-OF-PURCHASE, SERIES
Kisho Kurokawa Retrospective

Art Director Shin Matsunaga
Designers Hidenori Ito, Shin Matsunaga
Artist Kisho Kurokawa
Studio Shin Matsunaga Design Inc.
Client The Executive Committee of Exhibition of Retrospective of Kisho Kurokawa
Country Japan

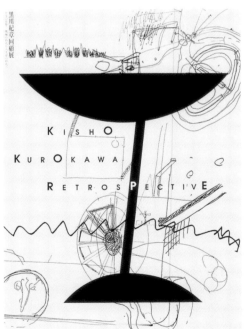

MERIT

**POSTERS: POINT-OF-PURCHASE,
SERIES**
AIGA Membership

Art Directors Richard Boynton,
Scott Thares
Designers Richard Boynton,
Scott Thares
Illustrators Ron Rockwell,
Scott Thares
Studio Wink
Client AIGA
Country United States

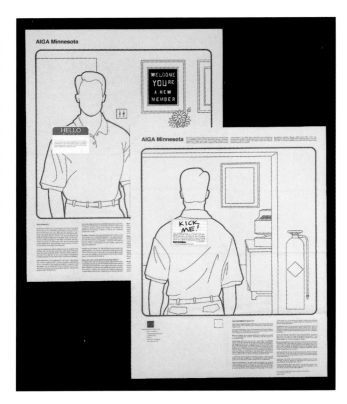

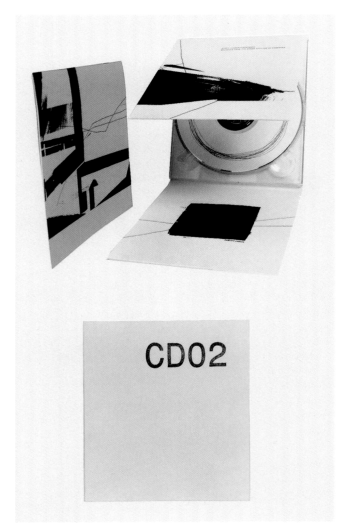

MERIT

PACKAGING: ENTERTAINMENT
Melodies from the Power
Station of Kirkenes

Art Director Thomas Kurppa
Illustrator Thomas Kurppa
Agency Bobby United Design
Client Stoft Ljudupptagningar
Country Sweden

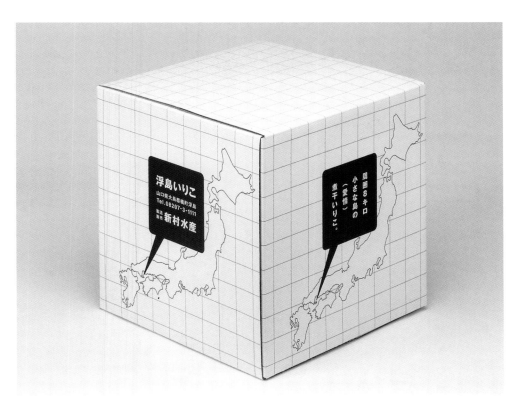

MERIT

PACKAGING: FOOD/BEVERAGE
Small Dried Sardines

Art Director Norito Shinmura
Designer Norito Shinmura
Copywriter Kazutaka Sato
Producer Masashi Shinmura
Client Shinmura Fisheries
Country Japan

341

MERIT

PACKAGING: FOOD/BEVERAGE
Clearly Canadian

Art Director Matthew Clark
Creative Director Maria Kennedy
Producer John Ziros
Agency Karacters Design Group
Client CC Beverage Corporation
Country Canada

MERIT

PACKAGING: SOFTWARE/OFFICE
Luna Sea—Period

Art Director Hideki Nakajima
Designer Hideki Nakajima
Photographer Yoshihiko Ueda
Client Universal Music Company
Country Japan

LUNA SEA | PERIOD
THE BEST SELECTION

Saucy peach and mango salsa

Spicy oranges for cold meat

Very hot Mexican salsa

MERIT

PACKAGING: FOOD/BEVERAGE
Down to Earth

Art Directors Andrew Gorman,
Rob Riche
Copywriter Rob Riche
Designer Rob Riche
Illustrator Paul Dixon
Client Down to Earth
Country United Kingdom

MERIT

**PACKAGING: FASHION/
APPAREL/WEARABLE**

Pleats Please Shopping Bag

Art Director Sayuri Shoji
Designer Atsuko Suzuki
Production Company Vinyl Technology
Studio Sayuri Studio
Client Issey Miyake Inc.
Country United States

MERIT

PACKAGING: COSMETICS
Contact Lens Solution/Cosmetics

Art Director Garrick Hamm
Designer Fiona Curran
Copywriter Richard Murray
Agency Williams Murray Hamm
Client Superdrug
Country United Kingdom

MERIT

PACKAGING: COSMETICS, SERIES
FSP Acne

Art Director Naomi Hirabayashi

Designers Naomi Hirabayashi,
Hideaki Izumi, Maki Takada

Copywriters Adriana Samaniego,
Shoko Yoshida

Client Axe Co., Ltd.

Country Japan

344

MERIT

**PACKAGING: GIFT/SPECIALTY
PRODUCTS, SERIES**
Castor & Pollux Packaging

Art Director Jon Olsen

Designer Jon Olsen

Copywriter Leslee Dillon

Illustrator Larry Jost

Production Designer Starlee Matz

Design Firm Sandstrom Design

Client Castor & Pollux

Country United States

MERIT

**WAYFINDING SYSTEMS/
SIGNAGE/DIRECTORY**

Brooklyn Academy of Music
Signage Program

Art Director Michael Bierut

Designers Michael Bierut, Karen Parolek, Robert Stern

Client Brooklyn Academy of Music

Country United States

MERIT

**WAYFINDING SYSTEMS/
SIGNAGE/DIRECTORY**

Wall of Honor

Art Director Stephen Doyle

Photographer Luca Piotelli

Client American Institute of Graphic Arts

Country United States

MERIT

TRADE SHOWS, SERIES
Baronet High Point Showroom
Spring 2000

Art Director Louis Gagnon
Designers Louis Gagnon,
Francis Turgeon
Agency Paprika Communications
Client Baronet
Country Canada

MERIT

TRADE SHOWS
QIORA' Presentation

Art Director Aoshi Kudo
Film Director Keiko Hirano
Designers Aoshi Kudo, Rikiya Uekusa
Client Shiseido Co., Ltd.
Country Japan

MERIT

ENVIRONMENT, SERIES
Chelsea Carwash

Art Direction Base Design
Design Base Design
Production MTM Printing and Selectoflash
Client Chelsea Carwash
Country United States

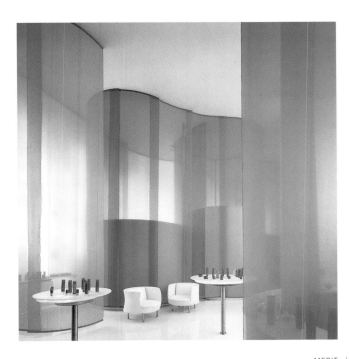

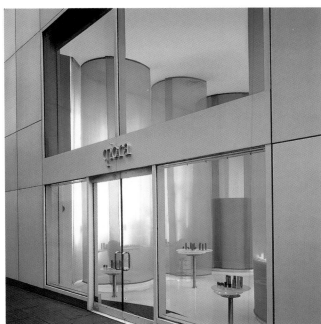

MERIT

INDOOR ENVIRONMENT
QIORA' Store and Spa NY

Art Director Aoshi Kudo
Creative Director Aoshi Kudo
Designers Aoshi Kudo, Architects Research Office
Client Shiseido Co., Ltd.
Country Japan

MERIT

INDOOR ENVIRONMENT
Construction Barricade for
Harajuku Y-Building

Art Director Yuki Kikutake
Designer Yuki Kikutake
Photographer, vol. 2 Shizuo Hayakawa
Digital Artist, vol. 1 Kaori Innami
Model Artist, vol. 2 Michio Kasugame
Producer Kumi Murai, Takenaka Design
Client Yoku Moku Co., Ltd.
Country Japan

MERIT

INDOOR ENVIRONMENT
I.R.I.S.

Art Director Eli Kuslansky
Designer Cesar Martin
Copywriter Unified Field
Production Unified Field
Client Goldman Sachs
Country United States

MERIT

INDOOR ENVIRONMENT, SERIES
Hair Neo

Art Director Masayoshi Kodaira
Designer Masayoshi Kodaira
Photographers Naoki Ishizaka
(models), Kozo Takayama (installation
photos)
Client Hair Neo
Country Japan

MERIT

ENVIRONMENT, SERIES
Vending Machines for Coca-Cola

Art Director Fernando Tige
Creative Director Fernando Tige
Designer Fernando Tige
Illustrator Guta
Client The Coca-Cola Company
Agency DPZ Propaganda
Country Brazil

MERIT

**GALLERY/MUSEUM EXHIBIT/
INSTALLATION, SERIES**
50 Years of TV and More

Principal Ralph Appelbaum
Project & Design Director James
Cathcart
Project Manager Francis O'Shea
Project Coordinator Jessica
Holbrook
Exhibition Designers Jake Barton,
Tim Ventimiglia
Graphic Designers Mona Kim,
Christiaan Kuypers
Graphics Production Nancy Hoerner
Editor Sylvia Juran
Media Designers Allegra Burnette,
Joshua Pearson
Media Assistant Kate Wharton
Renderings George Robertson,
Pia Samrithikul, David Troutman
Models Don MacKinnon,
Larry Majesky
Country United States

MERIT

**GALLERY/MUSEUM EXHIBIT/
INSTALLATION, SERIES**
The Clore Centre for Education

Art Director Lorenzo Apicella
Photographer Timothy Soar
Architects Lorenzo Apicella, Matthew Clare,
David Gausden, Dragan Sukljevic
Quantity Surveyors Boyden & Co.
Contractors E&F Shopfitters Ltd.
M&E Consultants Radford Consultants Ltd.
Client Natural History Museum
Country United Kingdom

MERIT

**GALLERY/MUSEUM EXHIBIT/
INSTALLATION, SERIES**
Emery Vincent Design Exhibition

Art Director Garry Emery
Designer Emery Vincent Design Team
Country Australia

MERIT

**GALLERY/MUSEUM EXHIBIT/
INSTALLATION, SERIES**
Modernism Kiosk Installation

Art Director David Ryan
Designers Ruth Dean, Jim Ockuly
Fabricator Al Silberstein
Agency The Interactive Media Group
Client The Minneapolis Institute
of Arts
Country United States

MERIT

GALLERY/MUSEUM EXHIBIT/ INSTALLATION, SERIES
Fighting Dinosaurs:
New Discoveries from Mongolia

Art Director David Harvey
Exhibition Designer Gerhard Schlanzky
Managing Editor Lauri Halderman
Graphic Designers Patrick Bell, Stephanie Reyer
Developer Robert Vinci
Graphics Manager Jayne Hertko
Media Producer Geralyn Abinader
Installation Manager Deborah Barral
Media Manager Frank Rasor
Sculptor/Preparator Jason Brougham
Preparators Joyce Cloughly, Alan Walker
Assistant Video Editor David DeMallie
Interactive Programmer D. Dixon
Video Editor Sarah Galloway
Evaluator Ellen Giusti
Animator Molly Lenore
Illustrators Kevin McAllister, Andrea Raphael
Artist/Preparator Sean Murtha
Video Researcher Lee Patrick
Mount Maker/Preparator Tony Rodgers
Editor Karen de Seve
Interactive Designer Joseph Stein
Software Developer Kevin Walker
Client American Museum of Natural History
Country United States

Multiple Awards

MERIT

**TV IDENTITIES/OPENINGS/
TEASERS, SERIES**

and MERIT

ANIMATION, SERIES

Jasper Campaign—Wire Plane •
Wire Copter • Hover Craft

Art Director Next Next
Producer Laura Corby
Production Assistant Joe Pappalardo
Client Noggin
Country United States

MERIT

**TV IDENTITIES/OPENINGS/
TEASERS**

Jet Set Download

Art Directors Michael Goedecke, Eric Saks
Designers Michael Goedecke, Eric Saks
Copywriters Michael Goedecke, Eric Saks
Photographers Michael Goedecke,
Eric Saks
Executive Producer Steve Kazanjian
Producer Eric Saks
Studio Belief
Client Belief
Country United States

MERIT

TV IDENTITIES/OPENINGS/
TEASERS
Life Buoy ID

Art Director Neil Burns
Producer Essie Chambers
Animation Neil Burns, Headgear
Client Noggin
Country United States

MERIT

TV IDENTITIES/OPENINGS/
TEASERS, SERIES
MTV 2

Art Director Jen Roddie
Creative Director Jeffrey Keyton
Designer Bill Zimmer
Design Director Romy Mann
Bumper Animation Manhattan Transfer
Feature Animation Thierry Gaubert,
Mike Piscitelli
Agency MTV Design
Country United States

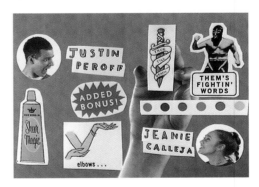

MERIT

**TV IDENTITIES/OPENINGS/
TEASERS**

Siggraph 2000

Art Directors George Fok, Daniel Fortin
Designers George Fok, Daniel Fortin
Client Avid/Softimage
Country Canada

MERIT

**TV IDENTITIES/OPENINGS/
TEASERS**

Our Hero

Producers Karen Lee Hall, Persis Reynolds
Director/Animator Julian Grey
Client Canadian Broadcasting
Corporation
Country Canada

MERIT

CINEMA: OPENING TITLE SEQUENCE

Hollow Man

Creative Director Rick Probst
Designers David Hutchins, Bill Lebeda
Executive Producer Eric Ladd
Producer Scott Narrie
Client Columbia Pictures
Country United States

MERIT

CINEMA: OPENING TITLE SEQUENCE

Electric Dragon 80000 V

Art Director Sei Hishikawa
Designer Masato Okada
Studio Drawing And Manual
Client Suncent Cinemaworks Inc.
Country Japan

MERIT

ART VIDEO
Digital Petraglyph for
Herman Miller

Art Director Rick Valicenti

Designers Gregg Brokaw, Matt Daly,
Rick Valicenti, Velo Virkhaus

Executive Producer Barbara Valicenti

Producer Rick Valicenti

Studio Thirst, Inc.

Client Herman Miller, Inc.

Country United States

MERIT

MUSIC/SOUND DESIGN
Noggin.com Rap

Writer/Arranger Kovasciar Myvett

Producers Jocelyn Hassenfeld,
Brenda Schait

Sound Design Michael Ungar

Client Noggin

Country United States

Uwe Grahl, Architekt

DIE WELT GEHÖRT DENEN, DIE NEU DENKEN.

MERIT
MUSIC/SOUND DESIGN
Jazz

Art Director Tilmann Trost

Creative Directors Arno Lindemann, Stefan Meske

Copywriter Michael Meyer

Producer Vera Portz

Film Producer Tempomedia Filmproduktion GmbH

Agency Film Producer Natascha Teidler

Agency Springer & Jacoby Werbung GmbH & Co. KG

Client Mercedes Benz AG

Country Germany

MERIT
MUSIC/SOUND DESIGN
Wheelchair

Art Director Bastian Kuhn

Creative Directors Alexander Schill, Axel Thomsen

Copywriter Alexander Weber

Producer Jenny Krug

Studio Cobblestone Pictures, Hamburg

Agency Springer & Jacoby Werbung GmbH & Co. KG

Client Axel Springer Verlag AG

Country Germany

MERIT

ANIMATION, SERIES
Radio to the Power of 4

Art Director Anton Ezer

Creative Director Steve Kelynack

Copywriters Anton Ezer, Alex Lyons

Producers Jeremy Barrett (Tomato), Polly Hudson (BBC)

Director Dirk Van Dooren

Sound Design Martin Green

Agency BBC Corporate Creative Services

Client BBC Radio 4

Country United Kingdom

MERIT

ANIMATION, SERIES
Johnny Law • Chicken Sandwich • G-Force

Art Directors Dave Clemans, Andrew Keller

Copywriters Tom Adams, Bill Wright

Producer Sara Gennet Lopez

Director Peter Chung

Agency Crispin Porter & Bogusky

Client Rally's

Country United States

photography
and illustration

Crosby, Stills, Nash, Young

Multiple Awards
(see also Graphic Design)

SILVER

MAGAZINE EDITORIAL, SERIES

Art Director Fred Woodward
Photo Editor Rachel Knepfer
Photographer Mark Seliger
Client Rolling Stone
Country United States

David Crosby, Stephen Stills, Graham Nash & Neil Young
sit shoulder to shoulder on wooden stools around a forest of
microphones. On the far left, Stills plays a gentle riff on a
snow-white, wide-body electric guitar. Across from him,
Young, wearing a red flannel shirt and a black baseball cap,
strums an acoustic guitar and sings "Old Man," from his 1972
album, *Harvest.*

Young's shivery tenor sounds fragile in the cold dark
space of the Convocation Center in Cleveland. But when the
other three enter the chorus with swan-diving harmonies –
"Old man, look at my life/I'm a lot like you" – the song blooms
with fresh meaning. Crosby Stills Nash and Young are no
longer the four young bucks who overwhelmed rock in 1969
with pedigree and promise. They are in their fifties, and they
sing "Old Man," a reflection on passing youth and lost oppor-
tunity, with electrifying honesty. Unfinished business runs
deep in those bruised-gold voices.

There is no applause at the end – because there is no au-
dience. CSNY are in final rehearsals for their first concert tour
since 1974. Opening night, in Detroit, is four days away. But to
hear this band in a big, empty room is to experience magic in
its native state. Everything that makes CSNY one of rock's
premier melodramas – drugs; feuds; Crosby's 1994 liver trans-
plant and new celebrity as a sperm donor for lesbian moms
Melissa Etheridge and Julie Cypher; Nash's boating accident
BY DAVID FRICKE >>> PHOTOGRAPHS BY MARK SELIGER >

SILVER

BOOK

States

Designer Derek Samuel
Photographer Christopher Griffith
Producer Ben Freedman
Publisher Daniel Power/Power House Books
Country United States

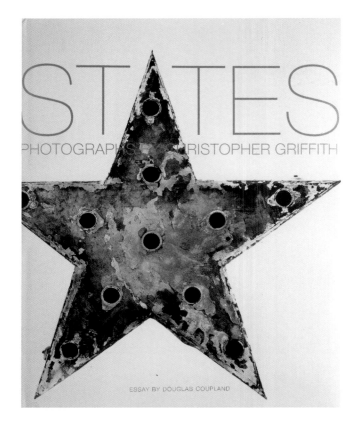

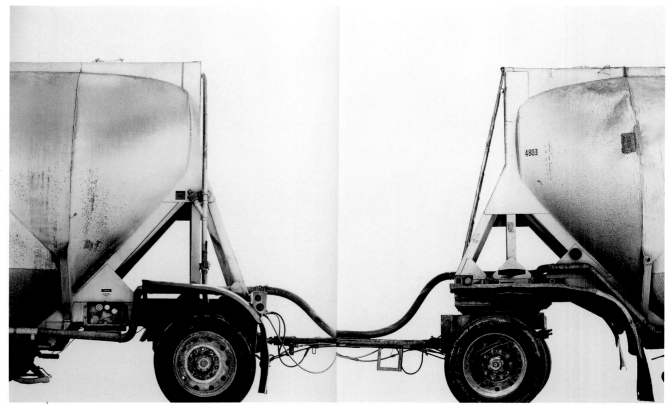

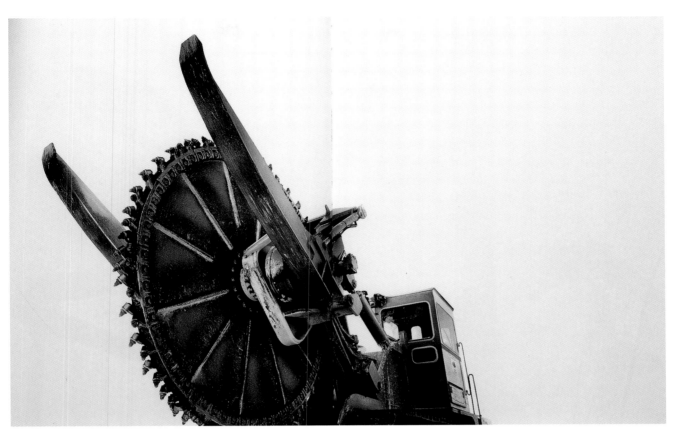

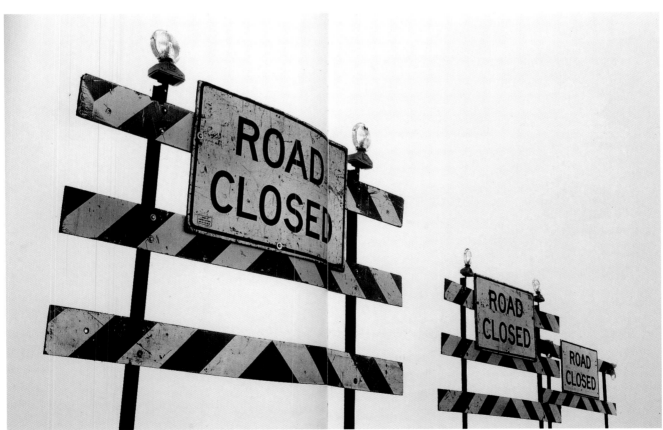

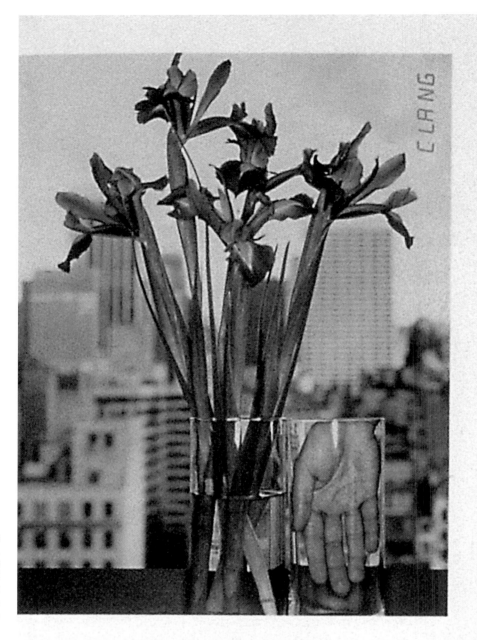

When I first decided to print a
mini-book of my photographs,
I wanted a design that truly shows
my sensibility. I approached
Theseus Chan, my collaborator on
most projects. I trusted him,
and I was right to.

Multiple Awards
(see also Graphic Design)

SILVER

SELF-PROMOTION, SERIES

Clang

Art Directors Theseus Chan, Mina
Designers Theseus Chan, Mina
Photographer Clang
Producer Elin Tew
Agency WORK
Client Clang
Country Singapore

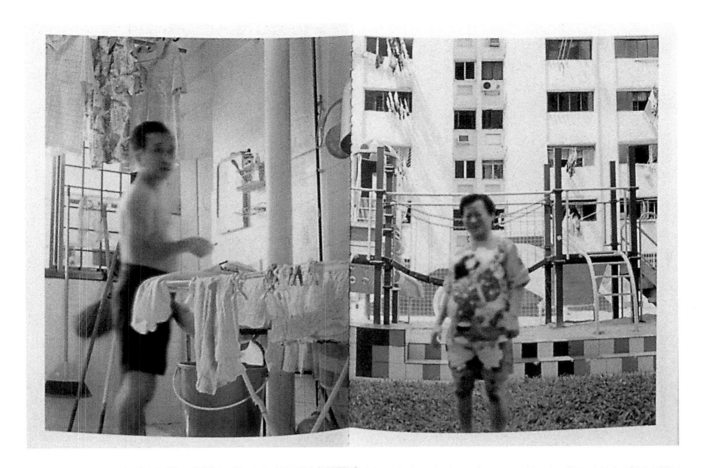

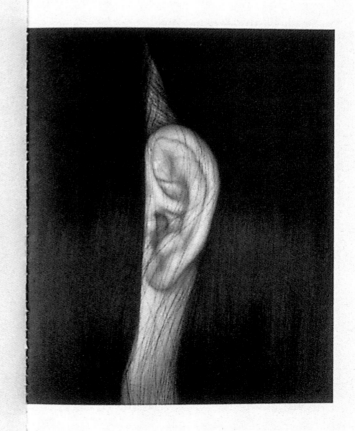

DISTINCTIVE MERIT

**NEWSPAPER ADVERTISEMENT,
SERIES**
Photo Wheelchair •
Photo Kitchen • Photo Grave

Art Director Carl-Erik Conforto
Assistant Art Director Nettan
Persson
Photographer Peter Gehrke
Copywriter Dagmar Kollstrøm
Agency Virtual Garden
Client Storebrand AS
Country Norway

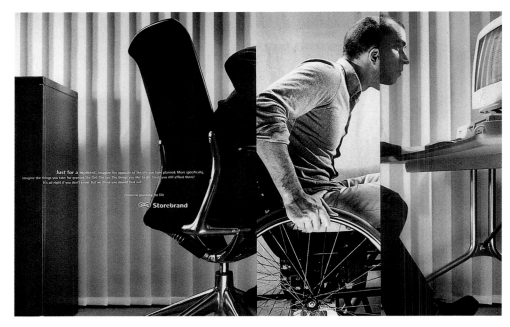

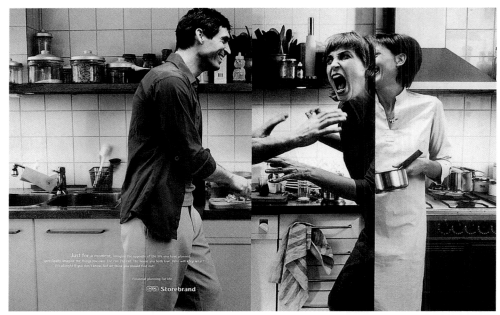

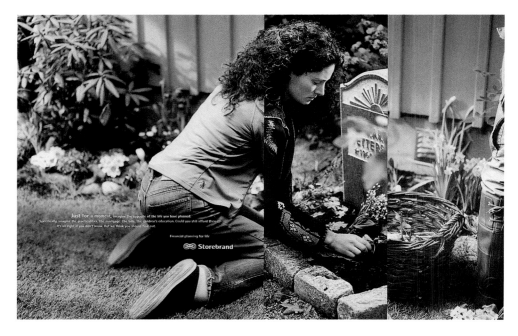

(t)here

ISSUE THREE
US $ 8.00 Canada $9.50

DISTINCTIVE MERIT
COVER: NEWSPAPER OR MAGAZINE
(t)here Issue Three Cover

Art Director Christopher Wieliczko
Photographer Jason Makowski
Copywriter Laura Silverman
Design Agency Cent-Degres Image
Country United States

DISTINCTIVE MERIT

CORPORATE/INSTITUTIONAL
The Progressive Corporation
1999 Annual Report

Art Directors Joyce Nesnadny,
Mark Schwartz
Designers Michelle Moehler,
Joyce Nesnadny
Photographer Gregory Crewd
Copywriter Peter B. Lewis
Agency Nesnadny + Schwartz
Client The Progressive Corporation
Country United States

PRODUCT PACKAGING
Put in Out—Finest Tunes
from St. Petersburg

Art Director Christoph Steinegger
Designer Christoph Steinegger
Photographer Henning Bock
Studio Büro X
Agency Büro X
Client Sabotage Communications
Country Germany

MERIT

MAGAZINE ADVERTISEMENT
Yesterday and Today—Wetland 1931

Art Director Mark Rosica
Copywriter Jeff Grutkowski
Photographer Jim Stinson
Illustrator Mark Rosica
Agency Eisner Communications
Client The Nature Conservancy
Country United States

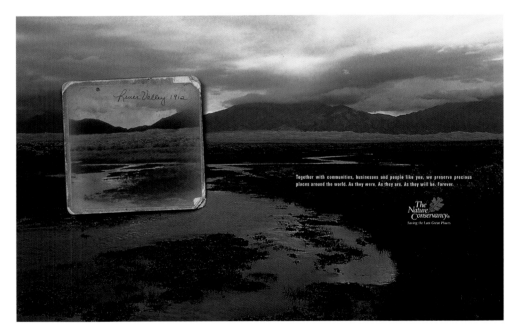

MERIT

MAGAZINE ADVERTISEMENT
Yesterday and Today—River Valley

Art Director Mark Rosica
Copywriter Jeff Grutkowski
Photographer Ron Simrod
Illustrator Mark Rosica
Agency Eisner Communications
Client The Nature Conservancy
Country United States

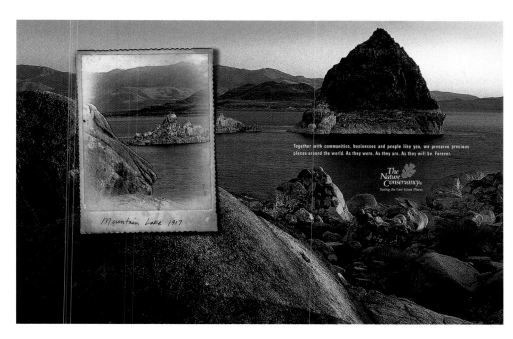

MERIT

MAGAZINE ADVERTISEMENT
Yesterday and Today—Mountain
Lake 1917

Art Director Mark Rosica
Copywriter Jeff Grutkowski
Photographer Alan St. John
Illustrator Mark Rosica
Agency Eisner Communications
Client The Nature Conservancy
Country United States

MERIT

MAGAZINE ADVERTISEMENT
Yesterday and Today—Prairie 1892

Art Director Mark Rosica
Copywriter Jeff Grutkowski
Photographer Ron Simrod
Illustrator Mark Rosica
Agency Eisner Communications
Client The Nature Conservancy
Country United States

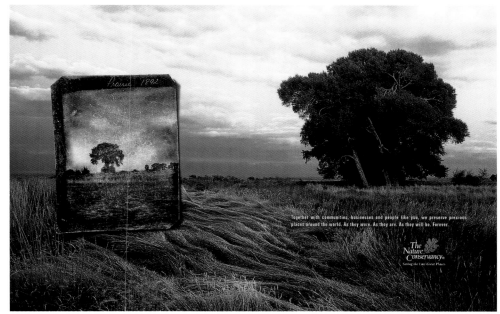

MERIT

MAGAZINE ADVERTISEMENT
Christ

Art Director Martin Cacios-La Rusa
Creative Directors Juan Cravero,
Dario Lanis
Copywriters Hernan Curubeto,
Martin Juarez
Producer Rolando Lambert
Agency CraveroLanis Euro RSCG
Client Peugeot
Country Argentina

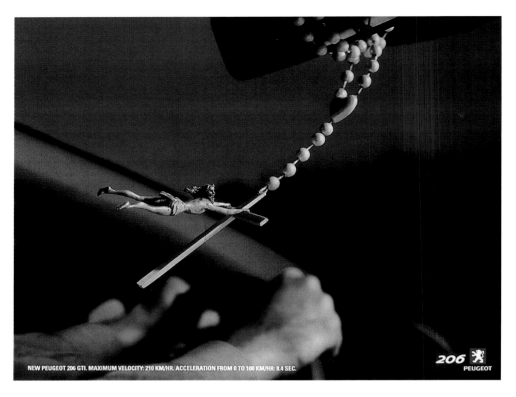

MERIT

**MAGAZINE ADVERTISEMENT,
SERIES**
Vail Summer Ad Campaign

Art Director Kelly Wright
Photographer Andy Anderson
Country United States

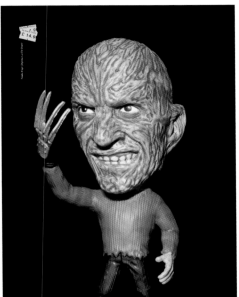

MERIT

**MAGAZINE ADVERTISEMENT,
SERIES**

Big Magazine 28: Horror—Toy Story

Art Directors Stuart Spalding,
Lee Swillingham
Designer Martin Sebald
Photographer Guido Mocafico
Country United States

MERIT

**NEWSPAPER ADVERTISEMENT,
CAMPAIGN**

Babyheads

Creative Directors Johannes Krempl,
Pius Walker
Photographer Uwe Duettmann
Agency Scholz & Friends Berlin
Client Deutsches Theater Berlin
Country Germany

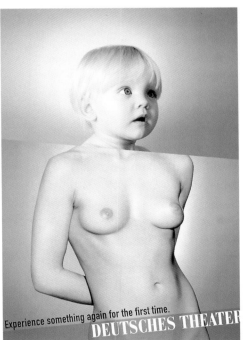

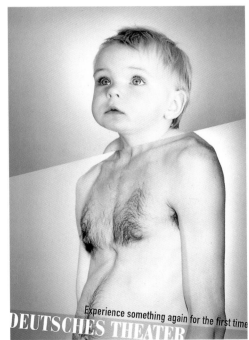

MERIT

MAGAZINE EDITORIAL, SERIES
Spring Reign

Creative Director Riley John-Donnell
Photographer John Clang
Fashion Stylist John Slattery
Client Surface Magazine
Country United States

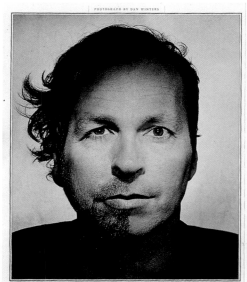

MERIT

MAGAZINE EDITORIAL
Farrelly Brothers

Art Director Fred Woodward
Designer Andy Omel
Photo Editor Rachel Knepfer
Photographer Dan Winters
Client Rolling Stone
Country United States

Multiple Awards
(see also Graphic Design)

MERIT

MAGAZINE EDITORIAL
Colors 41

Art Director Fernando Gutiérrez

Designer Anna Maria Stillone

Copywriters Michael Holden,
Jonathan Steinberg

Photographers Adam Broomberg,
Oliver Chanarin, James Mollison,
Stefan Ruiz

Producers Samantha Bartoletti,
Carlos Mustienes

Client Colors Magazine

Country Italy

MERIT

MAGAZINE EDITORIAL, SERIES
Dead Men Talking

Art Director Janet Froelich

Designer Catherine Gilmore-Barnes

Photo Editor Kathy Ryan

Photographer Sally Mann

Country United States

MERIT

MAGAZINE EDITORIAL, SERIES
Pretty Boys

Art Director Janet Froelich
Designer Claude Martel
Style Photo Editor David Farber
Photographer Burkhard Schittny
Country United States

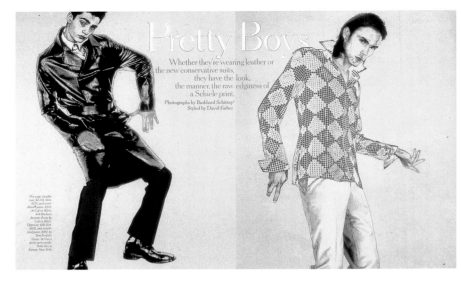

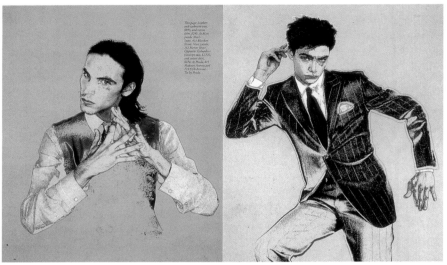

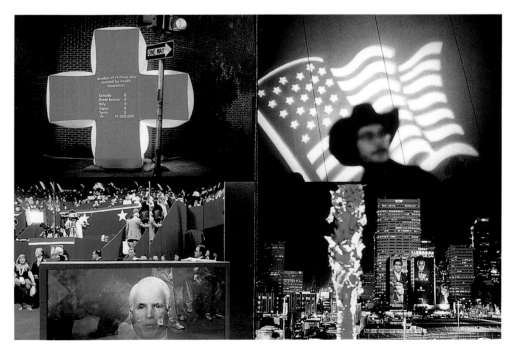

MERIT

MAGAZINE EDITORIAL, SERIES
Politics: The Color of Politics

Photographer Gilles Peress
Country United States

MERIT

MAGAZINE EDITORIAL, SERIES

Cynbad • Bag Laydee • Spider • Rocko

Art Directors Kevin Schluter, SPID
Copywriter Chris Lorimer
Designer Kevin Schluter
Photographer SPID
Illustrator Berrin Moody
Producers Chris Lorimer, Jorin Sievers
Studio fluidesign
Client Pulp Magazine
Country New Zealand

MERIT

MAGAZINE EDITORIAL, SERIES
The Invisible Poor

Art Director Janet Froelich
Designers Joele Cuyler, Janet Froelich
Photo Editor Kathy Ryan
Photographers Lauren Greenfield,
Brenda Anne Kenneally,
Jeff Riedel, Taryn Simon
Country United States

The Invisible Poor

BY JAMES FALLOWS

The way a rich nation thinks about its poor will always be convoluted. The richer people become in general, the easier it theoretically becomes for them to share with people who are left out. But the richer people become, the less they naturally stay in touch with the realities of life on the bottom, and the more they naturally prefer to be excited about their own prospects rather than concerned about someone else's.

All aspects of the convolution now affect our politics and culture, in a form with no exact precedent. The last time the United States self-consciously thought of itself as rich, in the early 1960's, discussions of how the wealth should be shared were under way even before real prosperity

MERIT

MAGAZINE EDITORIAL
Tom Green

Art Director Fred Woodward
Designer Siung Tjia
Photo Editor Rachel Knepfer
Photographer Mark Seliger
Client Rolling Stone
Country United States

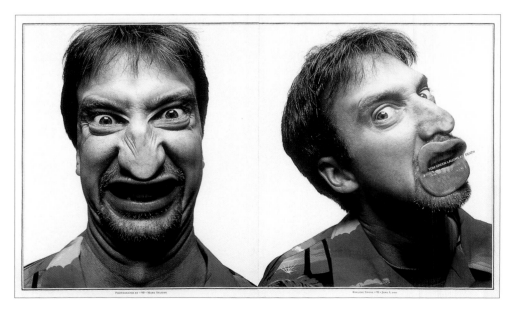

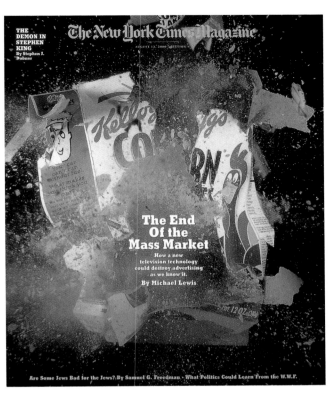

MERIT

COVER (NEWSPAPER OR MAGAZINE)
The End of the Mass Market

Art Director Janet Froelich
Designer Catherine Gilmore-Barnes
Photo Editor Kathy Ryan
Photographer Alexei Hay
Country United States

MERIT

BOOK
Ferrari Yearbook 2000

Art Director Frank M. Orel
Designer Seidl Cluss
Copywriter Carlo Caricchi
Photographers Fotostudio Frank M. Orel and others
Producer GZD Heimerdingen
Client Ferrari S.P.A.
Country Germany

MERIT

BOOK
Body Knots

Art Director Howard Schatz
Photographer Howard Schatz
Book Designer Karen Englemann
Country United States

MERIT

BOOK
Hutterites of Montana

Art Director Fred Woodward
Photographer Laura Wilson
Country United States

MERIT

CORPORATE/INSTITUTIONAL
Iowa State Fair

Art Director Carrie Hunt
Creative Director Giovanni Russo
Photographer Lloyd Ziff
Studio Number 11
Client The Council of Fashion
Designers of America
Country United States

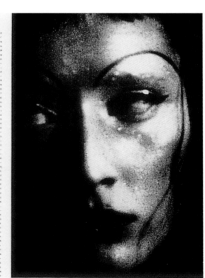

MERIT

**CORPORATE/INSTITUTIONAL,
SERIES**
Bravoturbeville

Art Directors Lisa La Rochelle,
Jurek Wajdowicz
Designers Lisa La Rochelle,
Jurek Wajdowicz
Copywriter Deborah Turbeville
Photographer Deborah Turbeville
Editors Edward Schneider,
Jurek Wajdowicz
Studio Emerson, Wajdowicz Studios
Client Domtar Communication Papers
Country United States

CORPORATE/INSTITUTIONAL, SERIES
Helmut Lang Parfums—Journal

Art Director Marc Atlan
Designer Marc Atlan
Copywriter Jenny Holzer
Photographer Marc Atlan and stock
Client Helmut Lang
Country United States

384

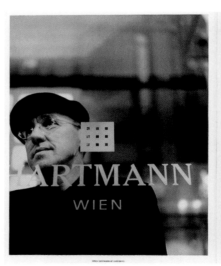

MERIT

SELF-PROMOTION
Wienna

Art Directors Arnold Haas,
Daniela Stallinger
Designer Susanna Barrett
Copywriter Lambeth Hochwald
Photographer Daniela Stallinger
Country United States

SELF-PROMOTION
Diner: Stories and Pictures

Art Directors Craig Cutler, Tom Wood
Designers Clint Bottoni, Tom Wood
Copywriters Mary Anne Costello,
Tom Wood
Photographer Craig Cutler
Agency Wood Design
Client Craig Cutler
Country United States

MERIT

SELF-PROMOTION
The Production

Art Directors Daniela Stallinger,
Eva Whitechapel
Designer Susanna Barrett
Photographer Daniela Stallinger
Country United States

MERIT

SELF-PROMOTION
Pier Nicola D'Amico Film and Print
Select 51

Photographer Pier Nicola D'Amico
Country United States

MERIT

SELF-PROMOTION
Aviator

Photographer Dominique Thibodeau
Studio at. 47
Country Canada

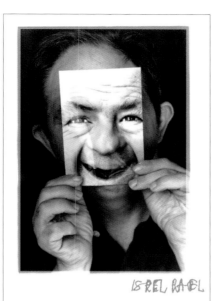

MERIT

SELF-PROMOTION

People from My Neighborhood

Art Director Tomek Sikora
Designer Your Design—Waciak
Copywriter Marek Grygiel
Photographer Tomek Sikora
Production Upstairs Young &
Rubicam Poland
Client Tomek Sikora
Country United States

MERIT

SELF-PROMOTION
AD Photo

Art Director Marc Atlan
Designer Marc Atlan
Photographer Marc Atlan
Client Marc Atlan
Country United States

MERIT

SELF-PROMOTION, SERIES
Cracked CD

Art Director Wang Wen Liang
Creative Director Wang Wen Liang
Designer Wang Wen Liang
Photographer Wang Wen Liang
Studio Leo Wang Studio
Country China

MERIT

SELF-PROMOTION, SERIES
Xavier Guardans Promo

Designer Michael Tashji
Photographer Xavier Guardans
Agents Liz Leavitt, Jeff Levine
Country United States

MERIT

SELF-PROMOTION, SERIES
Greek Cars

Photographer René Van Der Hulst
Country The Netherlands

MERIT

SELF-PROMOTION, SERIES
Teens

Photographer David Harry Stewart
Digital Work C. Michael Frey
Country United States

MERIT

SELF-PROMOTION, SERIES
View

Designers Brad Ruppert, Studio G
Photographer Jim Krantz
Country United States

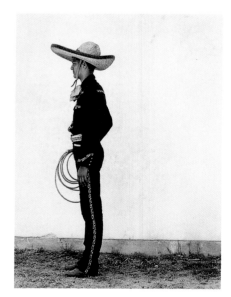

MERIT

SELF-PROMOTION, SERIES
The Traditional Life,
San Miguel de Allende, Mexico:
Three Girls • Cockfight • Caballero

Photographer Terry Vine
Country United States

MERIT

SELF-PROMOTION
Steffen Jahn Photography

Art Director Nic Zoeller
Photographer Steffen Jahn
Producer Druckerei Arnold
Client Steffen Jahn
Country Germany

MERIT

**CALENDAR OR APPOINTMENT
BOOK, SERIES**
The Mercedes-Benz Calendar 2001—
A History of Passion

Art Director Fritz Reuter
Photographer Dietmar Henneka
Producers Cornelia Bentel,
Hans-Georg Brehm
Agency Marketing Communication
Passenger Cars
Clients DaimlerChrysler AG,
Mercedes-Benz
Country Germany

MERIT

**CALENDAR OR APPOINTMENT
BOOK, SERIES**

Fantastic, Futuristic Architecture
Calendar

Art Directors Richard Fischer,
Bernhard Wipfler
Designer Michael Simon
Photographer Richard Fischer
Agency P-12 Rauenberg Germany
Client Edition Panorama
Country Germany

MERIT

**CALENDAR OR APPOINTMENT
BOOK**

F.A.Z. Calendar

Art Director Julia Schmidt
Creative Directors Petra Reichenbach,
Sebastian Turner
Photographer Alfred Seiland
Agency Scholz & Friends Berlin
Client Frankfurter Allgemeine Zeitung GmbH
Country Germany

MERIT

CALENDAR OR APPOINTMENT BOOK, SERIES

Data Morgana (Calendar for the University of Stuttgart)

Art Director Conny J. Winter
Photographer Conny J. Winter
Studio Studio Conny J. Winter
Country Germany

MERIT
POSTER OR BILLBOARD
Zinebi

Art Director Oscar Mariné
Photography Archive of Photonica
Client Festival International de
Cine Documental y Cortometraje
de Bilbao
Country Spain

MERIT

MISCELLANEOUS
Petronas Towers

Photographer George Apostolidis
Client Mandarin Oriental Hotel Group
Country Australia

MERIT

MISCELLANEOUS, SERIES
Mrs. Boehm

Photographers Oliver Sieber,
Katja Stuke
Publishers Oliver Sieber, Katja Stuke
Country Germany

‹lonely gay teen seeking same›

How Jeffrey found friendship, sex, heartache – and himself – online.
By Jennifer Egan

In the summer of 1999, when he was 15, a youth I will refer to by only his first name, Jeffrey, finally admitted to himself that he was gay. This discovery had been coming on for some time; he had noticed that he felt no attraction to girls and that he became aroused when showering with other boys after physical education class. But Jeffrey is a devout Southern Baptist, attending church several times each week, where, he says, the pastor seems to make a point of condemning homosexuality. Jeffrey knew of no homosexuals in his high school or in his small town in the heart of the South. (He asked that I withhold not only his last name but also any other aspects of his life that might reveal his identity.) He prayed that his errant feelings were a phase. But as the truth gradually settled over him, he told me last summer during a phone conversation punctuated by nervous visits to his bedroom door to make sure no family member was listening in, he became suicidal.

"I'm a Christian — I'm like, how could God possibly do this to me?" he said. "My mother's always saying, 'It'll be so wonderful when you meet that beautiful Christian girl and have lots of grandchildren,' and every time she said that, I was like, That's it: my life is going to be hell."

He called a crisis line for gay teenagers, where a counselor suggested he attend a gay support group in a city an hour and a half away. But being 15, he was too young to drive and afraid to enlist his parents' help in what would surely seem a bizarre and suspicious errand. It was around

Illustrations by Brian Cronin

LOL :)

I'm just so...tiredof being lonely

<out in cyberspace>

this time that Jeffrey first typed the words "gay" and "teen" into a search engine on the computer he'd gotten several months before and was staggered to find himself awash in a teeming online gay world, replete with resource centers, articles, advice columns, personals, chat rooms, message boards, porn sites and — most crucially — thousands of closeted and anxious kids like himself. That discovery changed his life.

"The Internet is the thing that has kept me sane," he told me. "I live constantly in fear. I can't be my true self. My mom complains: 'I can see you becoming more detached from us. You're always spending time on the computer.' But the Internet is my refuge."

Jeffrey and I met when he responded to an online message I posted, seeking gay teenagers willing to discuss their online lives. When we

online gay world using the "locate" feature on America Online, for example, which allows subscribers to find online "buddies" in whatever public chat room or other AOL area they happen to be visiting — a potential disaster for gay teenagers. A brainy, ebullient kid, Jeffrey is an excellent student, active in high-school government, with a number of close friends. He took a girl as his date to homecoming earlier this fall. But his free time belongs largely to the disembodied gay life he pursues online — from 8:30 p.m. to 2 a.m. during the school year, and for even longer stretches in summertime.

Jeffrey was hesitant to explore the online gay world at first, he said, certain he would somehow get caught. "I thought, Somebody's gonna get in my computer and find out," he said. "The paranoia was that bad." So he did the obvious

of his first name. A fellow Southerner a year older than Jeffrey whom Jeffrey called his "true love," though the two had never met, C. forgave him his online fabrications but pointed out that they complicated things. "After I told C.," Jeffrey explained, "he said, 'I still love you, but I don't know you.'"

For homosexual teenagers with computer access, the Internet has, quite simply, revolutionized the experience of growing up gay. Isolation and shame persist among gay teenagers, of course, but now, along with the inhospitable families and towns in which many find themselves marooned, there exists a parallel online community — real people like them in cyberspace with whom they can chat, exchange messages and even engage in (online) sex. The popularity of "cybering," as online sex is called — masturbating in real time to sexually explicit typed messages — has lately been supplemented (among boys, especially) with a mania for Web cams and microphones, which allow them to see and hear each other masturbate, using programs like Microsoft's NetMeeting. But this is only as important for gay boys as it no doubt is for the countless straight youths who flock to Internet sex sites. What was most critical to the gay kids I spoke with was the simple, revelatory discovery that they were not alone.

Indeed, gay teenagers surfing the Net can find Web sites packed with information about homosexuality and about local gay support groups and counseling services, along with coming-out testimonials from young people around the world. Gay pornography, too, can be a valuable resource; a number of youths I spoke with, male and female, said that the availability of online porn had proved critical to their discovery of their sexual orientation. Kyle, a 15-year-old youth from Florida I met online, wrote me an e-mail message: "What I did was go into gay chat rooms on AOL and ask where I could find free gay porno sites, my first gay porn I had ever seen. The pictures turned me on soooo much, and I loved it. It was just so clear to me, I am gay and I like men." I asked him how old he was when this happened. "I was about 11," he replied.

Parents' attempts to restrict their children's access to hard-core Web sites are rarely a match for their kids' surpassing computer skills. (Several teenagers I spoke with said they had accessed gay pornography on computers at school.) Which means that a curious teenager not only has ready access to graphic material,

‹ 'my mom complains: "i can see you becoming more detached from us. you're always spending time on the computer." but the internet is my refuge.' ›

were first getting to know each other, he made it clear that he could allow no overlap between his online gay life and the life he led in the "real world." He explained, "In our town, everybody knows everybody, and everybody knows everybody's business." He feared that if word of his sexual orientation were to reach his parents, they might refuse to support him or pay for college. From his peers at school he dreaded violence, and with good reason: according to a 1996 study of the Seattle public schools, one in six gay teenagers is beaten so badly during adolescence that he requires medical attention.

Jeffrey's computer is in his bedroom, garrisoned inside a thicket of codes and passwords. While he uses the Internet to communicate with high-school friends — Jeffrey is now 16 and a junior in high school — and to pursue his avid fandom of the group 'N Sync, he has separate screen names and "instant messaging" services for these activities. (An instant message, or I.M., allows two or more people to engage in a real-time dialogue on screen.) This way, no one from his "straight life" can track his forays into the

thing — the thing many Web pundits advise as a matter of safety when communicating with strangers online: he employed an alias, changed the town he came from and then threw in a few other "improvements" on his real identity. He said he came from a rich family, drove a BMW, had killer good looks and was 18 — old enough to cruise the adult gay chat rooms.

But as his online friendships deepened, the phony elements of Jeffrey's story began to oppress him: "I was like, I can't be myself in real life, and I come on the Internet and I still can't be myself. Yeah, I'm gay, but it's a lie." In June of this year, he mustered his nerve and began telling his online friends that he was not quite the person they had believed. "One of my really good gay friends has nothing to do with me now," he told me sadly one month after "coming out" online as his real self. "He has totally changed his e-mail, his screen name, everything. He was very protective of who he let close to him. He let me in, but he let in this false identity. When he found out, he blocked me." (To "block" someone is to preclude their being able to see whether you are online or send you instant messages or e-mail.)

By last summer, Jeffrey also had an online boyfriend, whom I will call C., the first initial

Jennifer Egan is a regular contributor to the magazine. Her novel "Look at Me" will be published next year.

Lonely Gay Teen Seeking Same

GOLD

MAGAZINE EDITORIAL, SERIES

Art Director Janet Froelich
Designer Catherine Gilmore-Barnes
Illustrator Brian Cronin
Country United States

< out in cyberspace >

and lesbians around the world (there are 122 chat rooms on the "youth floor" alone), with regional rooms for every state in America. The youth rooms are supposed to be restricted to those 17 and under, but in fact anyone can enter a youth room — I've done it numerous times — and unless older visitors blurt out something overtly abusive (which "bashers" sometimes do) or announce themselves as pedophiles, there is virtually no way to spot and block them.

There is plenty of frank sexual talk, which at times — evenings especially — makes up the bulk of conversation in the male teenage chat rooms, and to a much lesser extent in the lesbian teenage rooms. Chat-room occupants wishing to cyber together will usually switch to a "Pvt.," or a private chat session. There, they generally trade basic A.S.L. (age/sex/location) information, and then one or both will masturbate while typing messages to each other. Not all gay teenagers are into cybering; a number of the boys I met online complained that the pervasive sex talk eclipsed more substantive conversation. A 15-year-old named David wrote to me in an e-mail message, "There are thousands of nice, intelligent gay kids who hang back and don't talk much, while the small minority of people who are sex-crazed maniacs are also the loudest."

And even boys like P., who seem quite interested in cybering, tend to place it in a separate category from real-world relationships.

P.: I just made another online boyfriend yesterday. He asked me if I wanted to have a relationship with him.
Q: And what does "have a relationship" mean exactly?
P.: Um, cyber with him, support him.
Q: And what made you answer yes? Did you like him particularly?
P.: I don't care for him, so I won't care if I get dumped.
Q: But how can you have a relationship with someone you don't care about?
P.: It doesn't matter to me. It's just online anyway. I don't view it as real.

When I asked P. what he did view as real, he mentioned the boy he'd loved in sixth grade who moved away. P. has never seen that boy since, but they have communicated sporadically by phone and fax. "He's 99.9 percent of my life, everything else is that 1.1 percent," he typed. "Everything is microscopic compared to him. I think about him every day."

The prospect of older men preying on teenagers is a very real issue in the online gay community — though the problem is by no means limited to gays. Jeff Edelman, president of the Student Center, a Web community for college

students and high-school students, straight and gay, says that he worries equally about the danger of older men preying on young girls in the heterosexual chat rooms. And in lesbian teenage chat rooms, there is a recurrent suspicion that fellow "teenagers" might actually be straight men seeking out lesbian fantasies.

Among gay teenage boys, the attitude toward older men (known as oldies or sugar daddies) ranges from amusement to weary frustration over the fact that, rather than serving as friends and guides, the men seem to care only for sex. One boy I spoke with told me about an older man who'd tracked him down in his hometown after a conversation on the Internet. The boy eventually filed a restraining order against the man and still worries that he will be stalked again.

But most of the run-ins I heard of between teenage boys and older men were less aggressive than that and ranged in tone from consensual to creepy. Kyle, the 15-year-old from Florida, told me about an online relationship of several weeks he had with a fellow 15-year-old who later admitted he was actually 30 and married, with three children of his own. "He even had a picture of himself," Kyle marveled in an e-mail message. "Come to find out, that picture was his godson, really sick! He seemed to know everything about teen life, like he knew what clothes were popular, and how we talked, stupid abbreviations like Phat for cool.... He seemed so real. I would have never guessed."

Ultimately, the man confessed. "He told me he had been lying to me about a FEW things," Kyle wrote. "When I read that, my stomach about dropped to my knees. I flipped. Here I was trusting him with every word I typed, and he LIED about everything. It was a huge shock."

Unlike most of the kids I met, Kyle is out to his parents and his peers. Online, he impressed me as a cheerful and well-adjusted kid — in a picture he e-mailed me, I was struck by his broad grin and sharp, all-American looks. His mother, while accepting his sexuality, has been adamant that he not become involved with an other boy, Kyle told me. "She was always fine with me seeing girls, but after I came out, she told me no boyfriends until I was 18," Kyle wrote. "I love my mom more than anyone in the world, but I will go behind her back."

After recovering from the shock of the 30-

year-old's posing as a teen, Kyle began an online relationship this past summer with a 16-year-old named Brad, whom he described to me as "the sweetest, nicest guy I had ever met online." He went on to write: "It's weird, we were talking the other day about what we thought was really hot. We both agreed that we thought sitting home and hanging out watching TV or playing board games was a really big turn on."

Kyle and Brad moved from instant messaging to the telephone, and Brad, who lives 10 miles away, was pushing for a face-to-face meeting. Kyle was reluctant. "I can't figure out why I don't want to meet him," he wrote to me. "Maybe I am so afraid of him not liking me. It would be my first physical relationship."

In fact, there are excellent reasons for Kyle's reluctance, and Web sites geared toward gay youth abound with precautions for those who insist on meeting face to face with people they know only through the Net: be sure to meet in a public place; take a friend along or make sure someone knows where you're going; never get in anyone's car. Nonetheless, a majority of gay teenagers I spoke with had met at least one person they had gotten to know over the Internet. (Among lesbian teenagers, real-world meetings seem to be less common.) Some had formed permanent relationships; others had hooked up with older men and had sex — sometimes safe sex, other times not.

A young man I corresponded with who advises gay teenagers through the Gay Student Center Web site recommends viewing multiple pictures of a person before actually meeting, and ideally, speaking to them via Web cam to make sure that picture and person match up. "This I learned the hard way," he wrote in an e-mail message. "I was about 17 and decided I wanted to meet this 'kid' that I met online. I went to the local coffee shop to see my 17-year-old 5-9 blue-eyed stud turn into a 49-year-old, 300-pound dud He definitely passed himself off as a teen online, he was into the teen scene and was up-to-date. I walked out without speaking to him."

Of course, there is no way to make sure that the picture you've been sent is of the person you've been talking to; pictures of cute teenagers are floating all over the Net, and even some teenagers themselves admit that they've co-opted pictures of total strangers and pretended to be those people for online sexual encounters. According to the Gay Student Center adviser I exchanged e-mail with, plenty of pictures are simply fake. "If the picture looks too good to be true, then it probably is," he said, "especially if they only have one picture and it's really high quality." He also urges teenagers to pay attention to typing and spelling skills; "oldies" (whom he defines as over 40) are usually better typists and spellers than teens.

ADVISER: If you don't mind me asking. ... How old are you? LOL:). [:) and :o) are smiley faces; :(and :o(are sad faces.]
EGAN: 16 — can't you tell?
ADVISER: LOL :).
ADVISER: Nah, I would say about 26 (seriously).
EGAN: Actually, 38!? Almost an oldie.
ADVISER: WOW! I was off. See how the Net hides that?
EGAN: Yep.
ADVISER: Could have got me out on a date. ... LOL :).
ADVISER: Except I am gay! LOL :).
ADVISER: Of course for all I know you're a man!

When Kyle finally met Brad at the beginning of October, after months of online conver-

< they had dinner at a mall and shopped at the gap and at old navy. at the end of the evening, they kissed, something jeffrey had never done before. >

sation, he encountered the person he'd expected to encounter, sort of. He sent me an instant message that same day:

KYLE: I met Brad today, it was cool.
Q: Were you nervous?
KYLE: Oh, yeah, very! I tried to be perfect in every way. I don't think I have ever spent so much time styling my hair, LOL. We arranged it at a restaurant near me. It was walking distance.
Q: And did he look the way you expected?
KYLE: Ummm, he was definitely a little different from his picture. He had a different haircut, skinnier than I expected, and his face looked a little different all together.
Q: Did he seem more attractive or less so, at first?
KYLE: At first, he seemed less attractive, but as time went on, he started to look more attractive to me.
Q: And what did you talk about?
KYLE: Just about everything. Clothes, back-to-school, friends, parents, the food, the restaurant, anything really.
Q: What did you think of him, in the end?
KYLE: Before I met him, I had a list of the pros and cons of him. Cons: He seems very stuck up, rich, and has an attitude, and can be rude sometimes. Pros: Nice, good-looking, good sense of

humor and a good personality. But when meeting him today, I had one more con: he was a somewhat femmy guy.
Q: Hmmm. So how does that change your feelings about him, if at all?
KYLE: Ummm, I think of him now as more stuck up than I thought originally, and the way he dresses was COMPLETELY different than what I thought. Like he wore a DKNY shirt that was very gay-looking with the buttons starting way down, so you could see some chest.
Q: Now what's this about him being rude and stuck up? In what way?
KYLE: Like he feels that if you shop at Old Navy, you are a lower class. And he isn't very nice to strangers. He was somewhat rude to the waiter. I don't recall him ever saying thank you.
Q: Are you still interested in a relationship with him?
KYLE: Ummm, I don't really know. My immediate reaction when I saw him was a HUGE flamer and somewhat rude, but I still was interested. As these hours go by, I seem to be less and less interested.

A week later, Kyle wrote in an e-mail message: "Brad and I haven't called or talked since the meeting. When we are online, we don't chat either. I honestly don't know if we'll ever talk again."

They didn't talk again. But shortly thereafter, the indefatigable Kyle placed a personal ad on PlanetOut, a gay and lesbian Web site, seeking male teenagers in his region of Florida for a relationship. "I am really hoping that by the end of sophomore year, I will at least have kissed a guy, LOL," he wrote. "I am just so tired of being lonely."

Toward the middle of August, I e-mailed Jeffrey and didn't hear from him again; nothing. This is not especially unusual — one fallibity of Web communication is that people sometimes disappear abruptly. A number of my teenage correspondents faded away without warning — P., for example, the Latino boy in the Midwest, whose e-mail address suddenly ceased to work, leaving me to wonder, futilely, whether he'd changed it to avoid his 40-year-old admirer.

Vanishing friends and intimates are frequent laments among gay teenagers. L. B., a 13-year-old from a Middle Atlantic state, had an online relationship with a 15-year-old boy who he says provided him with enormous guidance and support. L. B. had called Continued on Page 128

< out in cyberspace >

but also can engage in sexual experimentation with peers that would be next to impossible in everyday life. As one 13-year-old put it in an e-mail message, "I could say that the Internet made my life a living hell. ... It made me realize I'm different. I hated it ... but then I realized the Net helped me realize I'm gay. ... I'd rather find out now than when I'm 30 and married to my wife with two kids or something."

Recent studies suggest that kids are identifying themselves as gay at much younger ages; among males the average age has dropped from 19-21 to 14-16, and in females from their early 20's to 15-16. Caitlin Ryan, a clinical social worker and the author of "Lesbian and Gay Youth: Care and Counseling," says, "Today, youths are coming out right in the middle of high school or earlier, and I think the Internet is playing an important role in that because it's providing information to help them label their feelings and figure out who they really are."

One might reasonably ask whether such heightened early awareness of sexual orientation is always a good thing. And for all the educational resources the cyberworld can offer gay youth — articles and studies and hot-line numbers and so on — the gay-sex cyberworld, like the much larger straight-sex one, is not an especially wholesome environment in which to tease apart one's sexuality. Type the words "gay" and "teen" into virtually any search engine, and you'll find yourself circling among interlocking porn sites, some featuring "twinks," or boys of allegedly legal age who appear to be younger (and in some cases obviously are), and other sites hawking lesbian scenes that clearly cater to heterosexual men. And of course, there is the simple fact that cyberspace is an incorporeal world, a world without flesh-and-blood people, and thus a peculiar realm in which to become one's "true self," as Jeffrey put it.

"The Internet is an inferior substitute for real-live human beings," says Kevin Jennings, executive director of the Gay, Lesbian and Straight Education Network, a national organization working to end antigay bias in schools. "But it's frankly better than nothing, which is what gay youth have had before."

LATE LAST SUMMER, JEFFREY RETURNED FROM a family vacation and wrote to me in an e-mail message: "We had such a great time, yes I missed my Internet so much. I had 'withdrawal' symptoms, you might even say ... LOL," (The abbreviation "LOL" is cyberspeak for ha-ha, i.e., "laughing out loud.") "I did contact my boyfriend, and using eVoice we were able to set up a time where I could call him or vice versa." (EVoice is an online voice messaging system.)

Online boyfriends and girlfriends were com-

mon among the gay teenagers I spoke with. In some cases, the relationships had a sexual component, but what startled me was the level of closeness and intimacy teenagers derived from these cyberrelationships. Jeffrey explained how he and C. sustained their intimacy without ever meeting. "We were in search of things we could do and share that were very personal and very intimate," he said. "We'd come up with little nicknames and little jokes between ourselves." They planned to attend the same college, he said, and had even discussed marriage and the adoption of children.

Like Jeffrey, many of the boys I talked to described themselves as "addicted" to the Internet. Girls, who responded in smaller numbers to my postings, seemed more aware of the Internet's

< 'he's like, "i'm sorry, things change."' jeffrey was haunted by the possibility that what had changed was the fact that he finally sent him a picture of himself. >

limitations. They were also more likely to have at least one off-line confidante — a parent, a friend, even several friends — who knew about their sexual orientation and accepted it. In the case of Jane, a 13-year-old African-American girl I met online, her mother knows, but with one exception her friends don't, and she's quite lonely in her eighth-grade class.

"The only word I can think of to describe it is small," she wrote in an e-mail message last summer. "People seem to be pretty narrow-minded. ... It's hard finding a niche anywhere. Even so I mostly hang around with the popular crowd. ... I'm not trendy. I mean I don't wear sweater sets. LOL."

Online, Jane, who says she has known she was gay since the fifth grade, has been able to find a number of lesbian girls her own age. "I have at least five people on my buddy list that are 13," she said. "The longest going thing I have is with my girlfriend. We've known each other online for 9 or 10 months." Like Jeffrey and C. Jane and her girlfriend, who lives four hours away, had not met. "In ways it's the same as a face-to-face relationship," Jane explained in one e-mail message, adding, "The only difference being that we don't see each other."

When I asked Jane whether having an online girlfriend — whom I will call S. — would keep

her from pursuing a relationship with someone she met in person, she wrote, "I would probably be at a crossroad because S. means so much to me. Ya never know tho."

A week later, Jane mentioned in an instant message that she and S. had broken up.

Q: You've broken up?
JANE: Yes. LOL. ... We fought a lot and I guess we both just lost interest.
Q: That's funny. I never had the impression you were fighting. How do you fight by e-mail?
JANE: We fight through instant messaging, it's quicker that way. LOL.
Q: Can you give an example of something you would fight about?
JANE: We would fight about no trust in the rela-

tionship, not talking, etc., etc. We never had anything to say to each other.

Soon after, Jane mentioned in another instant message she sent that she and S. were still talking nearly every day.

Q: Then it sounds the same as before.
JANE: Before ... meaning?
Q: Before you broke up.
JANE: No, we really didn't talk then. We never had much to say to each other.
Q: Do you think you might get back together?
JANE: Oh, heavens no. ... I don't work the first time. I don't know how it could a second.
Q: But it seems as if part of the problem was that you weren't communicating, and now you ARE communicating.
JANE: True, but neither I nor she is interested.

Two months later, as school began, Jane wrote to me: "S. e-mailed me earlier today saying she didn't think she was gay and that it was probably just a phase. Where does the drama end?"

The drama doesn't end, of course; these are teenagers. The remarkable thing is that via the Internet, gay teenagers are now able to partake of the normal Sturm and Drang of adolescent life, which before was largely off limits to them.

"Now that we have youth who are coming out during adolescence, that means they can experience the normal developmental milestones in time as opposed to off-time," says Caitlin Ryan. "If you have to delay being an adolescent until later in life, I don't think it's a healthy thing."

Jeffrey told me once, speaking of his relationship with C: "I think it's almost like an accelerated relationship. You can't go out to the movies, so there's nothing to fill the space. You have to talk. It creates this intimacy between you; it draws you closer. Our relationship isn't based on

looks or financial status or anything physical. There's no space fillers, because you can't just sit there for 15 minutes and not say anything."

And while language itself seems to buckle against the vagaries of online experience — phrases like "I met ..." and "I talked to ...," are too easily confused with RL (real life) — there is something of the schoolyard and the mall in the hours of hanging out that many teenagers, gay and straight, do on their computers each night. To understand the texture of this online loitering, I got in the habit of asking gay teenagers what they

had on their screens at a particular moment — it was usually some combination of homework, e-mail, games, browser searches, chat rooms and, most of all, instant-messaging sessions — often several at one time. The resulting dialogues tend to be fragmented and disjointed, like a hybrid of a telegram and an overseas phone call.

At 12 o'clock one evening in October, I was in an instant message conversation with P., a 13-year-old Latino boy from the Midwest, and asked him what he had on his screen. "Umm," he typed, "a naked pic, couple I.M.'s and a private chat room." Which was nothing, he hastened to assure me, compared with the feats he'd performed soon after discovering the online gay world a year ago. "The first few weeks I went sex-crazy," he typed. "I cybered every night, with like five guys at once."

P. is a palpably lonely kid who admits that in the real world, he speaks in such a soft voice that people often can't hear him and spends the better part of his weekends asleep. "About three-fourths of the people my age don't like me because I act gay and stuff," he wrote me in one instant message. "I have no male friends whatsoever." Two years ago, when he was in the sixth grade of the public school he still attends, P. fell in love with another boy who briefly reciprocated his feelings then moved away, leaving P. feeling suicidal. Soon after, he discovered the online gay world, which he explores clandestinely on his mother's computer, carefully deleting his "history," or the list of sites he has visited, along with the pornographic pictures he trades with older boys. Now an eighth grader, he is online several hours each day.

Early on in our correspondence, P. told me by e-mail, "Well, right now the 40 y.o. guy says he loves me so much. ... He keeps pestering me to meet him, he just doesn't get the hint, but I don't like using the ignore button so I just put up with it. ... He said one day in the future he wanted to drive over here and take me to some hotel and spend the night together. I refused his offer. You can tell that I feel sorry for him."

P. met this older man in a chat room — he can't remember if it was a teen room or an adult one. It could have been either; teenage boys often visit adult chat rooms to meet older men (a number mentioned to me a wish to find an older gay man who would serve as a mentor or a role model), and older men notoriously troll the teen chat rooms, sometimes pretending to be teenagers themselves. Among the most popular chat rooms are those at Gay.com, a massive site offering hundreds of virtual "rooms" for gay men

American Illustration 19 Cover

SILVER

BOOK JACKET

Art Director Tom Brown
Designer Tom Brown
Illustrator Brian Cronin
Assistant Designer Jenn Roberts
Studio tba & d
Client Amilus, Inc.
Country United States

Multiple Awards
(see also Graphic Design)

DISTINCTIVE MERIT

MAGAZINE EDITORIAL, SERIES
Couture Voyeur

Art Director Janet Froelich
Designer Claude Martel
Illustrator Maira Kalman
Country United States

MERIT

BOOKS
The Risko Book

Art Director Michael Bierut
Designers Michael Bierut,
Brett Traylor
Illustrator Robert Risko
Client Monacelli Press
Country United States

MERIT

MAGAZINE ADVERTISEMENT
Holiday Ad

Chief Creative Officer Ron Lawner
Group Creative Director Alan Pafenbach
Art Director Don Shelford
Copywriter Carl Loeb
Illustrator Harry Bliss
Production Manager Stephanie Kaiher
Printer Unigraphics
Agency Arnold Worldwide
Client Volkswagen of America, Inc.
Country United States

MERIT

MAGAZINE ADVERTISEMENT
Louder Than Words

Art Director Frank Maddocks
Illustrator Kay Sung-in Chung
Client Warner Brothers Records
Country United States

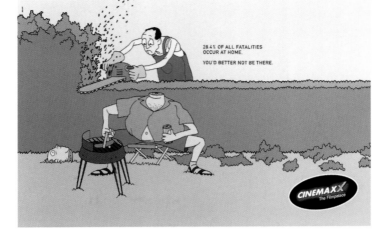

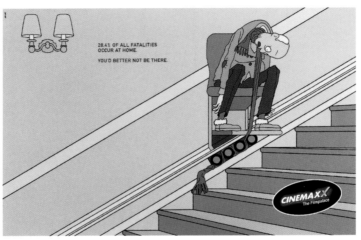

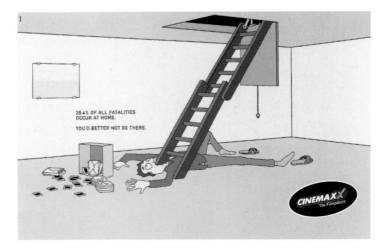

MERIT

**MAGAZINE ADVERTISEMENT,
CAMPAIGN**

Fatalities Campaign:
Hedge • Stairlift • Hatch

Art Directors Raphael Milczarek, Christian Reimer,
Hans Weishaupl

Creative Directors Niels Alzen, Thim Wagner

Copywriters Willy Kaussen, Jens Daum

Illustrator Felix Reidenbach

Agency Jung von Matt Werbeagentur GmbH

Client H.-J. Flebbe Filmtheater/CinemaxX

Country Germany

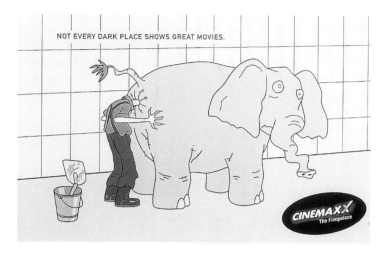

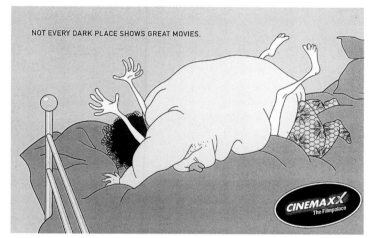

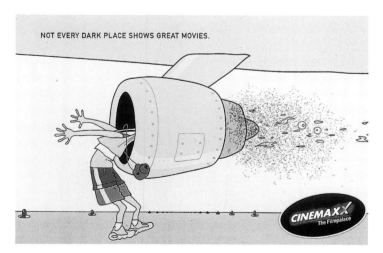

MERIT

**MAGAZINE ADVERTISEMENT,
CAMPAIGN**

Dark Campaign:
Elephant • Sex • Turbine

Art Directors Holger Bultmann, Christian Reimer
Creative Directors Niels Alzen, Thim Wagner
Illustrator Felix Reidenbach
Copywriter Niels Alzen
Client H.-J. Flebbe Filmtheater/CinemaxX
Agency Jung von Matt Werbeagentur GmbH
Country Germany

MERIT

MAGAZINE EDITORIAL
Life/Work—November 2000

Design Director Patrick Mitchell
Designer Kristin Fitzpatrick
Illustrator Laurent Cilluffo
Client Fast Company
Country United States

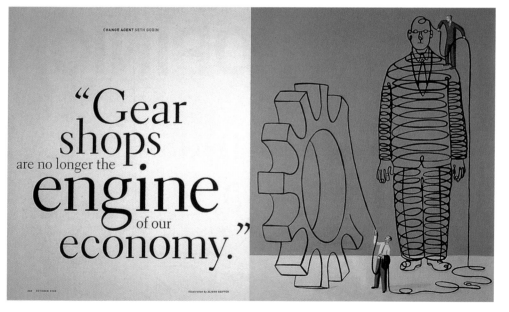

MERIT

MAGAZINE EDITORIAL
Change Agent—October 2000

Design Director Patrick Mitchell
Designer Kristin Fitzpatrick
Illustrator Alison Seiffer
Client Fast Company
Country United States

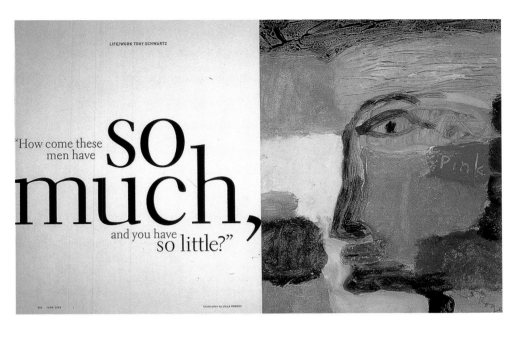

MERIT

MAGAZINE EDITORIAL
Life/Work—June 2000

Design Director Patrick Mitchell
Designer Kristin Fitzpatrick
Illustrator Lilla Rogers
Client Fast Company
Country United States

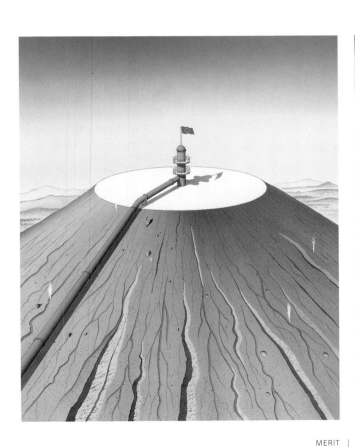

MERIT

MAGAZINE EDITORIAL
Volcano

Art Director Dick Barnett
Illustrator Guy Billout
Client Worth Magazine
Country United States

Multiple Awards
(see also Graphic Design)

MERIT

MAGAZINE EDITORIAL
Gore Opener—October 2000

Design Director Patrick Mitchell
Designer Julia Moburg
Illustrator Philip Burke
Client Fast Company
Country United States

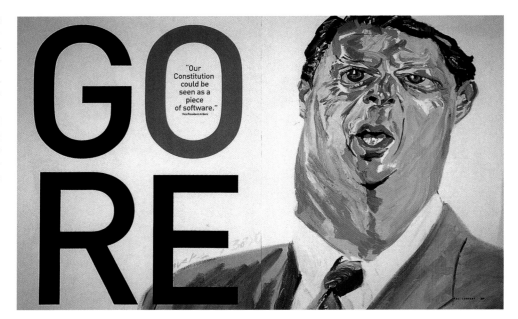

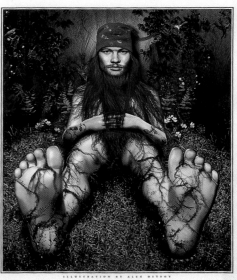

MERIT

MAGAZINE EDITORIAL
Axl Rose—The Lost Years

Art Director Fred Woodward
Illustrator Alex Ostroy
Designer Gail Anderson
Client Rolling Stone
Country United States

MERIT

MAGAZINE EDITORIAL
Prometheus

Art Directors Robin Gilmore Barnes,
Judy Garlan
Illustrator Guy Billout
Client The Atlantic Monthly
Country United States

MERIT

MAGAZINE EDITORIAL
Notorious B.I.G.

Art Director Fred Woodward
Illustrator Jason Holley
Client Rolling Stone
Country United States

What if
the odds of emerging from your doctor's office hale and hearty ran two-to-one against you? We'd be a nation swamped with shamans instead of surgeons. Fortunately, a visit to the doctor is generally nothing to fear. But your PC's trip to the repair shop may be another matter.

That's the sorry conclusion we must draw from our investigation of the state of PC repair. (We were joined for portions of our research by an under-cover team from the TV newsmagazine *Dateline NBC*, researching its own feature on the topic.) When we first tackled this topic back in 1998 (see www.pcworld.com/apr98/repair), we encountered sloppy technicians, unnecessary repairs, and rampant rudeness. Two years later, have matters improved? Sadly, the more things change, the more they stay the same.

In all, we did business with 18 repair stores in six states. A dozen of these stores were branches of three national chains—Best Buy, Circuit City, and CompUSA—which together boast over 1200 outlets nationwide. This time we extended the investigation to include 6 mom-and-pop–style shops in as many cities across the country. We wanted to see if independent stores live up to their reputation of offering better customer service than the chains.

Chain retailers and independents don't exhaust your service options. Man-ufacturers that sell PCs directly, such as Dell and Gateway, handle repairs themselves, often via on-site service. And if you work in a medium-size or large company, you probably call on your IS department for help. But national chains and local computer shops remain a primary repair choice for consumers, especially for PCs bought at retail and those out of warranty.

Judging from our findings, that's terrible news. For every store that solved our problems quickly, courteously, and competently—and some did—more dropped the ball. When we left malfunctioning PCs for repair, half of ▶

PC Repair
Undercover BY GREGG KEIZER

Over half the repairs in our investigation were botched or overpriced. Here's how to protect yourself when your computer goes to the shop.

118 **PC WORLD** / AUGUST 2000 ILLUSTRATIONS BY JORDIN ISIP

MERIT

MAGAZINE EDITORIAL
PC Repair Undercover

Art Director Beth Kamoroff
Creative Director Robert Kanes
Designer Beth Kamoroff
Illustrator Jordin Isip
Client PC World
Country United States

MERIT

MAGAZINE EDITORIAL
The Emperor's New Pose—
Jim Carrey

Illustrator Edmund Guy
Client Entertainment Weekly
Country United States

MERIT

MAGAZINE EDITORIAL
Going Out Alone Is Great!

Art Director Sylvie Durand
Illustrator Nathalie Dion
Copywriter Editions
Transcontinentales
Client Coup de Pouce
Country Canada

MERIT

MAGAZINE EDITORIAL
Digital Matters—July 2000

Design Director Patrick Mitchell
Designer Kristin Fitzpatrick
Illustrator Guy Billout
Client Fast Company
Country United States

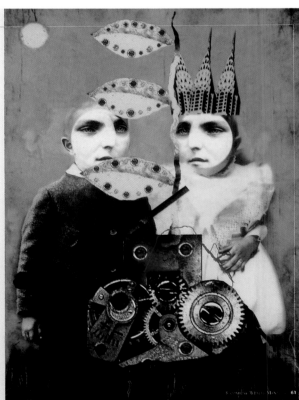

MERIT

MAGAZINE EDITORIAL, SERIES

Packing It In

Art Director Laura Zavetz
Designer Beatrice McDonald
Illustrator Micheal Morgenstern
Client Bloomberg Wealth Manager
Country United States

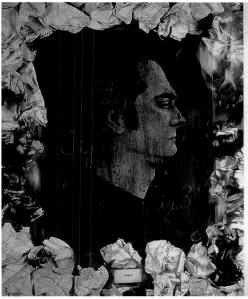

"Emotional intelligence" is starting to find its way into companies, offering employees a way to come to terms with their feelings—and to perform better. But as the field starts to grow, some worry that it could become just another fad. The real question is

"How do you feel?"

BY TONY SCHWARTZ ILLUSTRATIONS BY CYNTHIA VON BUHLER

MERIT

MAGAZINE EDITORIAL
Emotional Intelligence—June 2000

Design Director Patrick Mitchell
Designer Julia Moburg
Illustrator Cynthia Von Buhler
Photo Coordinator Alicia Jylkka
Client Fast Company
Country United States

ILLUSTRATION EDITORIAL

411

Appreciation, apprehension, defensiveness, inadequacy, intimidation, resentment.

Twenty mid-level executives at American Express Financial Advisors are gathered in a room at a conference center outside Minneapolis. Each has been asked to try to convey a specific emotion—by reading a particular statement aloud. The challenge for listeners is to figure out which emotion each speaker is trying to evoke. It seems like a relatively straightforward exercise but only a fraction of the group comes anywhere close to correctly identifying speakers' emotions.

"I sometimes wish I had a corporate decoder for each relationship," one woman laments. "It's very hard to know what people are feeling in my office and how I should respond." Her comment prompts a discussion about the difficulty in the workplace of finding a balance between reasonable openness and respectful discretion.

"When one of my direct reports starts talking to me about her medical problems, I don't want to be unsympathetic, but it makes me very uncomfortable," says a male department head. "I find myself joking by saying to her, 'Too much information.' But I'm not really sure how to get the message across."

Conversations like that one, focusing on the importance of emotions in the workplace, are occurring with greater frequency in all kinds of American companies. Inside American Express, training sessions on emotional competence take place at the Minneapolis facility several dozen times a year. An unlikely pioneer in the field of emotional competence, AmEx launched its first experimental program in 1992. An eight-hour version of the course is now required of all of its new financial advisers, who help clients with money management. During a four-day workshop, 20 participants are introduced to a range of topics that comprise an emotional-competence curriculum, including such fundamental skills as self-awareness, self-control, reframing, and self-talk.

Much of that material represents new territory for these business-people. "The majority of those we work with are very cognitive and not very experienced with emotions," explains Darryl Grigg, a psychologist who practices in Vancouver, British Columbia and conducts about 20 workshops each year for AmEx and other organizations. "We're introducing people to a whole new language."

Most attendees of these emotional-competence workshops are compelled to learn a new language for one simple reason: They're visiting a foreign land. Over the past 50 years, large companies have embraced a business dictum that told workers to check their emotions at the door. A legacy from the days of The Organization Man and The Man in the Grey Flannel Suit, this never-spoken but widely shared policy reflected the sensibility that frowned on employees who brought messy emotions and troubling personal issues to work.

Employees, for their part, complied with that prevailing mindset. Until recently, the workplace was dominated by male employers—and most of them were just as eager as their employees were to avoid the ambiguous complications and unexplored terrain of personal feelings.

One notable exception to that tacit pact occurred in the 1970s and early 1980s, when the influence of the human-potential movement prompted a brief corporate romance with such experiential techniques as sensitivity training and encounter groups. But those approaches lacked the rigor to endure. Before long, business got back to business. A backlash set in, and the focus returned to no-nonsense training methods that were highly quantifiable, happily free of emotions, and demonstrably able to produce results that would show up on the bottom line.

Today, more than 20 years later, companies in a variety of industries are once again exploring the role of emotions in business. This renewed interest in self-awareness is, in part, the result of the rising corporate power of baby boomers. The increasing presence of women in the workplace and the higher comfort level they bring to the territory of emotions have also nudged companies in this direction. And the arrival of the new economy has made companies realize that what they need from their workers goes beyond hands, bodies, and eight-hour days.

While the field of emotional competence appears to have emerged overnight, it has, in fact, been 15 years in the making. In 1985, Reuven Bar-On, 56, a psychologist who practices in Israel, first coined the term "emotional quotient," or EQ. Bar-On had moved to Israel at age 20 and became interested in the field while studying for his PhD in South Africa. "A ly simple—almost simplistic—question in the beginning was, 'Are there factors that determine one's ability to be effective in life?'" he explains. "Very quickly, I saw that people can have very high IQs, but not succeed. I became interested in the basic differences between people who are more or less emotionally and socially effective in various parts of their lives—in their families, with their partners, in the workplace—and those who aren't." For his thesis, Bar-On identified a series of factors that seemed to influence such success. He then developed a tool that assessed strengths or deficits, based on those factors. (See "My EQ: The Good News and the Bad News," page 302.)

A diminutive, bearded man with a genial style, Bar-On, now a research fellow at Haifa University, is a meticulous researcher who has gathered more scientifically validated data worldwide about emotional intelligence than anyone in his field has. His work has

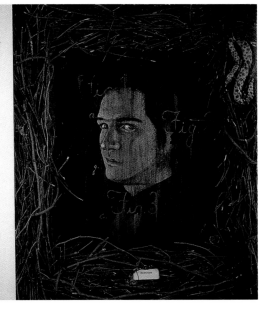

recently focused on developing EQ "profiles," which reveal the specific competencies that characterize high performers in a range of professions. In 1996, he launched the EQi, a self-administered test designed to assess specific emotional competencies. Companies and organizations, from the Bank of Montreal to Fannie Mae to the Toronto Maple Leafs, have used his test to assess job applicants. "To measure emotional intelligence is to measure one's ability to cope with daily situations and to get along in the world," argues Bar-On, whose test is marketed through Toronto-based Multi-Health Systems. "I've conceptualized emotional intelligence as another way of getting at human effectiveness."

But if Bar-On pioneered the field, Daniel Goleman, 54, formerly a behavioral- and brain-sciences writer for the New York Times, brought it to popular attention. Drawing on the work of two academic psychologists, John D. Mayer and Peter Salovey, Goleman published Emotional Intelligence (Bantam, 1995). The book became an instant best-seller—with more than 5 million copies in print worldwide—and sparked inevitable criticism from Mayer and Salovey, who believed that Goleman distorted their work and made sweeping claims about the benefits of emotional intelligence.

Goleman has gone on to advance the case for emotional competence in the workplace. He published a second book, Working with Emotional Intelligence (Bantam, 1998), aimed specifically at business-people. He then authored two articles for the Harvard Business Review. He also coedited a forthcoming book of essays written by leaders in the field, cofounded the Consortium for Research on Emotional Intelligence, a group of academics and businesspeople with interest in the field. Later, he began working with the Hay Group, a Philadelphia-based consulting firm that specializes in human-resources issues, to deliver emotional-intelligence training.

All of this should come as welcome news to residents of the new economy. Companies can continue to give top priority to financial performance—but many now also realize that technical and intellectual skills are only part of the equation for success. A growing number of organizations are now convinced that people's ability to understand and to manage their emotions improves their performance, their collaboration with colleagues, and their interaction with customers. After decades of businesses seeing "hard stuff" and "soft stuff" as separate domains, emotional competence may now be a way to close that breach and to produce a unified view of workplace performance.

But like other good ideas that started in psychology and later found new applications in business, emotional competence is confronting the challenge of its own sudden popularity. Increasingly, emotional competence is being sold as a solution to each of the categories for which companies have training budgets, from leadership to motivation to leveraging diversity—competencies that are emotional only by the most ambitious of stretches. The emerging field has sparked the almost inevitable scramble to cash in on the spreading claims of its potential applications.

As emotional competence grows in application, so do the questions: Are these new dimensions of emotional competence genuine and verifiable categories? Can they be effectively taught and measurably improved? And what is the risk that emotional competence will veer badly off course and end as the next short-lived fad?

AMEX'S EMOTIONAL-INSURANCE POLICY
It's difficult to imagine a less likely setting for a training program on emotions than American Express—that buttoned-up, by-the-numbers, financial-services giant, which last year had more than $21 billion in sales. In fact, the company launched its program in 1992 as a possible solution to a simple business problem that defied a logical solution. More than two-thirds of American Express clients were declining to buy life insurance, even though their financial profiles suggested a need for it. Jim Mitchell, then president of IDS, American Express's Minneapolis-based insurance division, commissioned a skunk-works team to analyze the problem and to develop a way to make life insurance more compelling to clients.

The team's findings took the company in an unexpected direction. The problem, the team discovered, wasn't with AmEx's product—or even with its cost. Put simply, the problem was emotional.

Using a technique called "emotional resonance," the team identified the underlying feelings that were driving client decisions. "Negative emotions were barriers," explains Kate Cannon, 51, formerly an AmEx executive who eventually headed the team and whose interest in the role of emotions in the workplace was in part sparked by her background in mental-health administration. "People reported all kinds of emotional issues—fear, suspicion, powerlessness, and distrust—involved in buying life insurance."

But the team's second finding proved the clincher: The company's financial advisers were experiencing their own emotional issues. "All kinds of stuff going on was holding them back—feelings of incompetence, dread, untruthfulness, shame, and even humiliation," explains Cannon. The result was a vicious cycle. When

MERIT

MAGAZINE EDITORIAL, SERIES
Divide and Conquer

Art Director Laura Zavetz
Designer Beatrice McDonald
Illustrator Jason Holley
Client Bloomberg Wealth Manager
Country United States

MAGAZINE EDITORIAL, SERIES
Learning Respect—Sexual
Harassment in Schools

Art Director Leslie Heimbaugh
Illustrator Jon Krause
Client Central Pennsylvania Magazine
Country United States

ILLUSTRATION EDITORIAL

413

MERIT

MAGAZINE EDITORIAL, SERIES

Fast Pack 2000—March 2000

Design Director Patrick Mitchell
Designer Emily Crawford
Illustrator Adrian Tomine
Client Fast Company
Country United States

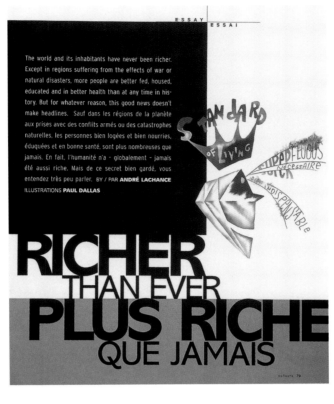

The world and its inhabitants have never been richer. Except in regions suffering from the effects of war or natural disasters, more people are better fed, housed, educated and in better health than at any time in history. But for whatever reason, this good news doesn't make headlines. Sauf dans les régions de la planète aux prises avec des conflits armés ou des catastrophes naturelles, les personnes bien logées et bien nourries, éduquées et en bonne santé, sont plus nombreuses que jamais. En fait, l'humanité n'a - globalement - jamais été aussi riche. Mais de ce secret bien gardé, vous entendez très peu parler. BY / PAR **ANDRÉ LACHANCE**
ILLUSTRATIONS **PAUL DALLAS**

RICHER
THAN EVER
PLUS RICHE
QUE JAMAIS

MAGAZINE EDITORIAL, SERIES
Richer than Ever

Art Director Danielle Lebel
Designer Denis Paquet
Illustrator Paul Dallas
Agency Spafax Canada
Client Enroute/Air Canada
Country Canada

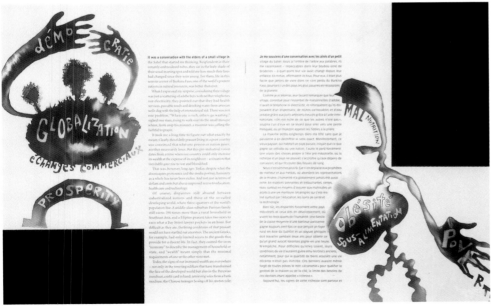

MERIT

MAGAZINE EDITORIAL, SERIES
Out from Under

Art Director Laura Zavetz
Designer Laura Zavetz
Illustrator Melinda Beck
Client Bloomberg Wealth Manager
Country United States

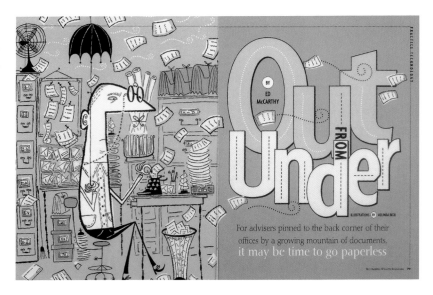

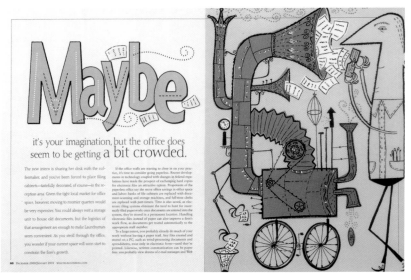

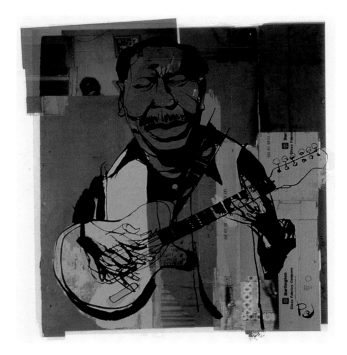

MERIT

NEWSPAPER EDITORIAL
Muddy Waters

Art Director Evan Gubernick
Illustrator P J Loughran
Client Guitar World
Country United States

MERIT

NEWSPAPER EDITORIAL, SERIES

Mobile Future

Art Director Brigitta Bernart-Skarek	
Illustrator Davor Markovic	
Client Der Standard	
Country Austria	

MERIT

NEWSPAPER EDITORIAL, SERIES

World of Innovation

Art Director Brigitta Bernart-Skarek	
Illustrator Davor Markovic	
Client Der Standard	
Country Austria	

MERIT

BOOK

New York's 50 Best Book Stores for
Book Lovers

Art Director Helene Silver
Designer Don Wise
Illustrator Tristana Maccio
Client City & Company
Country United States

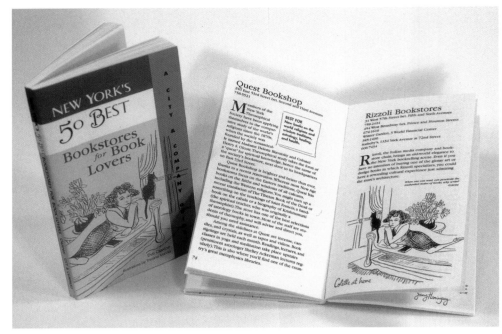

MERIT

BOOK JACKET

RESFEST Program Guide

Art Director Colin Metcalf
Designer Colin Metcalf
Illustrator Colin Metcalf, Ben Radatz
Agency RESFEST
Client RESFEST
Country United States

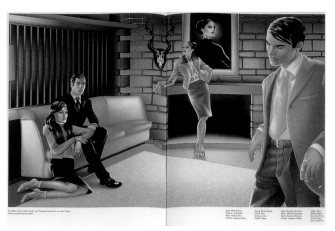

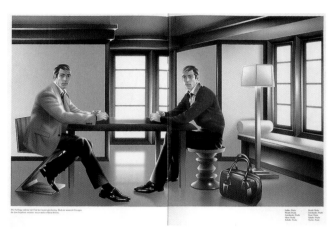

MERIT

CORPORATE/INSTITUTIONAL
Holy's Manual 6—Elaphidae. A
Deadly Bite.

Art Directors Alexander Stehle,
Tobias Ulmer
Illustrator René Habermacher
Copywriter Gordana Matusan
Agency Werbewelt, Ludwigsburg
Country Germany

MERIT

CORPORATE/INSTITUTIONAL
Kai in the Land of the
Ice Cold Angel

Art Director Sara De Pasquale
Creative Directors Ruth Holden,
Wolfgang Zimmerer
Designer Sara De Pasquale
Illustrator Griff
Copywriters Peter Buck,
Torsten Wirwas
Agency E-fact Limited
Client Oryx GmbH
Country United Kingdom

MERIT

CORPORATE/INSTITUTIONAL
Elle Spring/Summer Trend
Report, 2001

Art Director Robert Nolan
Designer Luis Vega
Illustrator Tanya Ling
Copywriter Coco Myers
Printer Dell Graphics
Studio Elle U.S.
Agency Elle U.S.
Client Elle U.S.
Country United Kingdom

420

MERIT

SELF-PROMOTION
Log Cabin Poster

Art Director Brian Stauffer
Designer Brian Stauffer
Illustrator Brian Stauffer
Studio Log Cabin Studio
Country United States

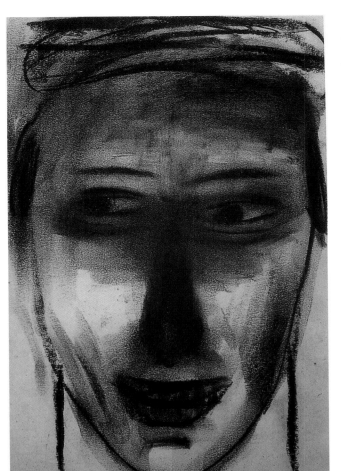

MERIT

SELF-PROMOTION
Moe's

Designer Ward Schumaker
Illustrator Vivienne Flesher
Client Vivienne Flesher
Country United States

MERIT

SELF-PROMOTION
Z.C. Sterling Art

Designer Pol Turgeon
Illustrator Pol Turgeon
Client Pol Turgeon
Country Canada

MERIT

SELF-PROMOTION, SERIES
Alphabet to the Letter

Art Director Mark Tellok
Illustrator Mark Tellok
Country Canada

MERIT

SELF-PROMOTION

You Have 70 Years: What Are You
Going to Do With It?

Art Director Mark Tellok

Illustrator Mark Tellok

Copywriter Benoit Bunico

Country Canada

MERIT

SELF-PROMOTION
Log Cabin Poster #2—Butterfly

Art Director Brian Stauffer
Designers Alina Stauffer, Brian Stauffer
Illustrator Brian Stauffer
Studio Log Cabin Studio
Country United States

MERIT

SELF-PROMOTION, SERIES
Issue 1, 2, 3

Art Director Sharon Werner
Designer Sarah Nelson
Agency Werner Design Werks
Country United States

MERIT

SELF-PROMOTION, SERIES
Studio Calendar

Art Director Richard Hart
Designer Richard Hart
Illustrator Richard Hart
Copywriter Richard Hart
Studio Disturbance Design
Client Disturbance
Country South Africa

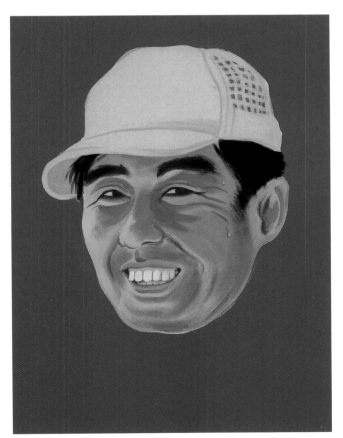

MERIT

SELF-PROMOTION
The Lingering Summer Heat

Art Director Keiko Shindo
Designer Keiko Shindo
Illustrator Keiko Shindo
Country Japan

MERIT

**CALENDAR OR APPOINTMENT
BOOK**
January 2001

Art Director Alain Lachartre
Illustrator Anja Kroencke
Agency Vue sur la Ville, France
Client Vue sur la Ville, France
Country United States

MERIT

**CALENDAR OR APPOINTMENT
BOOK**
2001 Calendar—The Great
Mountains in Japan

Art Director Kenny Roi Kin Gen
Designer Kenny Roi Kin Gen
Illustrator Yasuhiko Kida
Producer Tadayuki Ito
Studio Kenny Design Office
Client Iwatani International
Corporation
Country Japan

MERIT

POSTER OR BILLBOARD, SERIES
Exteriart

Art Director Daichi Suzuki
Designer Daichi Suzuki
Illustrator Norihisa Tojimbara
Producer Masakazu Eguchi
Studio Creative Mind Co., Ltd.
Agency Dentsu Inc.
Client Sanwa Shutter Corporation
Country Japan

ILLUSTRATION POSTERS AND BILLBOARDS

427

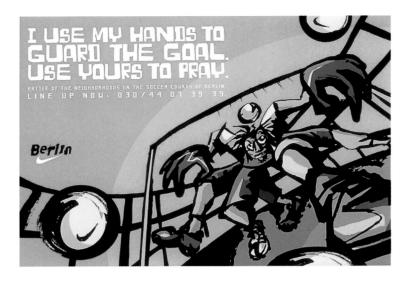

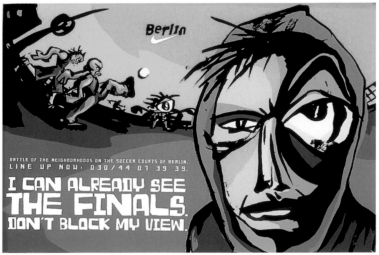

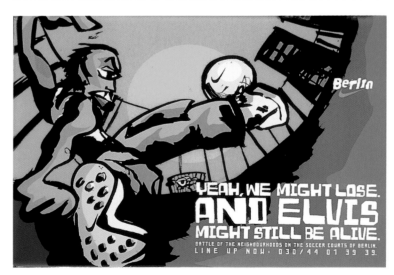

MERIT

POSTER OR BILLBOARD, SERIES
Hands • View • Elvis • Name • Rest

Art Directors André Aimaq, Lars Oshlschlaeger
Designer Elke von Dithurth-Siefken
Illustrator Sinead Madden
Copywriter Oliver Frank
Agency Aimaq. Rapp. Stolle-Werbeagentur GmbH & Co. KG
Client Nike International
Country Germany

MERIT

MISCELLANEOUS
A Fashion Odyssey

Art Director Bridget De Socio
Designer Bridget De Socio
Illustrator Tanya Ling
Copywriter Kim Hastreiter
Producer Paper Magazine
Studio Paper Magazine
Agency Paper Magazine
Client Paper Magazine
Country United Kingdom

MERIT

MISCELLANEOUS
How Shall I Live?

Art Directors Ben Casey, Alan Herron
Designers Billy Harkcom, Alan Herron
Illustrators Various
Copywriter Tim Gardom
Producer Eve Ritscher
Agency The Chase
Client New Millennium Experience
Company
Country United Kingdom

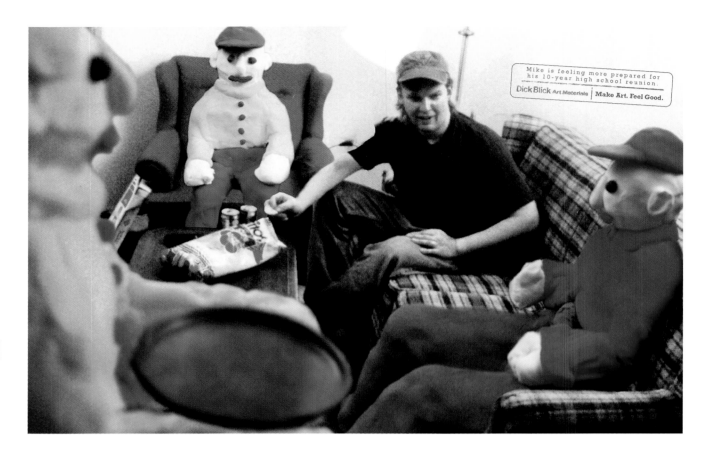

Mike is feeling more prepared for his 10-year high school reunion.

DickBlick *Art Materials* | **Make Art. Feel Good.**

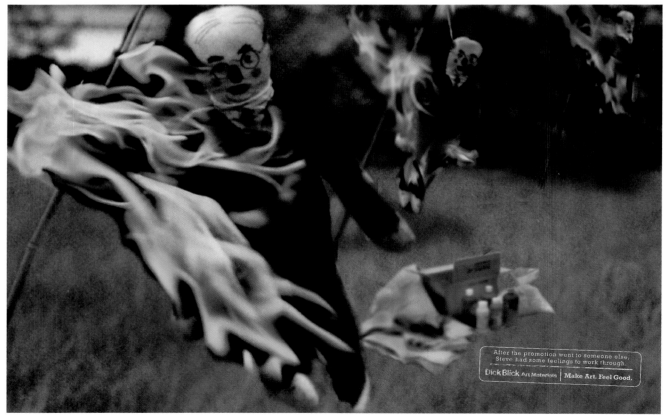

After the promotion went to someone else, Steve had some feelings to work through.

DickBlick *Art Materials* | **Make Art. Feel Good.**

Our goal was to encourage all kinds of people to shop at Dick Blick—not just art students or professionals. We reminisced about how much fun art class was in grade school. But most people have left art out of their lives because they're too busy to "do art" for fun. We talked about how art is good for you in a therapeutic sense: It's a calming, relaxing way to spend time and a healthy way to express your feelings.

From there it was a matter of finding ways people could feel better and deal with their emotional issues through art. The visuals have an unpolished, in-your-face look to make art feel relevant to everyday life for people who are not "artsy" types.

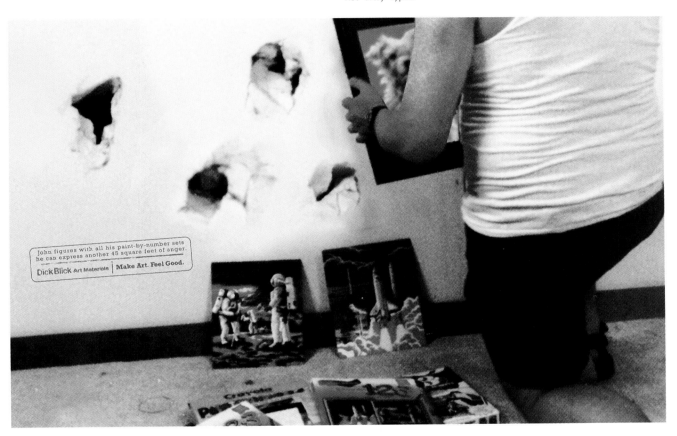

John figures with all his paint-by-number sets he can express another 45 square feet of anger.

DickBlick Art Materials | Make Art. Feel Good.

SILVER

CONSUMER MAGAZINE: SPREAD, CAMPAIGN

313 Dick Blick

Art Director Jay F. Miller
Copywriter Sharon Green
Instructor Brock Davis
School Brainco, the Minneapolis School of Advertising
Client Dick Blick Art Materials
Country United States

SILVER

CARTOON/COMIC BOOK

Art Director Martina Wember
Illustrator Martina Wember
School Kunsthochschule Berlin Weissensee
Country Germany

Perspectives On Everyday Life— Dissertation

I approach everyday life through the medium of drawing. Communication, confrontation, exchange, alteration— all this happens when drawing. The little things of our everyday life come into contact, mutually influencing each other, changing their shapes, gradually breaking up and coming together again. Drawing changes the way we perceive reality. Looking at things either from a graphic perspective or from an interhuman point of view triggers different associations. This graphic experiment is all about finding out how familiar shapes change and how unusual perspectives can bring about something new.

DISTINCTIVE MERIT

CONSUMER MAGAZINE: SPREAD

Toe Sock Fashion

Art Director Kristin Sommese
Designer Heidi Spacher
Copywriter Heidi Spacher
Photographer Heidi Spacher
Illustrator Heidi Spacher
Instructor Kristin Sommese
School Penn State University
Country United States

DISTINCTIVE MERIT

**COMPLETE PRESS/PROMOTIONAL
KIT, SERIES**
Windhover Art and Literature

Art Directors Kyle Blue,
Michael Metz
Designers Kyle Blue, Michael Metz
Copywriters Kyle Blue, Michael Metz
Editor Emily Townley
Photographers Kyle Blue,
Michael Metz
School North Carolina State
University
Client Windhover/SMA North
Carolina State University
Country United States

DISTINCTIVE MERIT

HYBRID/ART/EXPERIMENTAL
Nomad Typeface

Art Director Byoung-Il Choi
Designer Byoung-Il Choi
Producer Byoung-Il Choi
Studio Cranbrook Academy of Art
Country United States

MERIT
TV: 30 SECONDS OR LESS
Good Morning to You, Too

Art Directors Fred Abercrombie,
Bobby Kwan, Al Rios
Copywriter Bobby Kwan
Director Justin Fellers
Editor Isaac Sanfir
Instructor Brian McCarthy
School Academy of Art College
Client Starbucks Coffee Company
Country United States

GOOD MORNING TO YOU, TOO

Open on row of office cubicles (music throughout)

Cut to mailroom guy with mailcart, eager to start the day. He aggressively flings mail across desks. It smacks people in the face and knocks things over.

He fires mail into a cubicle; without looking, an employee grabs it just before it can knock over his cup of Starbucks. He retrieves a package from his outbox and stalks the mail guy, who makes a run for it. The man takes aim and fires.

Cut to logo

Cut to mailroom guy, sprawled unconscious on the floor.

MERIT

**CONSUMER MAGAZINE:
FULL PAGE, CAMPAIGN**

Piercing Scenes

Art Director Tommy Noonan
Copywriter Tommy Noonan
Instructor Scott Schindler
School Fashion Institute of Technology
Client Andromeda Piercing
Country United States

MERIT

**CONSUMER MAGAZINE:
COVER, SERIES**

Bon Appétit

Art Director Kuan Ling Lin
Designer Kuan Ling Lin
Instructor Michael Ian Kaye
School School of Visual Arts
Country United States

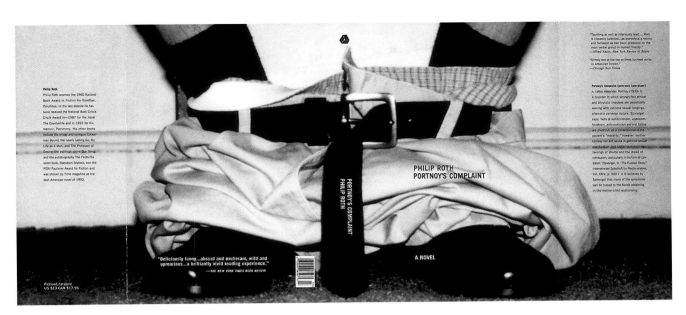

MERIT

BOOK JACKET

Portnoy's Complaint

Designer Molly Sheahan
Photographer Molly Sheahan
Instructor Michael Kaye
School The School of Visual Arts
Country United States

441

MERIT

BOOK JACKET, SERIES

A Cultural History—The Russians,
French, Spanish, Germans

Art Director Esther Mun
Designer Esther Mun
Instructor Carin Goldberg
School School of Visual Arts
Country United States

MERIT

**LIMITED EDITION/PRIVATE
PRESS/SPECIAL FORMAT BOOK**
REdesigned

Art Director Van Sanders
Designer Wes Pendergast
Photographer Peter Swan
Instructor Helmut Stenzel
School University of Ballarat
Country Australia

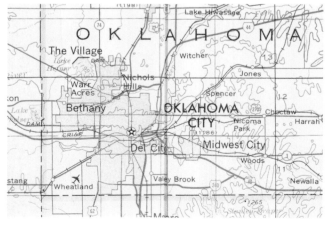

MERIT

**LIMITED EDITION/PRIVATE
PRESS/SPECIAL FORMAT BOOK**
. . . so that i can see you better

Art Director Susan Gnaiger
Designer Susan Gnaiger
Copywriter Susan Gnaiger
Illustrator Susan Gnaiger
Instructor Uwe Loesch
School Universität Wuppertal
Country Germany

Multiple Awards
(see also Graphic Design)

MERIT

BOOKLET/BROCHURE
Grad Book

Art Directors Chris Dooley, Sean Dougherty, Gary Williams
Designer Gary Williams
Photographer Stephen Franco
Illustrator Saiman Chow
Instructors Axel Foley, Hal Frazier
School Art Center of College Design
Country United States

MERIT

**CORPORATE IDENTITY STANDARDS
MANUAL**
H & H Bagels

Designer Yoshiko Kusaka
Instructor Paula Scher
Country United States

444

MERIT

CORPORATE IDENTITY PROGRAM, SERIES

Jet Set Couriers

Designer Abby Bennett
Instructor Alice Drueding
School Tyler School of Art, Temple University
Country United States

MERIT

LOGO/TRADEMARK

Empire Seafood Company

Designer Brian Owens
Instructor Rob Lawton
Country United States

MERIT

PROMOTIONAL, SERIES
Halloween Party

Art Directors Mark Elias,
Thomas Klimek, Brian McCall
Designers Mark Elias,
Thomas Klimek, Brian McCall
Instructor Lanny Sommese
School Penn State University
Country United States

MERIT

**PUBLIC SERVICE/NONPROFIT/
EDUCATIONAL**
When in Heat Protect Yourself

Art Director Kristin Sommese
Designer Kim Decker
Photographer Kim Decker
Instructor Kristin Sommese
School Penn State University
Country United States

MERIT

PACKAGING: ENTERTAINMENT, SERIES
Yuhki Kuramoto

Art Director Hyun-Soo Kim
Instructor Stefan Sagmeister
School School of Visual Arts
Country United States

MERIT

PACKAGING: RECREATION
Assembly Required

Art Director Kristin Sommese
Designer Karin Satrom
Instructor Kristin Sommese
School Penn State University
Photographer Image Resource Center
Country United States

MERIT

PACKAGING: GIFT/SPECIALTY PRODUCT
Valentine's Day Self-Promotion

Art Director Kristin Sommese
Designer Janet O'Neil
Instructor Kristin Sommese
Client Sommese Design
School Penn State University
Country United States

MERIT

TYPOGRAPHY
Believe

Art Director Jimmy Sheehan
Designer Kori Girard
Instructor Genevieve Williams
School School of Visual Arts
Country United States

MERIT

**CALENDAR OR APPOINTMENT
BOOK**

M2—It All Depends on
Your Standpoint

Supervisor Volker Liesfeld

Designers David Bascom,
Dirk Brömmel, Tanja Mann,
Martin Mörsdorf

Photographers Dirk Brömmel,
Martin Mörsdorf

Client The University of Applied
Sciences of Wiesbaden

School Fachhochschule Wiesbaden,
Germany

Country Germany

We discovered a few oversights in last year's Annual. We would like to set the record straight by publishing the following omitted judges and Merit winners of the Art Directors Club 79th Annual Awards.

STEPHEN DICKSTEIN is currently partner/executive producer for the internationally acclaimed commercial production company, Partizan Films and Entertainment. Attracted to the early music video works of David Fincher, Dominic Sena, and Michael Bay, Dickstein was instrumental in introducing and nurturing these artists into the commercial arena. During his tenure at Propaganda Films, Dickstein consulted for the talented stable of directors, including Spike Jonze, Dante Ariola, and Jeffery Plansker. He was responsible for the expansion of Propaganda by creating the architecture for Satellite Commercial, as well as a London-based operation that served England and continental Europe. In addition, he brought Paris-based Partizan to the U.S. as a co-venture with Propaganda.

While president of the commercial division of Propaganda Films, Dickstein was responsible for the growth and development of what became the largest and one of the most influential commercial production companies worldwide. Working with marketers, including Coca-Cola, Intel, Mercedes, Nike, Budweiser, Pepsi, and IBM, Dickstein successfully administered, through creative leadership, one of the first brand name companies ever created in the field of commercials production. In feature films, Dickstein has acted as director's consultant on *Being John Malkovich*, *The Game*, *Fight Club*, and *Nurse Betty*.

Upon graduating from Batley Art and Film School at age 19, **JAMES SOMMERVILLE** and friend Simon Needham opened a graphic design studio in James's grandma's attic bedroom. Since then, James has been a major force in positioning ATTIK as one of the world's most innovative groups of people, with offices in Huddersfield, London, New York, San Francisco, and Sydney. ATTIK currently employs over 160 creative individuals from various disciplines within the commercial communication field, from strategic planners, filmmakers, and

directors, to interactive, broadcast, print, and environmental designers. Aside from the numerous awards given in recognition of his creative achievements, James resided on the panel of the "Labour Government Internet Inquiry," was honored by Huddersfield University with a Degree of Honorary Doctor of Letters, and has been requested by HRH The Prince of Wales Trust to become actively involved in The Princes' Youth Business Trust as an advisor to new business in the 21st Century.

MERIT

**ADVERTISING,
POSTERS: PROMOTIONAL**

Arm

Art Director Erh Ray
Copywriter José Henrique Borghi
Illustrator Pedro Luis
Producers Elaine Carvalho,
Yoshito Yagura
Agency DM9 DDB Publicidade
Client Universo Online
Country Brazil

MERIT

**ADVERTISING,
POSTERS: PROMOTIONAL**

Continental Tires: Much Safer on Wet

Art Director Cesar Finamori
Photographer Fabio Bataglia
Copywriter Miguel Bemfica
Agency Almap BBDO
Comunicações Ltd.
Client Volkswagen
Country Brazil

MERIT

**ILLUSTRATION,
NEWSPAPER EDITORIAL**

Richard the Lionheart

Art Director Leanne Shapton
Illustrator Emmanuel Pierre
Designer Leanne Shapton
Country Canada

MERIT

**ILLUSTRATION, CALENDAR, OR
APPOINTMENT BOOK**

An India Ink Picture for 2000 Calendar

Art Director Masaya Ito
Illustrator Masaya Ito
Client Graphic Station
Country Japan

MERIT

**ADVERTISING,
CONSUMER MAGAZINE: SPREAD**
Celica, Now with V-6 Engine

Art Director Luciano Santos
Copywriter Eduardo Lima
Photographer Rodrigo Ribeiro
Producers José Roberto Jekl,
Magda Mendonça
Agency F/Nazca S&S
Client Toyota
Country Brazil

451

MERIT

ILLUSTRATION, MAGAZINE EDITORIAL, SERIES
Person of the Century and Two Runners Up:
Einstein • FDR • Gandhi

Art Directors Jay Colton, Arthur Hochstein, Sharon Okamoto
Illustrator Tim O'Brien
Client Time magazine
Country United States

MERIT

**ILLUSTRATION,
MAGAZINE EDITORIAL, SERIES**
Pants 2000
(Pantalons de l'an 2000)

Art Director William Stoddart
Illustrator Anja Kroencke
Client Madame Figaro
Country France

MERIT

**ILLUSTRATION,
MAGAZINE EDITORIAL**
Bull-Headed

Art Director Mark Maltais
Illustrator Ed Fotheringham
Designer Mark Maltais
Country United States

MERIT

**ILLUSTRATION,
NEWSPAPER EDITORIAL**
Ring Out the Noise,
Ring Out the Funk

Art Director Lucy Bartholomay
Illustrator Gary Clement
Writer Ed Siegel
Client The Boston Globe
Country Canada

MERIT

**ILLUSTRATION,
MAGAZINE EDITORIAL**
How to Manage Geeks

Art Director Patrick Mitchell
Illustrator Edwin Fotheringham
Designer Patrick Mitchell
Country United States

The New York Times Magazine — MARCH 21, 1999

Rose's Turn In his role as a new correspondent on '60 Minutes II,' Charlie Rose has arrived — but makes you nostalgic for everything you never knew you liked about him.

By Rebecca Johnson

There are three reasons Charlie Rose doesn't think this article should have been written. "No. 1, I'm boring," he says over his usual lunch, Cobb salad, at his usual table, front and center, at his usual restaurant, Michael's, the kind of place where water costs $6 a bottle and the man in the pinstripe suit at the next table is likely to be the C.E.O. of a media conglomerate. "No. 2," he goes on, "I don't want to be out front on this '60 Minutes' thing." This "'60 Minutes' thing" is "60 Minutes II" or, as they say in the business, "62," the clone of the original television newsmagazine that had its premiere in January. "No. 3," he finishes, "it's not the cover."

Charlie Rose is kidding about No. 1 and No. 3. Kind of. Look at it this way: if No. 1 is true, then he shouldn't be on the cover, but if he were on the cover, then No. 1 can't be right. So which is it? Let's start with reason No. 1: Charlie Rose is boring. As with all jokes, there's some truth to it. Ask him a question and his answers are filled with long pauses, digressive clauses and tedious avoidance of anything overtly controversial or negative. If Charlie Rose were a guest on his show, "Charlie Rose," in other words, you might change the channel.

Yet, somehow, the slumbling, 6-foot-4, Southern-accented, droopy-lidded, mussy-haired former frat boy, who, early in his career, lost more than one on-air job in television, has managed to transform his tiny, shoestring budget of a local daily public television show into a national phenomenon. Scan the guest list of the last seven and a half years and you'll find an extraordinary array of America's elite in the arts, politics, sports and business. Now, perhaps strangest of all, the network that once banished "Nightline," the nightly interview show he was the host of from 1984 to 1992, to the one-digit hours of the morning has given him a spot on the first legitimate offspring of "60 Minutes," its most golden child,

Illustration by Steve Brodner

MERIT

ILLUSTRATION, MAGAZINE EDITORIAL
Charlie Rose

Art Director Janet Froelich
Illustrator Steve Brodner
Designer Claude Martel
Country United States

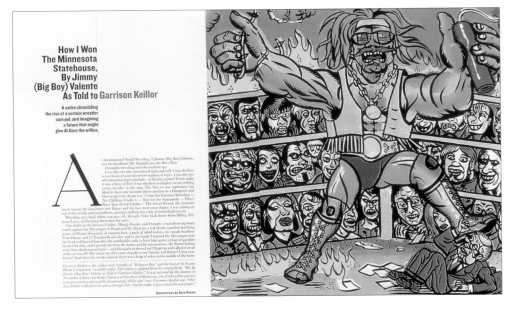

How I Won The Minnesota Statehouse, By Jimmy (Big Boy) Valente As Told to Garrison Keillor

A satire chronicling the rise of a certain wrestler cum pol, and imagining a future that might give Al Gore the willies.

At International World Wrestling, I, Jimmy (Big Boy) Valente, was the headliner, Mr. Magnificent, the Boss Man.

I brought wrestling into the modern age.

I was the one who introduced rock-and-roll. I was the first to use loops of accordion-wire in place of ropes. I was the one who introduced pyrotechnics. A flaming genius! Every night it was a King of Fire! I was the first to employ sweat-seeking cruise missiles in the ring. The first to use explosives; we liked to have one wrestler throw another in a Dumpster and blow it up. Our slogan was "Come See Extreme Wrestling — No Children Under 6 — Not for the Squeamish — Don't Wear Your Good Clothes." The blood flowed, the monster truck roared, the ring burst into flames and the fans went away happy. I was sitting on top of the world, earning millions, getting a million hits a day at jimmybigboy.com.

Wrestling gets hard when you pass 40, though. Your back hurts from lifting 300-pound guys and heaving them into the seats.

One night in the Boston Garden, Hump Hooley and I fought a marathon tag-team match against the Messenger of Death and Mr. Disaster, a real shorts-soother involving quarts of blood, thousands of vampire bats, a pack of rabid wolves, six suicide bombers from Hamas and 12 Tomahawk missiles, and in the finale I hoisted the Messenger over my head and heaved him into the turnbuckle, only to have him ignite a moat of gasoline around the ring, and I passed out from the fumes and lay unconscious, the flames licking at my feet, death near at hand — and then pure awakened me! I leapt up and called in an air strike on myself! The cruise missiles came straight at me! Smoke and flames! Utter confusion! And when the smoke cleared, there was a heap of ashes in the middle of the burn-

Garrison Keillor is the author most recently of "Wobegon Boy" and the host of "A Prairie Home Companion" on public radio. This article is adapted from his coming book, "Me, by Jimmy (Big Boy) Valente as Told to Garrison Keillor." It was inspired by the election in November of Jesse (the Body) Ventura as Governor of Minnesota, one of whose first acts was to propose cutting aid to public broadcasting. Of his own "new Governor, Keillor says: "He's Jesse Helms with pectorals and a stronger chin. And he makes it fun to read the newspaper."

Illustrations by Gary Panter

MERIT

ILLUSTRATION, MAGAZINE EDITORIAL
How I Won the Minnesota Statehouse

Art Director Janet Froelich
Illustrator Gary Panter
Designer Nancy Harris
Country United States

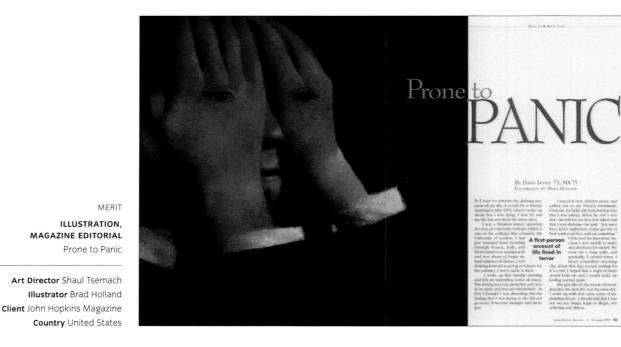

MERIT

**ILLUSTRATION,
MAGAZINE EDITORIAL**
Prone to Panic

Art Director Shaul Tsemach
Illustrator Brad Holland
Client John Hopkins Magazine
Country United States

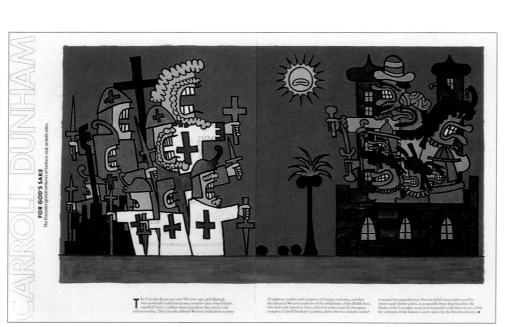

MERIT

**ILLUSTRATION,
MAGAZINE EDITORIAL**
For God's Sake

Art Director Janet Froelich
Project Art Director Joele Cuyler
Illustrator Carroll Dunham
Designer Ignacio Rodriguez
Country United States

MERIT

ILLUSTRATION, BOOK JACKET
Golden Days

Designer Yukimasa Matsuda
Illustrator Tatsuro Kiuchi
Client Wave Publishers
Country Japan

MERIT

**STUDENT ILLUSTRATION,
SELF-PROMOTION**
Shanghai 1972

Illustrator Michael Kwong
Instructor Dave Groff
School Columbus College of Art
and Design
Country United States

STUDENT ILLUSTRATION, BOOK
Respectively Lines
(Beziehungsweise Linien)

Illustrator Martina Wember
School Kunsthochschule Berlin
Weissensee
Country Germany

GESÄUBERT

MERIT

STUDENT ILLUSTRATION, BOOK
Cleansed
(Gesäubert)

Illustrator Gerald Moll
Artist Traget Sorge
School College of Figurative
Arts, Hamburg
Country Germany

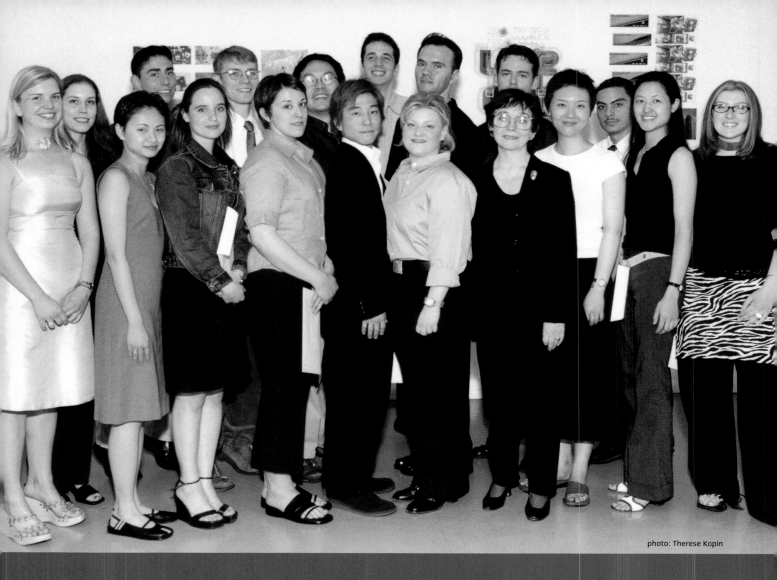

photo: Therese Kopin

Art Directors Club Scholarship Recipients

THE COOPER UNION SCHOOL OF ART

Marcos Kotlhar
Karen Lau
Brent Schumann

William Taubin Advertising Design Scholarship Award:

Marcos Kotlhar

FASHION INSTITUTE OF TECHNOLOGY

Howard Herrarte
Jeffrey Lin
Hillary Soll

William Brockmeier Graphic Design Scholarship Award:

Hillary Soll

NEW YORK CITY TECHNICAL COLLEGE

Yuliya Levina
Sefkija Music
Cesar Rodriguez

Mahlon A. Cline Editorial Design Scholarship Award:

Sefkija Music

PARSONS SCHOOL OF DESIGN

Christian Drury
Purvi Shah
Daiju Aoki

John Peter Publication Design Scholarship Award:

Purvi Shah

PRATT INSTITUTE/ PRATT MANHATTAN CENTER

Katie Koch
Erica A. Kramer
Jean Delano

Gene Federico Advertising Design Scholarship Award:

Katie Koch

SCHOOL OF VISUAL ARTS

Elizabeth Ennis
Natasha (Dai-San) Jen
Fon Lin Nyeu

Shinichiro Tora Publication Design Scholarship Award:

Natasha (Dai-San) Jen

Friends of the Foundation

(Contributors of $100 or more)

Mahlon A. Cline
Chermayeff & Geismar
David and Grace Davidian
Kathy Fable
Gene and Helen Federico
Carl Fischer
Robert Fitzgerald
Ruby Miye Friedland
Bob Gage
Robert Giraldi
Milton Glaser
Abe and Carmen Greiss
Kurt Haiman
Jon Kamen
Ruth Lubell
Bernard Most
Toshiaki Nozue
Bernard Owett
Robert Pliskin
Ernest G. Scarfone
Eileen Hedy Schultz
Louis Silverstein
Len Sirowitz
Harold Sosnow
Joseph O. Wallace

The Art Directors Scholarship Foundation was founded in 1978 by members of The Art Directors Club. Its mission is to provide recognition and financial rewards to talented and deserving design students.

This year, the Foundation awarded scholarships to three students from each of the six top design schools: The Cooper Union School of Art, Fashion Institute of Technology, New York City Technical College, Parsons School of Design, Pratt Institute, and The School of Visual Arts. We awarded scholarships in memory of Bill Brockmeier, Gene Federico, John Peter, Shin Tora, Bill Taubin, and Mahlon Cline.

The funds that the ADSF distributes are contributed to the Foundation by The Art Directors Club, its members, friends of the Club and of the Foundation, and various corporations. Donations to the ADSF are tax-deductible.

Over the years, scholarship winners have told us how important it has been for their careers to have won these awards from The Art Directors Club.

These awards make a difference. Costs for tuition and equipment are higher than ever. The drawing board, T-square, and rubber cement have long been replaced by the computer, scanner, color printer, and a shelf full of expensive software. Equally important is recognition. Over the years, scholarship winners have told us how important it has been for their careers to have won these awards from The Art Directors Club.

The Foundation is run by able, experienced, and dedicated volunteers. In addition, The Art Directors Club provides us with our headquarters, help from staff members, and advice. For this and for the generosity of our contributors, we are sincerely grateful.

—Meg Crane,
PRESIDENT OF THE ART DIRECTORS
SCHOLARSHIP FOUNDATION, INC.

SATURDAY CAREER WORKSHOPS

A. Students in Gail Anderson's typeplay workshop

B. Student work from typeplay workshop

C. Bill Oberlander leading advertising workshop

D. Student work from Diana La Guardia's magazine design workshop

E. Marshall Arisman sharing student work

photo: Susan Mayer

T his has been an exceptionally gratifying year. Thanks to the ADC staff and our colleagues at The School Art League, Jane Clark Chermayeff, Renee Darvin, and Naomi Lonergan, the program continues to inspire talented high school juniors to consider careers in visual communications.

This year alone we introduced almost 100 students to advertising, photography, graphic design, typography, and illustration through workshops with professionals in these fields. Our Fall 2000 sessions were led by Gail Anderson, Deputy Art Director at *Rolling Stone*; artist, illustrator and educator Marshall Arisman; Diana LaGuardia, Art Director at *Gourmet*; advertising creative director Bill Oberlander; and photographer John Pinderhughes. In addition to our scheduled workshops, we also held our first Art College Seminar, where participants were joined by last year's alumni, parents, and teachers. Representatives of The Cooper Union School of Art,

We plan to initiate a mentoring program to match ADC members with student participants in their senior year in high school, and scholarship assistance for students who are accepted into art school.

Fashion Institute of Technology, Parsons School of Design, Pratt Institute, New York City Technical College, The School of Visual Arts, and the NYU School of the Arts made presentations followed by questions and a break-out session. A second seminar is planned for Fall. This past Spring, illustrator Christoph Niemann joined the ranks of instructors. Throughout the year, we were assisted by Parsons students Jonathan Chan, Jiang Chen, Jack Egan, Karen Lew, Jeanette Mooney, Sean Ryan, and Holly Scull, as well as Elisa Halperin, Creative Director of Time, Inc., and David Mayer. We thank them all.

Special thanks to our first benefactor, The Coyne Foundation, whose generous contribution will enable us to expand our program and help transform the students' goals into life-changing careers. We plan to initiate a mentoring program to match ADC members with student participants in their senior year in high school, and scholarship assistance for students who are accepted into art school. We hope to exhibit some students work and that of workshop leaders, and to create a video to inspire other organizations to create similar programs. I encourage members who want to help in any way to get in touch. Thank you.

—Susan Mayer,
SATURDAY CAREER WORKSHOPS COMMITTEE CHAIR

October 2000

EXHIBITION: Deutsch
October 20–November 17, 2000

Voted "Agency of the Year" for the second year in a row by *Adweek*, the ADC Board of Directors unanimously agreed to invite Deutsch Inc. to exhibit the ad agency's commercial and print campaigns for clients such as Domino's, Mitsubishi Motors, Tommy Hilfiger, IKEA, Procter & Gamble, and Ashford.com. Donny Deutsch, chairman and chief executive officer, was a featured speaker in the ADC Speaker Series on October 25. Soon after the exhibition, Interpublic Group announced its acquisition of Deutsch for $265 million in stock.

Donny Deutsch celebrates the evening with his father, David, founder of Deutsch Advertising (1969).

An aerial view of the Deutsch exhibition

September 2000

EXHIBITION: R/GA's "Transformation"
September 14–October 13

"Transformation" was a retrospective exhibition of R/GA's evolution through film, broadcast, interactive, and broadband. Over the past 23 years, Robert Greenberg's design and production company has become one of the leaders in the convergence between film, video, and computers. Work on display included the flying film titles from "Superman," the Diet Coke commercial with Paula Abdul dancing with a young Gene Kelly, and the award-winning kiosks designed and stationed in Discovery stores around the world.

Robert Greenberg in the director's chair at the ADC

Opening reception of the multimedia exhibition, *Transformation*

photo: Howard Baden

November 2000

BLACK TIE EVENT:
HALL OF FAME 2000
November 2

The ADC inducted four laureates into the Hall of Fame in 2000.

Prolific New York type designer and accomplished lettering artist Ed Benguiat has set the tone for type since the 1970s. His designs range from Spencerian scripts to casual Gothics to formal Romans to Art Nouveau and novelty faces. He has designed over 600 typefaces, and prefers to draw alphabets by hand.

From the unforgettable opening of Stanley Kubrick's *Dr. Strangelove* to the revolutionary split-screen montage of the original *The Thomas Crown Affair*, Pablo Ferro has put his indelible stamp on the moving image for four decades. His distinctive hand-drawn opening segments have appeared in films ranging from *Stop Making Sense* to *Men in Black*.

Tadanori Yokoo's LaChapelle Book

Pablo Ferro's *Good Will Hunting*

Acclaimed commercial director Joe Sedelmaier has a reputation for making outrageously funny commercials featuring quirky personalities such as the FedEx "World's Fastest Talking Man" and the little old lady with the loud, obnoxious voice who asked the now famous question, "Where's the beef?" in the Wendy's ad.

One of the most influential Japanese commercial illustrators, Tadanori Yokoo, accepted his award with an interpreter, who related a humorous story about how he nearly didn't accept the Hall of Fame honor because the person who translated the ADC's letter translated "Hall of Fame" as "rich people's mansion." Such an award didn't appeal to him at all. Finally, another friend with a better grasp of English told him, "This is a great honor. You have to go."

CALL FOR ENTRIES: "Living In A World Without Art Direction"

Past ADC President Bill Oberlander designed the ADC 80th Annual Awards Call For Entries with the theme, "Living in a World Without Art Direction." The poster features a black-and-white image of a squinting freckled-face. More than 17,000 entries were received (a 10% increase from the year before). Entries were received from over 53 countries around the world: 47% advertising, 47% graphic design, and 6% new media.

Aerial view of Advertising Judges evaluating commercials

One of a series of ADC Interactive events headed by committee chair, Jonathan Gottlieb

ADC INTERACTIVE EVENT: "What Were They Thinking?" November 14

The New Media Judges of the ADC 78th and 79th annual competitions discussed the work they selected as winners and why. Moderated by Jonathan Gottlieb, the panel included: Heidi Dangelmaier, Jeffrey Tyson, Anette Weintraub, and Ray Wood, among others.

SPEAKER SERIES: Luba Lukova November 15

Bulgarian designer/illustrator Luba Lukova engaged the audience with her work and life story: from an artist working under the arm of a communist government to landing her first illustration assignment with *The New York Times*, where more than 200 of her drawings have been published. She currently lives in New York City and teaches graphic design at The School of Visual Arts.

Luba Lukova enjoying her 'one woman speaker show' at the ADC

Past ADC President Lou Dorfsman hugging a fellow lifetime member

Graphic Design Judges with Chair, Stefan Sagmeister

December 2000

EXHIBITION: "AMERICA ILLUSTRATA" December 7–22

"America Illustrata" is an Italian exhibition featuring the works of 37 of the best American illustrators, including: Milton Glaser, Seymour Chwast, Anita Kunz, Paul Davis, Maira Kalman, Gary Baseman, Julien Allen, Steven Guarnaccia, and Brad Holland. Organized by the Associazione Culturale Teatrio, the exhibition made its U.S. debut at the ADC Gallery with an accompanying new media exhibition, "Illustrators In Motion," featuring animation and interactive work by the artists.

LIFE MEMBERSHIP DINNER December 1

For the first time in the ADC's history, the Club held a dinner party to celebrate our Life Members. Approximately 75 people gathered together to reminisce with familiar friends. ADC life member Bruno Brugnatelli designed the invitation and collected old photographs from the Club's archives to display that evening.

ADC INTERACTIVE EVENT: "Beyond the Push Button Interface— How Digital Gaming Is Changing Web Design" December 5

It was a very timely topic for Web professionals as the redirection of shockwave.com and the demise of sites like pop.com suggested a need to present content on the Internet that is intrinsic to the medium, and more than just video through a new pipe. The panel brought traditional game designers together with developers applying game-like forms to editorial and advertising purposes. Local producers of on-line entertainment spoke about the kind of work they look for and the creative directions in which their sites are headed.

January–February 2001

80TH ANNUAL AWARDS JUDGING

Wieden + Kennedy's executive creative director, Susan Hoffman, was advertising chair; Stefan Sagmeister, who has built a reputation particularly within the music industry working with the Rolling Stones, Lou Reed, and David Byrne, was graphic design chair; and Peter Girardi of Funny Garbage, to whom Art Spiegelman once referred to as "the best of the new gardeners landscaping our new virtual jungle," was new media chair.

March 2001

PHOTO PORTFOLIO REVIEW
March 14

Photographers in the New York metropolitan area had a rare opportunity to spend three hours in one room with the industry's most pursued art directors, art buyers, and photo editors at the ADC Gallery. More than 50 reviewed the portfolios of 100 photographers, who were accepted on a first-come, first-served basis. Each photographer was guaranteed 10 minutes with at least three reviewers.

The reviewers represented ad agencies like Cliff Freeman & Partners, Fallon McElligott, Grey, Ogilvy; and magazines such as *Conde Nast Traveler, InStyle, Martha Stewart Living, The New Yorker*; and graphic design firms like Chermayeff & Geismar, Pentagram, and Primedia, among several others.

ADC INTERACTIVE EVENT:
"Designing For Handheld Devices: Possibilities And Pitfalls"
March 15

A panel of digital design innovators talked about the challenges (both technical and creative) of designing for the smallest of screens, Web-enabled cell phones, and palm devices. They included: Greg Costikyan, founder and chief design officer of Unplugged Games, Evan Uhlfelder, CEO of HipNTasty, and moderator Mary Jo Fahey, author of four books on Web design, Web 3D and Animation, Web Advertising, Broadband, and Web Entertainment.

SPEAKER SERIES: Red Sky Interactive
March 21

The interactive ad agency that designs and engineers online brands such as Absolut, Altoids, and Miller Lite, Red Sky Interactive, called a town meeting for creatives in the digital domain. President Howard Belk and executive creative director Hans Neubert illustrated the qualitative aspects of design now used in new media, and how to uphold them when working with the technical and marketing requirements of a client.

April 2001

EXHIBITION: Young Guns III
April 6–May 10

The open reception broke an all-time record. More than 1,200 people attended Young Guns III NYC, the ADC's third biennial, invitational exhibition featuring the work of outstanding young (that is, 30 & under), art directors, photographers, illustrators, graphic designers, new media, and Web designers working in New York. A long list of notable creatives in New York nominated their favorite young professionals who are producing impressive, cutting-edge work. Out of 250 nominees, only 90 were selected to represent the next wave of influential visual innovators.

Brian Rea's t-shirt collection

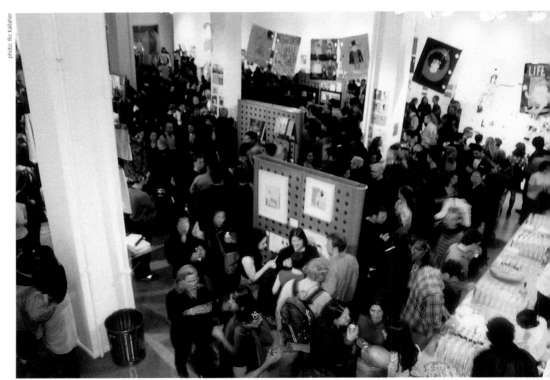

Aerial view of Young Guns III exhibition

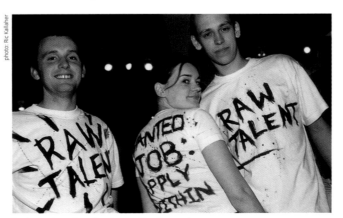

Party crashers from London looking for work

ADC INTERACTIVE EVENT:
"One Story, Many Tellings—How Producers Are Using The Web to Promote Their Films "
April 10

Film companies, cable channels, and advertisers—all are using the Web to build out their narrative's back story and engage audiences in novel ways. ADC Interactive talked to the people responsible for their creation, including: Sarah Cotsin of HBO; Robert Nuell, art director from Miramax Films; Amyn Kaderali, writer and director of the Scream 3 Web site (Miramax), and others.

The Art Directors
80th Annual Exhibition

photo: Tim Lehmacher

photo: Ric Kallaher

Melvin van Pebbles speaks out at "Brand Black"

May 2001

EXHIBITION:
"The Art of the Commercial"
May 15–31

The photo exhibit honoring 75 of the world's most distinguished cinematographers featured portraits, reels, and quotes by each, commenting on the power of their art form as a universal language for expressing concepts, particularly in television commercials. The portraits were selected from the Kodak advertising campaign "On Film," which profiles cinematographers as artists. The exhibition was supported by the Entertainment Imaging division of Eastman Kodak Company, and photographed by the legendary Douglas Kirkland.

CREATIVE DIFFERENCES:
"Brand Black"
April 25

Advertising and marketing currently rely on powerful images and attitudes connected with the African-American community. Yet minority participation in creating these potent commercial messages is fleeting, insufficient, and almost nonexistent. A panel of 20 media makers examined race as a brand, and brought up questions such as "what or who makes a brand 'black,'" "why 'All-American' seldom means black," "what is 'urban' vs. 'cosmopolitan,'" and "who is profiting from the exploitation of black culture." Fat Daddy Loves You writer/ director/creative director Charles Hall moderated the evening with Advertising Age's creative editor, Anthony Vagnoni.

ADC 80th ANNUAL AWARDS GALA
June 6

It was a night to celebrate amid the proud and prestigious winners and judges of the annual awards. After the 14 Gold and 45 Silver Medals were awarded, the crowd of advertising, graphic design and new media creatives gathered around to watch and listen to a special performance by E-magine recording artist Waldeck. The evening also served as the opening reception for the 80th Annual Awards Exhibition. 280 Design created the inventive installation. Four copies of the show will travel year-round, worldwide.

SPEAKER SERIES: Howard Bingham
June 13

Personal photographer of Muhammad Ali since the 1960s, Howard Bingham is also the Executive Producer of the major motion picture Ali, directed by Michael Mann, which stars Will Smith as Cassius Clay. As part of the ADC Speaker Series, Bingham discussed the 10-year investment he has made in filming Ali—from Los Angeles to New York to Mozambique—and his experiences documenting one of the most important cultural icons of the last 40 years.

**2000/2001
Board of Directors**

Richard Wilde
School of Visual Arts
President

Parry Merkley
Merkley Newman Harty and Partners
First Vice President

Peter Cohen
Second Vice President

Alexander Gelman
Design Machine
Secretary

Leslie Singer
The Publishing Agency
Treasurer

Jackie Merri Meyer
Warner Books
Assistant Secretary/Treasurer

Roy Grace
Advertising

Tony Granger
Bozell New York

Robert Greenberg
R/GA Associates

Jon Kamen
@radical.media

Victoria Peslak
Platinum Design

Dean Stefanides
Hampel/Stefanides

**2000/2001
Committee Chairs**

Bill Oberlander
Advisory Board

Robert Greenberg
80th Awards Gala

**Richard Wilde
Peter Cohen
Jackie Merri Meyer**
Student Portfolio Review

Alison Curry
Photography Portfolio Review

Ruby Friedland
Speaker Events

Jeffery Metzner
Young Guns NYC 3

Jonathan Gottlieb
New Media

**Art Directors Club
Administration**

Myrna Davis
Executive Director

Olga Grisaitis
Associate Director

Emily Henning
Annual Awards Program Manager

Glenn Kubota
Annual Awards Associate

Elizabeth Meltz
Annual Awards Associate

Jen Griffiths
Annual Awards Assistant

Adam Parks
Annual Awards Assistant

Michelle Ott
Assistant to the Executive Director

Mary Fichter
Public Relations

Alison Curry
Development Consultant

Rick Stinson
Development Associate

Ann Schirripa
Membership Administrator

Kimberly Hanzich
Administration Associate

Romy Maldonado
Facilities Manager

Pierre Michel Hyppolite
Porter

Tony Zisa
Financial Consultant

Margaret Busweiler
Waitstaff

Winnie Tam& Co., P.C.
Certified Public Accountant

Chris Loh
Design Intern

**The Art Directors Scholarship
Foundation, Inc.**

**2000-2001
Board of Directors**

Meg Crane
President

Peter Adler
FirstVice President

Lee Epstein
Second Vice President

David Davidian
Treasurer

Diane Moore Behrens
Assistant Treasurer

Dorothy Wachtenheim
Secretary

Gladys Barton
Assistant Secretary

Robert Pliskin
Director

Eva Machauf
Director

Andrew Kner
Director

Sam Reed
Director

SPECIAL THANKS

80th Call for Entries

Kirshenbaum, Bond and Partners
Design

Rainer Behrens
Photographer

Sappi Fine Paper
Paper

Merrill/Daniels
Printing

80th Awards Invitation

Paul Sahre
Design

80th Awards Winners Book

Vertigo Design, NYC
Design

Stevens Press
Printing

Sappi Fine Paper
Paper

ADC Publications, Inc

Jackie Merri Meyer
President

Joseph Monatabello
Vice President

Nicholas Callaway
Secretary

Myrna Davis
Treasurer

Stefan Sagmeister
Director

ADC PAST PRESIDENTS

Richard J. Walsh, 1920-21
Joseph Chapin, 1921-22
Heyworth Campbell, 1922-23
Fred Suhr, 1923-24
Nathaniel Pousette-Dart, 1924-25
Walter Whitehead, 1925-26
Peirce Johnson, 1926-27
Arthur Munn, 1927-28
Stuart Campbell, 1929-30
Guy Gayler Clark, 1930-31l
Edward F. Molyneuz, 1931-33
Gordon C. Aymar, 1933-34
Mehemed Fehmy Agha, 1934-35
Joseph Platt, 1935-36
Deane Uptegrove, 1936-38
Walter B. Geoghegan, 1938-40
Lester Jay Loh, 1940-41
Loren B. Stone, 1941-42
William A. Adriance, 1942-43
William A. Irwin, 1943-45
Arthur Hawkins Jr., 1945-46
Paul Smith, 1946-48
Lester Rondell, 1948-50
Harry O'Brien, 1950-51
Roy W. Tillotson, 1951-53
John Jamison, 1953-54
Julian Archer, 1954-55
Frank Baker, 1955-56
William H. Buckley, 1956-57
Walter R. Grotz, 1957-58
Garrett P. Orr, 1958-60
Robert H. Blattner, 1960-61
Edward B. Graham, 1961-62
Bert W. Littmann, 1962-64
Robert Sherrich Smith, 1964-65
John A. Skidmore, 1965-67
John Peter, 1967-69
William P. Brockmeier, 1969-71
George Lois, 1971-73
Herbert Lubalin, 1973-74
Louis Dorfsman, 1974-75
Eileen Hedy Schultz, 1975-77
David Davidian, 1977-79
William Taubin, 1979-81
Walter Kaprielian, 1981-83
Andrew Kner, 1983-85
Edward Brodsky, 1985-87
Karl Steinbrenner, 1987-89
Henry Wolf, 1989-91
Kurt Haiman, 1991-93
Allan Beaver, 1993-95
Carl Fischer, 1995-97
Bill Oberlander, 1997-2000

CORPORATE MEMBERS

Aquent, Inc.
ArtByte Magazine
Bernstein Investment Reasearch and Management
Children's Television Workshop
Deepend New York, Inc.
Dreyfus Corporation
Gale Group
Getty Images
GoCard
McCall's Magazine
Merrill Daniels Corporation
Miami Ad School
Paladin
Pisces
Rolling Stone Magazine
Scholz & Volkmer Intermediales Design
Shiseido Co., Ltd.
Stone
The Alternative Pick
The Attik
The Black Book
The Eastman Kodak Company
Winslow Press
Zero Design

UNITED STATES

Aaron, Joanne
Abu-Nimah, Ruba
Acanfora, Massimo
Adamek, Tina
Adams, Gaylord
Adams, Cornelia
Adams, Phil
Adams, Sean
Adelman, Jim
Adler, Peter
Adorney, Charles S.
Albemarle, Rufus
Altenpohl, Peggy
Altschul, Charles
Alvey, Patricia A.
Amaditz, Michael
Anderson, Jack
Andreozzi, Gennaro
Annechiarico, Mike A.
Aquintey, Patrick
Arnold, Rebecca
Aronov, Igor
Arzt, Sarah
Atienza, Jayson
Atri, Abraham
Aue, Jennifer
Azuma, Chika
Babitz, Jeff M.
Babyatt, Aimee
Bach, Robert O.
Bacsa, Ronald
Baer, Charles H.
Baer, Priscilla
Baker, Kim
Baker, Lindsey
Balkin, Bruce
Ballance, Georgette F.
Bank, Adam
Baravalle, Giorgio
Baron, Richard
Barron, Don
Barrow, John
Barthelmes, Robert
Barton, Gladys
Barzey, Des
Basilio, Frederick
Baumann, Mary K.
Baxi, Aporva
Baybura, M. Naci
Bazarkaya, Toygar
Bean, Chris
Beane, Maryann V.
Beaver, Allan
Becker, Kris
Beker, David
Bender, Lois
Bennett, Edward J.
Berg, John
Berkowitz, Terry
Bernard, Walter L.

Berwald, Patty
Best, Robert
Bevington, William
Blank, Peter J.
Blechman, R.O.
Blend, Robert H.
Bogusz, Anna
Boiles, Paloma
Bonadio, Joe
Bonavita, Donna
Bonnanzio, Deborah C.
Borzouyeh, Jason
Bourges, Jean
Bowman, Harold A.
Boyd, Doug
Braga, Jonathan
Brauer, Fred J.
Braunstein, Douglas
Braverman, Al
Brennan, Tracy
Brenner, Jay
Brenner, Jason
Breslin, Lynn D.
Bridges, Kristi
Briggs, Kelley
Brodie, Paul
Brodsky, Ed
Brody, Ruth
Brugnatelli, Bruno E.
Bucher, Stefan G.
Buckley, William H.
Buckley, Paul
Bullard, Gene
Burkhart, David
Burns, Red
Byun, David
Cacossa, Jeff
Cadge, Bill
Cafritz, Jodi
Callaway, Nicholas
Cammarata, Andrew
Canniff, Bryan G.
Cannizzaro, Louis A.
Carnase, Thomas
Carson, Marcie
Carter, David
Casado, Ralph
Casarona, Chris
Castillo, Maribel
Catherines, Diana
Cayabyab, Ivan
Ceradini, David
Chang, Hsiu-Chen
Chaplinsky Jr., Anthony
Chavira, Daniel
Chen, Jack CK
Chen, Yingnan
Chen, Meiling
Chermayeff, Ivan
Chernik, Lazarus
Chester, Laurie
Cheuk, Deanne
Cho, Ginger
Choi, Heesun Lisa
Christie, Seema
Chu, Calvin
Chuang, John
Chung, Shelly
Church, Stanley
Churchill, Traci
Churchward, Charles
Chwast, Seymour
Cirlin, Scott
Clark, Herbert H.
Clark, Brett
Clemente, Thomas F.
Cohen, Peter
Cohen, Rhonda
Cohn, Karen
Coll, Michael
Conner, Elaine
Cook-Tench, Diane
Cooke, Kenneth
Cooney, David
Cooper, Jonathon
Coppa, Andrew
Cortes, Andres Felipe
Cory, Jeffrey
Cotler, Sheldon
Cotler-Block, Susan

Cox, Robert
Crabb, Christine
Craig, James Edward
Crane, Meg
Crawford, Virginia
Crespo, Fuster Damaso
Crossley, Gregory
Crozier, Bob
Curry, Alison Davis
Curry, Christine
Curtiss, Lisa
Cusick, Lori
Cutler, Ethel R.
Cutro, Fabio
D'Elia, Michelle
Darmstadt, Kim
Darula, Kathryn
Davidian, David
Davis, Barbara Vaughn
Davis, Herman
Davis, J. Hamilton
Davis, Paul B.
Davis, Randi B.
DeCardona, Reed Maria
Deegan, Faith E.
DeFede, Matthew L.
deHaan, Stuart
Del Sorbo, Joe
Del Valle, Rosemary
Dery, Mark
Desidero, Suzanne
Determan, Cara
Deutsch, David
Diecks, W. Brian
DiGianni, John A.
Dignam, John F.
Dorfsman, Louis
Dorian, Marc
Dorr, Cheri
Douglas, Kay E.
Doyle, Stephen
Driver, Paul
Duboff, Rori
Duffy, Donald H.
Duffy, Joe
Duncan, Suzanne
Dunn, Giles B.
Dunne, Anthony
Duplessis, Arem K.
Eason, Annamaria
Eckstein, Bernard
Edgar, Peter
Eisenman, Nina
Eisenman, Stanley
Elder, Karen M.
Ellis, Judith
Epstein, David
Epstein, Lee
Ericson, Shirley
Ermoyan, Suren
Esposito, Christine
Essex, Brad
Fable, Kathleen
Fajardo, Camilo
Fales, Gordon
Fanning, Gabriella
Farina, Carlos Frederico M.
Faucher, Stephanie
Feng, Yi
Fenga, Michael
Ferrell, John
Ferrell, Megan
Ferrero, Carl
Fetty, Cynthia
Finkel, Wendy
Finzi, Sylvia
Fiore, Louise
Fiorenza, Blanche
Fischer, Carl
Fitzpatrick, Wayne N.
Fleming, William
Flock, Donald P.
Flynn, Jennifer
Ford, Herrick Kristine
Fowler, Nichole A.
Fraioli, John
Frankfurt, Stephen O.
Fredy, Sherry
Freeland, Bill
Friedland, Ruby Miye

Friedland, Kenneth L.
Frith, Michael K.
Fritz, Stephen
Fu, Heidy
Fujita, Neil
Fury, Leonard W.
Gale, Mindy
Gallardo, Juan
Gallo, Danielle
Galore, Kaminsky Missy
Ganton Jr., Brian
Gardner, Beth
Garlanda, Gino
Gary, Steven
Gavasci, Alberto Paolo C.
Gayle, Marlaina
Geismar, Tom
Geissbuhler, Steff
Gelman, Alexander
Gennadiou, Evgenia
Genova, Barbara
Geranmayeh, Vida
Germakian, Michael
Gibson, Kurt
Gillespie, Porter
Gilligan, Kevin
Ginsberg, Frank C.
Giovanitti, Sara
Giraldi, Bob
Glaser, Milton
Glazer, Jacob
Gleason, Maureen R.
Glicksman, Jon
Gnafkis, Nassos
Gobé, Marc
Gold, Bill
Goldfarb, Roz
Goldstrom, Mort
Goodfellow, Joanne
Goodin, Jennifer
Goodwin, Ray
Goshi, Minoru
Gothold, Jon
Gottlieb, Michael W.
Gottlieb, Jonathan W.
Govoni, Jean
Grace, Roy
Granger, Tony
Green, Beth
Green, Erica
Greenberg, Karen L.
Greiss, Abe S.
Grey, Judith
Griffin, Jack
Groglio, Glen P.
Growick, Phillip
Grubshteyn, Raisa
Gruppo, Nelson
Gumus, Remzi
Hack, Robert
Hagel, Bob
Haiman, Kurt V.
Haines, Jennifer
Hall, Crystal
Halvorsen, Everett
Hama, Sho
Hambly, Terra
Hamilton, Lewis
Haney, David
Harris, Cabell
Hasting, Julia
Heins, William
Heit, Amy
Heller, Steven
Hendler, Noah
Hendler, Jared
Hensley, Randall
Hentea, George
Hewitt, Victor
Higgins, Kristin
Hill, Chris
Hill, Andy
Hillsman, Bill
Hirsch, Peter
Hively, Charles
Hodges, J. Drew
Hoffenberg, Harvey
Hoffner, Marilyn
Holbrook, Christina
Holden, Robert

Holguin, Rafael A.
Holland, Barry K.
Horn, Steve
Hortens, Michael
Hughes, Daniel M.
Hutter, Brian
Ilic, Mirko
Inada, Manabu
Ito, Miro
Jackson, Christina
Jacobs, Harry
Jacobs, Sharona
Jaffee, Lee Ann P.
Jamison, John E.
Javit, Nuri D.
Jerina, Patricia
Jervis, Paul
Jeurissen, Dimitri
Johnston, John
Jones, John
Josephs, Dan
Jubert, Joanne
Kalam, Ahmer
Kalayjian, Vasken
Kamen, Jonathan
Kaprielian, Walter
Kay, Leslie
Kay, Norman
Keavy, Caroline
Kelly, Billy
Kelly, Brian
Kenney, Richard
Kent, Nancy
Kessenich, Diane F.
Khaja, Samarra
Kiesche, Paul
Kikutake, Satohiro
Kinch, Greg
Kindred, Amy
Kirshenbaum, Susan
Kittredge, Christel
Klein, Judith
Kline, Robert
Klyde, Hilda Stanger
Kner, Andrew
Knoepfler, Henry O.
Kohler, Nani
Komai, Ray
Kopeck, Jeanne
Koranache, Benier J.
Korpijaakko, Kati
Kovich, Steven
Krauss, Agnes
Krieger, Veronique
Kroencke, Anja
Kuhn, Peter
Kusunoki, Masako
Kutsovskaya, Lina
La Petri, Anthony
LaFleur, Stephanie
Lakloufi, Greg
Lange, Poul
LaRocca, Mark
LaRochelle, Lisa
Lash, Robyn
Laubach, David
Lavish, Anastasia
Lawrence, Mark M.
Lazzarotti, Sal
Lee, Mark
Lee, Paul
Lee, Jennie
Leeds, Gregory B.
Leon, Maru
Leone, Cheri
Levine, Rick
Levy, Richard S.
Levy, David
Levy, Sari
Liberace, Mairead
Lim, Huy Iu
Lin, Autumn
Linskey, John
Lipetz, Ellie
Liska, Steven
Litt, Sarabeth
Livingston, Deborah
Lloyd, Douglas
Locke, Monda Robin
Lois, George

Lott, George
Love, Ong-shen Barbara
Lubell, Ruth
Lucci, John
Lucker, Haniph Sandra
Ludes, Antonia
Luger, Diane
Lyons, Michael J.
MacFarlane, Richard
MacInnes, David H.
Macrini, Carol Dietrich
Magdoff, Samuel
Maglionico, Linda
Magnani, Lou
Maisel, Jay
Manfredi, Michael
Mann, Romy
Marcellino, Jean
Marchese, Frank
Marcy, Tosca
Margolis, David R.
Marino, III Leo J.
Mariucci, Jack
Mariutto, Pam
Marmet, Roger
Marquez, Andrea
Marquez, Jocelyn
Marsh, Julie Lamb
Marzena, Marzena
Mason, Joel
Masson, Baily Linda
Matsumoto, Kiyotaka
Matura, Nedeljko
Mayer, Susan
Mayhew, Marce
Mayoral-Medina, Margarita
Mazzola, Michael
McBride, Matthew
McCaffery, William
McCarron, Stephen
McCarthy, Gillian
McDonald, Lauren
McMayo, Nasser
McQueen, Sean Louis
Medalia, Jaye
Meher, Nancy A.
Merkley, Parry
Merritt, Suzan
Metz, Mike
Metzdorf, Lyle
Metzner, Jeffrey
Meyer, Jackie Merri
Mezzone, Linda A.
Mifsud, Carin A.
Mihaltse, Elizabeth
Milbauer, Eugene
Miller, Joshua
Miller, Lauren J.
Milligan, John
Millikan, Amy
Millon, Irene
Mininni, Theodore A.
Minor, Wendell
Miranda, Michael
Mitchell, Susan L.
Mitchell, Patrick
Modenstein, S.A.
Monahan, Jeffrey S.
Mongkolkasetarin, Sakol
Montebello, Joseph
Montone, Ken
Moore, Tina
Moore, Behrens Diane
Moran, Paul
Moran, Jim
Morioka, Noreen
Morita, Minoru
Morris, Allison
Morrison, William R.
Moses, Louie
Moss, Clark
Munoz, Roberto
Muollo, Kimberly
Murer, Sophia
Musick, Marla
Musmanno, Anthony M.
Nardone, Joseph
Nash, Wylie H.
Navon, Orna
Nessim, Barbara

Newman, Susan
Ng, William
Nicholas, Maria
Nichols, Mary Ann
Nicosia, Davide
Nieman, Janice
Nissen, Joseph
Nobuto, Yoji
Noether, Evelyn
Norman, Barbara J.
Norris, Roger
Norton, Thomas
Noszagh, George
November, David
Nuell, Robert
O'Connor, Sandra
O'Reilly, Jane
Oberlander, Bill
Ohrt, Darryl
Okladek, John
Okudaira, Yukako
Olenyik, Hope
Orange, Lisa
Orlov, Christian
Ortiz, Jose Luis
Osius, Gary E.
Ovryn, Nina
Owett, Bernard S.
Paccione, Onofrio
Pace, Richard
Paganucci, Frank
Pallas, Brad
Panter, Andrew A.
Paradiso, Nicole
Parente, Lawrence
Park, Sam
Paz, Janet
Pearson, Marshall Tabitha
Pedersen, B. Martin
Peeri, Ariel
Perez-Nash, Maria
Perry, Harold A.
Peslak, Victoria I.
Petrocelli, Robert
Pettus, Theodore D.
Pfeifer, Robert
Pham, Anh Tuan
Philiba, Allan
Phipps, Alma
Pion, Carlos
Pioppo, Ernest
Pliskin, Robert
Polenghi, Evan
Powell, Neil
Pozzi, Monica E.
Puckey, Donald
Pulice, Mario J.
Quinn, Maryalice
Raboy, Doug
Ragusa, Maria
Rasheed, Nikki
Rathsam, Laura J.
Ray, Dennis Paul
Raznick, Ronald T.
Reed, Samuel
Reed, Barbara
Reilly, James
Reinke, Herbert
Reitzfeld, Robert
Remington, Dorothy
Renaud, Joseph Leslie
Reuss, David H.
Rhodes, David
Richards, Stan
Richardson, Hank
Richmond, Cox Phyllis
Riera, Laura
Rigelhaupt, Gail
Ritter, Arthur
Roberts, Joseph
Robertson, Scott
Robin, David
Robinson, Bennett
Rockwell, Harlow
Rodin, Yana
Rodriguez, Carolina
Rodriguez, Magdalena
Rodriguez, Nelson
Rogers, Brian
Romano, Andy

Romano, Dianne M.
Rosenfeld, Joel
Rosner, Charlie
Ross, Richard J.
Ross, Peter
Rossano, Fabian
Roston, Arnold
Rowe, Alan
Rubenstein, Mort
Rubin, Randee
Russell, Henry N.
Russo, Deborah
Ruther, Don
Ruzicka, Thomas
Sabnis, Rahul
Sacklow, Stewart
Sagmeister, Stefan
Saido, Tatsuhiro
Saks, Robert
Salkaln, Don
Salpeter, Robert
Salser, James
Salzano, James
Samerjan, George
Sams, Christoper
Sander, Vicki
Sawaf, Khaled
Sayles, John
Saylor, David J.
Scali, Sam
Scarfone, Ernest
Schaefer, Peter J.
Scher, Paula
Scher, Sandra
Scherrer, Randall
Scheuer, Glenn
Schilling, Sue B.
Schimmel, David
Schmalz, Paul
Schmidt, Klaus F.
Schneider, Stephen
Schrager-Laise, Beverly
Schroeder, Jill
Schultz, Eileen Hedy
Schwartz, Judith
Scoble, Stephen
Seabrook III, William
Seabrook IV, William
Seagram, Blair
Sedelmaier, J.J.
Segal, Ilene
Segal, Leslie
Seichrist, Pippa
Seidler, Sheldon
Seisser, Tod
Senecal, Michelle
Seow, Roy
Seow, Roy
Shachnow, Audrey
Shah, Kaushal R.
Sheffield, Susan
Shocher, Erez
Shova, Martin
Shumanov, Jasmine
Siden, Alexis
Silveira, Karen
Silverstein, Louis
Sim, Gyoo J.
Simmons, Rosemary
Simon, Johnson Andrew
Simpson, Milton
Singer, Leslie
Singer, Craig
Sirowitz, Leonard
Sloan, Cliff
Smith, Carol Lynn
Smith, Robert S.
Smith, Maureen
Smith, Virginia
Solomon, Russell L.
Solomon, Martin
Sosnow, Harold
Souder, Kirk
Spears, Harvey
Spinnell, Spencer
Spurlin, Brandon
Stanco, Susan
Stanfield, Aeon
Stanton, Mindy Phelps
Stauffer, Brian

Steele, Max
Steele, Dani
Stefanides, Dean
Steigelman, Robert
Steinbrenner, Karl
Stern, David W.
Sternbach, Ilene
Stevenson, Monica
Stewart, Daniel E.
Stewart, Gerald
Stewart, Richard
Stoffers, Marlene
Stone, Bernard
Stone, Charles
Stonebrecker, Dawn
Stoohs, Kevin R.
Storrs, Lizabeth
Stout, D.J.
Strongwater, Peter
Strosahl, William
Stroud, Steve
Stubi, Gerhard
Sudell, Mark
Sutton, Ward
Szorenyi, Emese
Taddoni, Virginia
Tague, Lauren
Tamblyn, Stephanie
Tashian, Melcon
Tauss, Jack G.
Taylor, Tracey
Tekushan, Mark
Tessler, Jonathan
Thorton, Jamie
Tibbetts, Susan
Tong, Joey
Tonuzi, Flamur
Toole, Lissa
Townsend, Tom
Tracy, Kieran
Trasoff, Victor
Trippetti, Mark
Trombley, Michele
Truppe, Doug
Tsiavos, Staz
Tsukerman, Roman
Tully, Joseph P.
Tung, James
Twomey, John D.
Udell, Rochelle
Valter, Stephan
Vasquez, James R.
Vazquez, Juan
Velgot, Jim
Viggiano, Jean
Vila, Manny
Vipper, Johan
Vitale, Frank A.
Vogler, David L.
Von Collande, Constance
Wachtenheim, Dorothy
Wahler, Adam
Wajdowicz, Jurek
Walker, Sonia
Wallace, Joseph O.
Wallace, Hannah
Walsh, Brendan
Walsh, Rose
Wang, Yong Zhi
Warakomski, Jennifer
Warner, Dorene
Watanabe, Catsua
Weber, Jessica
Weeeng, Joy
Weinstein, Roy
Weiss, Marty
Weiss, Jeff
Weithas, Art
West, Robert Shaw
Wilde, Richard
Williams, Allison
Wilmer, John Cody
Wittenberg, Ross
Wolan, Alan
Wolf, Jay Michael
Wolf, Juliette
Wong, Nelson
Wood, Ray
Woods, Laura E.
Woodward, Fred

Yamamoto, Naomi
Yang, Kyong
Yates, Peter
Yeh, Vincent
Yonkovig, Zen
Young, Jaci
Yu, Joon
Yurman, Joan
Zacks, Linda
Zaidi, Nadime
Zeigerman, David
Zheng, Ron L.
Zhukov, Maxim
Zielinski, Mikael T.
Ziff, Lloyd
Zilberman, Edward
Zlotnick, Bernie
Zwiebel, Alan H.

ARGENTINA
Stein, Guillermo
Vidal, Jorge
Visco, Sebastian

AUSTRALIA
Dilanchian, Kathryn
Musson, Alexander James
Weimer, Sylvia

AUSTRIA
Demner, Mariusz Jan
Klein, Helmut
Lammerhuber, Lois
Lammerhuber, Silvia
Merlicek, Franz
Reidinger, Roland A.

BRAZIL
Antacli, Fabiana
Cipullo, Sergio

CANADA
Aranoff, Robert
Atkinson, Brent
Beckerle, Matthew
Carter, Rob
Lacroix, Jean-Piere
Morgan, Stephen
Neray, Michel
Power, Stephanie
Riordon, Ric

CHILE
Cavia, Manuel Segura

CHINA
Freyss, Christina
Liu, Esther
Tin-yau, Martin K.
Xu, Wang
Yu, Zhu

ENGLAND
Hamm, Garrick
Shearing, Jeremy

FINLAND
Bergqvist, Harald
Manty, Kirsikka
Piippo, Kari
Virta, Marjaana

FRANCE
Delarue, Delphine
Leconte, Michel

GERMANY
Aumann, Oliver
Bagios, Jaques
Becker, Manfred
Brockmann, Heike
Ernsting, Thomas
Haas, Harald
Hebe, Reiner
Holzer, Felix

Koch, Claus
Leu, Olaf
Meier, Erwin
Mojen, Friederike
Mojen, Ingo
Nebl, Lothar
Nolte, Gertrud
Prommer, Helga
Schneider, Frank
Scholz, Anette
Spiekerman, Erik
Van Meel, Johannes
Volkmer, Michael
Von Falkenburg, Rene

IRELAND
Nolan, Eoghan

ISRAEL
Reisinger, Dan

ITALY
Diaferia, Pasquale
Fabiani, Titti
Moretti, Gianfranco
Poggio, Carlo
Ragone, Rocco
Sala, Maurizio

JAPAN
Akiyama, Takashi
Aoba, Matuteru
Aotani, Hiroyuki
Asaba, Katsumi
Fujishiro, Norio
Fukushima, Shigeki
Furumura, Osamu
Hirai, Akio
Hiroaki, Izumiya
Hosoda, Kazunobu
Inoue, Kogo
Iokawa, Hiroaki
Ito, Yasuyuki
Iwata, Toshio
Izutani, Kenzo
Kaneko, Hideyuki
Kashimoto, Satoji
Katsui, Mitsuo
Katsuoka, Shigeo
Kida, Yasuhiko
Kinoshita, Katsuhiro
Kisso, Hiromasa
Kitazawa, Takashi
Kiyomura, Kunio
Kobayashi, Pete
Kojima, Ryohei
Kotani, Mitsuhiko
Krakower, Pepie
Matsumoto, Arata
Matsumoto, Takao
Matsunaga, Shin
Matsuura, Iwao
Miyasaka, Kuniaki
Mizutani, Koji
Morimoto, Junichi
Mutsuo, Iwaki
Nagatomo, Keisuke
Nakajima, Hideki
Nakazawa, Jun
Nishimura, Yoshinari
Nobumitsu, Oseko
Nogami, Shuichi
Nomura, Sadanori
Oba, Yoshimi
Ohama, Yositomo
Ohashi, Toshiyuki
Ohkura, Kyoji
Ohsugi, Manabu
Ohsugi, Gaku
Okumura, Akio
Saito, Toshiki
Sakamoto, Hiroki
Sakamoto Ken
Shigeo, Okamoto
Shimagami, Koichi
Shinmura, Norito
Suguira, Shunzaku
Suzuki, Zempaku

Takahama, Yutaka
Takahara, Matsumoto
Takanokura, Yoshinori
Takeo, Shigeru
Takeshi, Kagawa
Tanabe, Masakazu
Tanaka, Ikko
Tanaka, Soji George
Tanaka, Hiroshi
Tomoeda, Yusaku
Uejo, Norio
Watanabe, Yoshiko
Watanabe, Masato
Yamamoto, Akihiro H.
Yamamoto, Yoji
Yoshida, Masayuki
Zama, Kaoru

KOREA
Chung, Joon
Chung, Bernard
Kim, Kwang Kyu

MALAYSIA
Lee, Yee Ser Angie
Wong, Peter

MALTA
Ward Edwin

MEXICO
Beltran, Felix
Ramirez, Luis

THE NETHERLANDS
Brattinga, Pieter
Dovianus, Joep

PHILIPPINES
Abrera, Emily A.
Pe, Roger B.

POLAND
Lempke, Christopher
Piechura, Tadeusz

PORTUGAL
Aires, Eduardo
Anelli, Luigi Montaini

ROMANIA
Musteata, Silviu

RUSSIA
Leonid, Feigin
Pioryshkov, Dmitry

SOUTH KOREA
Hong, Dong-Sik

SPAIN
Bermejo Ros Ricardo

SWEDEN
Jikander, Theodor
Kurppa, Thomas
Olsson, Olle
Palmquist, Kari
Petersson, Percy

SWITZERLAND
Bundi, Stephan
Dallenbach, Bilal
Gaberthuel, Martin
Jaggi, Moritz
Netthoevel, Andréas
Oebel, Manfred
Schuetz, Dominique Anne
Syz, Hans G.
Welti, Philipp

THAILAND
Eng, Chiet-Hsuen

The Art Directors Club mourns all
who were lost on September 11, 2001
and thanks members and friends around
the world for their expressions of
concern and solidarity.

index

NEW MEDIA AGENCIES AND STUDIOS

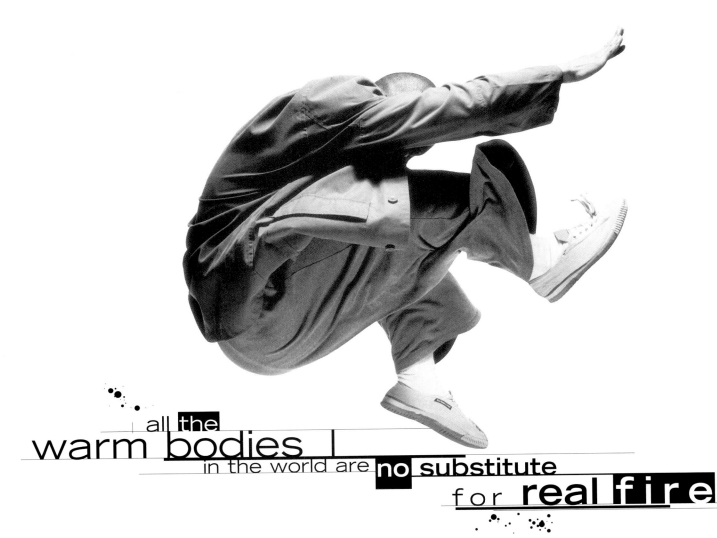

all the warm bodies in the world are **no substitute** for **real fire**

Freelance designers. Production artists. Writers. Aquent represents and places
more of them than any other talent agency on Earth. And each and every Aquent freelancer
is screened, interviewed, and assessed before we add them to our ranks.

Now we can do even more to help you hire the people you need.
Because **RitaSue Siegel Resources,** a search and consulting firm with more than 30 years'
experience, has become an Aquent company. This makes us uniquely qualified to fill
your management and director-level positions in graphics, industrial, interior,
environmental, and architectural design as well.

Learn how we bring new passion to work.
Call **877-2-AQUENT (877-227-8368).** And visit **aquent.com**
to see thousands of our freelancers' portfolios online.

AQUENT
International Career Partner
of The Art Directors Club

You make the commercials that people like to see again and again and again and again. Thanks for making every second count.

TAKE A BOW. TAKE ANOTHER.

RE

DNW

I want
one person, vertical, splattered, exhaustion, american, outdoors, success

I need
gettyimages.com

The new discovery engine from Getty Images. Resources for your creativity at
your fingertips, in your mind, in your work.

images.motion.fonts.audio.services. 800 462 4379

By Getty Images

Stone	FPG
PhotoDisc	EyeWire
The Image Bank	Artville
Allsport	National Geographic
Image Bank Film	Archive Films
Hulton Archive	and …

YOUR TIME – We value it as if it were our own. That's why Merrill/Daniels offers all the tools, technology and service you need to produce any type of print project – from quality-sensitive annual reports and other showpieces to quick-turnaround jobs to highly customized, targeted marketing pieces. All the resources you need in one place. That leaves more time for you. **Isn't it about time?**

M E R R I L L / D A N I E L S

40 Commercial Street | Everett, Massachusetts 02149 | 617.389.7900 | 800.553.7733
225 Varick Street | New York, New York 10014 | 212.620.5600
6 Way Road | Middlefield, Connecticut 06455 | 860.349.7056

NEED WHIZBANG?

CRACKERJACK DESIGN!

KILLER SERVICE!

WHIZBANG PRODUCTION!

1981 Marcus Avenue
Lake Success, NY 11042
voice 516/352-4505
fax 516/352-3084

IBC SHELL
WORLDWIDE
IMPORTED PACKAGING

YOU WANT MORE?? TRY........
outrageouspackaging.com

A Superstar of the IBC Corporate Group

©IBC 2001

...in search of digital culture

art style design goods reviews architecture sound screen interviews

PHOTOGRAPHY: RYAN PETERS

artbyte

Working hard every day.
Portfolio Center. The School for Design & New Media
Writing, Art Direction, Photography & Illustration
125 Bennett Street Atlanta, GA 30309
Call 1.800.255.3169 x19

Visit www.portfoliocenter.com

Design
Events
Fall 2001

The
Cooper
Union
School
of Art

g r a
p h i
c o o
p e r

Please call 212.353.4207 or 4021

All events
are free
and open
to the public

No reservations
are required

Design Lecture Series in The School of Art

All lectures take place on Monday evenings at 6:30 pm

Wendy Siuyi Wong
September 17
Wollman Auditorium
The Past and the Future:
Politics and History
of Graphic Design in
Greater China

Mervyn Kurlansky
October 15
Wollman Auditorium

Alain Le Quernec
October 29
Wollman Auditorium

Massin & Milton Glaser
in Conversation
November 5
The Great Hall
Moderated by
Robert Rindler, Dean,
The Cooper Union
School of Art

Luba Lukova
November 26
Wollman Auditorium

Bruno Monguzzi
December 10
Wollman Auditorium

Wollman Auditorium
Albert Nerken School of Engineering
51 Astor Place
between Third and Fourth Avenues

The Great Hall
The Foundation Building
7 East 7th Street at Third Avenue
Lower Level

Exhibitions in The Herb Lubalin Study Center of Design and Typography

Chinese Graphic Design
Towards the International Sphere
September 4 through October 13

Opening reception following curator's lecture
Monday, September 17, 8 to 10 pm

New scholarship on modern graphic design
in China, telling the story of its development
and emergence onto today's international
stage. Includes over 100 works of graphic
design — posters, advertisements, logos,
books, editorials and typography — from
the Greater China Region of Hong Kong,
Taiwan, Macau and mainland China.

Massin In Continuo: A Dictionary
October 30 through December 15

Opening reception
Tuesday, October 30, 6 to 8 pm

An interpretive alphabet guides viewers through
the depth and range of Massin's multiple roles
as a book designer, typographer, art director,
author and photographer in celebration of
his interest in alphabets. The exhibition
includes books, posters, photographs and
ephemera never seen in the United States.

The Herb Lubalin Study Center of Design and Typography
The Foundation Building
7 East 7th Street at Third Avenue

Exhibition hours:
Weekdays 11 to 7; Saturdays 1 to 5;
Closed Sundays and holidays

Lecture series and exhibitions organized by
Philippe Apeloig, Ann Holcomb and Robert Rindler

MARENGO TABLES

Design D'Urbino, Lomazzi
Cameo Carlo Poggio

ZERO FURNITURE

U.S.A.
Zero U.S. Corporation
Industrial Circle - Lincoln, RI 02865
Tel. (401) 724-4470
Fax (401) 724-1190
www.zerous.com
zerous@earthlink.net

New York showroom
560 Broadway - STE 606
New York, NY 10012
Tel. (212) 925-3615
Fax (212) 925-3634
zeroshowroom@earthlink.net

P. 212.529.4550
F. 212.529.8248
900 broadway. suite 606
new york. ny 10003

vertigo design www.vertigodesignnyc.com

P. 212.529.4550
F. 212.529.8248
900 broadway. suite 606
new york. ny 10003

http://
www.
idea-mag.
com

 Go BAG
 Go BOARD
 GoCAMP
 GO.COASTER "Coasters Coast to Coast"
 GoCONDOM

 GoCUP
 GoFORTUNE
 GoGLASS
 GoHANGER
 Go INDOOR

 GoMATCHES
 GoMONEY
 GoPIZZA
 GoPOSTER

 GoSAMPLING
 GoSCHOOL
 GoSIDEWALK
 GO SPRING BREAK!

 GoSWIZZLE
 GoWHIZZ
 Go WIPES
 GoZARF
 WILD CARD

GoMODELS

GoNAPKIN

GoPOST

Go PROJECTION

GoSUGAR

GoGORILLA MEDIA ☎ 212-925-2420 · "Advertising Will Never Be The Same"

CREATIVE REVIEW IS A MAGAZINE 12 ISSUES A YEAR ON GRAPHIC DESIGN, ADVERTISING, PHOTOGRAPHY, NEW MEDIA, ILLUSTRATION, TYPOGRAPHY, FILM AND EFFECTS. THE HOTTEST NEW TALENT. THE LATEST TRENDS. THE BEST NEW WORK. THE SHARPEST ANALYSIS A POSTER SIX-PAGE PULL OUT CENTREFOLD POSTER BY A LEADING IMAGEMAKER FREE WITH EVERY ISSUE. PREVIOUS CONTRIBUTORS: ELAINE CONSTANTINE, IAN WRIGHT, EBOY, JASON EVANS, FUTURA 2000, JOHN WARWICKER, TOBY MCFARLAN POND, LAURENT FETIS, PAUL DAVIS, PHIL POYNTER A DVD TWO ISSUES A YEAR. ALL THE MAJOR AWARD WINNERS. THE BEST COMMERCIALS, MUSIC VIDEOS, SHORT FILMS, PHOTOGRAPHY, MOTION GRAPHICS, ANIMATION, MULTIMEDIA, MOTION GRAPHICS, ILLUSTRATION. ABSOLUTELY FREE TO SUBSCRIBERS A WEBSITE SEARCHABLE EDITORIAL ARCHIVE. BREAKING NEWS. TOP JOBS. WWW.CREATIVEREVIEW.CO.UK. FULL ACCESS FREE TO SUBSCRIBERS **MALCOLM GARRETT SAYS** CREATIVE REVIEW HAS ITS INNOVATIVE FINGER ON THE PULSE OF ALL THAT IS NEW IN THE CREATIVE WORLD **TREVOR BEATTIE SAYS** ONCE YOU'VE HAD CREATIVE REVIEW, ALL OTHER MAGAZINES SEEMS SO... RECTANGULAR SUBSCRIBE FAX +44 (0)207 970 4099 OR CALL +44 (0)207 292 3703 EMAIL CRCIRC@CENTAUR.CO.UK

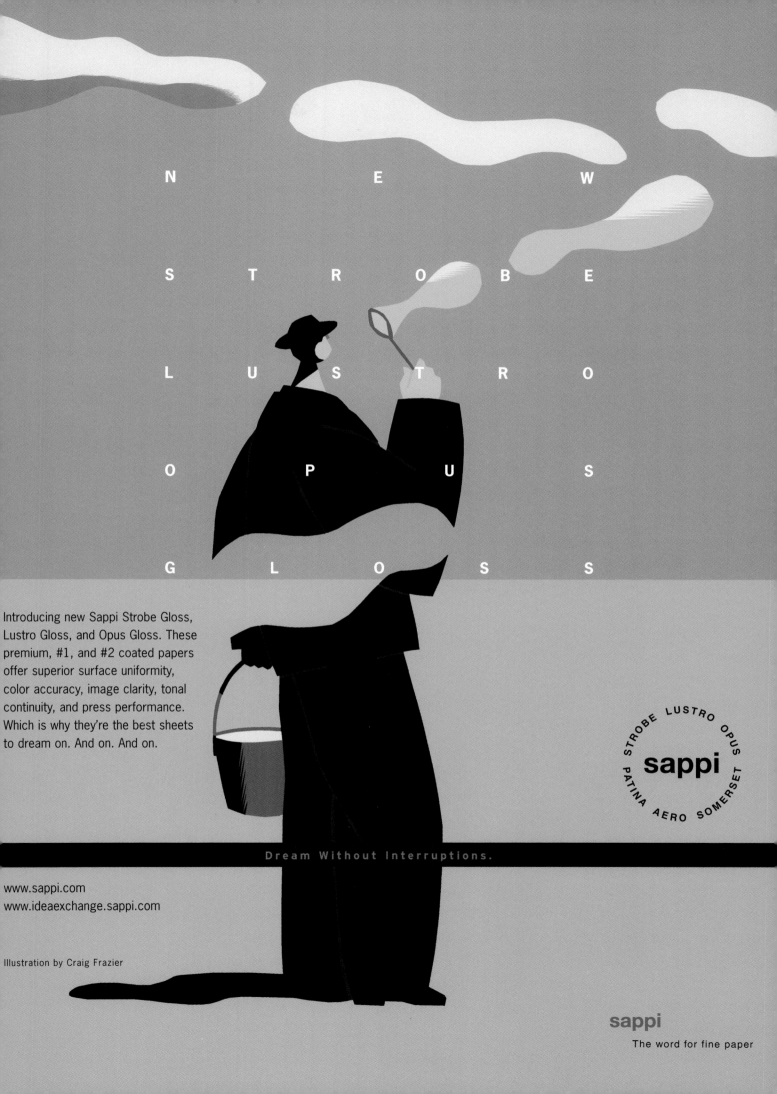

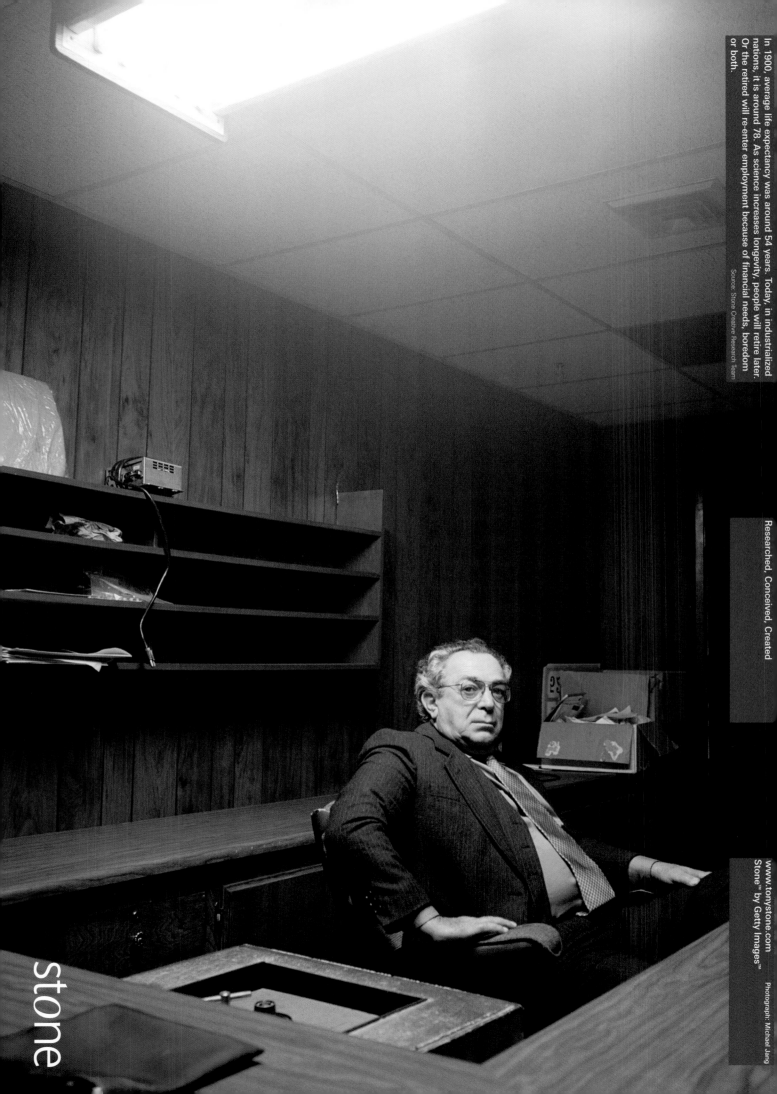

stone